Pre-Columbian Art

Pre-Columbian Art

by LEE A. PARSONS

Photography by Jack Savage

Charts and Drawings by Ryntha Johnson

The Morton D. May
and The Saint Louis
Art Museum Collections

Icon Editions

HARPER & ROW, PUBLISHERS

NEW YORK

Cambridge London
Hagerstown Mexico City
Philadelphia São Paulo
San Francisco Sydney

1817

FIRST EDITION

Designer: C. Linda Dingler

Library of Congress in Publication Data

Parsons, Lee Allen, 1932–
 Pre-Columbian art.

 (Icon editions)
 Bibliography: p.
 1. Indians—Art—Catalogs. 2. May, Morton D.,
1914– —Art collections—Catalogs. 3. St.
Louis Art Museum—Catalogs. I. Savage, Jack.
II. Johnson, Ryntha. III. Title.
E59.A7P33 1980 730'.0972'074017866 80–7593
ISBN 0–06–437000–3

80 81 82 83 10 9 8 7 6 5 4 3 2 1

For Rose

"—behold Charles the Fifth's day; another, yet the same;
behold Chatham's, Hampden's, Bayard's,
Alfred's, Scipio's, Pericles's day,
—day of all that are born of women.
The difference of circumstance is merely costume."

Ralph Waldo Emerson

Contents

Italic numbers refer to objects illustrated in the catalogue.

A Collector's Note

The art produced in the Americas during the 2,500 years before Columbus ranks with the greatest art known to the world.

In 1520, when the famous artist Albrecht Dürer saw the Aztec artifacts brought back to Europe by Cortes, he wrote in his diary: "But I have never seen in all my days what so rejoiced my heart, as these things. For I saw among them amazing artistic objects, and I marveled over the subtle ingenuity of the men in these distant lands." (Kelemen, 1943, p. 3)

In spite of this high artistic praise, during the next 425 years Pre-Columbian artifacts were considered more often objects of archaeological interest than artistic quality. In recent years art museums and collectors have finally reappraised Pre-Columbian art, and now appreciate its aesthetic beauty. Top-quality clay figurines, painted or carved bowls, gold and jade jewelry, stone objects, and the like are both rare and high-priced.

My first interest in Pre-Columbian art came in the late 1930s, when I saw two large Nayarit figures in Chicago at the apartment of the well-known collectors Mr. and Mrs. Samuel Marx. These polychromed terra cotta figures from the West Coast of Mexico produced around A.D. 100 to 300 were so powerful and expressive that I wanted to start collecting Pre-Columbian sculpture for my new modern house, which Mr. Marx was designing. However, World War II started before the house was finished, and I was in active service in the Navy until the end of 1945. Shortly after the war, I began reading whatever illustrated literature I could find, and started looking for Pre-Columbian art dealers.

Early in 1947 a young St. Louis painter, who had been working in Mexico, returned with a collection of small Colima figures which he hoped to sell to finance another year of painting in Mexico. These small Colima figures started my Pre-Columbian collection, and some of them are at The St. Louis Art Museum. Soon afterwards I began to make purchases from galleries on the West Coast.

In 1958 on a business trip to Los Angeles I learned that a collection of Colima pottery vessels, reputed to be the best in existence, might be available. I immediately went after it, and was able to acquire this collection of forty-five top-quality pieces, which are now in The St. Louis Art Museum. While I continued to make individual purchases, both in New York and on the West Coast, I was fortunate in the sixties to obtain an important collection of Zapotec urns and a large part of the Pepper Preclassic collection. These two purchases, along with the Colima pottery vessels, formed the nucleus of my collection.

While some Pre-Columbian cultures produced art clearly superior to others, it is this collector's opinion that every culture produced some objects with artistic merit. One of the most interesting aspects of Pre-Columbian art is the great variety of styles. Yet it is not usually difficult to identify the cultures to which objects belong, regardless of whether they were created in different areas at approximately the same time or in the same areas in different epochs.

Many types of artifacts from many different cultures are represented in my collection, and while there was some concession to forming a collection of archaeological significance, my basic interest was to acquire objects of aesthetic quality that could some day be at home in The St. Louis Art Museum.

<div style="text-align: right">Morton D. May</div>

Preface

The St. Louis Art Museum houses one of the most comprehensive and distinguished Pre-Columbian art collections among American art museums, owing mainly to the discerning collecting efforts of Morton D. May. The total Museum collection in this area numbers about 3,000 objects, of which about 500 have been selected for illustration and discussion in this "catalogue." Heretofore, The St. Louis Art Museum has not been sufficiently known for Pre-Columbian art, in that relatively few of the objects had been published or even exhibited in the Museum's galleries. In 1980, however, a permanent pair of exhibition halls for Pre-Columbian art was newly installed following the organization of this book, and incorporating a somewhat larger selection from the collection for public viewing.

Although heavily weighted toward Mesoamerica (70 percent), the collection is unusually well rounded for every significant style, medium, culture, and time period of ancient civilization from Mexico to Peru; and from Olmec and Chavin, to Aztec and Inca. With very few gaps in the above inventory, the collection permits an almost encyclopedic overview of Pre-Columbian America; it will thus serve as a comprehensive text for the art from that area. Other museums have their share of Pre-Columbian masterpieces, but few can match the scope, depth, and overall quality of our collection.

The St. Louis Art Museum began buying Pre-Columbian art as early as 1932, and continued adding fine objects periodically over the next thirty years. For example, a pair of Coastal Tiahuanaco polychrome vessels from Peru was purchased in 1942 [454 and 455], two exquisite Mixtec polychrome ceramics from Mexico in 1950 [158 and 159], and a stunning set of Paracas textiles from the Peruvian South Coast in 1956 [442 and 443]. Through this period, a number of important acquisitions came to the Museum by gift from private collectors, such as a significant group donated by J. Lionberger Davis in 1954. During the 1930s and 1940s, most art museums had no special interest in the Pre-Columbian field, with the notable exception of the Brooklyn Art Museum; natural history and anthropology museums, on the other hand, have been displaying substantial collections for almost a century. Considering the keen and widespread interest in Pre-Columbian art today, it is

difficult to recall the fact that the first general Pre-Columbian art book was not published until the early 1940s, and that was written by an art historian (Pal Kelemen in 1943). The first major special exhibition in an art museum to receive national attention was mounted by The Museum of Modern Art in the early 1950s (Wendell Bennett in 1954), although that was preceded by a little-remembered Pre-Columbian art exhibition held at the Boston Museum of Fine Arts a third of a century before. Currently, most art museums devote some permanent gallery space to New World archaeology.

The St. Louis Art Museum credits its exceptional strength in the Pre-Columbian field to the private collection of one local benefactor, Morton D. May. He actively collected Pre-Columbian objects from the late 1940s through the 1960s, with enthusiasm matched only by Jay Leff in Pennsylvania. Mr. May started loaning massive amounts of this material to the Museum in the mid-sixties.* While certain outstanding objects from the May Pre-Columbian Collection have been donated to the Museum over the past twenty years, in 1978, 1979, and 1980 substantial portions were transferred outright to The St. Louis Art Museum. As a result all May Collection objects in this catalogue have been given to the Museum. A full 86 percent of the Museum's Pre-Columbian holdings were collected by Mr. May; 7 percent were Museum purchases; and 7 percent were presented by other donors.

Areas of exceptional depth in the May Collection include Zapotec urns from Oaxaca (over 100), West Mexican effigy pottery (ca. 150), and Middle Preclassic Mexican figurines and ceramics (ca. 1,500). The last group compromises the better part of the ex-George Pepper Collection, originally assembled in Mexico City by Mr. Pepper and sold in New York in the late sixties. It includes about 1,100 clay figurines of Tlatilco- and Olmec-related types, and about 400 whole pottery vessels and lapidary works of the same styles—all dating between 1200 and 500 B.C. Another parallel group in the May Collection comprises about 100 Tlatilco style figurines and vessels from a mound at San Pablo, Morelos.

The era of large-scale collecting in the Pre-Columbian art field is almost over, due to moves by the U.S. government in the early 1970s to respect and enforce the antiquities laws of the Latin American nations by outlawing the importation of such material. Conscientious museums and private collectors are no longer buying archaeological objects unless it is known that they had been exported before the 1969–72 period. While such documented antiquities will continue to recirculate through dealers and auction galleries, their direct importation to this country from Latin America is no longer acceptable. Therefore, the May Collection is one of the last great private collections to be acquired from a then-booming art market and given to a museum.

The Museum objects illustrated here are primarily sculptural, consisting of relatively small portable ceramics and stone carvings, but including a wide

*His equally important collection of Oceanic art is becoming widely acknowledged through the publication of a special catalogue (Parsons, 1975), and its permanent installation at this Museum. Since 1975, that entire exhibition has been given to The St. Louis Art Museum.

range of media from textiles to wood, shell, and metals. Therefore, this catalogue is not totally representative of the art of the ancient New World civilizations, since it lacks examples of truly monumental stone sculpture and the architecture (but includes some "architectural elements")—both of which were major Pre-Columbian art expressions. We may note that one famous Maya stone monument (Stela 8, Naranjo), on loan from the Guatemalan government, is presently on exhibition at this Museum, although it is not illustrated here.

The general organization of the book is geared to the objects in the collection, although the brief introductory sections are intended to supply a broad survey of the field. The photo captions themselves provide considerable detail and, if read in sequence, comprise a rather complete text of Pre-Columbian art. The presentation is meant to be popular, yet it incorporates frequent dashes of more esoteric information based upon the author's specialized professional experience in Pre-Columbian art and archaeology. Scholarly references have deliberately been kept to a minimum: many assertions lack the citations to existing literature that would be obligatory in a strictly academic publication. But those references considered absolutely necessary are given, plus citations of books where objects were previously published. The fact that the preponderance of the collection has never been published, and that many of the objects are unique, will make this contribution of interest to the specialist as well. Fresh comparative material is as crucial to the scholar as it is exciting to the general art devotee.

Actually, the field archaeologist has very limited access to well-preserved grave goods and luxury items, which the majority of art museum collections represent, because these are rare finds on any particular scientific excavation. Usually, an archaeologist is forced to be content with broken potsherds, and all too often, the New World archaeologist, not being trained in art history, does not know how to classify or interpret a whole pot. The study of art styles, as revealed in the preserved élite objects, is often the sole recourse we have for analyzing the iconography, religion, and ethos of an ancient culture. (The Maya was the only Pre-Columbian civilization to have an advanced system of writing, but even that is not yet completely deciphered for the rich content it will eventually yield.) Unfortunately, too, the nature of the world market in antiquities has been such that most of the objects in museums and private collections were not professionally excavated. As a result, their exact site of origin and original burial associations largely have been lost. Most of this collection had to be identified by art style and comparative research—dealers' provenances not always proving reliable.

The Contents list provides the precise outline of the book, which is arranged geographically from north to south, from Mexico to Peru. The objects have been organized to build a continuous, interrelated picture of the development of the various Pre-Columbian civilizations from the first millennium B.C. to the Spanish conquest. For each art style and cultural region, the objects are sorted from early to late. Pottery vessels (and figurines) are shown

development of the various Pre-Columbian civilizations from the first millennium B.C. to the Spanish conquest. For each art style and cultural region, the objects are sorted from early to late. Pottery vessels (and figurines) are shown first, then the stone and lapidary work, and finally any miscellaneous media for each region.

A word on the format of the headings to the photo captions: the top line says what the object is; this is followed by its geographical and cultural attribution and the Pre-Columbian epoch, with the dates in our chronology; next we name the media; and finally we list the source of acquisition, the Museum catalogue number, and the dimensions of the piece, as well as citing former collections or previous places of publication. In all captions, the word "Purchase" signifies a St. Louis Art Museum acquisition; "Gift" means "Gift of Morton D. May"; in other cases, the complete gift or loan credit is individually spelled out. The essential measurements are calibrated in centimeters (H. = height; W. or D. = width or depth; L. = length; and Diam. = diameter). For the smallest objects, measurements are read to the millimeter; for the larger objects, the dimensions are normally rounded off to the half centimeter. It should be noted that the diacritical, especially accent, marks on Spanish words and proper names generally have been omitted.

While this catalogue in the largest sense is dedicated to Morton D. May, we also wish to credit the other donors, here listed alphabetically: Mr. and Mrs. William Bernoudy, Mr. and Mrs. George K. Conant, Jr., J. Lionberger Davis, Gail and Milton Fischmann, Allan Gerdau, Mrs. John R. Green, Ben Heller, Mr. and Mrs. Alois J. Koller, The May Department Stores Co., Edward Murphy, Mr. and Mrs. Alvin Novak, Alan R. Sawyer, and Mr. and Mrs. Milton Tucker. In addition, there are two "permanent" loans: one from the Archaeological Institute of America [316], and one from the Missouri Historical Society [332].

Finally, it is the author's privilege to acknowledge all those who have contributed significantly to completing a publication. I personally wish to express my pleasure in being given the opportunity to be in curatorial charge of the May Collection and in receiving the utmost cooperation and generosity during the past six years from Marge and Buster May (as well as his secretary, Betty McNichols). I also appreciate the implementation provided by the former Directors, Charles Buckley and James Wood, and especially the new Director, James Burke. The visual merits of the book are to the credit of Jack Savage, with his superb photographs, his empathy for the material, and his spirit of doing a job right. Louise Walker, our coordinator of photography, gave of herself fully to the enormous task, as we have too easily grown to expect of her. Ryntha Johnson, my curatorial assistant, expertly executed all the maps, time charts, and renderings from the objects. Lastly, I would like to thank Lois Gruendler for her patient and careful typing of the final manuscript.

Lee A. Parsons

Pre-Columbian Art

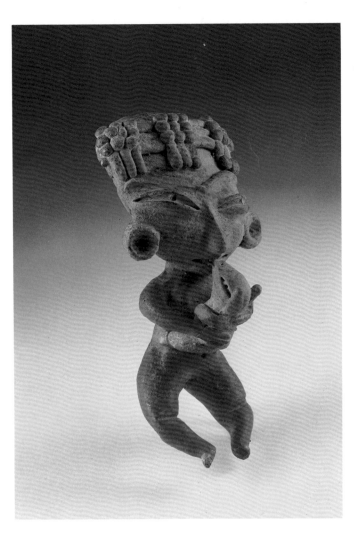

2. Girl With Dog Figurine.
Tlatilco (page 19)

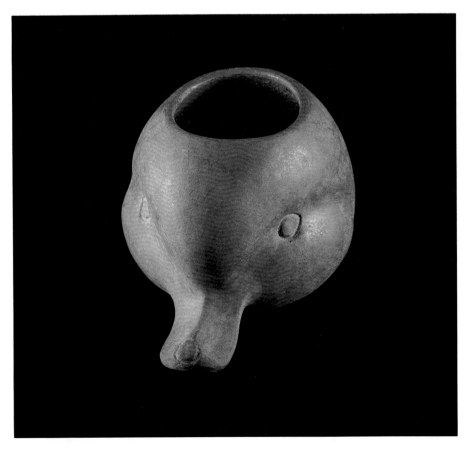

11. Duck-Head Pot.
Tlatilco (page 25)

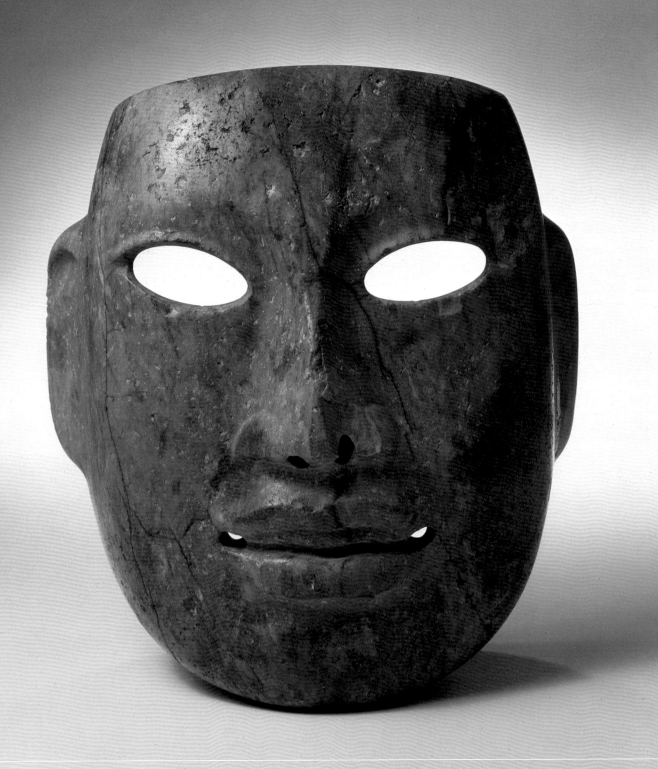

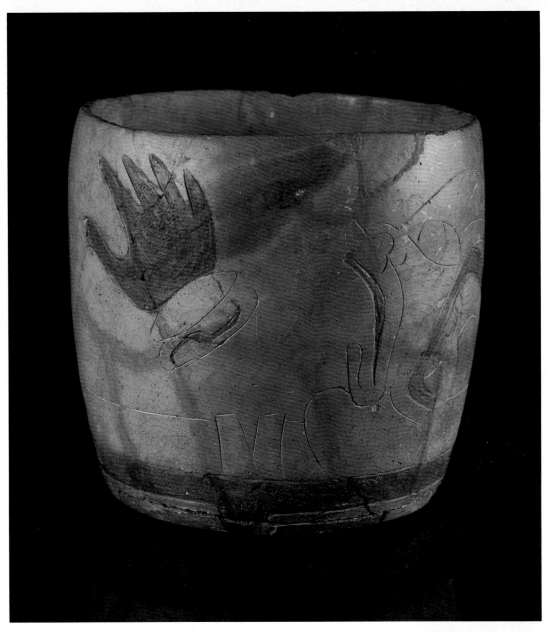

39. Incised Vase.
Olmec (page 41)

59. Fat Demon Jade Pendant.
Post-Olmec (page 55)

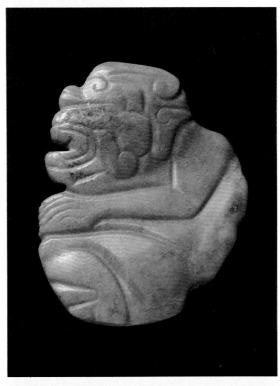

44. Jade Funerary Mask.

Olmec (page 47)

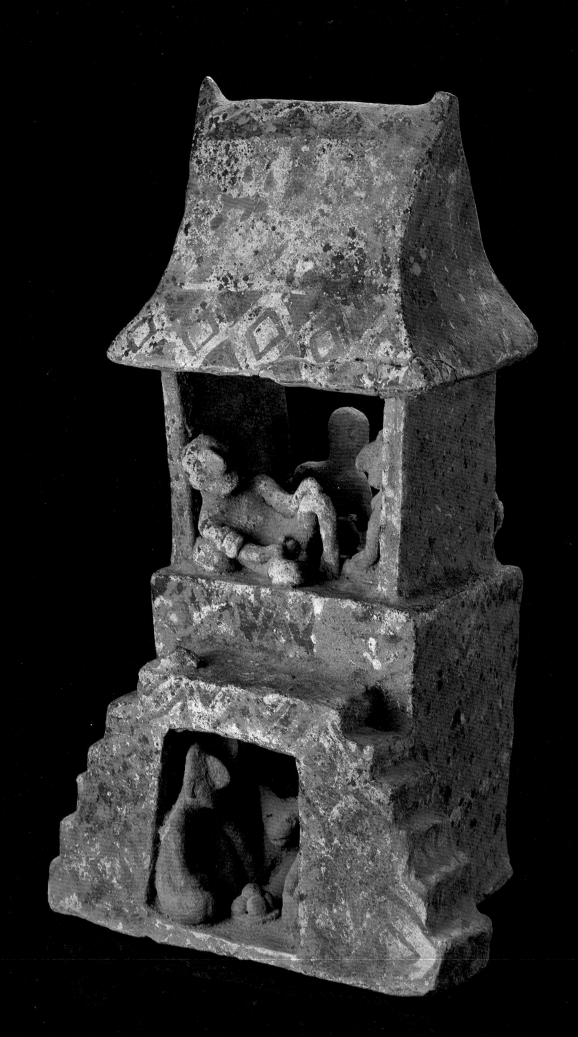

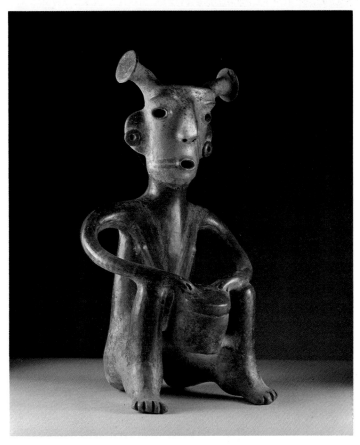

83. Male Drummer.
Zacatecas (page 69)

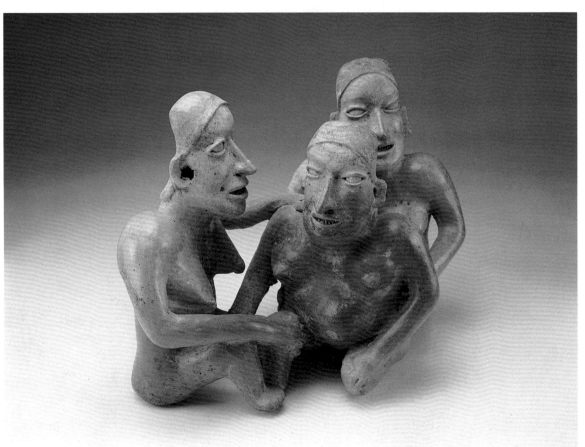

85. Pregnant Woman and Midwife Group.
Jalisco (page 70)

76. Two-Level House Model.
Nayarit (page 65)

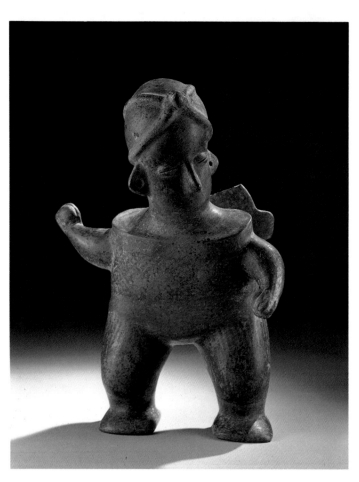

89. Warrior or Guardian.
Colima (page 72)

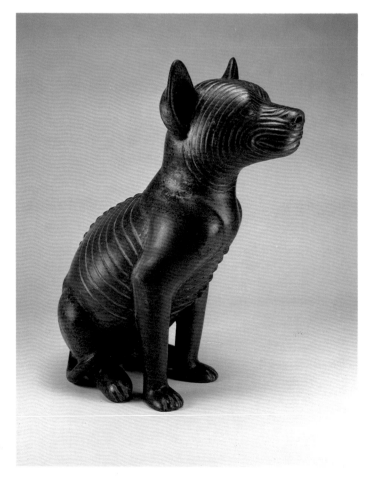

96. Large Seated Dog.
Colima (page 75)

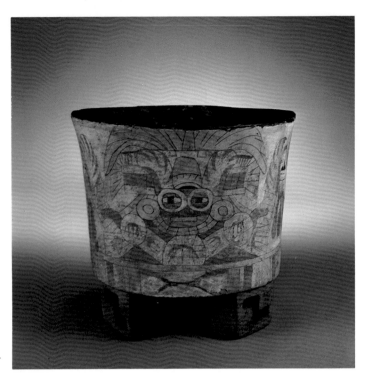

134. Frescoed Cylindrical Tripod Vase.
Teotihuacan (page 98)

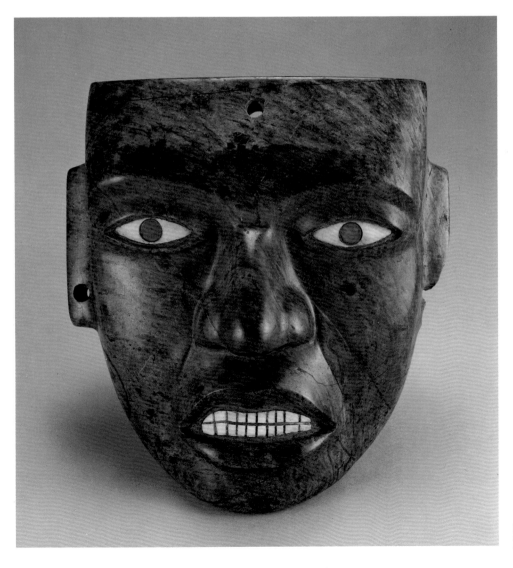

150. Inlaid Stone Funerary Mask.
Teotihuacan (page 106)

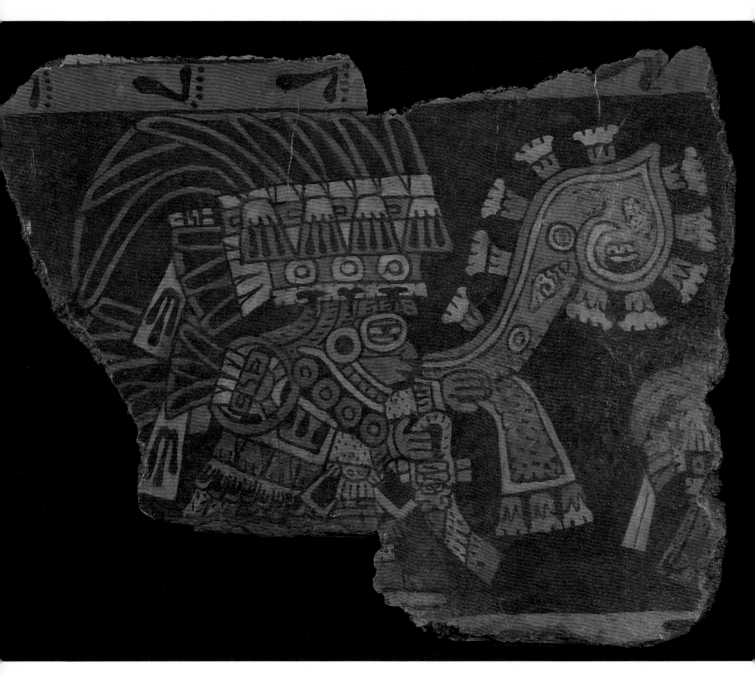

153. Fresco Mural Fragment.
Teotihuacan (page 109)

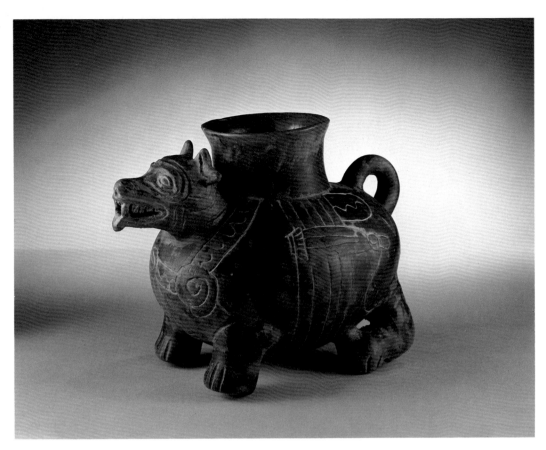

156. Deer Effigy Vessel.
Toltec (page 110)

159. Polychrome Plate.
Mixtec (page 111)

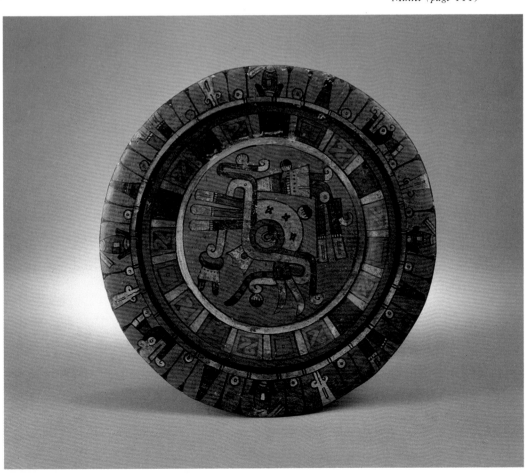

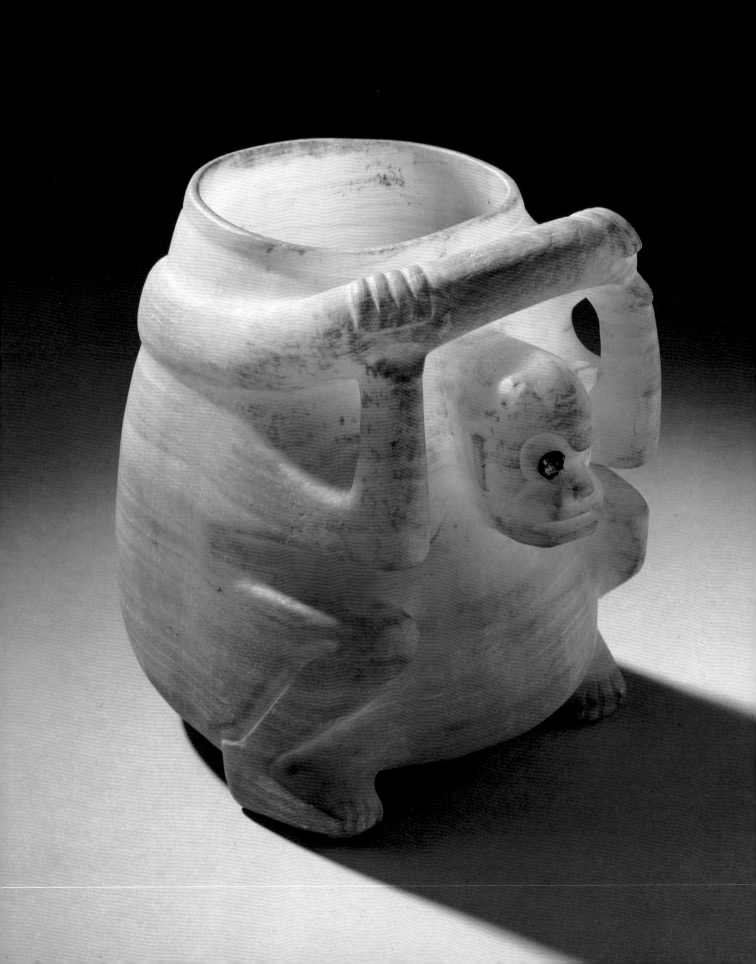

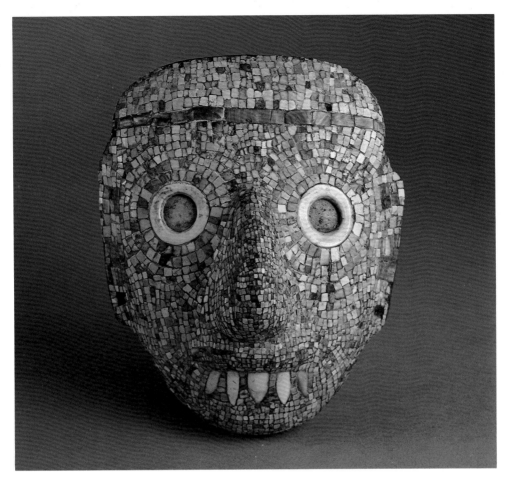

174. Mosaic Stone Mask of Tlaloc.
Mixtec (page 119)

176. Mosaic Wooden Jaguar Pectoral.
Mixtec (page 120)

180. Gold Labret With Eagle.
Mixtec (page 121)

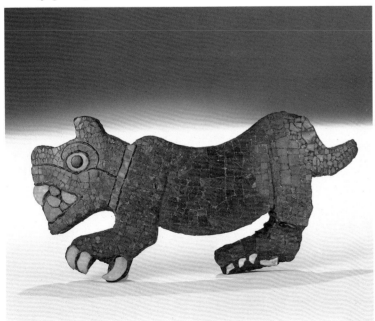

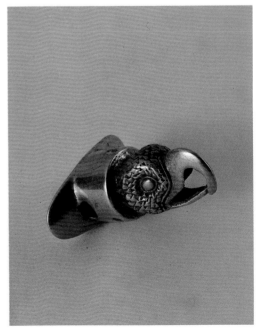

173. Spider Monkey Onyx Vase.
Mixtec (page 118)

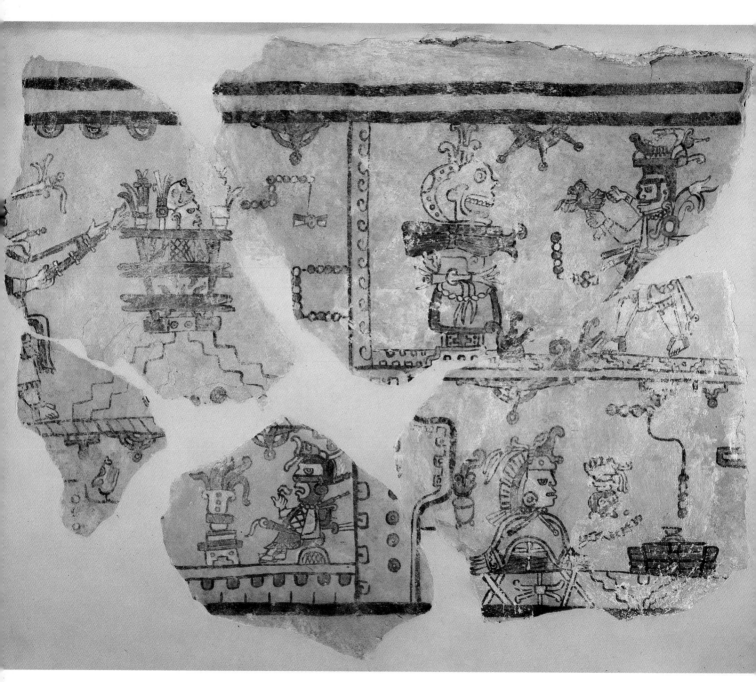

182. Frescoed Mural Fragment.
Mixtec (page 122)

187. Stone Merchant or Slave.
Aztec (page 125)

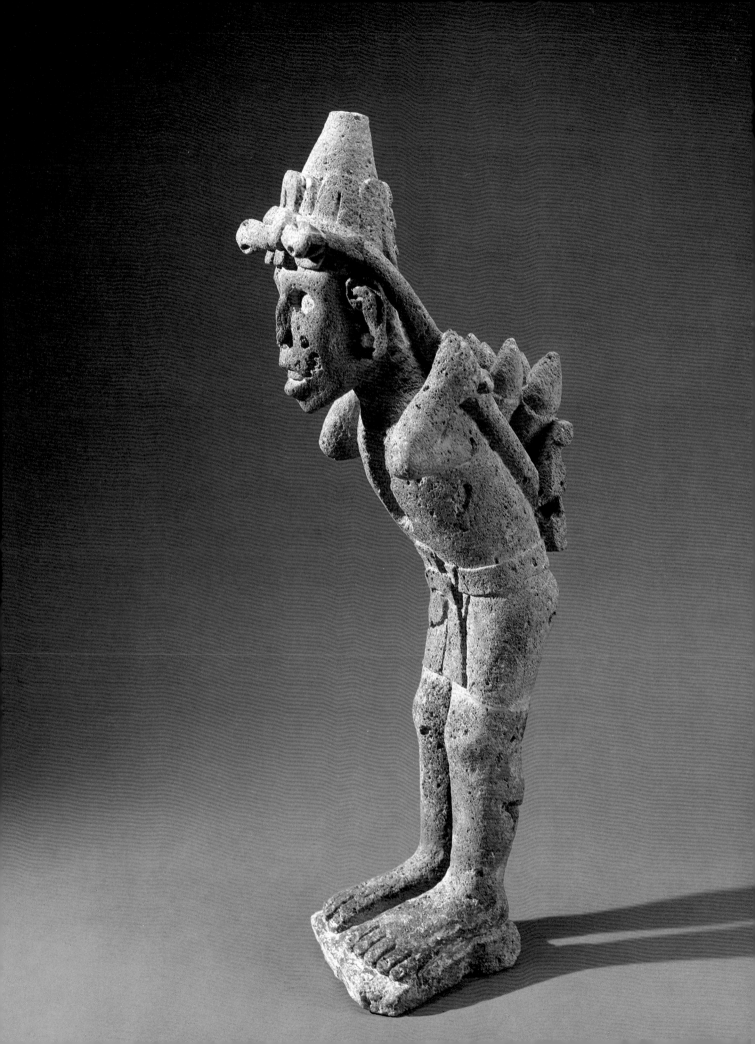

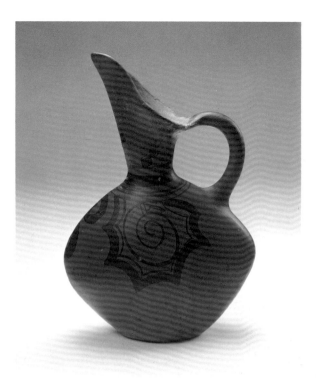

183. Pitcher.
Aztec (page 123)

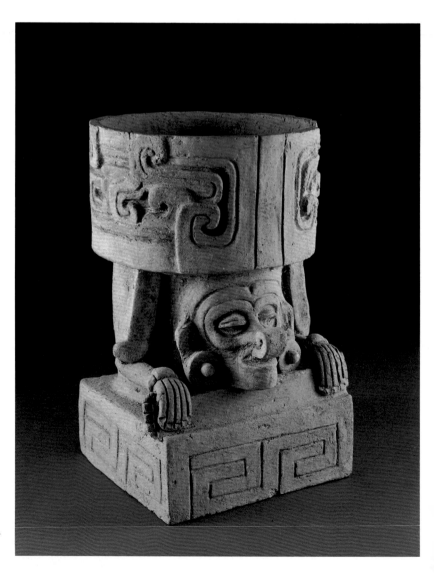

189. Effigy Brazier.
Ñuiñe (page 129)

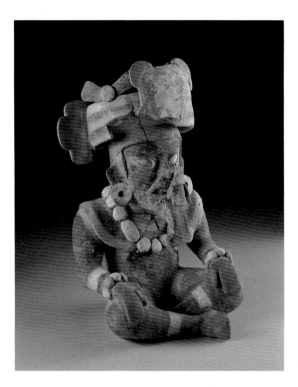

208. Urn Figure With Mouth Mask of the Serpent.
Zapotec (page 137)

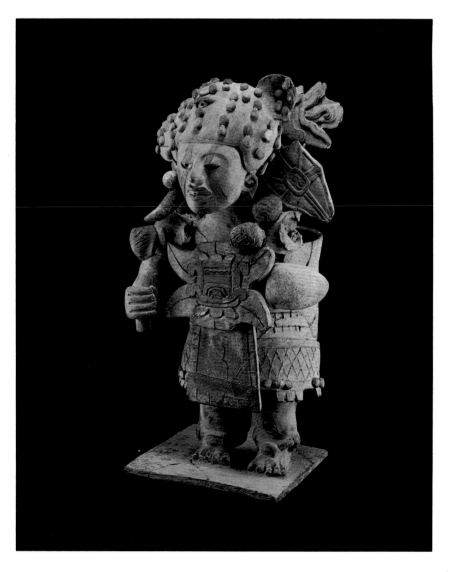

214. Standing Figure With Urn.
Zapotec (page 141)

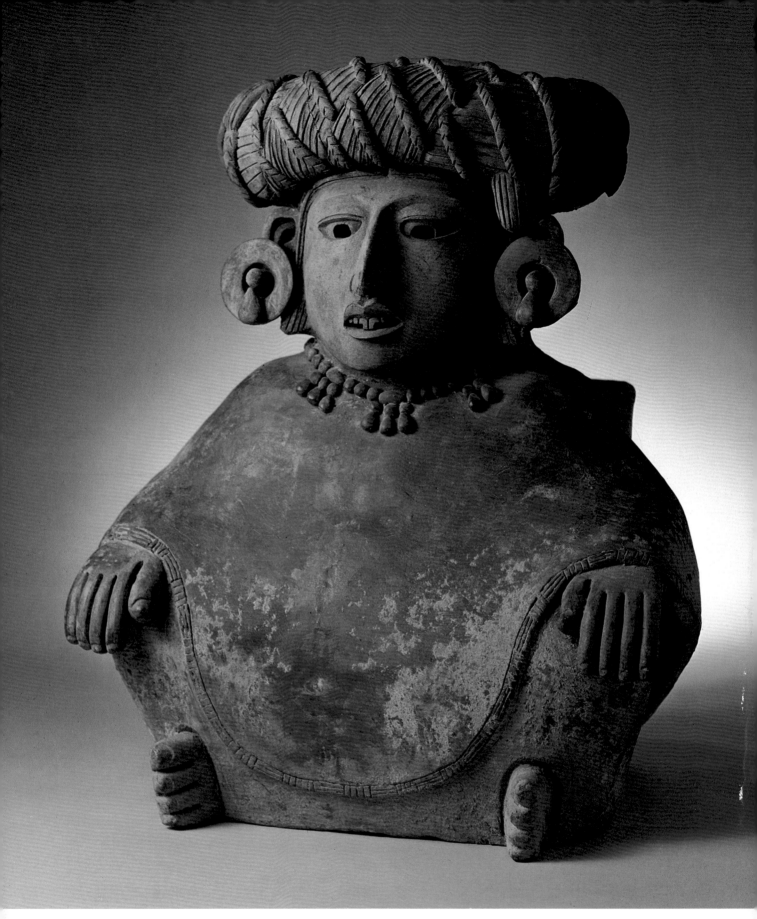

213. Urn With Seated Female.
Zapotec (page 141)

242. Heroic-Sized Seated Female.
Remojadas (page 160)

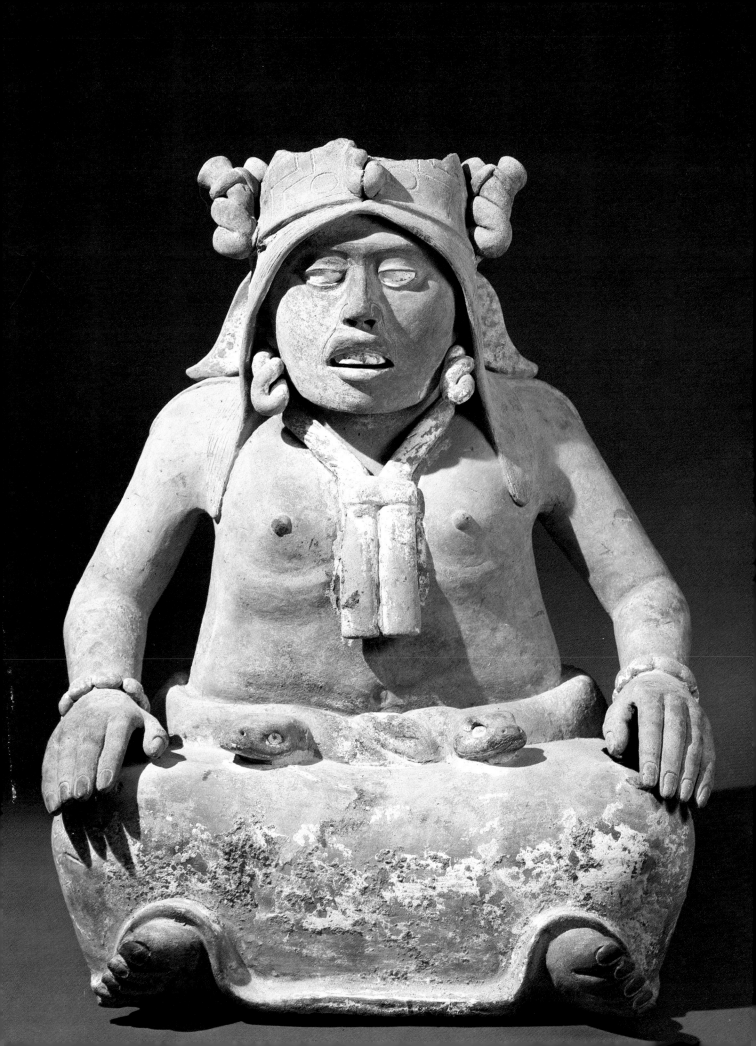

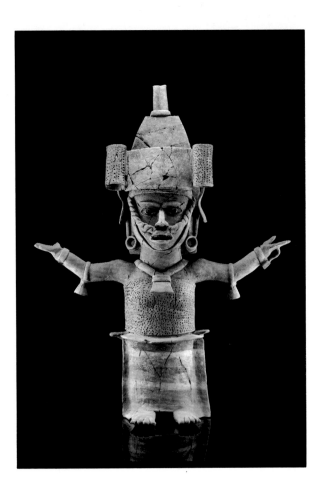

250. Displayed Female Figure.
Remojadas (page 164)

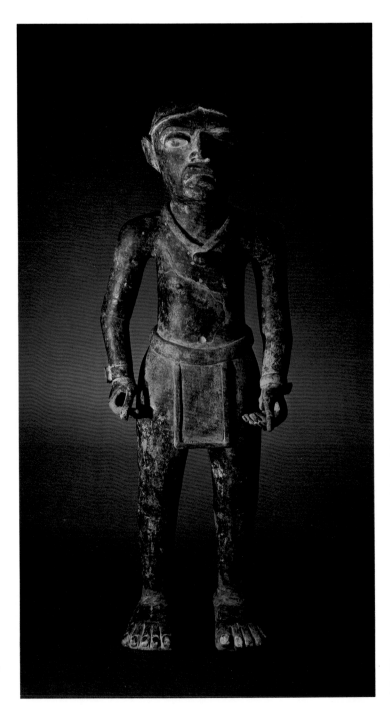

253. Large Standing Male.
Remojadas (page 165)

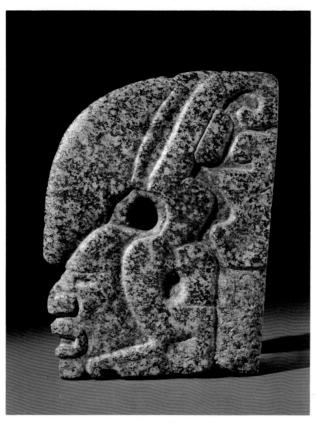

279. Ballgame Stone (Hacha)
Cotzumalhuapa (page 179)

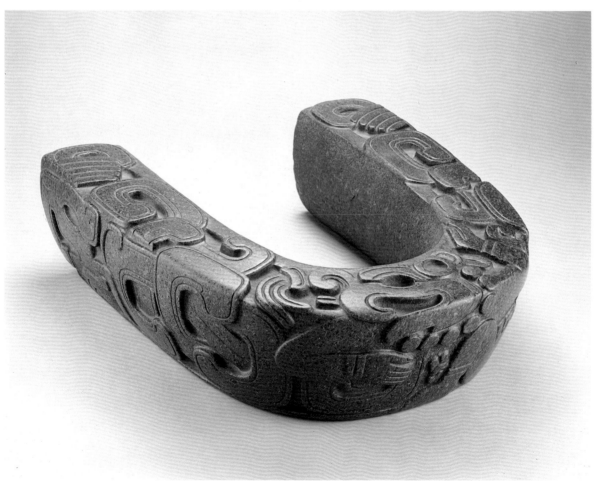

267. Carved Stone Ballgame Yoke.
Classic Veracruz (page 172)

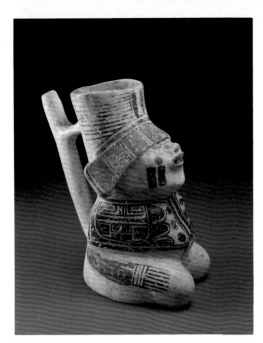

282. Human Effigy Vessel.
Huastec (page 180)

296. Seated Stone Figure With Rear Tenon.
Maya-Toltec (page 194)

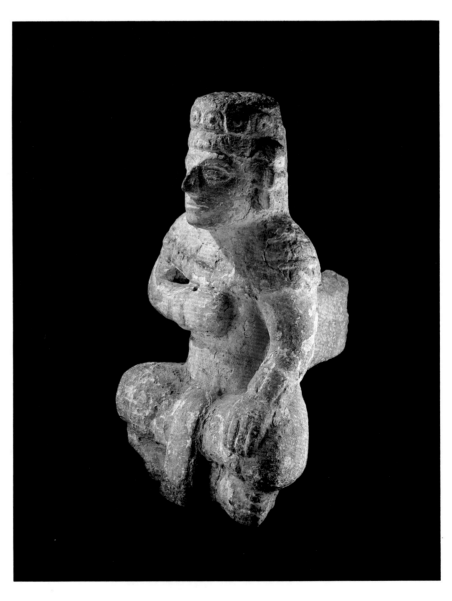

310. Painted Cylindrical Vase Depicting the Ballgame.
Maya (page 201)

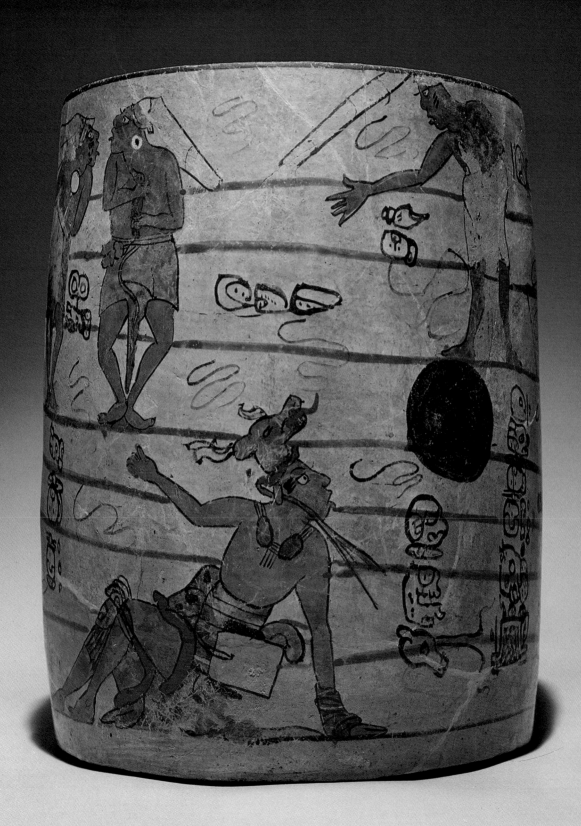

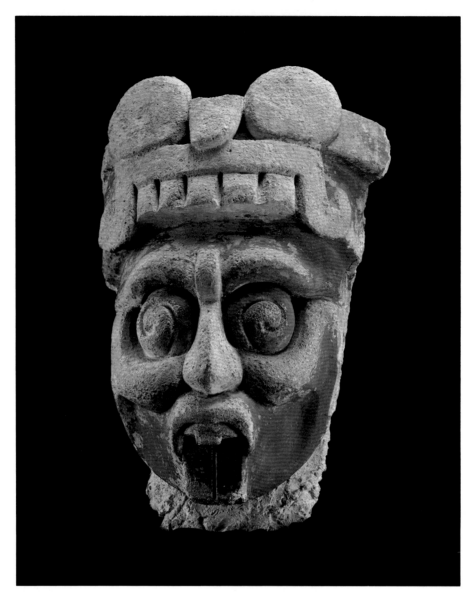

318. Stucco Head of Sun God With Headdress of Tlaloc.
Maya (page 205)

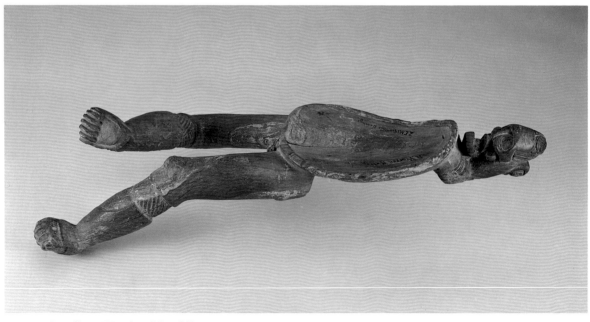

332. Male Effigy Wooden "Stool."
Taino (page 217)

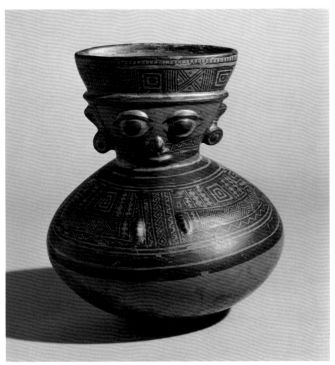

341. Face-Neck Jar.
Costa Rica (page 221)

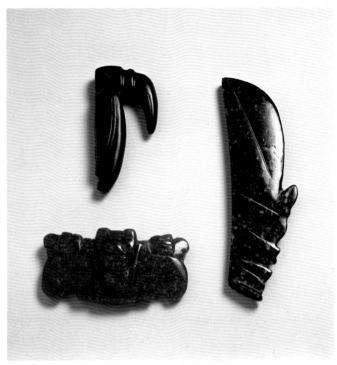

353–355. Three Jade Pendants.
Costa Rica (page 227)

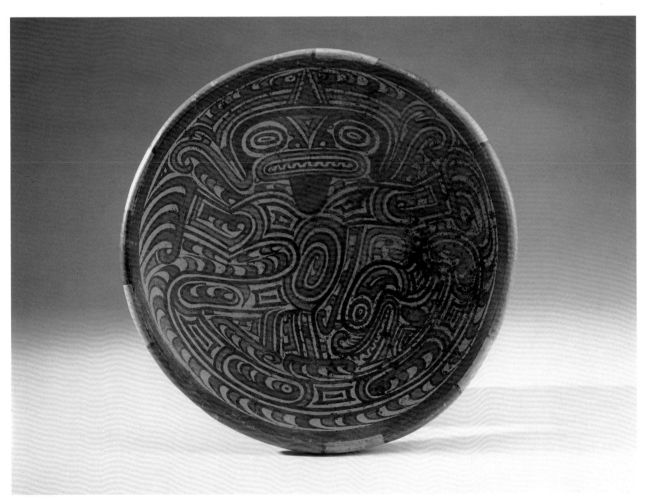

366. Painted Plate.
Cocle (page 231)

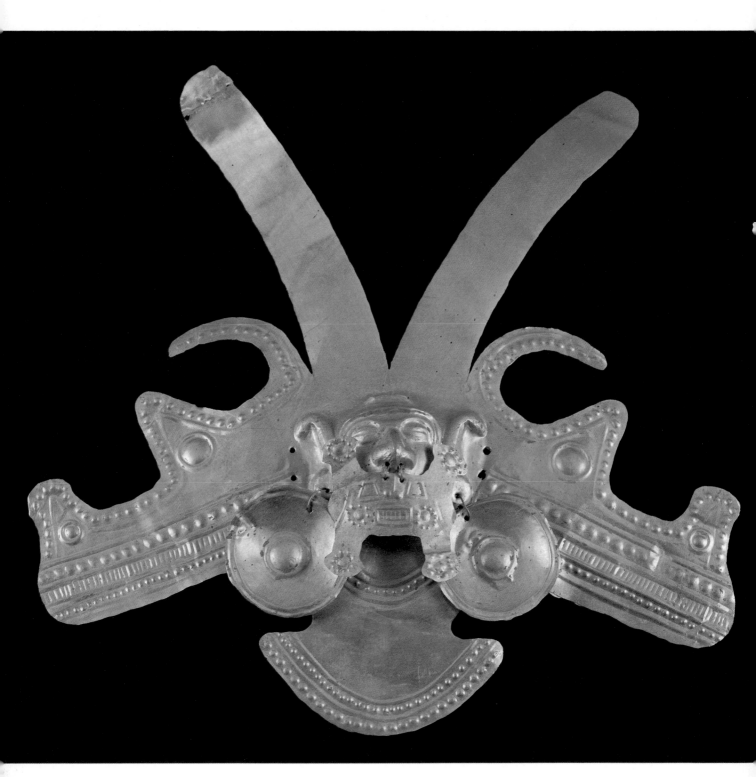

381. Gold Breastplate.
Calima (page 241)

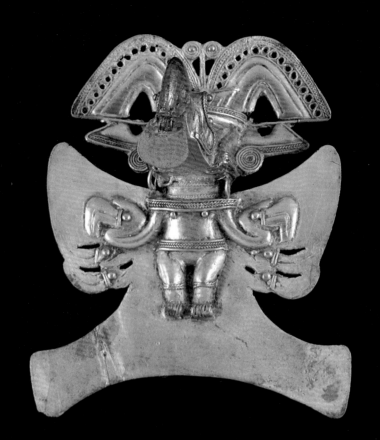
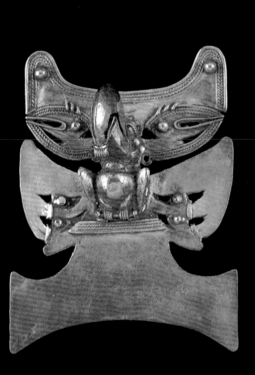
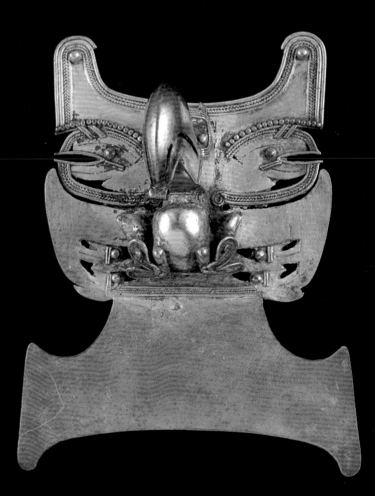

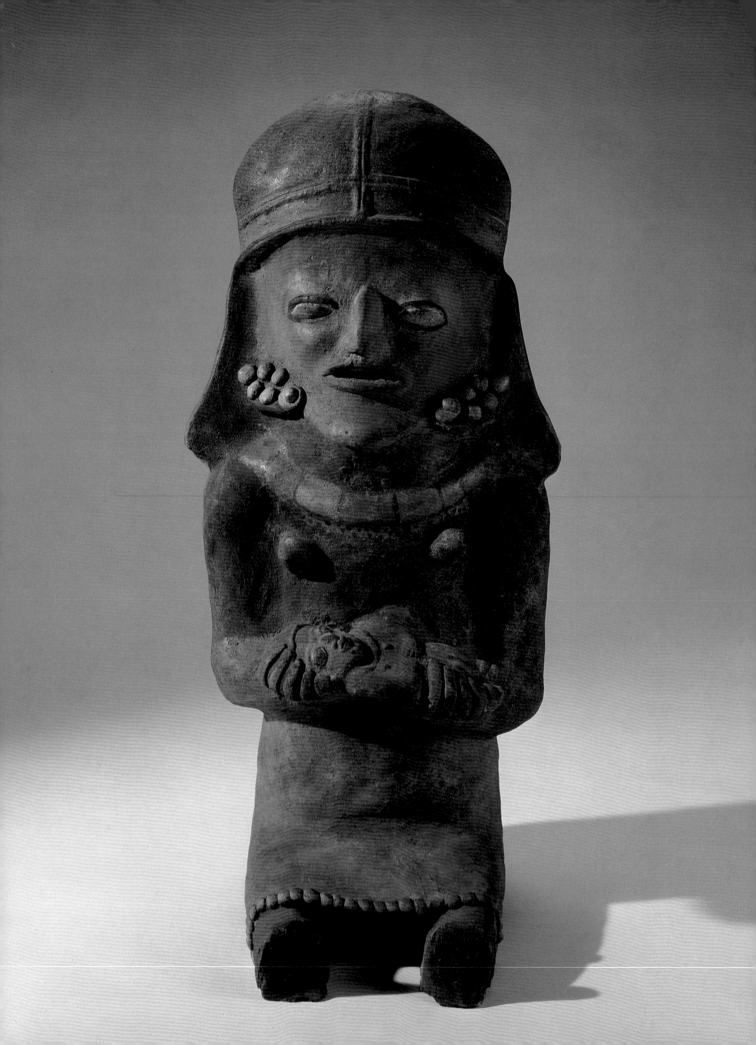

389. Large Seated Female Figure.
Manabi (page 245)

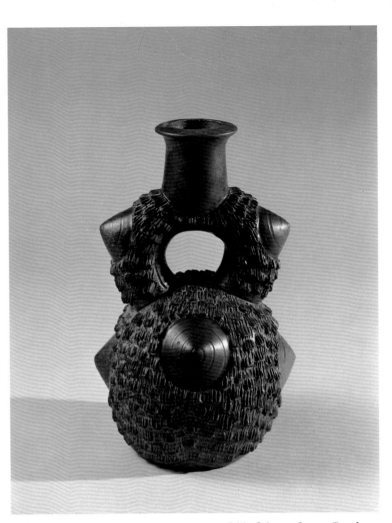

393. Stirrup-Spout Bottle.
Cupisnique (Chavin) (page 259)

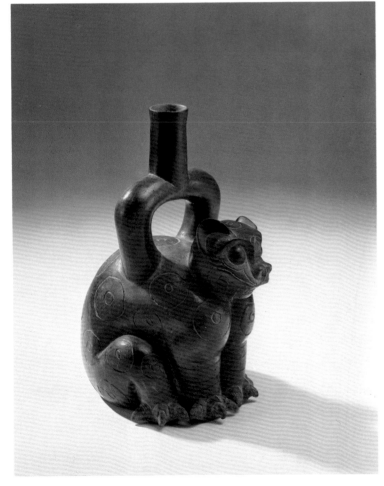

397. Jaguar Effigy Vessel.
Tembladera (Chavin) (page 261)

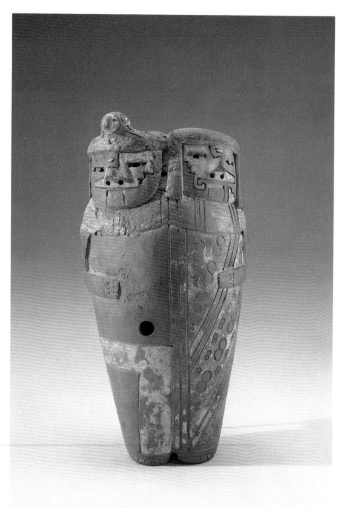

399. Embracing Male and Female Couple.
Tembladera (Chavin) (page 262)

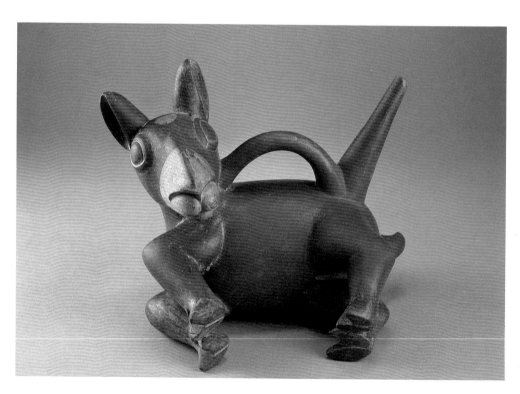

401. Reclining Llama.
Early Vicus-Salinar (page 263)

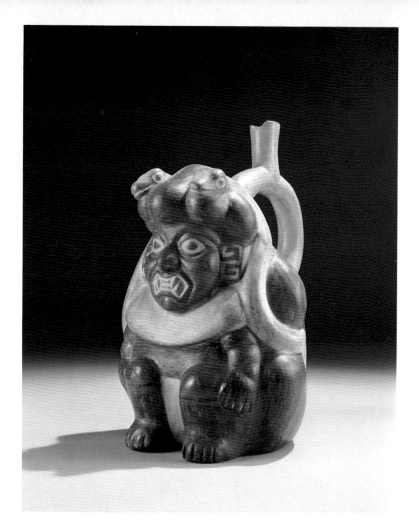

425. Gold Goblet.
Chimu (page 276)

411. Deity on the Sacred Mountain.
Mochica (page 268)

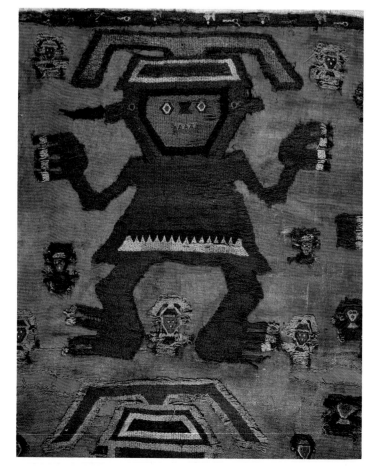

434. Large Embroidered Mantle (detail).
Chancay (page 284)

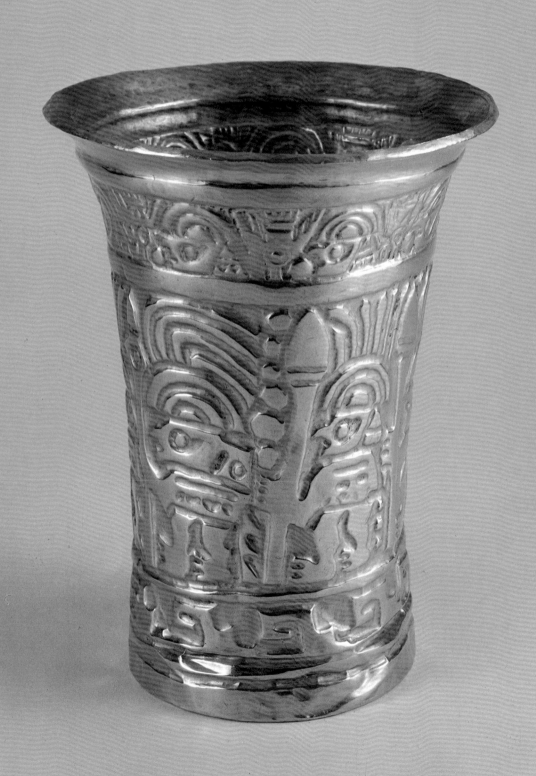

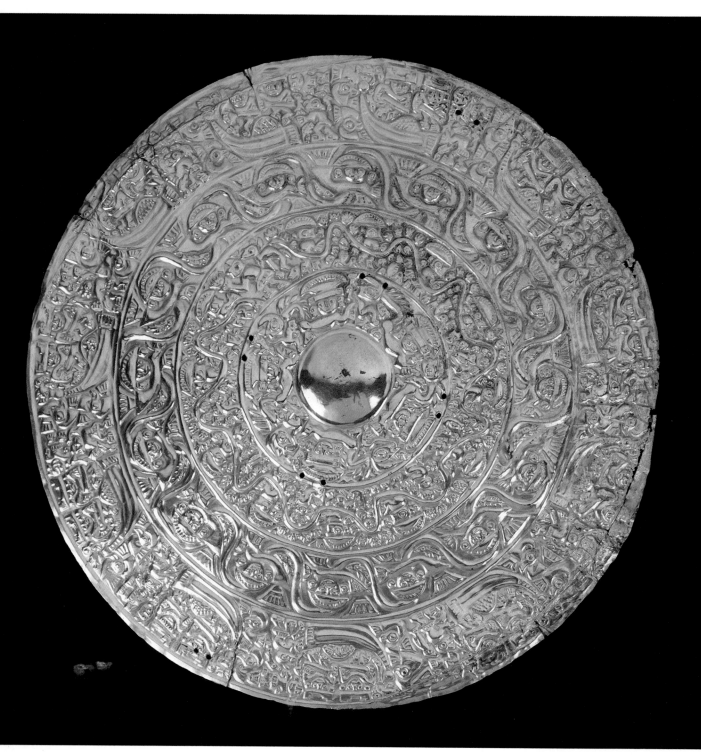

428. Silver Repoussé Disc.
Chimu (page 277)

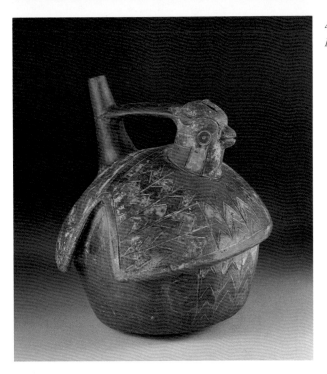

436. Falcon Effigy Bottle.
Paracas (page 289)

442. Embroidered Poncho.
Paracas (page 292)

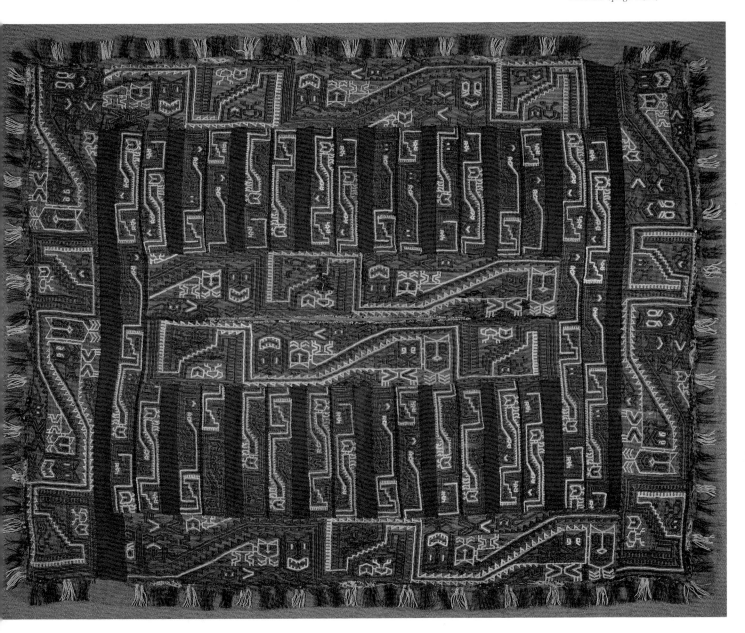

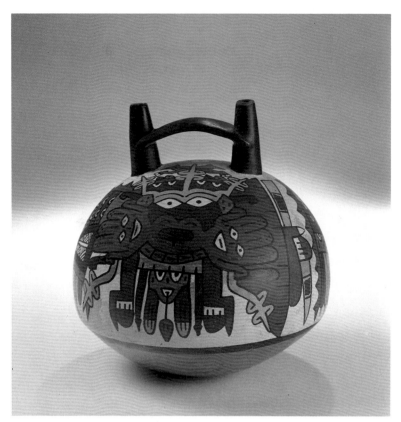

449. Double-Spout-and-Bridge Bottle.
Nazca (page 296)

454. Flat-Bottomed Bottle.
Coastal Tiahuanaco (page 299)

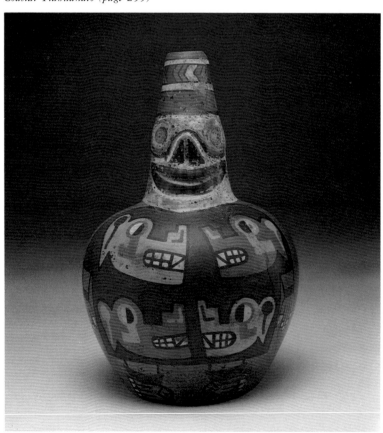

458. Section of Poncho Shirt.
Coastal Tiahuanaco (page 301)

460. Tapestry Shirt.
Ica (page 302)

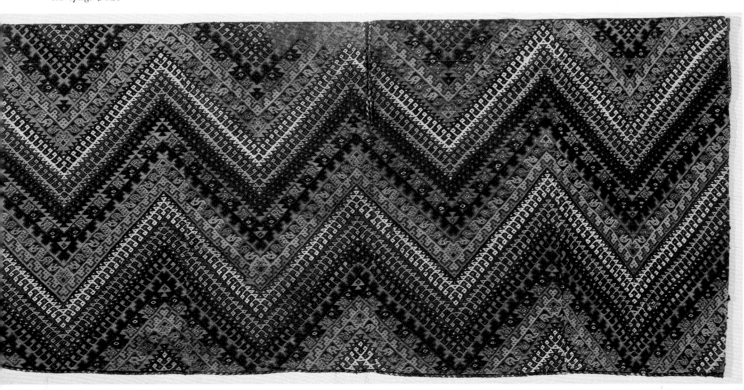

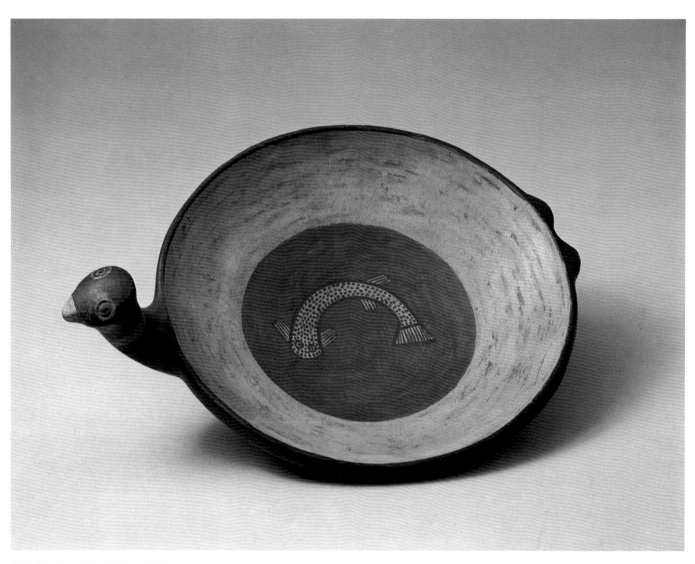

463. Shallow Bird-Effigy Dish.
Inca (page 303)

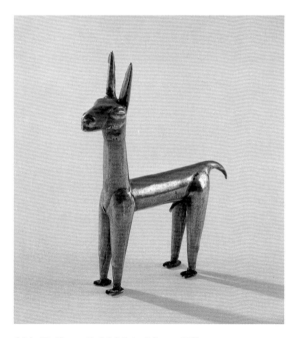

464. Hollow Gold Male Llama Effigy.
Inca (page 304)

422 and 456. Mosaic Wooden Earplug.
Chimu (page 274); and Miniature Male Turquoise Figure.
Tiahuanaco (page 300)

468. Feather Mosaic Panel.
Inca (page 306)

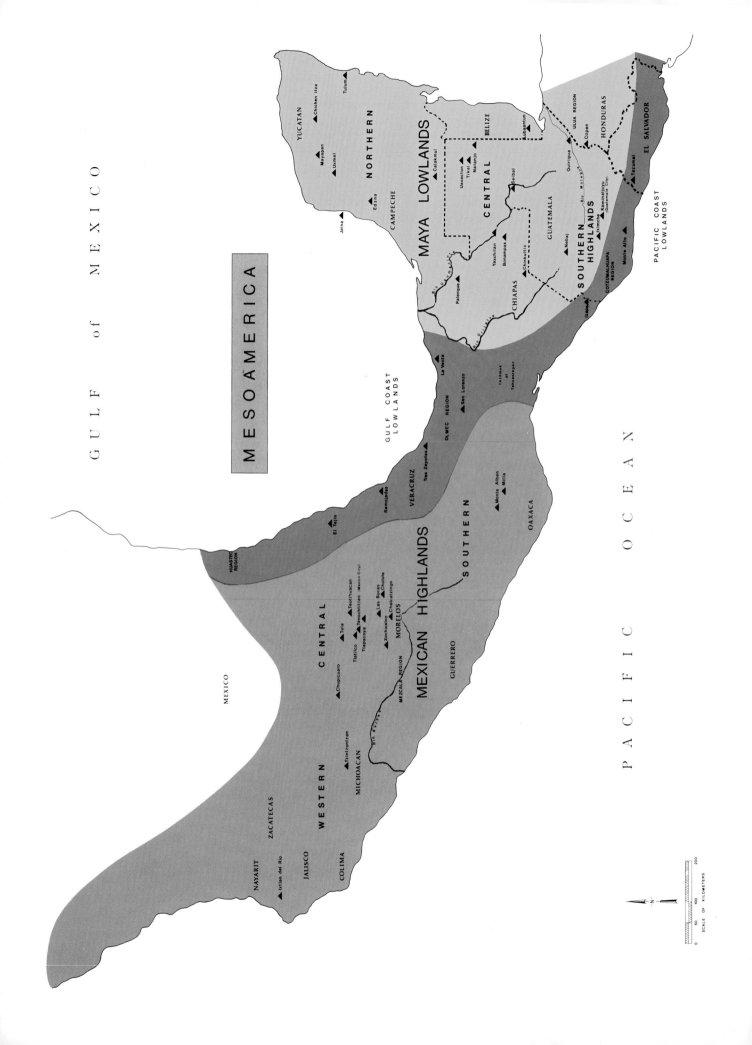

CARIBBEAN SEA

PACIFIC OCEAN

MESOAMERICA

Yucatan

MEXICO

BELIZE

GUATEMALA

EL SALVADOR

HONDURAS

NICARAGUA

Rio Coco

Nicoya

LOWER CENTRAL AMERICA

COSTA RICA

VERAGUAS

CHIRIQUI

DIQUIS

PARITA

COCLE

PANAMA

DARIEN

Rio Magdalena

TAIRONA

CHIBCHA

Rio Cauca

QUIMBAYA

MUISCA

CALIMA

VENEZUELA

COLOMBIA

San Agustin

NORTHERN ANDES

TUMACO

ESMERALDAS

CARCHI

MANABI

ECUADOR

GUAYAS

Valdivia

PERU

EQUATOR

CENTRAL ANDES

INTERMEDIATE AREA

N

SCALE OF KILOMETERS

0 100 200 300 400

CENTRAL ANDES

PACIFIC OCEAN

COLOMBIA

BRAZIL

ECUADOR

PERU

BOLIVIA

CHILE

Río Napo

Río Amazonas

Río Marañón

Río Ucayali

Río Urubamba

Lake Titicaca

Tiahuanaco

Pucara

Machu Picchu

Cuzco

Wari
Ayacucho

Kotosh

Chavin de Huantar

Recuay

Nazca

Juan Pablo
Ica
Ocucaje

Paracas

Pachacamac

Ancon

Chancay

Lurín

Cañete

Chincha

Pisco

Ica

Rímac

Casma

Santa

Piura

Vicus

Batan Grande

Chongoyape

Lambayeque

Cupisnique

Huaca Prieta

Chicama

Chanchan

Moche

Pacasmayo

Viru

TROPICAL
LOWLANDS

ANDEAN
HIGHLANDS

NORTHERN

CENTRAL

SOUTHERN

DESERT
COAST

NORTHERN

CENTRAL

SOUTHERN

SOUTH AMERICA

PERU

SCALE OF KILOMETERS
0 100 200 300

N

Introduction

To express the fullest explanatory connotations, this book could well be titled "The Art of Native American Civilizations Before Columbus," rather than the simple rubric "Pre-Columbian Art." We shall introduce our subject by reference to the longer combination of expressions. What do we mean by "Native American"; what is "Civilization"; and what of "Pre-Columbian"? (We will not attempt directly to answer the question, What is art?) In a sentence, we are dealing with the art of the advanced civilizations of the New World, created by indigenous American Indians, and developed primarily in the Mexico-Guatemala and Peru-Bolivia areas from 1,200 years before Christ to the time of Columbus and the Spanish conquest about 1,500 years after Christ. These civilizations began, and reached early peaks, in periods partially contemporary and comparable to the end of the Egyptian and Mesopotamian empires, as well as overlapping the Early Dynastic Chinese civilizations, of the Old World. By no means are we addressing ourselves to "tribal" or "primitive" art.

By "Native American," we are emphasizing not only the independent development of the full evolutionary course of civilization in the New World but the fact that these achievements are to the credit of the American Indians who first migrated to the western hemisphere during the Ice Age. This occurred in the same period that Cro-Magnon "Man" was executing Palaeolithic cave paintings in southwestern Europe (35,000–20,000 years ago). By 8000 B.C. the entire western hemisphere became inhabited by nomadic hunters, gatherers, and fishermen; and by 5000 B.C. plants were being domesticated in the environmentally favorable uplands of Mexico and Peru. The earliest cultivated corn has been discovered at Tehuacan in Highland Mexico and at Ayacucho in the Peruvian Andes, along with other staple crops. By 3000 B.C. fired pottery was invented, and we can speak of a full "Neolithic," settled village, farming economy in the New World. Then, around 1000 B.C., we can recognize the first incipient civilizations in Latin America. Almost

1

simultaneously in Mexico and Peru two civilizations began to crystallize, the groundwork for a surplus subsistence having been laid: the Olmec in the north, and the Chavin in the south, both now dated from the twelfth to the fifth century B.C. Granted, all these landmark developments took place perhaps 2,000 years later here than they first occurred in the Old World, but the course of civilization was parallel to the latter—only different in content.

We may even grant certain periodic trans-Pacific contacts from Asia to explain minutiae of increments to New World civilizations through their several millennia of high culture, but it has never been proven that any of this meager evidence was instrumental to their growth. (But, please, let us not try to transport pyramids from Egypt—the New World structures are not truly pyramidal, being stepped-sided and flat-topped. Nor let us not conjure up landings from outer space to try to explain what has been well documented through many millennia of indigenous cultural evolution.)

By "Civilization," we mean cultures developed beyond the Neolithic base, especially in the areas of political and economic organization, and social structure. By no means do scholars agree on any universal definition of the term "civilization." Not all New World civilizations were "urban" or "literate" in the Old World sense, or even used bronze to the same degree. Although some did satisfy all these criteria, they did above all express a sense of permanence, as seen in their coherent religions with hierarchies of gods, their monumental stone sculpture, and their enormous feats of public and ceremonial architecture.

Clearly, we are looking at dynastic political rulerships, and ultimately "states," and occasionally "empires." In these, the few controlled the economy as well as the masses, by extracting tribute and labor forces from them. They spread their power over wide territories, and economic surpluses from state-controlled irrigation or terracing projects were redistributed by the élite. A sharply defined social stratification is also evident, with the rulers and priests at the apex of the social pyramid; warriors, merchants, and professional artisans in a second level of "nobility"; and the peasant farmers (and captive slaves) in the preponderant majority. The extant art styles poignantly illustrate the rich symbolic content of the complex religions as well as the philosophy and structure of these élite cultures. The religious hierarchy was priest-controlled, and the governments were ruled by dynastic families who could verify their divine ancestry and who were elevated to the status of gods upon their death. Both the sacred and secular élites surrounded themselves with luxury goods often procured from distant regions. Therefore, intellectual knowledge and political power were the exclusive monopoly of the privileged few.

The greatest flowering of civilization in the north was achieved between A.D. 300 and 900 (the "Classic" period) by the Maya, who inhabited the rain forests of Guatemala and Yucatan, and who have been called the Greeks of the New World. They perfected systems of writing, mathematics, and astronomy—the last being manifest in their accurate recorded calendar. In the south, "Classic" civilization was achieved between about 200 B.C. and A.D.

700 by the Mochica on the desert coast of Peru. They excelled in ceremonial architecture, irrigation control, and advanced arts and technology. Ultimately, the Aztecs of Mexico and the Incas of Peru became the dominant powers, establishing great empires by military conquest. However, at the time of the Spanish conquest both had been in full reign only about one century. They were preceded by more than twenty-five centuries of the waxing and waning of other civilizations. "Nuclear America" (Mesoamerica and the Central Andes) had a headstart in agriculture and technology and the whole process of civilization; by the time of the conquest, relatively little of its accomplishments had time to diffuse into North America or into the marginal areas of South America. Most of those areas remained at a basic Neolithic farming or hunting economy (with the partial exception of the late "temple mound" cultures of the southeastern United States).

"Before Columbus" assumes the generally accepted term "Pre-Columbian." These expressions only infer the recognition of the New World by Europeans after Columbus's first landing in the Caribbean in 1492. Technically, all Native American Indian cultures before the sixteenth century are "Pre-Columbian," and are known to us primarily through archaeology; but the civilizations encountered and conquered in Mexico and Peru by Cortes and Pizarro are more commonly implied by the term. "Pre-Conquest" ("pre-Hispanic"), or "pre-Cortes" and "pre-Pizarro," might be more accurate labels for the areas and chronologies covered by this book. Native American civilization was terminated in Mexico in 1521 with the overthrow of the Aztecs, and in 1532 in Peru with the fall of the Inca—the dates that inaugurate the Spanish-Colonial period in Latin America, after the incredibly successful Spanish tours of conquest.

The accounts of the Spanish chroniclers are emotionally revealing about the splendors of the civilizations they discovered: Tenochtitlan, the island capital of the Aztecs, was described as rivaling Venice or any other contemporary European city. They extolled Moctezuma's exotic zoological gardens; they marveled at the Sun Temple of the Incas in Cuzco, with its gilded rooms and its gardens filled with life-sized replicas of llamas and corn plants fabricated in pure gold. The large cities, the imposing architecture, the unexpected sophistication of the cultures and, above all, the gold vastly impressed those who reported their expeditions to Charles V of Spain. The conquistadores sent back to royal European Hapsburg families such token art treasures as Moctezuma's gift of his Quetzal feather headdress, featherwork shields, intricately inlaid mosaic artifacts, and a modicum of worked gold and silver ornaments, much of which may be found in European museums today. The observations of the Renaissance German artist Albrecht Dürer in regard to the art treasures he saw are frequently quoted. But unhappily, tons of beautiful hammered and cast gold objects were melted down to bullion before being transhipped to Spain. While the Spanish largely ignored, and quickly squelched in favor of their own culture and religion, the achievements they had described with astonishment, Europe soon became indebted to the New

World for such desirable new commodities as rubber and tobacco, chocolate and vanilla, the tomato and potato, beans and peanuts and, of course, corn and squash.

We have touched upon the nature of ancient American high civilization, but more should be said about the nature of Pre-Columbian art and technology by way of introduction to the array of objects illustrated from this collection. (The important topic of architecture—from pyramids to temples to palaces and "city planning"—will be briefly treated in the introductory sections for each area.)

The invention of processes for working rare metals occurred in the Central Andes as much as 1,000 years before Christ, when Chavin craftsmen fashioned luxury objects of gold. Silver working soon followed, as well as ingenious soldering and welding techniques. During the first millennium A.D., copper was used extensively and many metal alloys were devised, eventually including copper and tin (true bronze) [see 466]. Casting techniques became highly developed, as well as gilding. Gold has always been attractive to man because of its rarity, enduring brilliance, and the ease with which it can be manipulated into objects of adornment. Peru, Colombia, and Lower Central America specialized in gold working. There, the avarice of the conquistadores was amply rewarded. (In Mesoamerica, jade was more highly esteemed than gold.) Malleable gold was stretch-hammered and annealed by heating to form thin sheets, which were then decoratively embellished. Silver was handled in the same manner.

Another important technique, especially in the Intermediate Area, was "lost-wax" casting [e.g., 359]. Essentially, a model of the intended ornament was fashioned in wax, covered with a clay mold, and then the gold poured inside through vents to replace the wax that melted out. Upon breaking open the mold, the cast gold object was revealed. Actually, the technique for making hollow gold ornaments by this method is more complicated. An inner core had to be prepared of powdered clay and charcoal, over which the object was modeled in wax; then, later, a tube would be inserted for tapping out the core.

Metallurgical technology gradually diffused northward from Peru, reaching Colombia by A.D. 300, and Lower Central America by A.D. 500. It arrived in Mesoamerica relatively late. There, copper and gold working were not well established until about A.D. 1000. While the majority of Pre-Columbian metal objects were ornamental, utilitarian knives, chisels, pins, and weapons also became common in the later periods.

Woven textiles are common to all New World civilizations. In Mesoamerica, they are depicted in the art, but rarely recovered because of prevailing damp and humid conditions. However, from the arid desert coast of Peru, where natural preservation of perishable materials is phenomenal, thousands of striking fabrics have come to light—from cultures as early as 2000 B.C. Mummies in Peruvian graves were wrapped in many successive layers of ponchos, mantles, and decorated bands [e.g., 442]. Cotton was one

of the first plants to be domesticated, and natural white and brown cotton was the basic fiber spun into thread. Llama and alpaca wool was secondarily employed. Colored dyes, such as cochineal, lent variety to the woven patterns. The native backstrap hand loom limited cloth widths to the human arm span. (This type of loom is still used by the Indians of Latin America.) The variety and complexity of weaving techniques produced in Pre-Columbian times is staggering. Nearly every modern technique was known, as well as many unique weaves that are impossible to reproduce on our mechanical or machine looms.

One of the more flamboyant crafts in Pre-Columbian America was mosaic featherwork. Colorful tropical bird feathers were tied onto loose-weave backings, and meticulously arranged and trimmed to form patterns on various garments or decorative devices [468].

Pre-Columbian pottery apparently was never wheel-made; the wheel either was not invented or not usefully employed, although wheel-and-axle clay toys were excavated in Mesoamerica (one of the arbitrary culture traits introduced from Asia?). Vessels usually were built from coils of prepared clay, then smoothed, and after sun drying and stone polishing, were coated with a watery solution of powdered clay (which we call a slip) to impart the intended background color. They were often decorated with mineral paints, and finally fired to various degrees of hardness, but still best described as "earthenware." While the oldest known pottery has been dated to about 3000 B.C., by 1000 B.C. the first civilizations already were making technologically and artistically sophisticated ceramics. The oldest clay figurines were hand-modeled, but in the first millennium A.D. both figurines and vessels were sometimes formed in clay molds for a kind of mass production [cf. 146 and 421]. Large hollow ceramic figures always were given apparently unnecessary vent holes, to prevent their explosion during the firing process. Pre-Columbian ceramic work is among the finest of any ancient civilization, excelled only by some of the porcelain and glazed wares of the Old World.

Finally, a word on stone carving and miscellaneous crafts. In addition to monumental high- and low-relief sculpture, most of these cultures produced small stone carvings of superb quality. Stonework of all kinds remained essentially "Neolithic" in technology for Pre-Columbian civilizations; softer rock normally was manipulated with harder stone tools by pecking, chiseling, engraving, and polishing. Copper or bronze tools were available only in the latest periods, and even then were probably used mainly for adding decorative details. Lapidary work, as in jade (a stone harder than steel) [353–358] or obsidian (volcanic glass) [181], may have been accomplished by string or bamboo sawing and drilling, aided by quartz-sand abrasives. Other important crafts resulting in sumptuous objects utilized such easily worked substances as wood, gourd, bone, shell, and lime plaster or stucco [317–322]; mosaic inlays of facets of stone and shell are also outstanding wherever preserved [174]. One of the more expressive arts was polychrome (fresco) mural painting, which often decorated the architecture [153 and 182].

The core areas of Mesoamerica and the Central Andes each are characterized by the continuous, interrelated development of cultural traditions over time and space, and therefore have been labeled "co-traditions." The Mexican and Maya subareas of Mesoamerica were constantly in communication with one another through periods of intensive trade and intercolonization; and, for the most part, they grew from a common cultural and ideological base generally attributed to the Olmecs of the Gulf Coast. Although each region evolved independent stylistic traits and had its own peculiar cultural content, enough fundamental elements were held in common throughout their history to speak of a single culture area. Likewise, the Central Andes was integrated in time and space as a culture area, beginning with the Chavin civilization, which discovered and invented basic concepts that were then inherited, and elaborated and expanded upon, by all subsequent civilizations. Periods of widespread trade and conquest throughout Central Andean history further contributed to the interrelatedness of the various regional cultures, however distinct they may seem when studied in isolation.

The subject of Pre-Columbian trade and contact is a crucial one, and in the forefront of current scholarly investigation. The growth of each successive civilization was stimulated, reinforced, and vitalized by repeated contacts with other civilizations from neighboring regions and even adjoining continents. Occasional intercontinental contact between the Mesoamerican and Central Andean centers is becoming well established. Although the general course of development moved in its own localized direction in each area, certain close parallels between Mexico-Guatemala and Ecuador-Peru suggest some mutual communication in Pre-Columbian times [see, e.g., 17, 43, and 205]. Offshore navigation was the plausible means for such correspondences. (Complexes such as metal technology diffused from region to region much more slowly.) Pizarro himself observed well-stocked Inca sailing rafts along the Pacific Coast of northern South America just before the conquest.

Regional trade within culture areas, however, supplied the "life blood" to every ancient civilization. Organized merchant expeditions, by coastal and riverine navigation and overland trade routes, were maintained in times of peace between neighboring regions in both Mesoamerica and the Central Andes. These routes established economic and intellectual ties with cultures separated by as much as 1,000 miles. Exotic products that might not be available locally—jade, tropical bird feathers, and chocolate, for example—were demanded by the ruling classes; but utilitarian materials, such as salt, obsidian, and volcanic stone, were imported and exported also.

Although archaeological and art historical knowledge of Latin America is only approaching maturity, it is now possible to present a coherent synthesis of the many great indigenous civilizations that occupied the Americas before Columbus. However, it is well to emphasize that there remain fundamental gaps in our understanding of the total history and social structure, and even in the archaeological exploration of certain regions. Major discoveries are still being made, and are yet to be made. While there is substantial historical

documentation for the late Aztec and Inca cultures, which were described by the Spaniards, and also by a few Aztec and Inca élite persons who became literate in Spanish and recorded their own histories from their own oral traditions, we still do not know the precise origins or causes of the incipient Olmec and Chavin civilizations. Similarly, the one complex system of writing in the New World—amply recorded by the Maya—is not yet fully deciphered. It survives in the form of hieroglyphic stone inscriptions sequestered in the jungles of southern Mexico and Guatemala, and in several surviving Maya books or "codices." We already know that this writing primarily contains dynastic and other historical information, along with religious and other esoteric data. We also do not completely comprehend the decline and fall of the ancient Maya, which occurred centuries before the conquest. Nevertheless, we are beginning to reconstruct an outline of the history of ancient America, which is being rapidly amplified by new data and new scholars.

We have made reference to our major areas—Mesoamerica, the Intermediate Area, and the Central Andes. It remains to define them briefly (see also the maps for each of these cultural and geographical areas in the color section following page xvi). The invented term "Mesoamerica" (sometimes used synonymously with "Middle America," although the latter term usually also incorporates all of Central America) is applied in this field to demarcate the geographical limits of the entire northern area of Pre-Columbian civilization. This includes central and southern Mexico and the Yucatan peninsula, Guatemala, Belize, western Honduras, and El Salvador (the last four countries are today politically part of Upper Central America). We divide Mesoamerica into two principal cultural areas: "Mexico" and the "Maya" area. The Mexican area comprises the highlands west and north of the Isthmus of Tehuantepec, and the Maya area incorporates all the tropical lowlands to the east and south. We also define a third region between and peripheral to the Mexican and Maya divisions, which we call the Coastal Lowlands (the Gulf Coast of Mexico and the Pacific Coast south of the isthmus).

By the "Intermediate Area," we are referring to the entire zone lying between Mesoamerica and the Central Andes—the two prime centers of Nuclear American civilization. The northern sector of the Intermediate Area includes all the countries of Lower Central America: eastern Honduras, Nicaragua, Costa Rica, and Panama. Its southern sector includes the countries of the Northern Andes: Colombia and Ecuador. While the Intermediate Area participated in aspects of the high civilizations to the north and south of it, and developed some of its own unique cultural patterns, it did not advance to the same degree in the areas of political and social hierarchy, nor in ceremonial architecture. Styles of monumental stone sculpture and metallurgy diffused into the area from the Central Andes, while styles of pottery and lapidary work diffused southward from Mesoamerica. We may also consider the islands of the Caribbean as an offshoot of the Intermediate Area in late Pre-Columbian times.

The "Central Andes," then, comprises the southernmost center of ad-

vanced civilization—and was confined in pre-Inca times to Peru and western Bolivia. We conventionally divide this area into the North, Central, and South Highlands, as well as equal divisions for the Pacific Coast. While some of the primary cultures—Chavin, Tiahuanaco, and Inca—originated in the highlands, most of our archaeological knowledge to date has come from the desert coast, owing to the quality of excellent preservation and the ease of exploration there. The preponderance of objects in collections came from the North, Central, and South Coast, and that area therefore receives emphasis in this book.

MESOAMERICA

The northern area of Pre-Columbian civilization, called Mesoamerica, comprised much of Mexico and Upper Central America. There, the first complement of culture traits, which indicates the attainment of what may be called civilization, appeared relatively suddenly on the Gulf Coast Lowlands of Mexico at the beginning of the first millennium B.C. We call these people the Olmecs, who in that early era were already building large pyramids and planned ceremonial centers, and sculpting colossal stone monuments. The high point of civilization was achieved some 1,500 years later by the Maya in the tropical lowlands of eastern Mesoamerica. The Aztecs of the Mexican Highlands came on the scene very late and, as mentioned, had been in power not much more than a century when their progress was cut short by the Spanish conquest.

We distinguish three major environmental and cultural areas: the Mexican Highlands (northwestern Mesoamerica); the Coastal Lowlands (Gulf Coast of Mexico and southern Pacific Coast); and the Maya Lowlands (southeastern Mesoamerica). (See the Mesoamerican map in the color section following page xvi.) The semiarid Mexican Highlands are further subdivided into three regions: the Central Highlands (Valley of Mexico and its volcanic environs); West Mexico (the states bordering the Pacific Ocean to the west and north); and the Southern Highlands (the state of Oaxaca). The peripheral Coastal Lowlands are primarily alluvial plains and tropical rain forests, extending along the Gulf Coast (the state of Veracruz), crossing the Isthmus of Tehuantepec, and continuing southward along the Pacific Coast (from Chiapas to Guatemala to El Salvador). While the Coastal Lowland region was only recently defined (Parsons, 1977), we see it as a discrete intermediate region participating in both the Mexican and Maya traditions, but unified environmentally and culturally through the continuous passage of peoples over this natural corridor. At the very center of this region was the Olmec heartland, which gave rise to much of the content of the later Mexican and Maya

civilizations. The Maya area is subdivided into three regions: the Northern Lowlands (the relatively dry bush country of the limestone shelf called the Yucatan peninsula); the Central Lowlands (the tropical rain forest region crossing from Tabasco and northern Chiapas, through northern Guatemala and Belize and down into western Honduras and El Salvador); and the Southern Highlands (the volcanic stretch of uplands in Chiapas and Guatemala).

After several thousand years of agricultural experimentation in the semiarid Mexican Highlands, a large inventory of cultivated crops became available to the lowland Olmecs by the time of their incipient civilization in 1200 B.C.: maize (corn), beans (black, red, and "kidney"), pumpkins and a whole array of other squashes, chile peppers, tomatoes, cacao (chocolate), vanilla, and tobacco. (None of these now familiar staples were known in the Old World before Columbus.) The Pre-Columbian diet was supplemented by hunting and fishing; but honeybees, turkeys, Muscovy ducks, and even certain dogs were nurtured as food sources also. Farming in the highlands was aided by terraced hillsides and irrigation systems. In the lowlands it was carried out by "slashing and burning" small plots, rotated over large tracts of rain forest.

By the Classic period, and the rise of the state of Teotihuacan, the Mexican Highlands were characterized by urban cities with main avenues lined with massive pyramids, platforms, and temples; and outlying zones with residential palaces and houses connected by a grid system of streets. All New World "pyramids" functioned essentially as elevated bases for temples or shrines situated on their flat tops. Access was generally provided by a wide frontal staircase. (Many pyramids in the Maya area also have been discovered with royal tombs inside.) Their stepped sides were faced with cut stone, often frescoed or sculptured, while their interiors were solid masses of earth, blocks of pumice, or rubble. In the highlands, flat post-and-beam roofs were normally provided for the volcanic stone buildings, and the élite residences surrounded inner patios. In the tropical lowlands, however, we generally speak of ceremonial centers rather than true cities. Maya architecture was characterized by tall temple-pyramids, low platforms, palaces, and acropolises built around large open plazas—the various groupings often connected by raised causeways. Limestone masonry buildings, and their narrow rooms, were roofed by high vaults, while stone and stucco work decorated their facades. These élite ceremonial centers were sustained by peasant farmers, who lived in hamlets scattered in the forest over a radius of many miles. Monumental stone sculptures ("stelae" and "altars") were erected in the great plazas to commemorate rulers and the events surrounding their reign. (Monumental stone sculpture is more prevalent in the Maya Lowlands than the Mexican Highlands, and also more frequent in Mesoamerica than in the Central Andes.) All major Mesoamerican sites also boasted at least one architectural ball court.

Historical development in Mesoamerica is conventionally divided into the Preclassic, Classic, and Postclassic stages, each of which is subdivided into

an "early," "middle," and "late" phase—the "Classic" stage being predicated on the span of Maya hieroglyphic calendrical inscriptions circa A.D. 300–900. Several limited time periods within these developmental stages were characterized by the area-wide expansion of single civilizations through such mechanisms as intensive trading, colonization, military conquest, and religious proselytizing. This phenomenon created art style and cultural "horizons," and brought far-flung regions into temporary unification. By way of introduction to the outline of Mesoamerican history, we review these major integrative horizons: first the Olmec (Middle Preclassic period); then the Teotihuacan (Middle Classic period); and later, the Toltec and Aztec (Early and Late Postclassic periods). (These horizons are indicated in the chronological chart on p. 14 by horizontal gray bands.) Other than the lowland Olmecs, all these major powers originated in the Mexican Highlands. While the Olmecs' influence depended on their trade routes, Teotihuacan also established distant colonies, and the Toltecs and Aztecs created military empires. These relatively brief periods of pan-Mesoamerican integration were separated by longer periods of local, stylistic and cultural developments, such as the Zapotec, Classic Veracruz, and Maya civilizations, to name only three salient examples from the Classic period. In the ebb and flow of the many regional cultures, the respective histories frequently overlapped in time, and the total picture is relatively complex (see the chronological chart).

The initial Olmec horizon is dated essentially to the Middle Preclassic period, 1200–500 B.C. The Olmec "heartland" centered at the sites of San Lorenzo, La Venta, and Tres Zapotes in the swampy rain forest environment of southern Veracruz and Tabasco. There, civilization focused on large ceremonial centers. The great pyramid at La Venta, actually in the unique shape of a fluted cone, is about 100 feet in height. Its "Complex A" consists of a north-south alignment of flanking platforms, terminating in a ceremonial precinct enclosed by columnar basalt, and with a small mound containing a royal tomb of the same material as well as a carved stone sarcophagus. The ancient Olmecs were integrated by a persuasive religious cult featuring the "were-jaguar" (a half-human and half-feline creature) representing the divine source of their dynastic lineage. A composite serpent-bird monster, or "dragon," was another primary deity. Both monumental full-round stone sculpture and portable objects of jade and serpentine represent these water-earth-fertility gods. Colossal naturalistic stone heads and tiny clay figurines also portray idealized "baby face" individuals. The raw material for their 20–30 ton stone sculptures had to be transported from the nearest volcanic region 80 to 100 miles away. Their art style diffused to most parts of Mesoamerica, and as far south as Costa Rica, probably following established routes of procurement for the coveted jade. Olmec style objects are prevalent along these routes. While the Olmec tradition and art style penetrated various parts of the Mexican Highlands where a different cultural tradition was already developing, it persisted most effectively in the greater Maya Lowlands.

Although the Olmecs most probably invented such typically

Mesoamerican complexes as writing, the calendar, the ballgame, and basic religious and political doctrine, concrete evidence is sparse. However, there is an intermediate culture centered on the Pacific Coastal Lowlands, called Izapan (Late Preclassic period, 200 B.C.–A.D. 200), where we find such specific innovations as the stone stela and altar "cult" with narrative low-relief carving, early writing and calendar, and elaborated ritual iconography and symbolism. A significant offshoot of the Izapa style is found at Kaminaljuyu in the Guatemalan Highlands. All these features apparently derived from an Olmec legacy, and later contributed directly to Classic Maya civilization. The earliest inscribed calendrical dates in the Maya system are found in the Izapan region. (Izapan influence, somewhat limited in geographical spread, is also shown on the chronological chart by an expanding and contracting horizontal band.)

The next horizon of pan-Mesoamerican expansion may be attributed to Teotihuacan in the Central Highland Valley of Mexico. The roots of Teotihuacan go back into the Preclassic period, and around the time of Christ its enormous "Pyramid of the Sun," 200 feet in height, was started. Teotihuacan actually formulated the first absolute political state and "Classic" civilization in Mesoamerica that was earlier than, and independent of, the full Classic Maya civilization. We have mentioned its rambling urban complex, which was second in size to the Chimu city of Chanchan in Peru. While Teotihuacan culture was consolidated in the Early Classic period, its height of power was achieved in the subsequent Middle Classic period (A.D. 400–700). During that phase, Teotihuacan established colonies and effective control as far south as the Maya area in Guatemala. Its influence is reflected in the architecture, royal burial offerings, and stone sculpture of Kaminaljuyu and Tikal, for example. Wherever Teotihuacan presence was felt, we find the cylindrical tripod vase [305], "thin orange" ware [286], and the composite incense burner [285]. Teotihuacan also created a cultural impetus in the Mexican Highlands that eventually was carried on by the Toltecs and Aztecs in the Postclassic period.

During the intervening Late Classic period (ca. A.D. 700–900), the Maya in eastern Mesoamerica, living in regional isolation, overshadowed all other Mesoamerican civilizations, having reached an unprecedented peak of development. Maya heritage may be traced back to the Olmecs and Izapans, and their civilization began to crystallize in Early and Middle Classic times, just as Teotihuacan was beginning to expand. The center of this development was in the rain forest of northern Guatemala and adjacent territories, where spectacular ceremonial centers such as Palenque, Tikal, and Copan were built. At the outset of the Toltec horizon in the ninth century A.D., however, the great Maya ceremonial centers were abandoned one by one, and their calendrical inscriptions ceased to be inscribed.

We encounter the next period of integration in the Early Postclassic period, with the Toltec horizon. In the tenth century A.D. the Toltecs gained total power in Central Mexico. Their capital was at Tula, and the nature of

their particular civilization owed much to earlier Teotihuacan. The Toltecs successfully extended their commercial, colonial, and religious influence as far as the Yucatan peninsula and El Salvador between A.D. 900 and 1200. Toltec presence is usually marked in the archaeological record by the use of glazed "plumbate ware" [156 and 157]. Copper and gold working also became widespread on this horizon. Toltec history survives in the legends of the wanderings of their culture hero, Quetzalcoatl ("feathered serpent"). Chichen Itza in the Maya region of northern Yucatan was the most important Toltec outpost in this period, duplicating, for a time, the architecture of the home site of Tula.

The final empire to unify much of Mesoamerica was effected by the Aztecs from the Valley of Mexico. (They termed themselves the "Mexica," while their contemporaries dubbed them "barbarians from the north.") This occurred during the Late Postclassic period, A.D. 1400–1521. On an island in Lake Texcoco the Aztecs created their capital city, which they called Tenochtitlan. It was joined to the mainland by causeways, and was notable for its canals and "floating gardens" *(chinampas)*. The central walled precinct in the city contained the major ceremonial pyramids and temples, as well as the ball court and the marketplace. This became the site of modern Mexico City after the conquest by Cortes and the leveling of Aztec buildings. (The foundations of those structures are still being excavated some 12 feet below the present streets of Mexico City. In Spanish-Colonial times the lake was drained, leaving only remnants at Xochimilco.) Following in the footsteps of the Toltecs, the Aztecs built a geographic-patchwork empire based on a well-organized and institutionalized system of trade-and-conquest-and-tribute. Only those foreign regions were conquered that were of economic interest to the highland Aztecs, such as the prime cacao (chocolate)-growing belt on the Pacific Coast of Chiapas and Guatemala. (The cacao beans were used both as a form of currency in the markets and for an élite beverage spiced with chili peppers.) We may surmise that the Aztecs did not have time to extend their empire to the degree that the Incas were able to do in the Andes. We also might surmise that if the Spanish conquest had been delayed another century, the Aztecs and Incas themselves would have confronted each other, vying for total domination of their known civilized world.

We may now proceed to a regional survey of Mesoamerica, to fill in the picture of its many cultures (some of them not yet mentioned), and illustrations of their diverse art forms. To attempt a generalization about art style contrasts between the greater Mexican Highlands and the Maya Lowlands, one might say that the roster of highland styles tended to be more stiffly formalized and geometrically organized. Maya, and other lowland art styles, tended to be more luxuriantly flamboyant (if not ornate or even "baroque") and gracefully curvilinear. These broad predilections in the art of the two major areas no doubt could be related to the respective differences in environment.

We begin our examination of Mesoamerican art and culture with "Preclassic Mexico," the general early time period, rather than with one of the specific geographical regions. In the formative Preclassic period (1200 B.C.– A.D. 200), cultures throughout Mesoamerica were making figurines and pottery in certain fixed modes: the former with attenuated limbs, slit and punched, or "coffee bean" eyes; and the latter usually in monochrome or bichrome, and featuring simple bottle, dish, and bowl forms. Initially we will look at the early art styles of the Central Mexican Highlands; then at the pure Olmec style originating on the Gulf Coast, but also found in the highlands; and finally at some of the disparate Late Preclassic styles of the Mexican Highlands as well as the Coastal Lowlands. (This collection lacks specific examples of Preclassic objects from the Maya area per se, though obviously they do exist.)

The first region of the Mexican Highlands to follow "Preclassic Mexico" is "West Mexico," in that its principal art culture is dated to the Terminal Preclassic period. In most of the other regional presentations, we therefore will be able to begin their histories of art with the Classic period and trace them through to the Postclassic. For the Southern Mexican Highland sequence, however, the Zapotec culture is illustrated from its Preclassic origins to the onset of the Postclassic, in that the Zapotec maintained the continuous, almost uninterrupted development of a single regional art style.

CHRONOLOGICAL CHART OF MESOAMERICA

		MEXICAN HIGHLANDS			COASTAL LOWLANDS		MAYA LOWLANDS			
		WESTERN	CENTRAL	SOUTHERN	GULF COAST	PACIFIC COAST	SOUTHERN (Highlands)	CENTRAL	NORTHERN	
										1521
POSTCLASSIC	LATE	Tzintzuntzan	Tenochtitlan **AZTEC**				Iximche		Tulum	1400
POSTCLASSIC	MIDDLE		Cholula · MIXTEC	Mitla	HUASTEC				Mayapan	
POSTCLASSIC										1200
POSTCLASSIC	EARLY		**TOLTEC** Tula						Chichen Itza	
POSTCLASSIC										900
CLASSIC	LATE		Xochicalco	ZAPOTEC	CLASSIC VERACRUZ			**MAYA** Copan	Uxmal	700
CLASSIC	MIDDLE	**TEOTIHUACAN**		El Tajin	COTZUMALHUAPA		Palenque			
CLASSIC				Remojadas						400
CLASSIC	EARLY						Tikal			200
PRECLASSIC	LATE	COLIMA JALISCO NAYARIT ZACATECAS			IZAPA					AD / BC
PRECLASSIC	LATE	CHUPICUARO								200
PRECLASSIC	LATE	MEZCALA	Cuicuilco	POST-OLMEC	Monte Alto					500
PRECLASSIC	MIDDLE		Las Bocas	Tres Zapotes **OLMEC** La Venta						800
PRECLASSIC	EARLY		Tlatilco	San Lorenzo						1200
										1400

CHRONOLOGICAL CHART OF MESOAMERICA

Preclassic Mexico

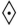

While the Olmecs are credited with the first civilization, other equally early developments were taking place independently in the Central Mexican Highlands. We have already noted that the origins of agriculture took place in the latter zone. By 1200 B.C., such village sites as Tlatilco, Tlapacoya, and others in the Valley of Mexico, Las Bocas in Puebla, and San Pablo in Morelos, were producing an amazing quantity and variety of clay figurines and elegant pottery forms [1–28], all of them unrelated in style to the Olmec. (One recently discovered style of figurine from Xochipala, far to the west in Guerrero, is said to predate both the Tlatilco and Olmec figurine types.) These ceramic offerings are found with burials in the massed cemetery at Tlatilco, and in graves at the other sites. The Tlatilco and its related art styles lasted through the Middle Preclassic, until about 500 B.C. Special features of Central Mexican art of this period include clay funerary masks [1], slit-and-punch-eyed painted figurines with endless assortments of hairstyles [2–10, 22–27], highly unusual effigy and compound vessels [11–21], and clay stamps [28]. Pottery vessels are usually monochrome red or black, but include two-color and resist-painted types [19], as well as such surface decorative techniques as incising, grooving, and rocker stamping [14]. One stirrup-spout form [17] may have been inspired from South America.

Although we date the Olmec civilization on the coast to the same period, its unique art style [29–54] apparently did not appear in the Mexican Highlands until around 1000 B.C. (This point is under controversy; some archaeologists argue for the Olmec style appearing in the Valley of Mexico as early as 1200 B.C.) Only a few Olmec objects in this collection are attributed to the Gulf Coast itself [31, 32, 44, 46, 47, and 50–52]. The balance was found at the same highland sites of Tlatilco, Tlapacoya, Las Bocas, and other unknown localities. Having been excavated in the same graves side by side with the indigenous offerings, clearly the élite Olmec art style was introduced and superimposed on the local highland tradition. We have mentioned

17

the Olmec trade routes, principally for acquiring jade somewhere in West Mexico. As a result, not only are Olmec style figurines and pottery identified in some of the highland graves but even Olmec style cave paintings have been discovered in Guerrero, and impressive Olmec rock carvings at Chalcatzingo in Morelos—both outposts on major trade routes. Further, small portable Olmec stone carvings are found in abundance in the highlands. In all these regions the style is represented in hollow ceramic baby-faced figurines [29–32], small solid figurines [33–36], effigy and incised pottery vessels [37–42], and hollow roller seals [43]. The finest Olmec pottery is fabricated of white kaolin clay, and some of it illustrates the complex religious iconography. Jade and other stone carving [44–54] is also eloquently expressive in the funerary masks, votive plaques and axes, baby-faced figures, chinless dwarfs, and were-jaguars. A few of the objects may be assigned to a Late Olmec phase, circa 800–500 B.C. [52–54], and herald a widespread, derived "Olmecoid" style to be shown for the post-Olmec period.

As the above cultures were Middle Preclassic, we may conclude the Mexican Preclassic stage with examples of Late Preclassic styles ranging from 500 B.C. to A.D. 200 [55–71]. The existence of a post-Olmec phase in art style development, which we date between 500 and 200 B.C. (Parsons, 1979), should be emphasized. Many disparate objects have long been called Olmecoid, with little specification or documentation as to their time period or relationship to classical Olmec except for the fact that they appear to be provincial or somehow degenerate. The best examples of this late derived style are the colossal stone heads at Monte Alto on the Pacific Coast of Guatemala (Parsons and Jenson, 1965). In addition, a great number of small stone carvings with trapezoidal mouths, fat bodies, and arms crossed over their bellies, found from West Mexico to Guatemala and throughout the Coastal Lowlands, probably may be assigned to this period [55–59].

The Late Preclassic period in Mexico is also characterized by a great diversity of clay figurine styles, each one peculiar to a particular subregion [61–68, and 70]. These styles evolved from a Tlatilco-Olmec heritage. One of the best known local cultures of this era is Chupicuaro, located in the state of Guanajuato and adjacent Michoacan. It features not only solid figurines but hollow figures and a variety of painted effigy pottery, often in three-color polychrome [66–69]. Another well known, and very abstract, style of small stone carving is peculiar to Mezcala in the Rio Balsas region of Guerrero (unfortunately not represented in this collection). The Terminal Preclassic period (200 B.C.–A.D. 200 or 300) is amply represented in the Mexican Highlands by the shaft-tomb culture of Colima and the nearby states of West Mexico. (The next section is devoted to this prolific art style region.) The last object in this section [71] is a little known type of human effigy vessel from Michoacan, which relates in style to Colima.

1. Funerary Mask

Mexico, Central Highlands, Tlatilco. Middle Preclassic,
1200–500 B.C.
Gray earthenware with red cinnabar
Gift, 65:1980; Diam. 11 cm. (Ex-coll. George Pepper)

A small, hemispherical mask of the type commonly found
on the faces of skeletons in burials at the site of Tlatilco
in the Valley of Mexico, on the west side of Lake Tex-
coco. They presumably were worn by the living (as well
as the dead) in dance ceremonies, as shown by clay figu-
rines with these little face masks. The eye orbits as well
as the mouth are open. The left ear is broken, and the
forehead "horn" was formerly balanced by a beardlike
prong on the chin. Note the protruding tongue. The
surface of the mask retains traces of red cinnabar mark-
ings, and the perimeter has three perforations for attach-
ment. (For funerary masks from other Mesoamerican
cultures, see 44, 149–151, and 174.)

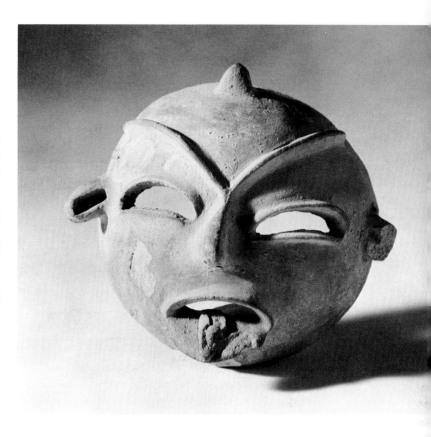

2. Girl With Dog

Mexico, Central Highlands, Tlatilco. Middle Preclassic,
1200–500 B.C.
Buff earthenware with white and specular-hematite red paint
(See color plate)
Gift, 57:1980; H. 14 cm. (Ex-coll. George Pepper)

Charming hand-modeled figurine (Type D-4), depicting
a girl kissing a pet dog held to her torso. (Not evident
in the photo is the fact that her legs are bent forward in
a seated position.) She wears an elaborate beaded head-
dress and forward-facing earplugs; her body is painted
deep red, while her face has a lighter wash of red. The
little dog bears traces of white paint.

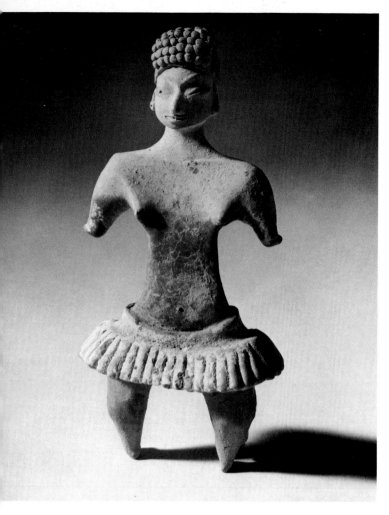

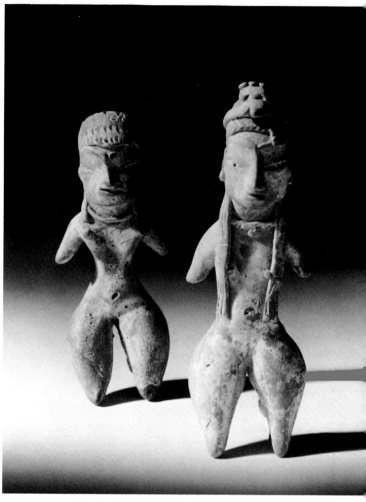

3. Skirted Female
Mexico, Central Highlands, Tlatilco. Middle Preclassic, 1200–500 B.C.
Polychromed buff earthenware
Gift, 105:1980; H. 13.5 cm. (Ex-coll. George Pepper)

This Type D-4 figurine has excellently preserved paint. The applied fringe skirt is painted white, the lower torso and arm tips are black, the shoulders and face are yellow, while the legs, hair, and facial details are red. The delicately modeled features include thin lines for clavicles, tiny ears with spools, a piled hairdo, and a single tress down the back of the neck. Diagnostic of Tlatilco Type-D figurines are the stubby arms and legs, and the narrow, slanting eyes with central punctations.

4. Two "Pretty Lady" Figurines
Mexico, Central Highlands, Tlatilco. Middle Preclassic, 1200–500 B.C.
Buff earthenware with yellow and red paint
Left: Purchase, 294:1951; H. 9 cm. Right: Gift, 106:1980; H. 10.5 cm. (Ex-coll. George Pepper)

Type D-1 figurines from Central Mexico have come to be considered "classical" expressions of the earliest solid, handmade figurines in Mesoamerica. They have stubby fat legs, attenuated arms, delicate necklaces, long tresses, and highly variable hairstyles. Both of these examples are stained yellow and also have remains of decorative red paint.

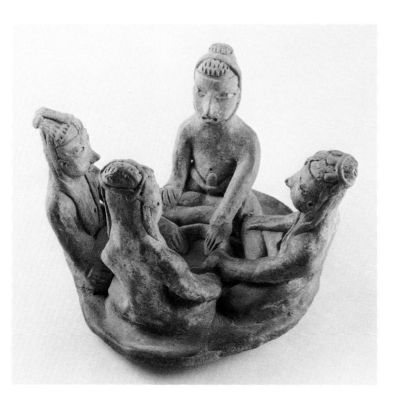

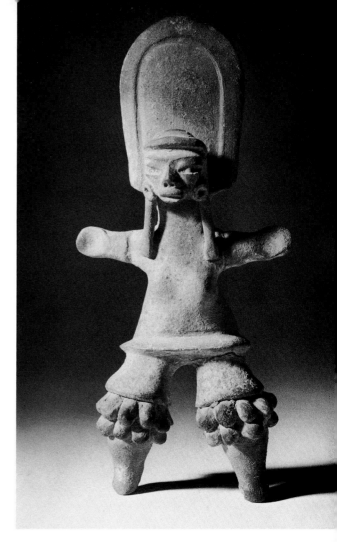

5. Circle Group of Four Seated Figurines

Mexico, Central Highlands, Tlatilco. Middle Preclassic, 1200–500 B.C.

Buff earthenware with yellow paint

Gift, 335:1978; H. 7.8 cm., Diam. 11.5 cm. (Ex-coll. Frederick Field) (Illustrated: Flor y Canto del Arte Prehispanico de Mexico, *1964, item 132; and Coe, 1965, item 107)*

A unique representational group of Type D-1 "pretty ladies." They are shown seated together, cross-legged, on a disc base. Their left hands all hold a ring or basin in the center. Three of the figurines have long tresses and assuredly are ladies. The fourth, however (rear in photo), lacks the tresses, wears a head strap and a tabbed loincloth, and therefore presumably is male. The meaning of the rite represented, unfortunately, is obscure. (Portions of the round base have been restored.)

6. Dancing Figurine

Mexico, Central Highlands, Tlatilco. Middle Preclassic, 1200–500 B.C.

Buff earthenware with traces of paint

Gift, 100:1980; H. 20.5 cm. (Ex-coll. George Pepper)

Complete figurines of this type are relatively rare (it is a Type-D variant). Like all early clay figurines, this one is hand-modeled, but here the face portion is separately applied to the tall U-shaped penache. (The face, also, apparently is masked.) She wears belted shorts with tufted fringes above the knees. Traces of white, yellow, and red paint may be seen on the surface.

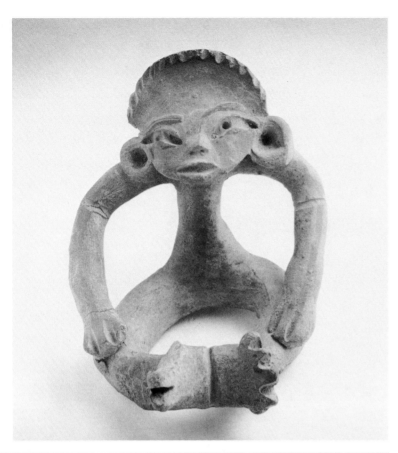

7. Seated Figurine

Mexico, Central Highlands, Tlatilco. Middle Preclassic, 1200–500 B.C.
Buff earthenware with red paint
Gift, 104:1980; H. 8 cm. (Ex-coll. George Pepper)

The legs of this figurine, a Type-D variant, are joined in a loop, while the expanded arms clasp the lower legs. Linear red details are painted on the face, torso, arms, and legs.

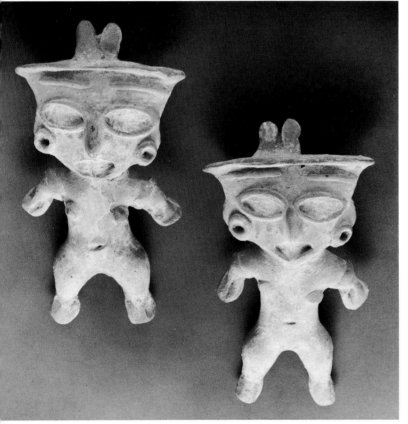

8. Pair of "Type-K" Figurines

Mexico, Central Highlands, Tlatilco. Middle Preclassic, 1200–500 B.C.
Painted buff earthenware
Gifts, 98 and 99:1980; H. 13 and 13.7 cm. (Ex-coll. George Pepper)

Type-K figurines distinctively have wide, outlined, oval eyes and broad heads, with bifurcated headdresses. The mouths are executed with double triangular punches. Both figures are stained yellow, the eyes and headdresses are whitewashed, while certain details are painted red.

9. Two Aberrant "Type-D" Figurines

Mexico, Central Highlands, Tlatilco. Middle Preclassic, 1200–500 B.C.
Buff earthenware with traces of paint
Gifts, 102 and 103:1980; H. 10 and 8 cm. (Ex-coll. George Pepper)

The figurine on the left has his head sharply tilted, which may or may not intend to depict a congenital malformation (he is not a hunchback type). He wears a tricorner hat and a long beard (perhaps "false"), decorated with cross-hatching and filled with white pigment. The skirted female on the right is one of the rare double-headed types that occur in Tlatilco iconography. Again, these heads are sharply tilted. It bears traces of red paint.

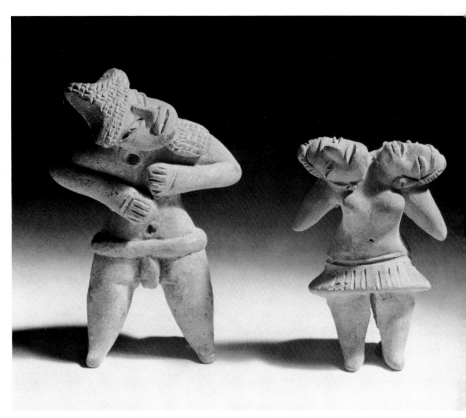

10. Pair of Seated Figures With Head Basins

Mexico, Central Highlands, Tlatilco. Middle Preclassic, 1200–500 B.C.
Buff earthenware with traces of yellow pigment
Gift, 101:1980.1,.2; H. 7.9 and 8 cm. (Ex-coll. George Pepper)

The figure with the hands on the knees is female, while that with the hands between the knees apparently is male. Both are in a cross-legged posture with the left foot over the right knee. They both have open, puckered mouths, but only the female has a thin necklace. The basins at the tops of the heads have two tiny perforations on their rims —possibly for attaching lids that are now missing. They may have functioned as miniature incense burners on the order of the large stone Teotihuacan censer [152]. They are Type-D figurine variants.

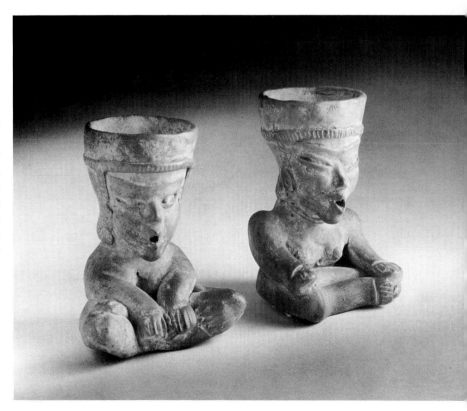

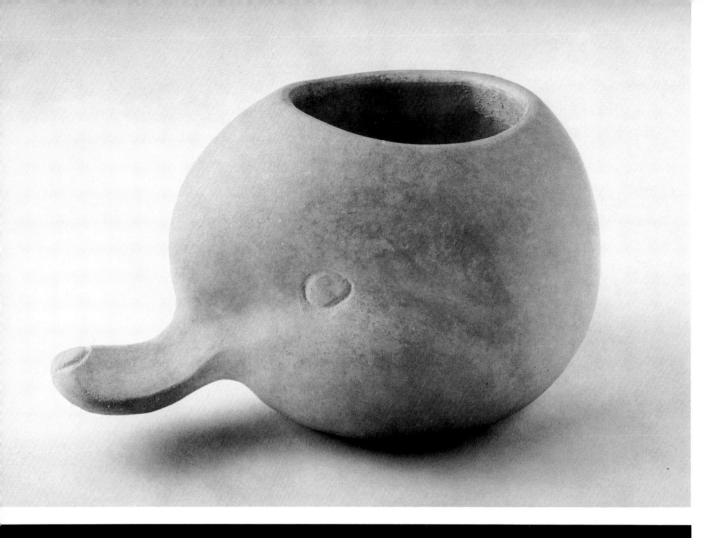

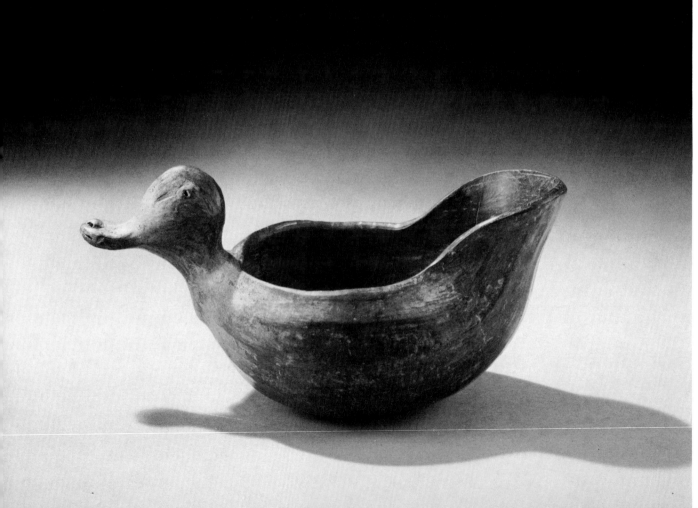

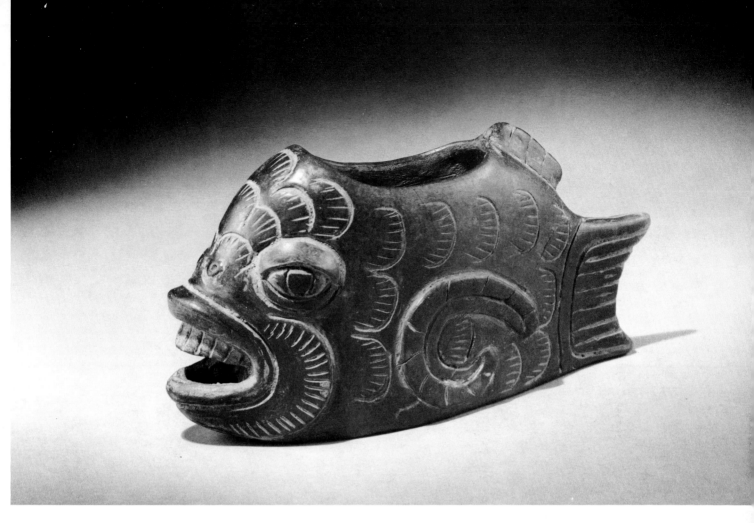

11. Duck-Head Pot
Mexico, Central Highlands, Tlatilco. Middle Preclassic,
1200–500 B.C.
Gray earthenware with traces of red cinnabar (See color plate)
Gift, 62:1980; L. 16 cm., H. 8.5 cm. (Ex-coll. George Pepper)

A naturalistic rendering of a duck—quite probably one of the domesticated Muscovy ducks of Pre-Columbian America. The incisions delineating the eyes and the bill are filled with red pigment. The same pigment covers the interior of this open-topped effigy vessel.

12. Duck Effigy Vessel
Mexico, Central Highlands, Las Bocas. Middle Preclassic,
1200–500 B.C.
Polished black earthenware
Gift, 68:1980; L. 19 cm. (Ex-coll. George Pepper)

This appealing vessel, although from the site of Las Bocas in Puebla, conforms to the Tlatilco range of naturalistic ceramic effigies, and is in no particular way Olmec-influenced. The outer surface is elegantly fluted to connote feathers; the eyes and nostrils are punctated.

13. Fish Vessel
Mexico, Central Highlands, Tlatilco style. Middle Preclassic,
1200–500 B.C.
Polished black-brown earthenware with red paint
Gift, 196:1979; L. 19 cm., H. 9.5 cm.

While the dealer's provenance for this object was given as central Veracruz, the type fits more comfortably in the Central Highland Tlatilco (or Las Bocas) tradition. Even so, the decorative incised details are highly unusual. These include C-shaped scales, incised gills, dorsal and tail fins, as well as winglike volutes on the sides. Only the last element resembles an Olmec motif. The vessel is flat-bottomed and the mouth is open (but not into the interior). Red paint is preserved on the mouth and teeth, and in the various incisions.

14. Armadillo-Shell Musical Resonator

Mexico, Central Highlands, Las Bocas. Middle Preclassic, 1200–500 B.C.
Burnished black earthenware
Gift, 67:1980; L. 36 cm. (Ex-coll. George Pepper)

A full-size replica, in fired clay, of a musical instrument made from an armadillo shell with attached (wooden?) handle and a bulbous plug (gourd?). This type of instrument was beaten and/or rasped with a stick. The rim of the opening on the right has two perforations. The scales of the armadillo shell are indicated by triangular incisions. The ends are decorated by rocker stamping—a Middle Preclassic decorative technique accomplished by rocking the curved edge of a sea shell back and forth in the wet clay.

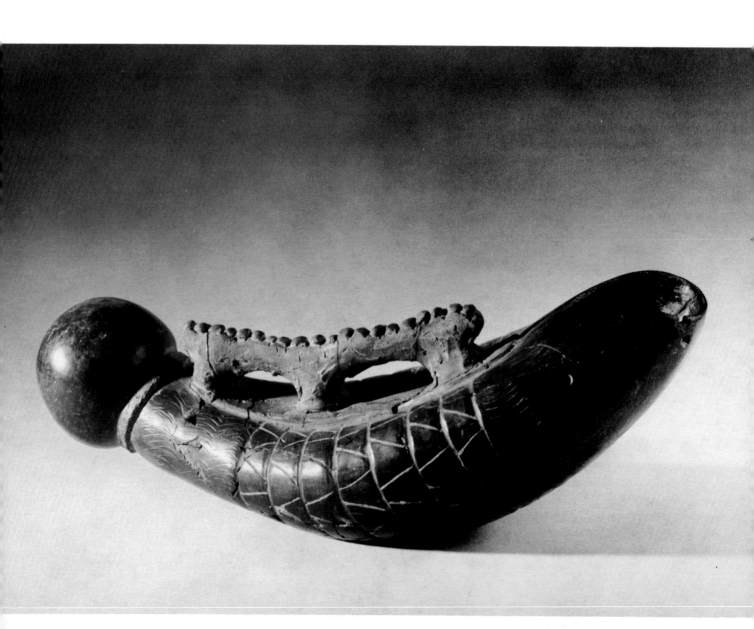

15. Pumpkin-Form Vessel

Mexico, Central Highlands, Las Bocas. Middle Preclassic,
1200–500 B.C.
Polished black earthenware
Gift, 69:1980; L. 16.5 cm., H. 9.5 cm. (Ex-coll. George
Pepper)

An exquisitely modeled squash or pumpkin effigy, cut
away at the top as an open vessel. The sides are deeply
lobed and the base is flattened. Both the top stem and the
bottom node are botanically correct.

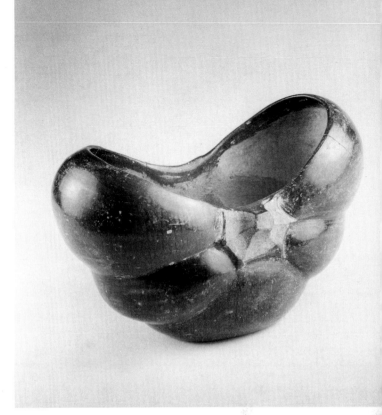

16. Human Effigy Vessel

Mexico, Central Highlands, Tlatilco. Middle Preclassic,
1200–500 B.C.
Polished red-slipped earthenware
Gift, 60:1980; H. 22 cm. (Ex-coll. George Pepper)

A seated fat figure holding its cheeks. The surface is
evenly slipped dark red. The base is dimpled, and there
is a rimmed opening at the top of the head. The forward
configuration of the forehead suggests that this effigy
vessel represents a dwarf—a common theme in Preclassic
Mexico.

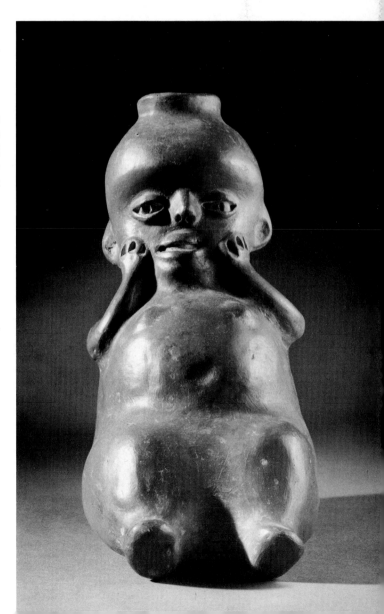

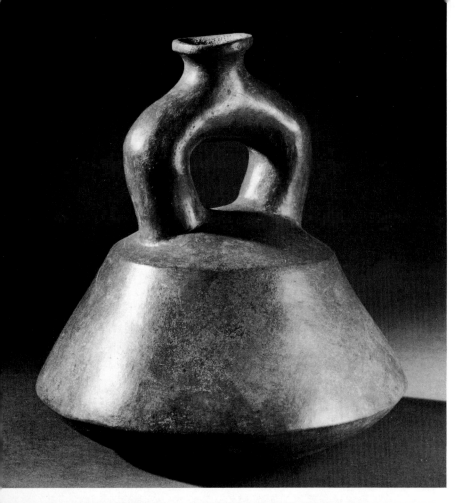

17. Stirrup-Spouted Bottle
Mexico, Central Highlands, Tlatilco. Middle Preclassic, 1000–500 B.C.
Red-painted brown earthenware
Gift, 59:1980; H. 21.5 cm. (Ex-coll. George Pepper)

We are relatively certain that the ultimate inspiration for the arbitrary stirrup-spout (handled) vessel was either Ecuador or Peru [see 393–398], where this form appeared even earlier than in West and Central Mexico. Such vessels are exceedingly rare in Mexico, whereas they are extremely prevalent in northern Peru. Therefore, this represents one of the many evidences of Pre-Columbian contact between the two continents. The red paint on this brown vessel breaks down into a latticework pattern on the sloping sides. The base is rounded.

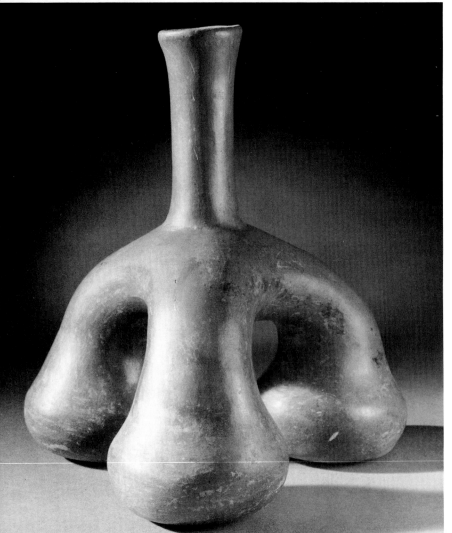

18. Three-Lobed, Long-Necked Bottle
Mexico, Central Highlands, Tlatilco. Middle Preclassic, 1200–500 B.C.
Polished red-slipped brown earthenware
Gift, 58:1980; H. 26.5 cm. (Ex-coll. George Pepper) (Illustrated: Coe, 1965, item 39)

Compound bottles such as this, while rare, are diagnostic of the place and period. The vessel is open to the bulbous tripods. A specular-hematite red slip covers the whole piece except for the bottom halves of the feet.

19. Composite Bottle

Mexico, Central Highlands, Morelos (San Pablo). Middle Preclassic, 1200–500 B.C.
Brown earthenware with specular-hematite red and black-negative paint
Gift, 405:1978; H. 28.5 cm., Diam. 20 cm.

This vessel, as well as objects 20, 21, and 24–28, came from a series of graves found in one large, circular burial mound in the state of Morelos—at a place called San Pablo. The mound was subsequently excavated (David Grove, 1970). This region is well known for its Tlatilco-related pottery vessels and hollow figurines cited in the literature as La Juana, Santa Cruz, and San Pablo. Olmec objects also have been found in the region, which seems to have been a trading outpost. This example has a dimpled convex base, concave sides, and a ridged conical top that culminates in a tall flaring neck. All except the base and alternating panels between the ridges are painted red. In addition, the vessel walls have negative-black-painted chevrons. (See 441 for a description of this technique, more correctly termed "resist" than "negative" painting.)

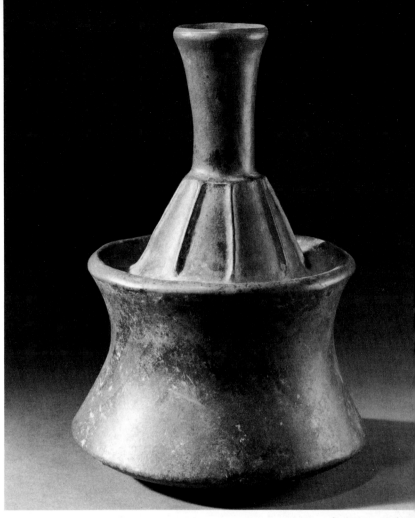

20. Bottle with Tall Neck

Mexico, Central Highlands, Morelos (San Pablo). Middle Preclassic, 1200–500 B.C.
Specular-hematite red-painted brown earthenware
Gift, 412:1978; H. 27.5 cm., Diam. 21.5 cm.

This vessel came from the large group of burial objects in one Morelos mound (about 100 in this collection). Simple bottle forms such as this are common to Tlatilco, Morelos, and the Middle Preclassic period in general (as well as to the Early Horizon in Peru). The subglobular body has wide grooves, creating vertical and diagonal designs. The red paint covers the neck, fills the grooves, and forms additional patterns between the grooves (not visible in photo).

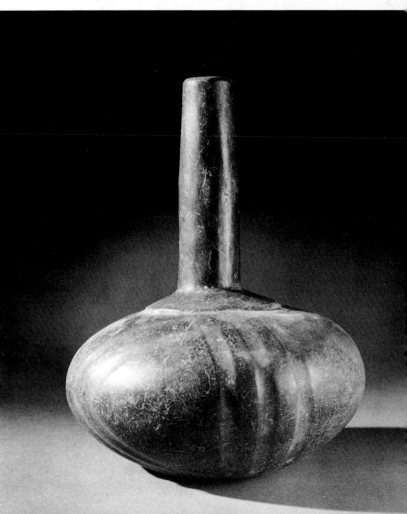

21. Tall Compound Bottle

Mexico, Central Highlands, Morelos (San Pablo). Middle Pre-
classic, 1200–500 B.C.
Specular-hematite red- and black-negative-painted earthenware
Gift, 418:1978; H. 34 cm.

This sort of three-tiered bottle, although found at Tla-
tilco, is especially common at the San Pablo site in More-
los. The entire vessel is painted red. The raised tiers have
diagonal grooves, and also have been overpainted nega-
tively in black, leaving circles that reveal the red under-
slip.

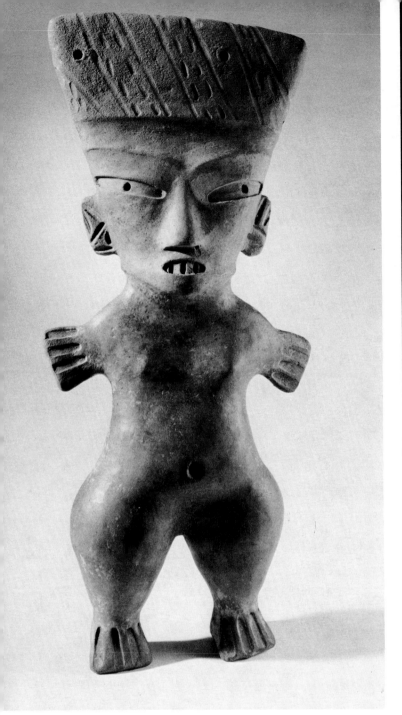

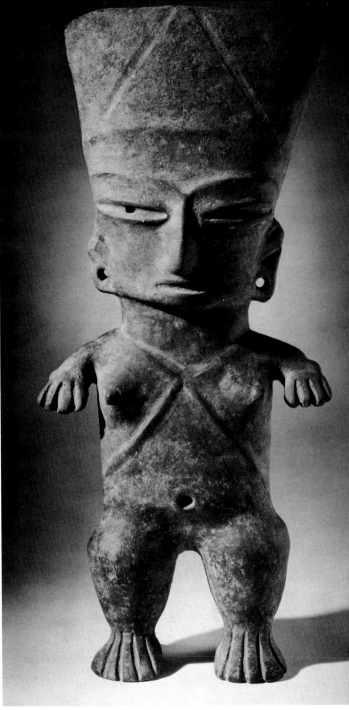

22. Hollow Figurine
Mexico, Central Highlands, Morelos (Santa Cruz). Middle Preclassic, 1200–500 B.C.
Red on brown earthenware with traces of white
Gift of Allan Gerdau, 186:1953; H. 43 cm.

This is related to the San Pablo group in the May Collection, and also to the large Tlatilco Type D-K figurines. Its navel is pierced, and pairs of asymmetrically placed perforations are found on the front and back of the trapezoidal headdress. The latter is unburnished brown and has grooved decoration. Zones of red paint may be discerned over the polished brown slip on the body. The various grooved details show traces of white paint.

23. Large Standing Figurine
Mexico, Central Highlands, Morelos. Middle Preclassic, 1200–500 B.C.
Brown earthenware with red paint
Gift, 360:1978; H. 47.5 cm.

While not documented as being from the San Pablo mound, this is another Type D-K hollow figure, either from Morelos or possibly from Tlatilco itself. There are perforations at the back of the head, and also in the eyes, earlobes, and navel. Typically, the grooved headdress is unburnished and the body is selectively painted red. Crossed straps outline the breasts, and the scapulae are distinctly modeled on the back.

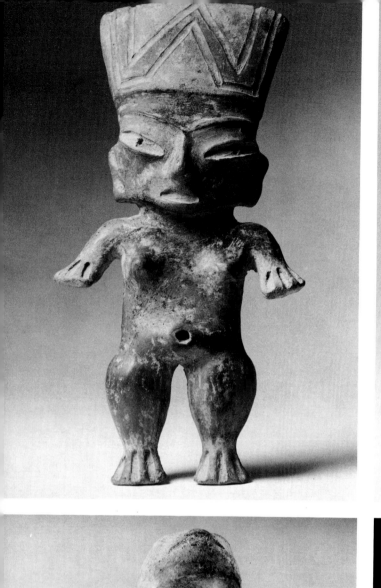
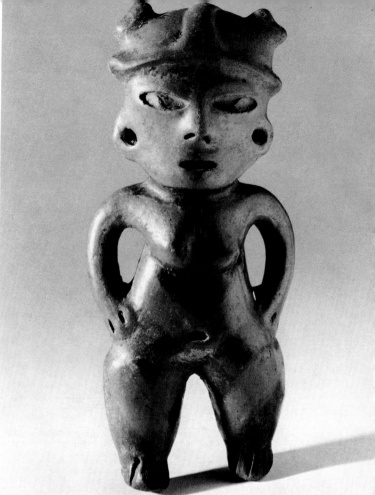
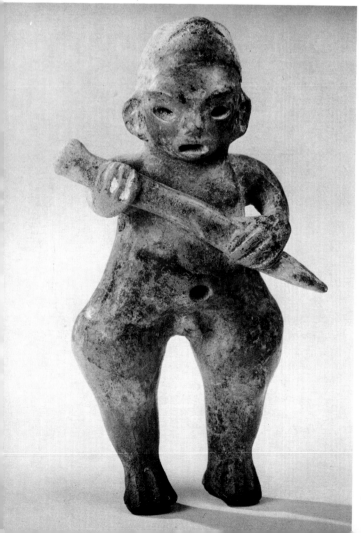
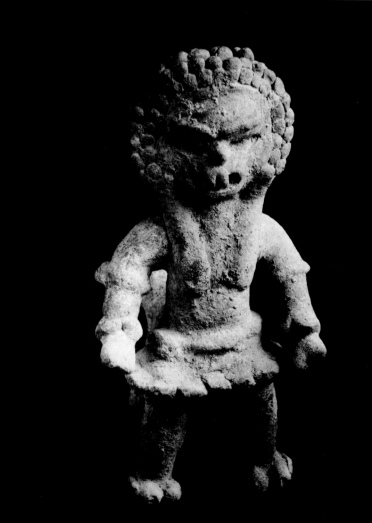

24. Standing Female (Upper left)

Mexico, Central Highlands, Morelos (San Pablo). Middle Pre-classic, 1200–500 B.C.
Red on brown earthenware
Gift, 426:1978; H. 23.5 cm.

Tlatilco style D-K hollow figurine, with elongated, diagonal, central-punched eyes; a tall, flat, expanded head-dress; stubby arms; and short, bulbous legs. The navel served as a vent hole during firing, and there also is a pair of perforations in the back of the headdress. The head-dress is decorated on both sides with groove-outlined, red-painted W motifs. The spaces between are unburnished brown, while most of the body and face is painted red. This, and the following objects, are from the same Morelos mound that produced all the Tlatilco style pottery.

26. Warrior Holding Dart

Mexico, Central Highlands, Morelos (San Pablo). Middle Pre-classic, 1200–500 B.C.
Red on brown earthenware with traces of white
Gift, 449:1978; H. 19.5 cm.

A hollow figure of a naked male, with an animal-head helmet or cap. The eyes, mouth, navel, and armpits are perforated. Red has been applied in diagonal patches, probably to represent the warrior's body paint. White remains in the grooved fingers and helmet.

28. Stemmed Stamp

Mexico, Central Highlands, Morelos (San Pablo). Middle Pre-classic, 1200–500 B.C.
Brown earthenware with traces of red paint
Gift, 457:1978; H. 5.2 cm., W. 6.4 cm., L. 8.7 cm.

A deeply carved clay stamp with a geometric design, like the contemporary roller seals [43], which could have been used to print patterns on the human skin (or textiles, or bark cloth). It came from the same group of ceramics found in the Preclassic San Pablo mound, even though it may seem to resemble Postclassic Mexican stamps. Stemmed stamps are also known from Tlatilco, where they often are in the shape of human feet.

25. Hollow Female Figurine (Upper right)

Mexico, Central Highlands, Morelos (San Pablo). Middle Pre-classic, 1200–500 B.C.
Red on brown earthenware with black-negative paint
Gift, 441:1978; H. 20.5 cm.

The majority of hollow figurines from San Pablo are of Type D-K. This differs in having punched double-triangle eyes and a hands-to-hips stance, relating to pure Tlatilco Type K [see 8]. The ears, nostrils, mouth, and navel are pierced. Red is painted selectively over the brown, while black-negative details have been superimposed.

27. Tripod Figurine

Mexico, Central Highlands, Morelos (San Pablo). Middle Pre-classic, 1200–500 B.C.
Buff earthenware with traces of yellow and red paint
Gift, 450:1978; H. 18.5 cm.

This is the most aberrant figurine type in the collection from San Pablo. It is solid, with double-punched eyes and "buck teeth" (probably fangs). A bustle and long, curved train extending back from the skirt serves as a third prop for the standing figure. The hair (or headdress) has multiple tufts, while the ankles, wrists, and elbows are encircled with ornaments (rattles?). The whole figure is stained yellow, and the lower arms and legs are painted red.

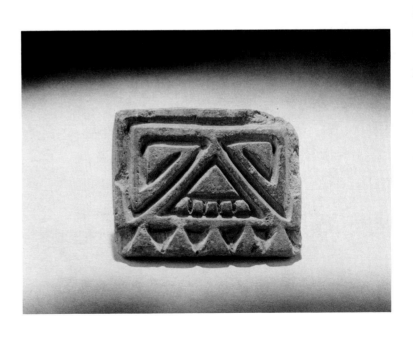

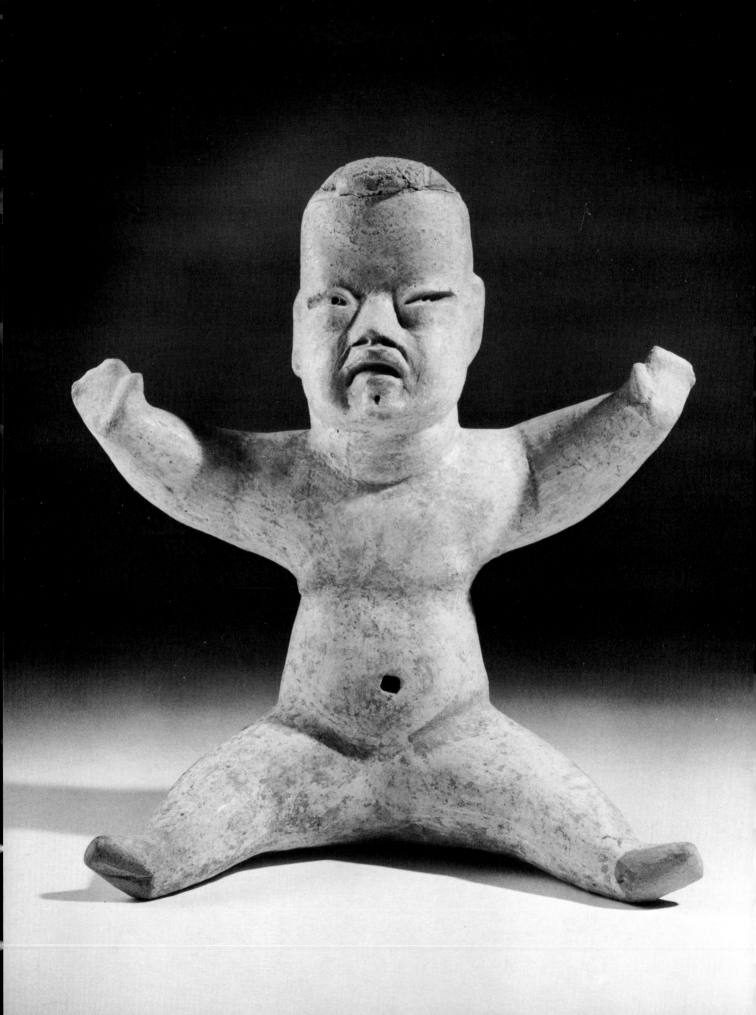

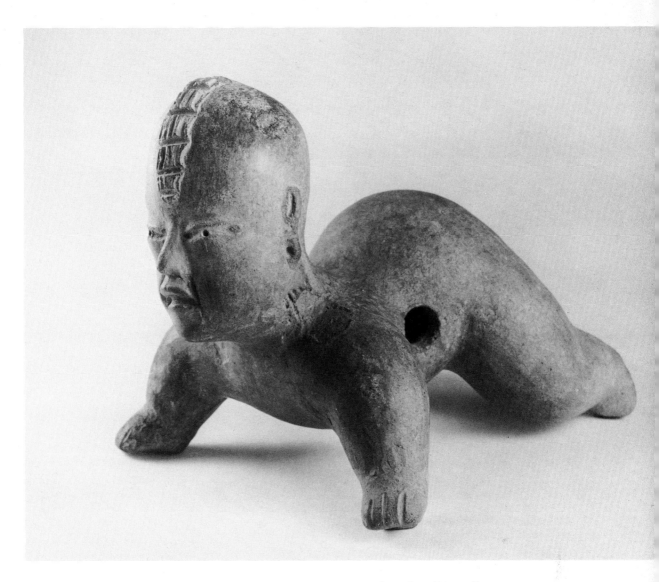

29. Hollow Seated Baby-Faced Figure

Mexico, Central Veracruz (Tenenexpan?), Olmec style. Middle Preclassic, 1000–500 B.C.
Gray earthenware with yellowish-white slip and red paint
Gift, 197:1979; H. 29 cm.

A classical Olmec splayed figure that more probably would be at home in the Central Highlands than the reported provenance on the Gulf Coast. It portrays the standard Olmec fat baby. The punctated hairband is outlined with grooves. The hair, ears, eyes, pouting mouth, and the hands are all painted red. Firing vent holes have been left in the base, navel, armpits, and back of the head.

30. Hollow Crawling Baby

Mexico, Central Highlands (location unknown), Olmec style. Middle Preclassic, 1000–500 B.C.
Buff earthenware with red paint and traces of white slip
Gift, 208:1979; H. 16 cm., L. 21 cm.

The more common posture for these large hollow Olmec "babies" is seated, as in the previous example, although the crawling position is also known. Presumably this is a Central Highland type showing Gulf Coast Olmec influence there. (See the small solid Olmec figurines from Las Bocas and Tlatilco, 33–36, for the same diagnostic Olmec "baby face" physiognomy.) This has large vent holes on either side of the midsection, blotches of fire-clouding, and only the barest trace of a former white slip. The mouth, grooved-and-notched head crest, ear spools, and the neck-to-shoulder "epaulets" (now chipped off), were all painted red.

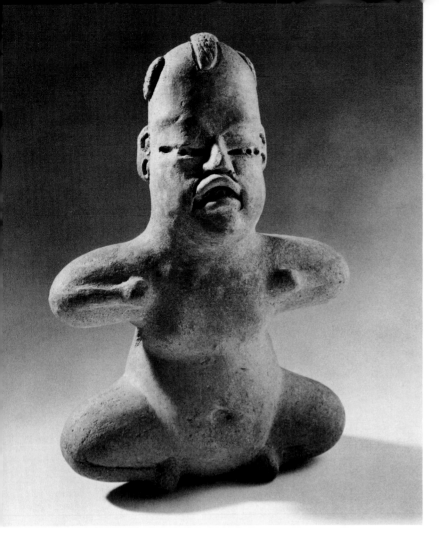

31. Hollow Baby-Faced Figure

*Mexico, Central Veracruz (Tenenexpan), Late Olmec style.
Middle Preclassic, 800–500 B.C.*
Buff earthenware with suggestion of former white slip
Gift, 132:1980; H. 23.5 cm.

The precise Gulf Coast provenance given for this and the
next item is probably correct. These variations on the
Olmec theme may well be later in the period of Olmec
hegemony. This example has a particularly dynamic, bent
position for the arms and legs; and the open mouth is too
expressive and asymmetrical for pure early Olmec can-
ons. A textured crest and top knots are added to the oval
head. Vent holes are found under the arms and on the
bottom.

32. Hollow Seated Figure

*Mexico, Central Veracruz (Tenenexpan), Late Olmec style.
Middle Preclassic, 800–500 B.C.*
Buff earthenware with traces of white and red paint
Gift, 192:1979; H. 9.5 cm.

Like the previous figure, this is an unusually dynamic
Olmec piece from the site of Tenenexpan, just north of
the modern city of Veracruz. It is depicted casually seated
with left leg bent, right knee drawn up and clasped by
both hands, and head turned to the left. The broken right
foot has been reshaped as a dowel for attaching another
foot (missing). This may be a Pre-Columbian repair, as
suggested for the lower arm of an Olmec stone figure
[48]. The hair is arranged as a forehead crest and a rear
bun. Vent holes are located under the arms and at the
bottom. The inside contains a clay rattle.

33. Pair of Miniature Solid Figurines

*Mexico, Central Highlands (Las Bocas), Olmec style. Middle
Preclassic, 1000–500 B.C.*
White earthenware with glossy white slip and red paint
*Gift, 109:1980.1,.2; H. 4 and 3.2 cm. (Ex-coll. George Pep-
per)*

Two tiny Olmec hand-modeled figurines from the high-
land site of Las Bocas. Both are seated cross-legged, with
right hands on right feet and left hands on right shoul-
ders. Both also have the Olmec feature of cleft, baby-
faced heads [see 39 and 45]. The clefts, ear spools, and
mouths are touched with red paint.

34. Female with Child at Knee

*Mexico, Central Highlands (Tlatilco), Olmec style. Middle Pre-
classic, 1000–500 B.C.*
Red earthenware with white slip and red paint
Gift, 96:1980; H. 8.2 cm. (Ex-coll. George Pepper)

A very expressive solid Olmec seated figurine from the
Valley of Mexico. The right hand holds an infant at one
knee, while the left hand holds the other knee. The
parent figure wears a red-painted turban.

35. Two Seated Figurines

*Mexico, Central Highlands (Las Bocas), Olmec style. Middle
Preclassic, 1000–500 B.C.*
Gray earthenware with glossy white slip and red paint
*Gifts, 107 and 108:1980; H. 7 and 10.2 cm. (Ex-coll.
George Pepper) (1592 illustrated: Coe, 1965, item 197)*

Naturalistically postured Olmec baby-faced figurines.
Note the pensive hand-to-cheek pose on one. The left
figure has a top knot and the right a turban, both of which
were painted red. The left figure's right foot, and both
feet on the right figure, are broken.

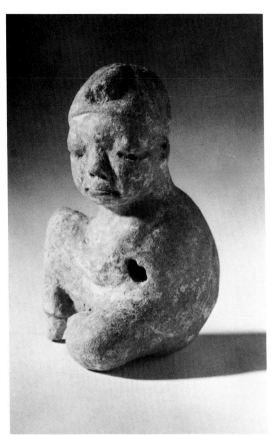

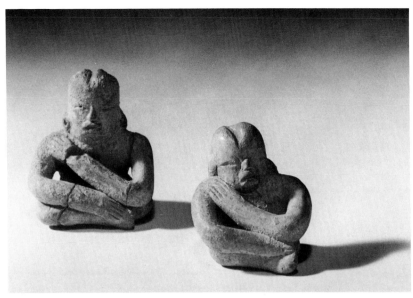

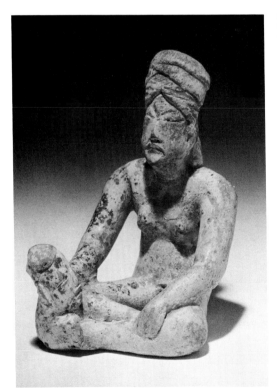

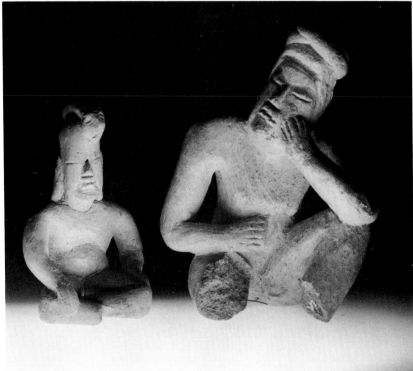

36. Solid Standing Figurine
Mexico, Central Highlands (Las Bocas), Olmec style. Middle Preclassic, 1000–500 B.C.
White earthenware with glossy white slip and red paint
Gift, 97:1980; H. 12.7 cm. (Ex-coll. George Pepper)

Other than being a type example of Las Bocas Olmec, the only special feature on this is the very precise and delicate treatment of the hairdo. The long side tresses are finely striated and the top section is cross-hatched, leaving triangular recesses. Only the hair and mouth are painted red.

37. Small Jaguar Vessel
Mexico, Central Highlands, Tlatilco. Middle Preclassic, 1000–500 B.C.
Polished black-brown earthenware with red pigment
Gift, 61:1980; H. 10.2 cm. (Ex-coll. George Pepper)

Although this relatively naturalistic modeled feline falls within the Tlatilco ceramic tradition, the subject matter relates closely to the Gulf Coast Olmec jaguar configuration. The cross-hatched belly and carved facial features are filled with red. The vessel opening is at the top of the head.

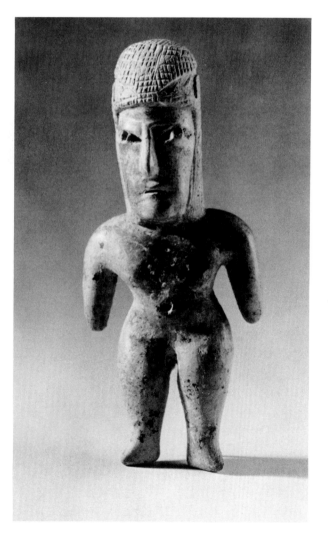

38. Spouted Tray

Mexico, Central Highlands, Tlatilco. Middle Preclassic, 1000–500 B.C.
Glossy white-slipped earthenware with areas of red pigment
Gift, 63:1980; L. 26 cm., W. 19.5 cm. (Ex-coll. George Pepper)

These are among the most refined and elegant of Tlatilco ceramic containers. They must have had some special, now unknown, function. The shallow rim is outwardly flaring, the floor of the tray is somewhat concave on the bottom, and the open spout turns downward. White kaolin ware is normally ascribed to Olmec influence, although these trays have not been found on the Gulf Coast.

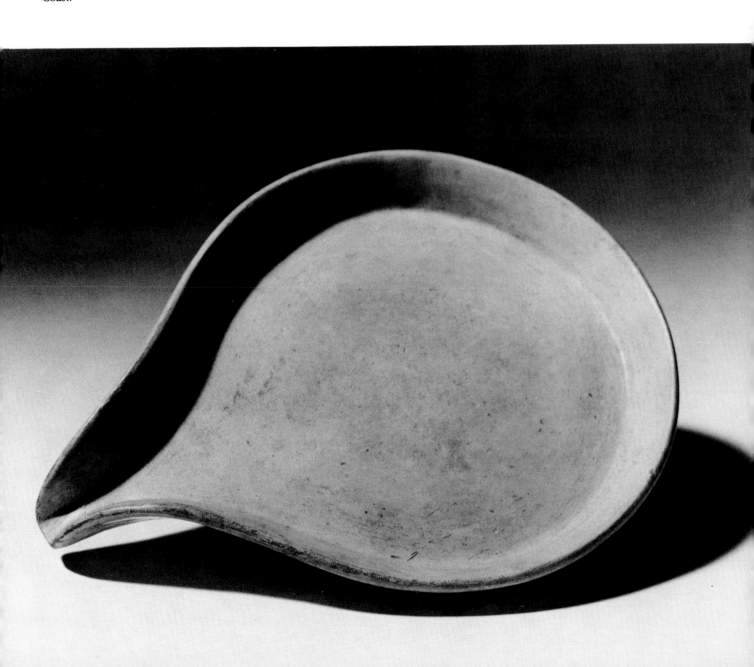

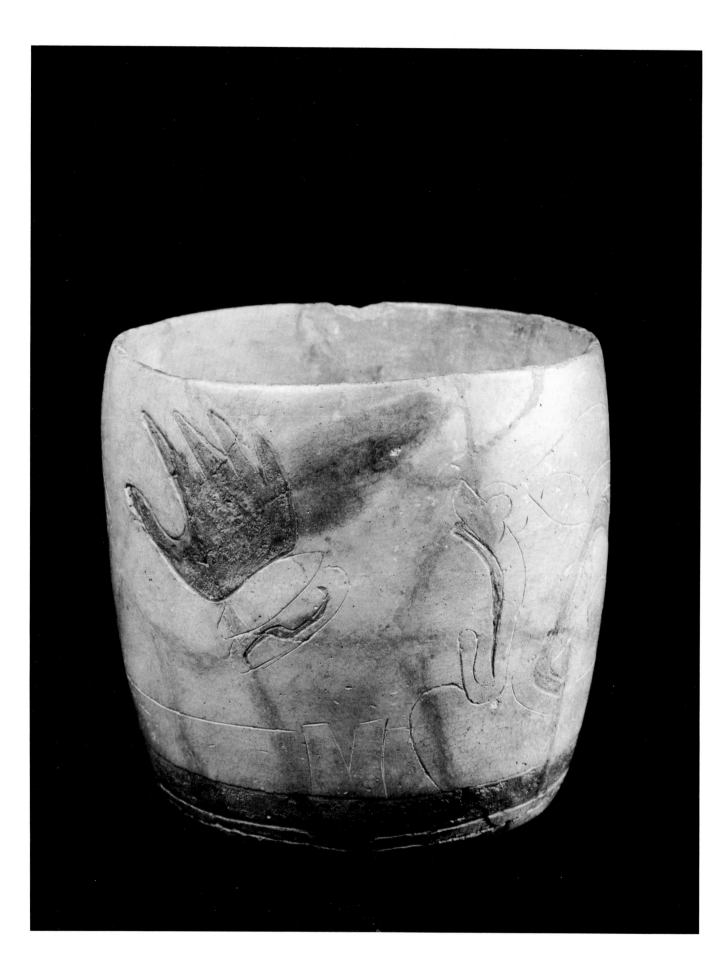

39. Incised Vase

Mexico, Central Highlands (Tlapacoya), Olmec style. Middle Preclassic, 1000–500 B.C.
Gray earthenware with polished white slip and red paint (See color plate)
Gift, 66:1980; H. 13 cm., Diam. 13.5 cm. (Ex-coll. George Pepper)

Tlapacoya is a site that produced Preclassic material related to Tlatilco and Las Bocas. This is a flat-bottomed, convex-walled vase with extraordinary Olmec iconography (see rollout drawing). Finely incised on the walls, in the best of Olmec draftsmanship, are two profile, open-mouthed, cleft heads, as well as two isolated hand motifs with cuffs. The hands are excised and filled with red. The upper gum and inner cleft borders are also excised and red-painted. The horizontal basal motif is partly incised and partly excised, with the application of red.

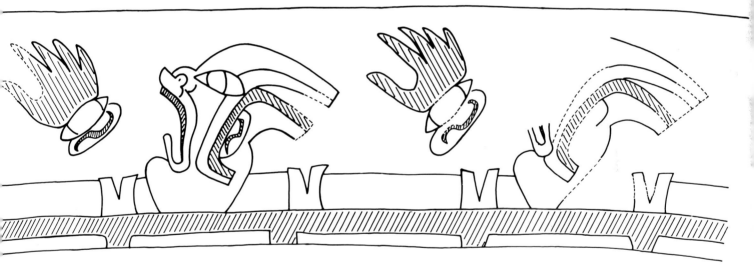

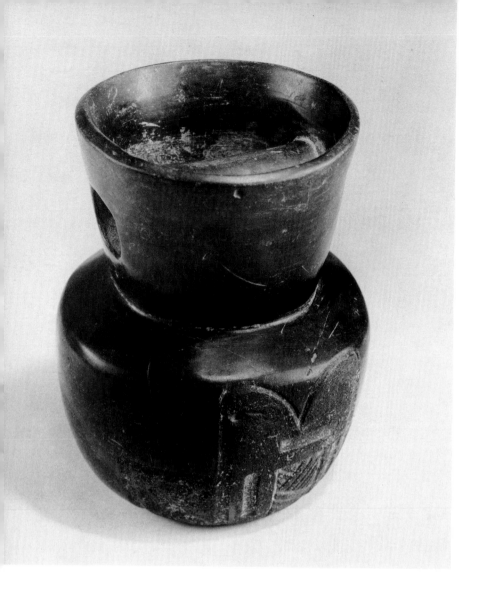

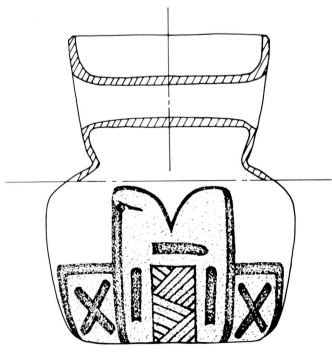

40. Decorated Jar with Interior Hollow Handle

Mexico, Central Highlands (Las Bocas), Olmec style. Middle Preclassic, 1000–500 B.C.

Burnished black earthenware

Gift, 70:1980; H. 15.5 cm. (Ex-coll. George Pepper) (Illustrated: Joralemon, 1971, item 123)

The form of this jar, with its unique interior tubular handle, is to our knowledge previously unpublished for Mesoamerica. (Such a form, however, is known for a Chavin bottle in Peru [Lapiner, 1976, item 96], and there is one other example from San Pablo, Morelos, in the May Collection.) One may wonder whether the prototype might not be of metal rather than clay but, of course, that is impossible for this period in Mexico. On the expanded body of the flaring-necked jar is an excised and broadly grooved Olmec design, left unburnished (see drawing). In the center is a cleft ("head") motif with a mat design and three bars ("mouth"), flanked by squares with diagonal cross motifs ("wings"). Joralemon interprets this as an abbreviated emblem for his God I, the reptile-bird-jaguar "earth dragon."

41. Cylindrical Vase

Mexico, Central Highlands (Tlatilco), Olmec style. Middle Preclassic, 1000–500 B.C.
Polished black earthenware with red pigment
Gift, 64:1980; H. 11.3 cm., Diam. 13.2 cm. (Ex-coll. George Pepper)

A flat-bottomed vase decorated by carving, deep grooving, and light incising. All the zones in the rollout drawing that appear white are unburnished and are filled with red. The unusually abstract design is difficult to interpret as a whole in Olmec iconography. It features a combination of mat designs and bracket motifs. However, the panel centered in the photograph may represent a profile mouth and mat-covered snout, with isolated eye and "flaming brow" motifs.

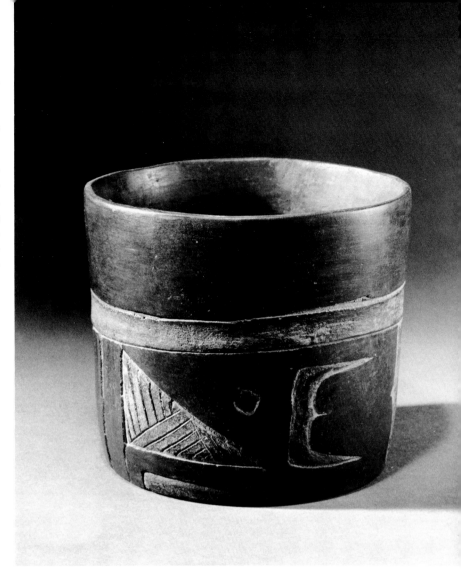

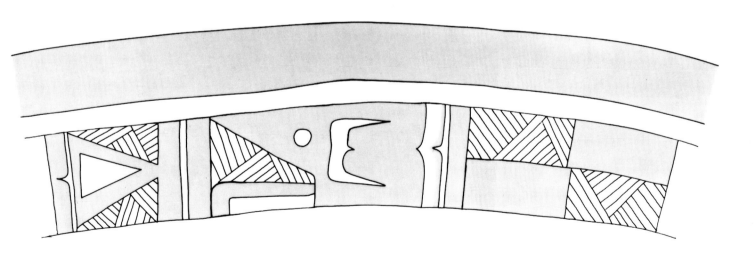

42. Two *Candeleros*

Mexico, Central Highlands (Las Bocas), Olmec style. Middle Preclassic, 1000–500 B.C.
Black (left) and white (right) earthenware with additions of red paint
Left: Gift, 71:1980; L. 7.0 cm., H. 2.5 cm., D. 3.5 cm.
Right: Gift, 72:1980; L. 7.2 cm., H. 2.5 cm., D. 3.8 cm.
(Ex-coll. George Pepper)

These small, two-chambered rectangular boxes are widely known for the Middle Classic Teotihuacan period, when they are usually called *candeleros* (or candleholders). More likely, however, they functioned as incense, paint, or sacrificial blood containers. It is not generally known that the form existed in Central Mexico prior to A.D. 300 and that they, in fact, seem to have been invented at Olmec-influenced sites prior to 500 B.C. Both of these examples have perforations: that on the left has an opposing pair on the side of each chamber, and that on the right is pierced in the septum between the chambers. This suggests that the objects were either suspended or had lashed-on covers. The second theory is probably correct, since other rectangular clay boxes in the Pepper Collection have associated effigy covers. The black *candelero* is decorated with deeply grooved U-motifs, filled with red. The white *candelero* has incised scroll panels and diagonal hatched sections; the alternate zones thus created are stained red.

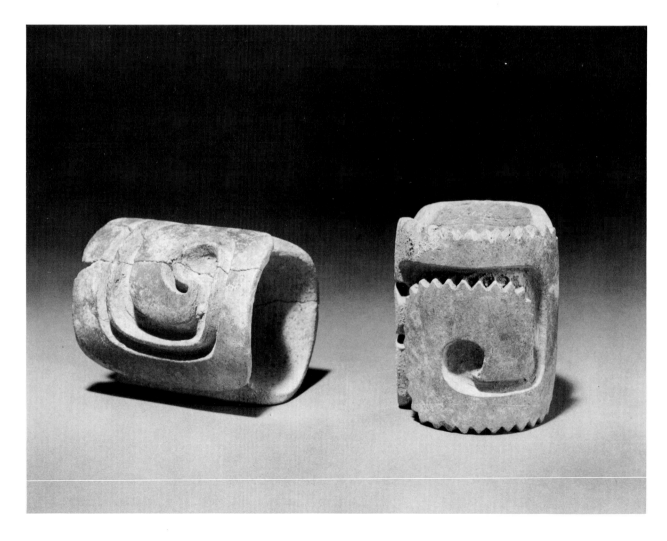

43. Hollow Roller Seals

Mexico, Central Highlands (location unknown), Late Olmec
style. Middle Preclassic, 800–500 B.C.
Unburnished black-brown earthenware
Gifts, 194 and 195:1979; H. 9 and 8.5 cm., Diams. 7 cm.

Cylinder seals, both solid and hollow, are distributed in
Preclassic times from Ecuador [387] to Central Mexico,
particularly at Tlatilco-related sites. This pair has deeply
carved, late Olmec scroll designs, which, when covered
with wet pigment, would produce continuous, repetitive,
curvilinear designs (see rollout drawings). Such seals
were used to apply patterns to the human body, and also
no doubt to textiles or bark cloth. Both seals have central
circle motifs separating their opposing wide scrolls. The
two differ in the direction of the scrolls, and one has
serrated edges.

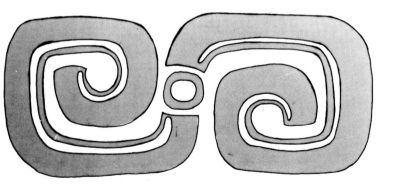
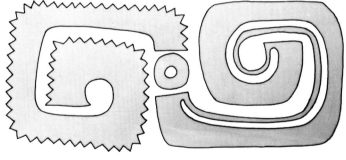

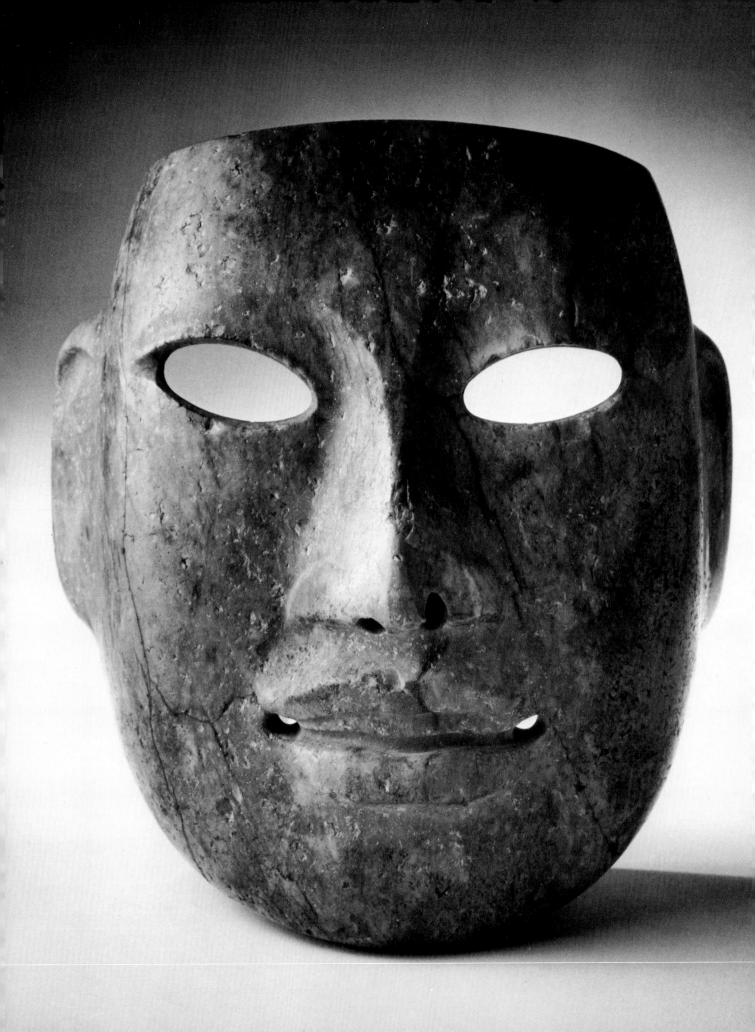

44. Funerary Mask

Mexico, southern Veracruz, Olmec culture. Middle Preclassic, 1000–500 B.C.
Mottled green jadeite (See color plate)
Gift, 178:1980; H. 21.5 cm., W. 20 cm., D. 11 cm.

Over a decade ago, a large cache of polished stone masks was accidentally uncovered at a place called Arroyo Pesquero along the Gulf Coast in the Olmec heartland—all of them of a quality (including extreme naturalism) hitherto unseen in Olmec art. These have become widely dispersed in collections. While we do not know for sure that this example was a part of that particular group (indeed, such objects logically could be found almost anywhere in Mexico, Guatemala, or Upper Central America through trading contacts), its exceptional size, depth (the hollowed-out cavity behind is 8.5 cm.), and expressive naturalism relate it to others found at Arroyo Pesquero.

Many of those masks, like this one, have cut-through eyes, realistic ears, and wide faces. Further, this object shows evidence of ceremonial sacrifice in Pre-Columbian times (terminal Olmec?) by exposure to extreme heat. (Note the spalling on the left nostril and forehead, the diagonal cracking; and the fire-clouded forehead, left cheek, and chin.) The convex top of the mask forms a ledge to the rear border, which, in turn, is continuous around to the deep chin on the bottom. Drilled suspension holes are found on the edges below the ears, with another in the center of the "ledge." Also, the nostrils and the corners of the mouth are pierced by drilling. Finally, note the exposed upper gum in the parted mouth.

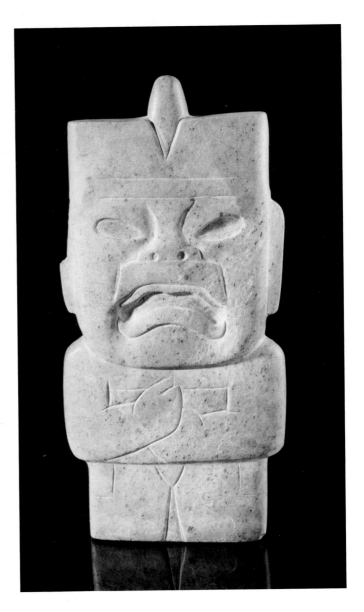

45. Fraudulent Jade Plaque

Mexico, Olmec style.
Light green jadeite
Gift, 359:1978; H. 23.5 cm., W. 11.5 cm., D. 1.5 cm.

If authentic, this would be one of the masterpieces of the collection. However, it has been strongly doubted as an ancient work of art. Although it is not customary to publish suspected falsifications knowingly, this one may be instructive as a warning about the skill of the forgers, and the difficulty of determining a fake stone carving on visual evidence. Fraudulent Pre-Columbian art is altogether too prevalent, and no large collection is free of a few examples. By and large the technology of the carving seems correct, but there is one aberrant feature of iconography: the vegetation sprout in the cleft of the head never has been found on this type of jade ax-plaque. Also, the excessive flatness of the reverse side is suspicious. Otherwise this appears to be an acceptable representation of the Olmec cleft-headed, were-jaguar deity.

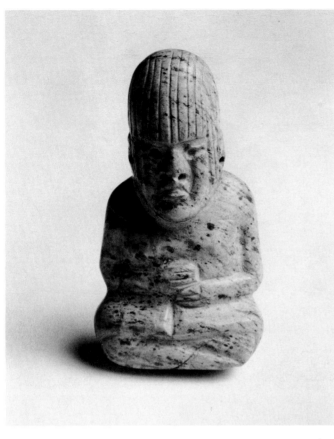

46. Seated Figurine

Mexico, Veracruz, Olmec culture. Middle Preclassic, 1000–500 B.C.
Black-veined, light green jadeite
Gift, 337:1978; H. 8.5 cm.

A cross-legged classical Olmec jade figure from the Gulf Coast, with creased kilt and simple striated hair. The earlobes and nostrils are delicately perforated.

47. Standing Stone Figurine

Mexico, Veracruz, Olmec culture. Middle Preclassic, 1000–500 B.C.
Green jadeite
Gift, 379:1978; H. 14 cm.

A characteristic Olmec small jade carving. Unfortunately, the extremities of all the limbs are broken. The face is intricately defined and the long tab ears are pierced. The elliptical head has an indentation behind, the spine is deeply grooved, and the knees are slightly bent.

48. Figure With Detached Arm

Mexico (provenance unknown), Olmec style. Middle Preclassic, 1000–500 B.C.
Light green stone (probably serpentine), with traces of red paint
Gift, 189:1979; H. 26.5 cm.

This sort of generalized Olmec portable stone figure was widely distributed in Mesoamerica during the Middle Preclassic period. Although relatively small, its powerful proportions make it seem monumental. There are drilled pits at the corners of the mouth and a conical pit at the top of the head. The fingers, toes, and female organ are incised. The last feature is rare, as most Olmec figures are rendered sexless. The most unusual aspect of this figure is the fact that the broken arm apparently was replaced with a carved stone forearm in ancient times (see separate limb in photo). The break in the upper arm was drilled to receive the prong on the replacement, which, incidentally, is of a different kind of stone.

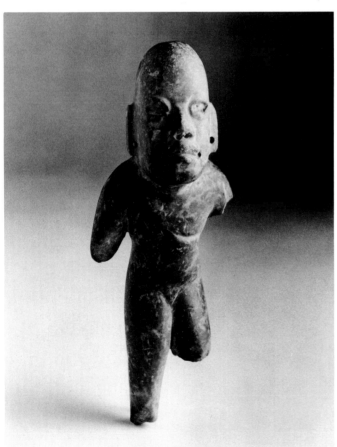

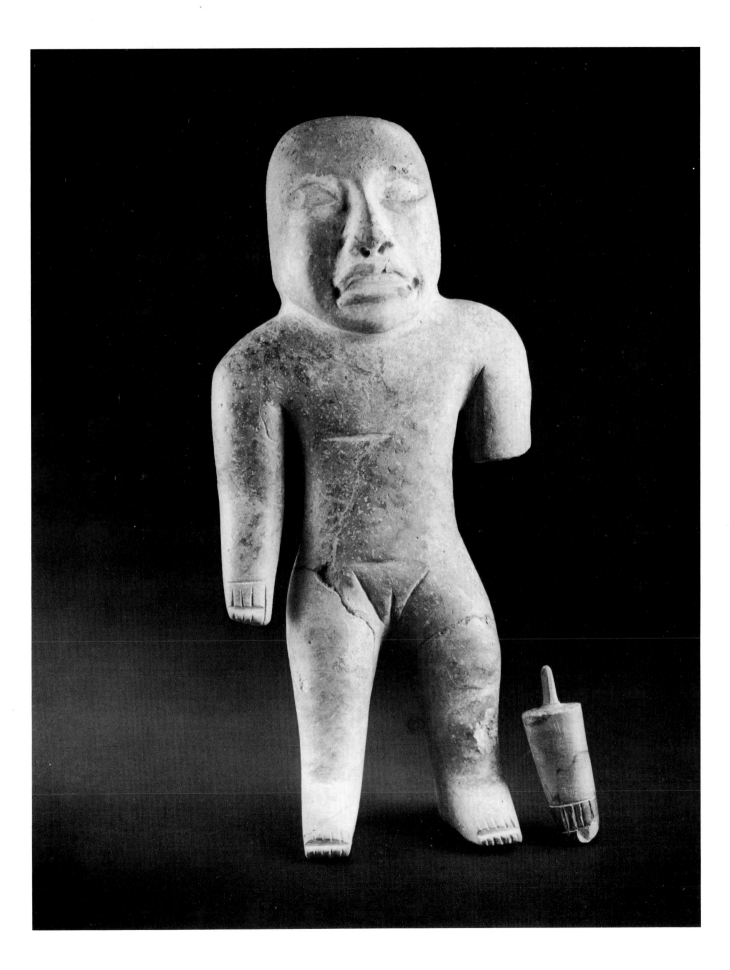

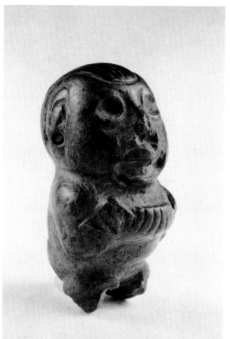

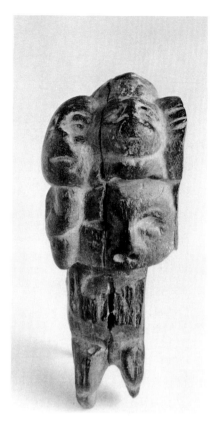

49. Kneeling Figure

Mexico (provenance unknown), Olmec style. Middle Preclassic, 1000–500 B.C.
Black volcanic stone
Gift, 89:1980; H. 10 cm. (Ex-coll. George Pepper)

An eroded miniature stone carving revealing a common Olmec subject, referred to as a chinless dwarf. The human figure kneels, with his arms held out in cross-armed position. The head is turned to look directly upward. While the facial features are much damaged, the Olmec character of the piece is unquestionable.

50. Dwarf Figure

Mexico, Gulf Coast, Olmec style. Middle Preclassic, 1000–500 B.C.
Fine-grained black stone
Gift, 154:1979; H. 6 cm.

Another representation of the Olmec "chinless dwarf." This miniature stone carving shows a large-headed figure crouching on its haunches, with its hands and fingers cupped forward as if to hold an offering. Its earlobes are laterally drilled and a central lock of hair, extending down the back of the head, is defined by parallel incisions. The nose and feet have suffered damage.

51. Chinless Dwarf with Multiple Figures on Head

Mexico, Tabasco, Olmec culture. Middle Preclassic, 1000–500 B.C.
Green schist
Gift, 88:1980; H. 9.5 cm. (Ex-coll. George Pepper)

A unique stone carving from the Gulf Coast, showing a standing dwarflike being with a cluster of five supplementary figures covering its head. The principal figure is agnathous (its mouth is depicted under the ledge formed below its nostrils). While the left side of the stone has flaked off, there were balanced crouching figures flanking the sides of its head. There is one supplementary head over the dwarf's forehead, another facing the opposite direction behind, and the last at the nape of the neck. All five of these head figures have their hands to their mouths.

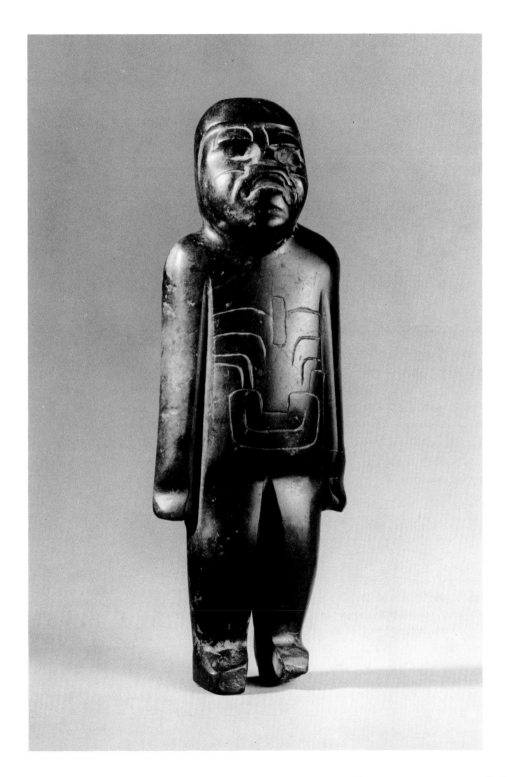

52. Standing Stone Figure

Mexico, Gulf Coast (?), Late Olmec style. Middle Preclassic, 800–500 B.C.

Polished, fine-grained black stone

Gift, 263:1978; H. 17 cm.

Although in most respects this is a diagnostic portable Olmec stone carving, the straight string-sawed grooves delineating the front and back of the arms, and the straight notch separating the legs, are peculiar. These technical features of cutting the stone are more characteristic of West Mexican (Guerrero) Preclassic stone figures than of the Gulf Coast provenance supplied by the dealer. On the other hand, the slight bend to the legs (as seen in side view) is entirely typical of Olmec figures. The head is carved in the standard Olmec mode for a were-jaguar (note the "snarling" mouth). Incised on the torso is a "proto-glyph" with bifurcated "vegetation" sprouting from a U basin. Variations of this emblem are found on other known Olmec objects, and it, in turn, presages the Zapotec Glyph C [see 209]. The incisions and depressions retain vestiges of red pigment.

53. Standing Figure

Mexico (provenance unknown), Late Olmec style. Middle Preclassic, 800–500 B.C.
Greenish-black stone
Gift, 87:1980; H. 11.5 cm. (Ex-coll. George Pepper)

A flat human figure carved in several planes. While the simplified, squared facial features imply a post-Olmec style, the grooved flanges at the shoulders and head more strongly suggest a Late Olmec convention. The four scroll-like flanges may be vegetal motifs. The figure wears an interesting kilt, which is split in the front and fans out on the reverse in two tiers. The arms are bent, with the hands joining at the midline in a symbolic gesture.

54. Two Standing Figurines

Mexico, Puebla (left) and Veracruz (right), Late Olmec style. Middle Preclassic, 800–500 B.C.
Greenish-black stone(left) and greenstone (right)
Gifts, 91 and 90:1980; H. 12.8 and 8.2 cm. (Ex-coll. George Pepper)

While of somewhat different purported provenances, both of these stone figures have characteristic Olmec baby faces and stances (the lower arms of the left figure are missing). Both have notches behind the knees and at the back of the head. However, the one figure has separations between the arms and legs and the other only has grooves. The larger figure has a belt indicated by a pair of deep grooves. The smaller figure has a more complexly designed belt, and its pectoral muscles are shown.

55. Standing Figure

Mexico, Guerrero (Iguala), post-Olmec style. Late Preclassic, 500–200 B.C.
Polished greenstone
Gift, 269:1978; H. 34.5 cm.

A number of stone objects from Guerrero show direct Olmec influence; others, like this from Iguala, indicate late, derived, Olmec traits. The style is no longer classical Olmec [cf. 48], but is more abstract in features and more dynamic in posture. The mouth is almost trapezoidal (apparently a post-Olmec stylistic trait), the eyes are wide open, and the tablike ears are notched.

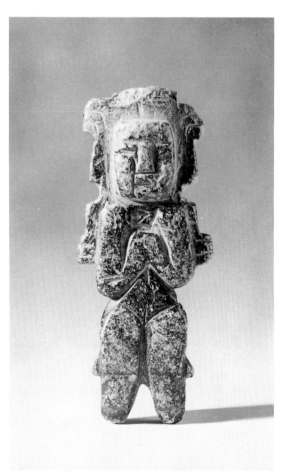

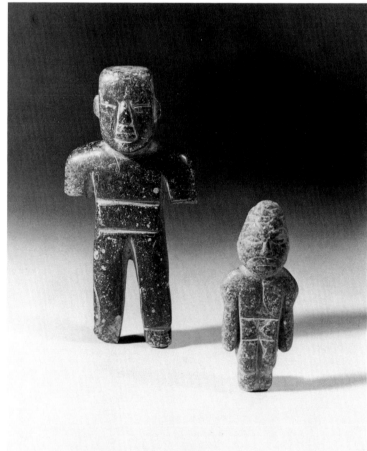

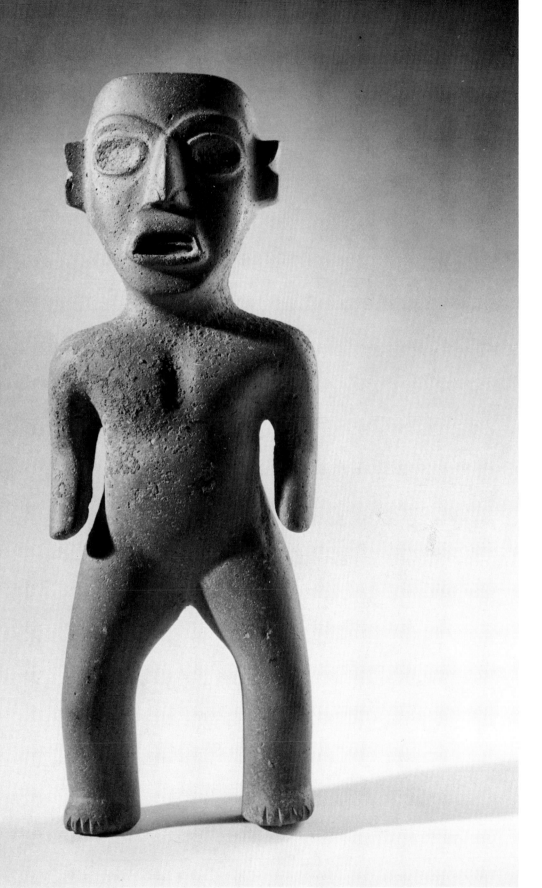

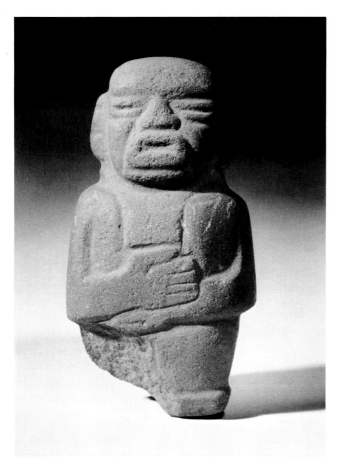

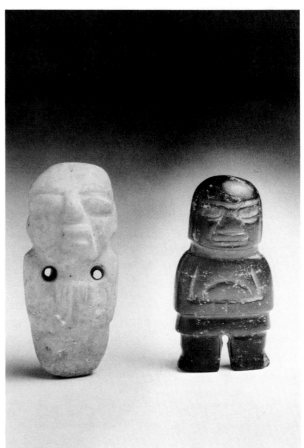

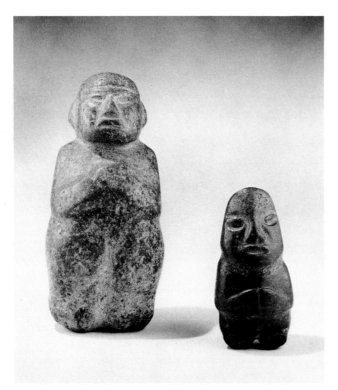

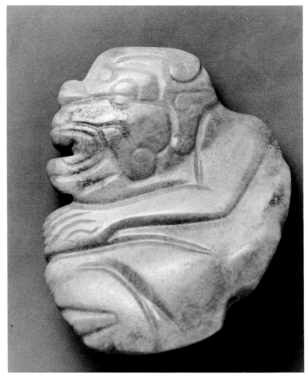

56. Fat Figure (Upper left)

Mexico, Veracruz (?), post-Olmec style. Late Preclassic, 500–200 B.C.
Gray basalt
Gift, 94:1980; H. 13.5 cm. (Ex-coll. George Pepper)

Although stylized "Olmecoid" figures such as this are more commonly known from West Mexico, the type is widely distributed in Mesoamerica. The Pepper Collection entry claims a Gulf Coast provenance on this. The distinctive trapezoidal mouth and fat body suggest a Late Preclassic temporal assignment, contemporary with the Mezcala style of Guerrero and the Monte Alto style of southern Guatemala (Parsons and Jenson, 1965), although there is some retention of Olmec traits. In profile the object is celt-shaped, with a shallow V-shaped groove dividing the legs. A collar falls as a bib in front. The arms are crossed over the belly and the fingers are well defined. (The right leg is flaked off.)

57. Two Miniature Olmecoid Figures (Upper right)

Mexico (location unknown), post-Olmec style. Late Preclassic, 500–200 B.C.
White marble (left), and polished blackstone (right)
Gifts, 93 and 92: 1980; H. 8.3 and 7.7 cm. (Ex-coll. George Pepper)

One might suspect that these come from West Mexico. The white stone figure has such generalized post-Olmec features as puffy eyes and trapezoidal mouth. The hands are raised in front of the torso and biconical drill holes are placed under the shoulders. The black figure is doubtless in a contemporary style, of which there are many variations. It has a similar triangular nose, depressed ovoid eyes, and a more rectangular mouth form. The arms are folded across the torso.

58. Olmecoid Stone Figures (Lower left)

Mexico (possibly Guerrero), post-Olmec style. Late Preclassic, 500–200 B.C.
Greenstone
Left: Gift, 248:1978; H. 16.5 cm. Right: Gift, 95:1980; H. 9.8 cm. (Ex-coll. George Pepper)

These fat stone figures with vaguely Olmec features are best described as "Olmecoid," and are no doubt post-Olmec in date. The type is common to West Mexico, but is also abundantly found as far south as Guatemala. Both have their arms clasped to their chests.

59. Fat Demon Pendant (Lower right)

Mexico or Guatemala (provenance unknown), post-Olmec style. Late Preclassic, 500–200 B.C.
Apple-green jadeite (See color plate)
Gift of May Department Stores Co., 38:1970; H. 10.5 cm., W. 8.2 cm.

The style of this jade carving is clearly Late Preclassic and seems to relate to the monumental "potbelly" stone sculptures on the southern Pacific Coast of Mesoamerica in the post-Olmec, 500–200 B.C., period (see Parsons and Jenson, 1965). One would expect such an object to have been found in the general Coastal Lowland region extending from the Gulf of Mexico to the Pacific Coast of Guatemala. The crouching, rotund figure carved in low relief has his arm and hand over his belly. The grotesque head has a volute coming out of the back of the open mouth, a scrolled supraorbital plate, a scroll-topped head, as well as a scrolled ear—all demon-like features, which appear in the art of the time period under consideration and which become further developed in the subsequent Izapan period. The back of the pendant is smooth and convex, and there is a horizontal perforation at the level of the chin. In addition, there are pairs of holes drilled diagonally on the edge at the top and bottom of the projecting back.

60. "Bib Head" Pendant

Southern Mexico (location unknown). Terminal Preclassic, 200 B.C.–A.D. 200
Apple green jadeite
Gift, 136:1980; H. 4.1 cm., W. 2.8 cm.

The front is carved as a stylized human head, with a plain biblike projection below (the back is uncarved). Note the abstract definition of the eyes. Tiny perforations for suspension are located at the top corners. (For a description and identification of this type of Preclassic artifact, which might otherwise be confused with the Mixtec style, see Easby and Scott, 1970, item 71.)

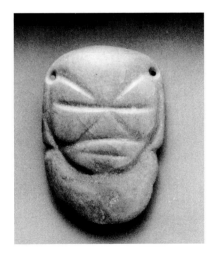

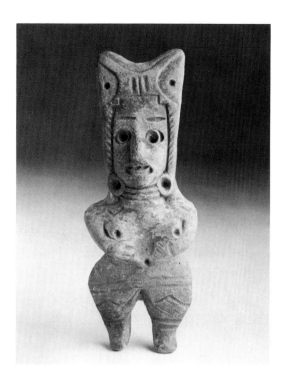

61. Solid Female Figurine (Above)

West Mexico, Guerrero (San Jeronimo). Late Preclassic, 500–100 B.C.
Buff earthenware
Gift, 243:1978; H. 13.5 cm.

This special type of clay figurine with its vertically elongated flat head is specific to the Pacific Coastal region, upshore from modern Acapulco. The front surface has been punctuated and textured by tooling the clay before firing. The variety of Late Preclassic figurine types in Mesoamerica is multitudinous, with each subregion producing its own peculiar expression, as will be apparent in the following selected examples.

62. Hollow Standing Female (Right)

Mexico, Guerrero, Rio Balsas region. Late Preclassic, 500–100 B.C.
Buff earthenware with thick gray encrustation
Gift, 283:1978; H. 28.5 cm.

A highly unusual figurine type, probably from the vicinity of Mezcala in Guerrero—a region not sufficiently well known archaeologically. This may be a late expression of the very early "Xochipala" type. It has a horizontally expanded head, tripartite headdress, continuous eyebrow, and punctuated rhomboid eyes and mouth. Two firing vent holes are located at the top of the head.

63. Seated Figure (Facing page, left)

Mexico, Veracruz (Tenenexpan), post-Olmec style. Late Preclassic, 500–200 B.C.
Buff earthenware with traces of red paint
Gift, 198:1979; H. 21 cm.

While Tenenexpan is a known Preclassic Gulf Coast site just north of the city of Veracruz, complete figurines in this style are not often seen. We are presuming that it is an Olmecoid variant, and post-Olmec in time, until excavation information is forthcoming. The elaborately coiffured head and the arms are solid, but the body and legs are hollow. There are two perforations in the back, and one at the bottom.

64. Large Hollow Figure (Facing page, right)

Mexico, Veracruz (Tenenexpan), post-Olmec style. Late Preclassic, 500–200 B.C.
Reddish-buff earthenware
Gift, 199:1979; H. 33 cm.

Although from the same Preclassic site as the previous figure, the style of this one is altogether different. Again, it seems to be a post-Olmec variation in figurines, but not yet classified. The skirted figure is seated cross-legged, with arms crossed over the chest. Vent holes are located at the knees, navel, elbows, and top of the headdress. The puffy mouth protrudes, and the perforated eyes are outlined by angular incisions.

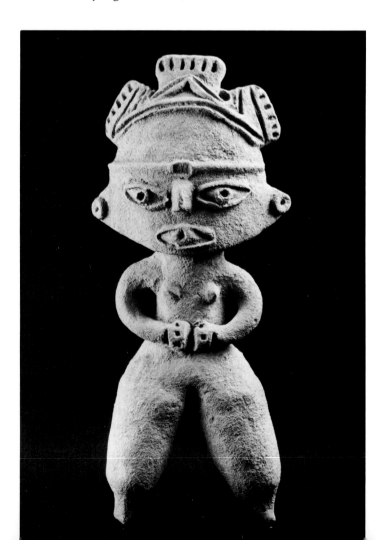

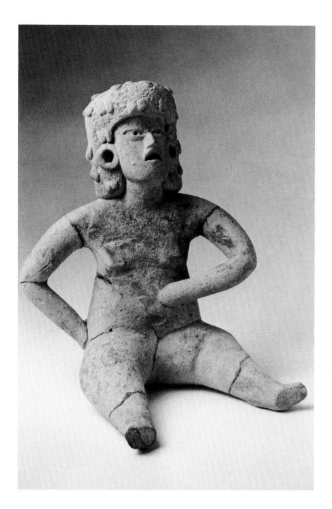

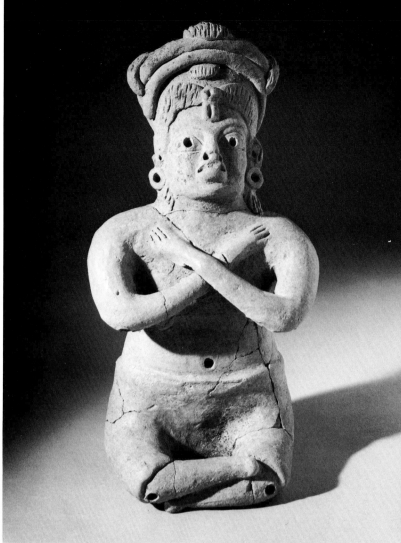

65. Ball Player Whistle Figurine

Mexico, Veracruz (Tenenexpan). Terminal Preclassic, 200
B.C.–A.D. *200*
Buff earthenware with red and white paint
Gift, 191:1979; H. 24.5 cm.

Another figurine purportedly from the site of Tenenex-
pan, which in type appears to be somewhat later than the
last two. This figure is hollow, with a round hole in the
torso, a whistle mouthpiece on the back of the head, and
two square finger stops behind the thighs. The ball player
wears his waist yoke, loincloth, knee pad, and foot guard
on his left leg. Hatchings on the yoke may indicate lash-
ings for tying it on; the yoke represented may well have
been of carved wood, unlike the Classic Veracruz cere-
monial stone yokes [see 266–269]. His askew headdress
is unusually complex. Selected areas of the accouter-
ments and body are painted red and white.

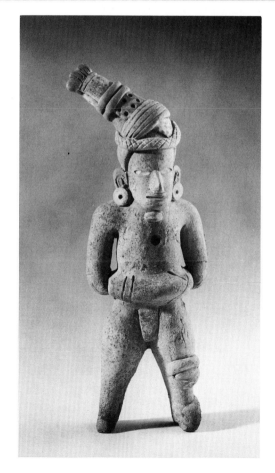

67. Miniature Circle Group

Mexico, Guanajuato, Chupicuaro style. Late Preclassic, 500 B.C.–A.D. 1
Buff earthenware with red and white paint
Gift, 110:1980; Maximum diam. 5.5 cm. (Ex-coll. George Pepper)

This tiny hand-modeled scene, depicting four figures linking arms in a circle, is reminiscent of the Tlatilco circle group [5]. The figures are joined on a rounded base with four clay pellets in the center. Only the faces are delicately painted. Each forehead is pierced (for suspension of the group?).

66. Two Chupicuaro Figurines

Mexico, Guanajuato, Chupicuaro style. Late Preclassic, 500 B.C.–A.D. 1
Buff earthenware with touches of red and white paint
Gifts, 112 and 111:1980; H. 10 and 9.5 cm. (Ex-coll. George Pepper)

Typical solid figurines in this regional style are flat-backed and feature extremely slanting "coffee bean" eyes. The little lady on the left has an applied necklace and ear spools, and evenly parted hair. The seated woman on the right carries a child on her left hip.

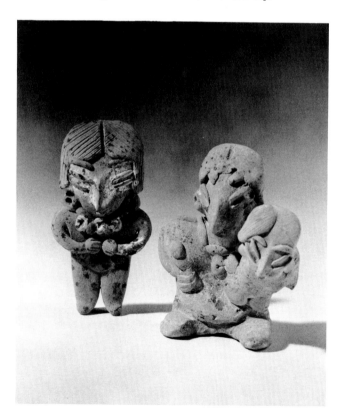

68. Hollow Female Figures (Facing page)

Mexico, Guanajuato, Chupicuaro style. Late Preclassic, 500 B.C.–A.D. 1
Red-, cream-, and black-painted earthenware
Left: Gift, 242:1978; H. 24 cm. Right: Gift, 144:1979; H. 26.5 cm.

Preclassic Chupicuaro ceramics range from miniature solid to large hollow figures, as well as a variety of three-color polychrome and polished black vessels. These two broad fat females epitomize the local expressionistic style of hollow figurines. Their earplugs are perforated, their mouths are open showing teeth, and their foreheads are grooved. Both have body painting consisting of zigzag cream lines, outlined with black, over a polished red background. Both also seem to have cream-colored "panties." One is overpainted with a black-line net effect.

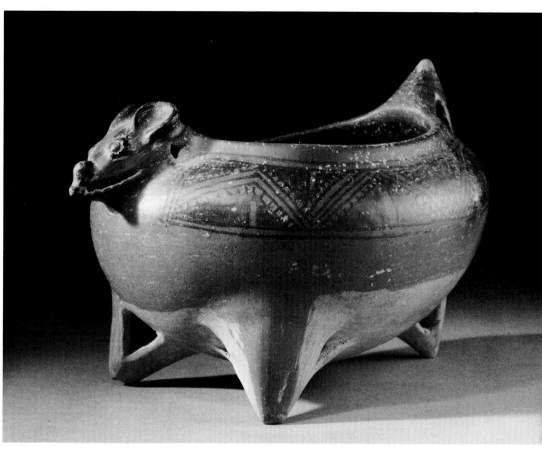

69. Animal Effigy Tripod Vessel

Mexico, Guanajuato, Chupicuaro style. Late Preclassic, 500
B.C.–A.D. 1
Polished red and black paint on buff earthenware
Gift, 73:1980; L. 27 cm., H. 18 cm. (Ex-coll. George Pepper)

Effigy pottery in both bichrome and three-color poly-
chrome is a special feature of the Chupicuaro zone. It is
thought to be the earliest true polychrome pottery in
Mesoamerica. This vessel has pierced conical tripod feet
(a prevalent Late Preclassic ceramic trait), a tail modeled
in the same fashion, and a hollow animal rim head. The
interior and upper sides are painted deep red, while
there is a band of black geometric designs below the rim.

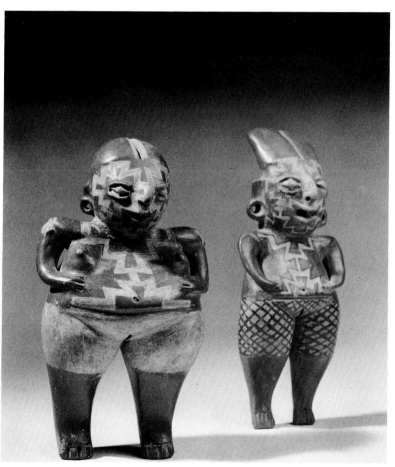

70. Solid Female Figurines

Mexico, Michoacan. Late Preclassic, 500–100 B.C.
Buff earthenware with traces of red and white paint
Gifts, 382:1978.7 and .11; H. 13.5 and 14 cm.

Located south of the Chupicuaro zone and west of the
Central Mexico-Morelos region, Michoacan demon-
strates another variation of Preclassic figurines, for which
these two are characteristic. Eye forms vary from "coffee
bean" to rhomboid, while hairstyles, as usual, differ con-
siderably. The figure with the cocked hairdo, oversize
earplugs, necklace, and loincloth also wears a tasseled
bustle.

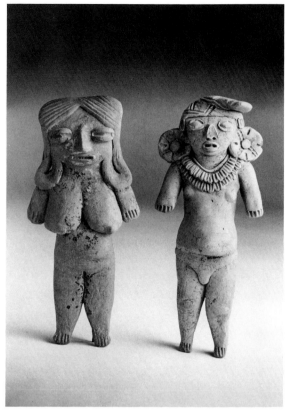

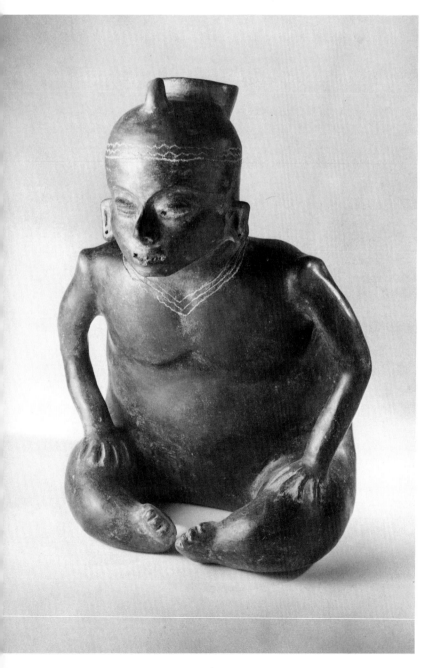

71. Seated Human Effigy Vessel

Mexico, Michoacan (Colima-related style). Terminal Preclassic,
200 B.C.–A.D. *300*
Polished black earthenware
Gift, 74:1980; H. 33.5 cm. (Ex-coll. George Pepper)

Although this vessel came from the state of Michoacan,
the style closely resembles the Colima shaft-tomb culture
of West Mexico (see the following section). The expres-
sionistically modeled figure leans forward, with its hands
on its thighs. It bears a horn on its forehead, which has
been identified as a shaman's device in the Colima cul-
ture. A raised spout is located at the back of the head, and
a headband and collar are incised on the surface.

West Mexico

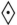

The highland region of West Mexico extends from Guererro northward to Sinaloa. However, the so-called shaft-tomb culture centered in the states of Colima, Jalisco, and Nayarit—which have lent their names to the major substyles of Terminal Preclassic tomb pottery, now dated from 200 B.C. to A.D. 300. Except for this relatively early, and certainly brilliant, outpouring of ceramic sculpture, West Mexico was on the fringe of the mainstream of Pre-Columbian development in the highlands. While the prolific and highly imaginative modeled clay effigies from Colima, Jalisco, and Nayarit may relate to the earlier cultures in Central Mexico, as at Tlatilco, the shaft-tomb culture was unique in Mesoamerica. The only other area of the New World with this style of burial chamber is found in the Northern Andes—the possible source of the concept. Little is known about the Classic period in West Mexico, and only in the Postclassic period did the whole region come into the sphere of Central Mexican influence. Both Toltec and Mixtec inroads are manifest, and by the Late Postclassic period, the Tarascans, who successfully resisted Aztec domination, are identified with their capital at Tzintzuntzan on Lake Patzcuaro.

The famous shaft-tomb culture, which the bulk of the objects in this section represents [72–124], used to be considered contemporary with the Classic stage in Mesoamerica. Miguel Covarrubias (1957) was the first to suggest that the style was Preclassic, and now a cluster of radiocarbon dates from the tombs confirms the 200 B.C.–A.D. 300 range, although to this day, no shaft tomb has been completely excavated professionally. The upper time limit overlaps Early Classic Teotihuacan, and indeed "thin orange" ware from the latter culture has been associated with a shaft tomb. The subterranean graves themselves are single or multiple chambers, carved out in dome shape some 15 to 45 feet below the ground. A square vertical shaft connects them to the surface. Burials were probably deposited in them over several generations, each extended skeleton being accompanied by a quantity of large hollow figures, effigy vessels, and small solid figurines.

This style of modeled ceramic sculpture from West Mexico has usually been described as secular or genre—realistically and narratively depicting scenes from everyday life (e.g., the Nayarit house models [76] and the Colima

circle dance groups [122], or simple naturalistic people, animals, and plants (much like the narrative Mochica ceramic style in Peru). However, the work of Peter Furst has demonstrated the strong funerary, religious, and shamanistic overtones of much of the inventory of shaft-tomb pottery. For example, the type of figure normally assumed to be an actual warrior engaged in battle [88 and 89] is argued by Furst to be a shaman dressed as a tomb guardian. This interpretation, further, is more in line with recent research on Mochica iconography, not to mention the contemporary Han and Haniwa tomb cultures of China and Japan, with their realistic ceramic sculptures.

We distinguish five substyles of West Mexican ceramic sculpture. The first, called Chinesco [72–75], was discovered in southwestern Nayarit a number of years ago and, surprisingly, did not resemble the well-known main style of south-central Nayarit. The heads of these figures are almost triangular and the strange eye treatment was deemed Oriental, hence the style became known as "Chinesco." The Nayarit style itself [76–81] is characterized not only by its house models but by its bold caricatures of men and women. These are in the form of hollow, seated or standing, painted figures with details of costuming and ornamentation. The clay is a low-fired red ware. Another newly discovered style is called Zacatecas [82–84], though it is found mainly in northeastern Jalisco. In this, open-headed, perforated eye-and-mouth, painted males and females are depicted—the males always with a pair of mushroom-shaped horns. The principal style of Jalisco [85–88] features sharp-nosed individuals, with wide-open bordered eyes, and in a variety of poses.

This collection is especially rich in Colima pottery and figures [89–123], the last region for the tomb culture. Colima effigy pottery is generally red-slipped and polished, well fired, and the human figures have "coffee bean" eyes. Rarely, negative black painting is preserved [112,113]. As in the other substyles, the surfaces usually are speckled with burial deposits from the surrounding soil, consisting of black manganese oxide. The smaller solid figurines [120–123] are unslipped buff clay and often conform to the flat "gingerbread" variety. Figurines here are especially revealing for aspects of clothing and cultural customs. The hollow figures and effigy vessels in the Colima style are particularly expressive and appealing: they range from shamans or warriors to acrobats and dwarfs; to naturalistic ducks, fish, parrots, and edible dogs as well as other fauna; to modeled cacti and squashes and other flora; to plain vessels, relief vessels, and even such unexpected forms as yokes and pyramids [116, 117]. Little is known yet for the architecture and villages associated with the shaft-tomb culture, other than the dwellings modeled in clay.

The final group of objects from West Mexico [124–127] includes such unusual items as a pair of Colima double flutes, a large Toltec period ceramic figure, and two aberrant types of incense burners, presumably Postclassic. (Reserved for the Mixtec section of the book are tall tripod bowls, a shell pectoral, and copper tweezers [164, 165, 175, and 177], all excavated in West Mexico, but just as representative of the general Postclassic Mixtec style.)

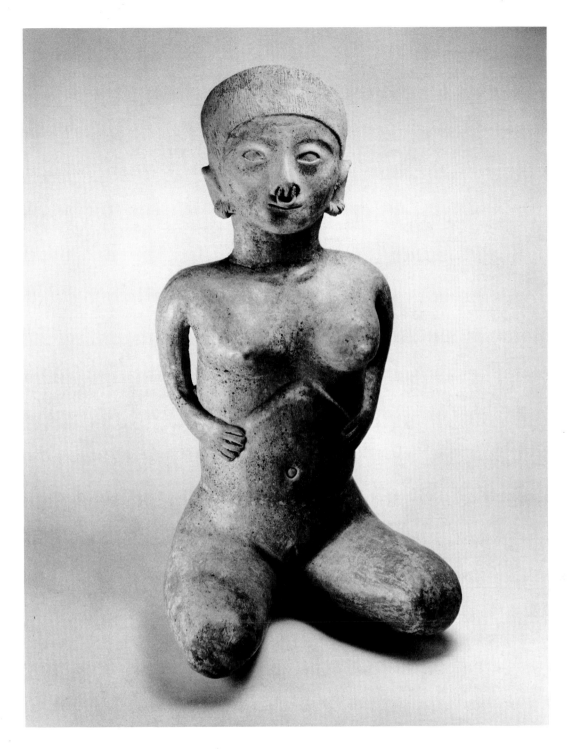

72. Large Hollow Kneeling Woman
West Mexico, Nayarit (Santiago Compostela), Chinesco style.
Terminal Preclassic, 200 B.C.–A.D. 300
Orange-slipped earthenware with traces of white paint
Gift, 181:1979; H. 60 cm.

The Chinesco substyle of Nayarit participated in the general shaft-tomb culture of West Mexico. This statuesque nude female, with hands on her waist and feet tucked under her buttocks, represents the best of the style. Her lower legs and feet are modeled in low relief under the fat thighs. The navel, lower ribcage, and clavicles are carefully demarcated. She is simply adorned, with a spiral nose ring and earrings. The hair is indicated by unslipped striations. Tiny white spots have been painted around the lower waist and about the neck.

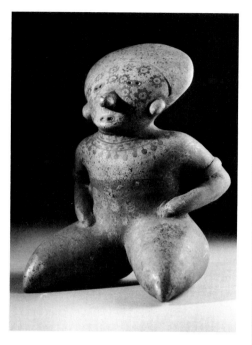 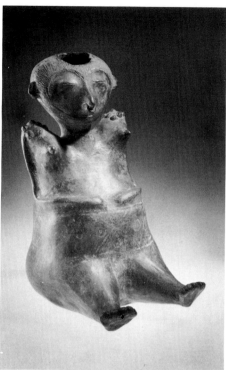 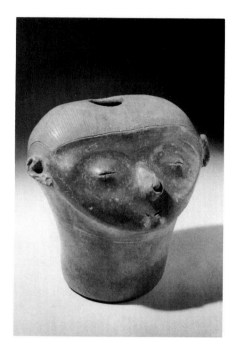

73. Seated Lady
West Mexico, Nayarit, Chinesco style. Terminal Preclassic, 200 B.C.–A.D. 300
Orange-slipped earthenware with red and black paint
Gift, 126:1980; H. 18.5 cm.

Small, hollow, Chinesco figure with vent hole behind the expanded, flat head. The bulbous, stubby thighs and legs, and the haughty posture, characterize this style. The body garment is painted in red, with resist circles showing the underlying orange slip. Rosettes on the face, the collar, and the punctated eyes and mouth are painted in black.

74. Seated Hunchback Female
West Mexico, Nayarit, Chinesco style. Terminal Preclassic, 200 B.C.–A.D. 300
Painted red earthenware with white paint
Gift, 145:1980; H. 29.5 cm.

A hollow modeled figure with hunched shoulders as well as hunched back. The breasts are placed high on the shoulders, which in turn are knobbed. Low-relief arms clasp the protruding belly. The base of the figure is

deeply dimpled, while the top of the head is open. The zone of hair around the heart-shaped face is finely incised and filled with white pigment. Also, a cross-hatched waistband has been applied with white paint.

75. Head Effigy
West Mexico, Nayarit, Chinesco style. Terminal Preclassic, 200 B.C.–A.D. 300
Burnished red-slipped earthenware
Gift, 159:1980; H. 18.5 cm.

The broad forehead, triangular face, and slit eyes surrounded by depressions identify the Chinesco variant of West Mexican art styles. The hair zone is finely scored and unpolished. Note the spiraled nose ring. The base is dimpled, and a hole is left in the top.

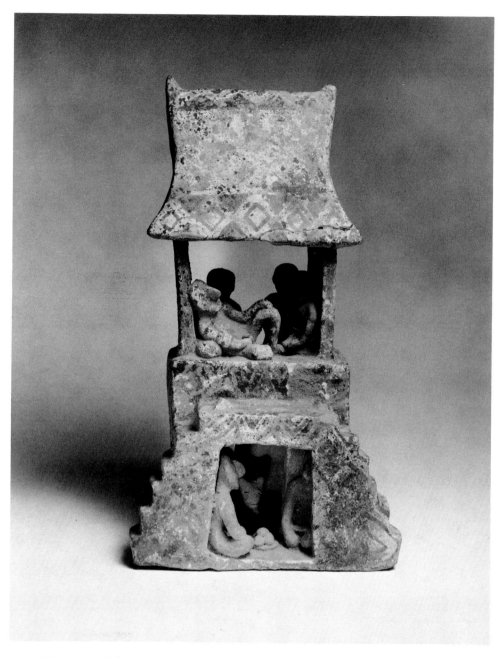

76. Two-Level House Model

*West Mexico, Nayarit (Ixtlan del Rio). Terminal Preclassic,
200 B.C.–A.D. 300*
*Red earthenware with remains of cream slip and red and black
paint (See color plate)*
Purchase, 223:1957; H. 36 cm., W. 20 cm., D. 15.5 cm.

Realistic ceramic house models, complete with occupants, are a special feature of Nayarit shaft-tomb offerings. Other group scenes modeled in clay include ball courts and pole ceremonies *(voladores)*. This model has a front double staircase covering a "porch," an inner square chamber with its own doorway behind the porch, and an upper, slab-sided, open deck with a high-gabled (thatched?) roof. The hand-modeled figures on the upper deck include a lounging naked male, a seated female to the right, and two other skirted females on the back with their legs dangling over the edge. In the center is a hearth with a round pot. (Formerly another figure rested on the upper left corner of the staircase.) Under the porch are a seated man and woman with a food tray between them. We also discover the household dog peeking out of the inner chamber. The cream-slipped surface of the house model is painted with red and black rhomboid decorations.

77. Standing Warrior

West Mexico, Nayarit. Terminal Preclassic, 200 B.C.–
A.D. *300*
Red-slipped earthenware with negative-black paint
Gift, 152:1980; H. 55 cm.

A proud male figure firmly resting on oversized squat
legs and highly arched feet. He carries his knobbed mace
over his right shoulder. Ornamentation consists of a left
armband, a two-strand necklace, laced earlobes, and a
hairdo in four strands with a forelock. In addition, his
torso is resist-painted in black in four quadrants. Two
diagonally opposed squares have zigzag lines and two
have vertical bands with circles. As with most large hol-
low ceramics, there is a firing vent at the top of the head.

78. Large Standing Male and Female Pair

West Mexico, Nayarit. Terminal Preclassic, 200 B.C.–
A.D. *300*
*Red-slipped earthenware with black, white, orange, and yellow
paint*
Gift, 145:1979.1 and .2; H. 56 and 51.5 cm.

The male on the left carries a dart-shaped fan or club and
wears a conical headdress, a V-necked shirt, as well as
short pants with a "cod cover." His female partner car-
ries a bowl on her right shoulder, wears a thick turban,
a crescent-shaped neck piece, a tasseled armband, and a
wide skirt. Both have complex loop ear and nose orna-
ments. They are posed on heavy feet and have vents on
their heads. The female is simply decorated in black and
white, while the male is painted in orange, yellow, and
white.

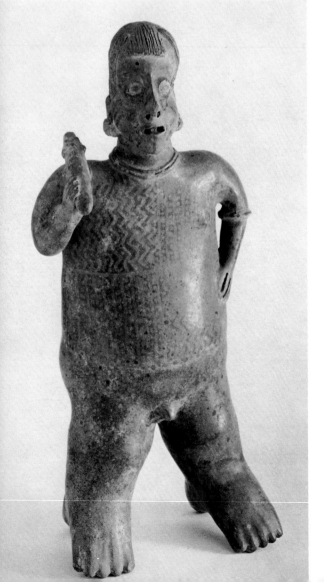

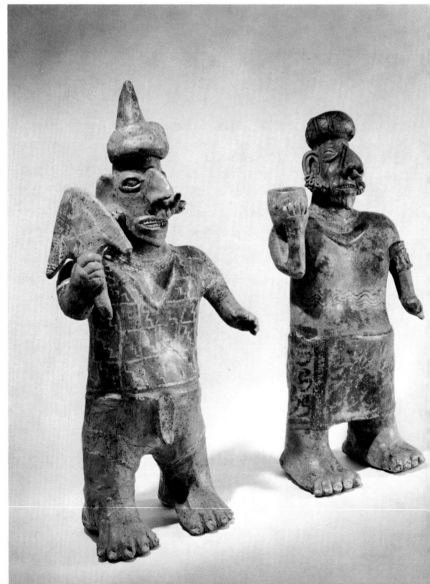

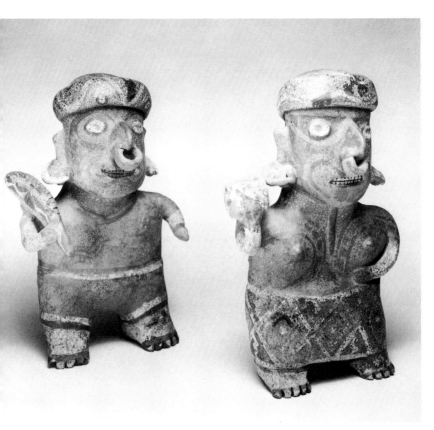

79. Male and Female Couple

West Mexico, Nayarit. Terminal Preclassic, 200 B.C.–A.D. *300*
Red-slipped earthenware with black, white, and yellow paint
Purchase, 356 and 357:1952; H. 31 and 30.5 cm.

This pair is a smaller counterpart to the previous one. The male on the left carries a notched fan or club over his right shoulder and has a painted belt (or short pants?), with a triangular projection at the back. The female again carries a bowl on the same shoulder and wears a painted skirt. Both figures have similar painted turbans, looped nose rings, woven ear ornaments, and elaborate face and body painting. The vents are located in the backs of the heads.

80. Pair of Seated Figures

West Mexico, Nayarit. Terminal Preclassic, 200 B.C.–A.D. *300*
Painted red earthenware
Gift, 424 and 426:1955; H. 31 and 29.5 cm.

The left figure is a skirted female holding a vase, while the right figure is a male with his breechcloth and a fan-shaped object. The lady's legs are folded to one side, while the male's are crossed. Both are decorated in great detail with white, black, and yellow paint. They wear banded conical hats, though the male's hat is more elaborate. Each is adorned with looped ear ornaments, nose rings, armbands, and crescent-shaped breast medallions.

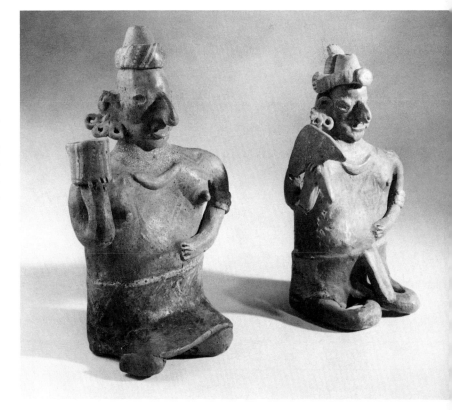

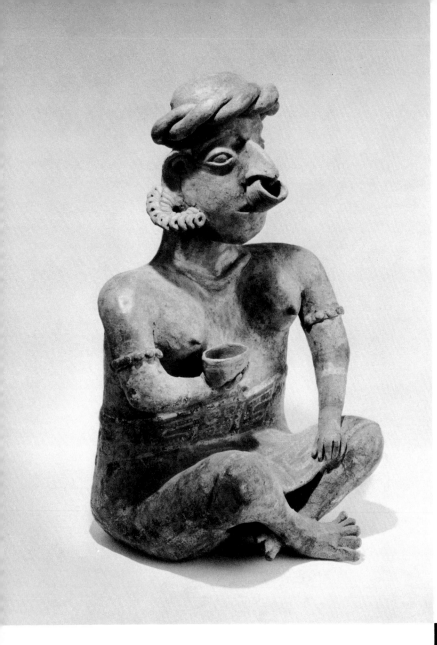

81. Seated Female Cup Bearer

West Mexico, Nayarit. Terminal Preclassic, 200 B.C.–A.D. *300*
Red-slipped earthenware with white paint and manganese oxide deposits
Gift, 321:1978; H. 55 cm.

This massive hollow figure has a single firing vent hole at the top of the head. She wears a wrap-around skirt over her crossed legs. The opened mouth reveals two rows of teeth. Applied ornaments include armbands, nose ring, multiple-ringed ear pendants, and a twisted turban. White-painted decoration is found on the elbows and skirt.

82. Human Effigy Jar

West Mexico, Zacatecas style. Terminal Preclassic, 200 B.C.–A.D. *300*
Three-color negative-painted earthenware
Gift, 214:1979; H. 33 cm., Diam. 24.5 cm.

This substyle of the West Mexican shaft-tomb culture comes from the Jalisco-Zacatecas border area. The example here is a rare, round-bottomed jar form, with applied hollow human head, and arms and feet in relief. The top of the horned head is open, while the eyes, mouth, and earlobes are perforated. The slip of the vessel is a buff color that appears under negative-painted black decoration. The remaining zones of color are deep red.

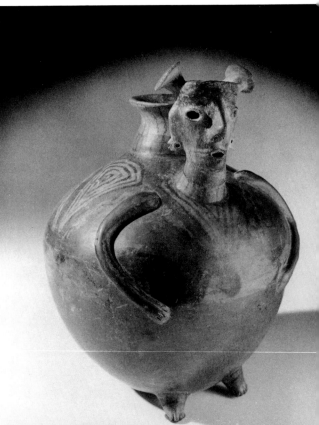

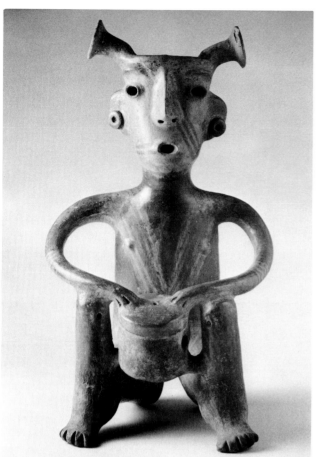

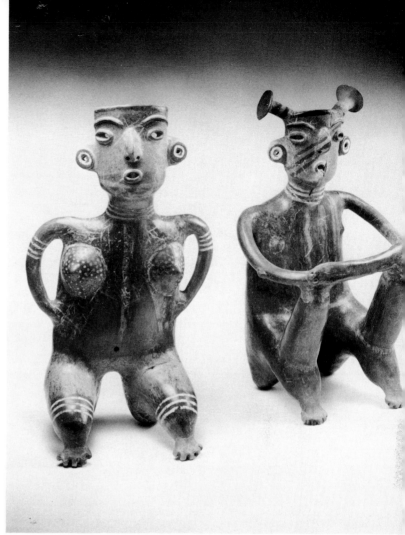

83. Male Drummer

West Mexico, Zacatecas style. Terminal Preclassic, 200 B.C.–
A.D. *300*
Three-color negative-painted earthenware (See color plate)
Gift, 247:1978; H. 39.5 cm.

Males in the Zacatecas style generally have a pair of
expanded top knots (or shaman's "horns"). This figure's
thin, wide-arched arms beat an open-bottomed cylindri-
cal drum held between his knees. The drum has a circular
hole on one side and a perforation on top. The flat head
of the hollow figure is characteristically open to the inte-
rior, as are the eyes, nostrils, and mouth. The cream-
slipped body is selectively painted in red, with
negative-painted black stripes.

84. Male and Female Couple

West Mexico, Zacatecas style. Terminal Preclassic, 200 B.C.–
A.D. *300*
*Cream-slipped earthenware with red, white, and negative-black
paint*
Gifts, 204 and 203:1979; H. 41 and 42 cm.

These figures, seated on their haunches, have the charac-
teristic flat-topped open heads, open eyes and mouths.
The female has prominent breasts, while the male dis-
plays the usual pair of "horns" and diagonal facial stripes.
Like the previous male drummer, his knees have unnatu-
ral extensions that meet the thin, crossed arms. In addi-
tion to the red and negative-black paint, they have zones
of white stripes and dots.

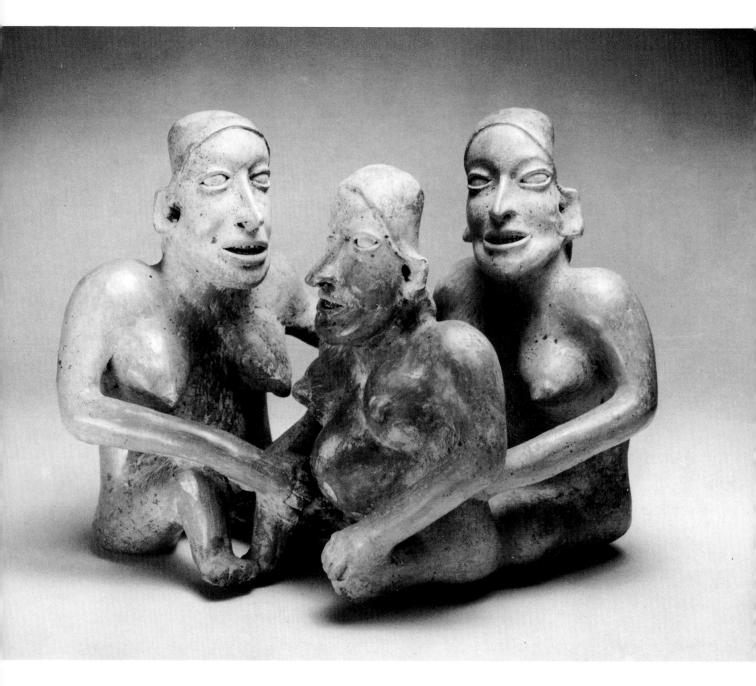

85. Pregnant Woman and Midwife Group
West Mexico, Jalisco. Terminal Preclassic, 200 B.C.–A.D. *300*
Polished gray earthenware (See color plate)
Gift, 323:1978; H. 21.5 cm., L. 20 cm.

An extraordinary modeled ceramic group, consisting of three joined female figures. The central woman is kneeling, with one knee raised in the birthing position. Aiding her from behind is a skirted midwife, who pushes on her waist. Another assistant crouches to the side, holding the pregnant woman by her raised knee and shoulder. All three hollow figures are perforated through their ears, and reveal traces of negative-black paint, in spirals, on their breasts.

86. Large Seated Female

West Mexico, Jalisco. Terminal Preclassic, 200 B.C.–A.D. *300*
Buff earthenware with traces of red and black paint
Gift, 324:1978; H. 55.5 cm.

The exaggerated long head and nose are characteristic traits of much of Jalisco shaft-tomb sculpture. This figure seems to wear red-belted pantaloons, which are cross-hatched with black. The head, with its vent hole, is ringed with a turban. The ears have fancy attachments, and the arms have bands. The breasts are encircled with black lines, as is the waist.

87. Male and Female Couple

West Mexico, Jalisco (Ameca). Terminal Preclassic, 200 B.C.–A.D. *300*
Polished buff earthenware with black and red paint
Gifts, 148 and 149:1980; H. 38.5 and 42.5 cm. (Illustrated: Von Winning, 1968, items 129 and 130)

The female carries a bowl of food over her left shoulder as she kneels in a plain skirt. The male is distinguished by his crested head, ear spools, and short pants. He is seated, with one hand holding his stomach, like his partner. The man's pants and the woman's skirt are painted black, while the body of the woman is red. The only perforations are in the ears and the corners of the wide-open eyes.

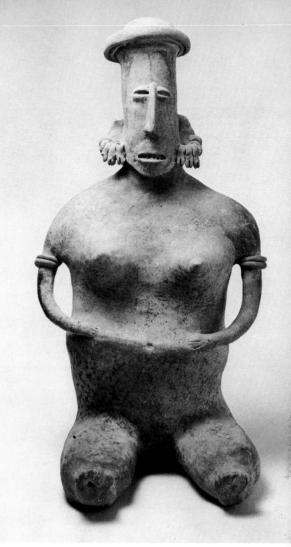

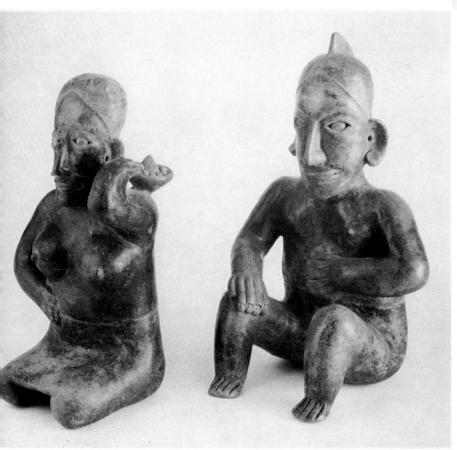

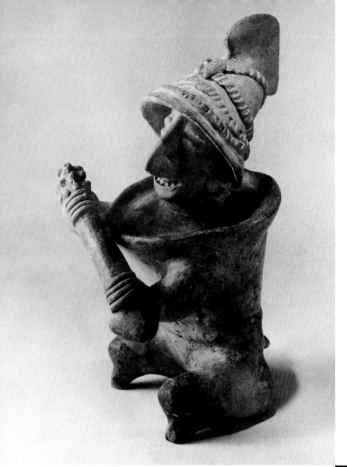

88. Armored Warrior

West Mexico, Jalisco. Terminal Preclassic, 200 B.C.–A.D. 300
Buff earthenware with red and black paint
Gift, 158:1980; H. 31 cm.

A common theme in West Mexican effigy pottery is the
warrior with an encircling suit of armor and a visored
helmet, who wields a weapon [cf. also 89]. It has been
suggested that these represent shamanistic tomb guard-
ians, with their heads turned to the left to ward off "sinis-
ter" evil. The prominent long nose and the surface
treatment pin this example down to the Jalisco area. The
helmet seems to be wrapped with rope and is crowned
by a triangular crest. A triangular projection also
emerges from the rear of the barrel-like armor. His
weapon is knobbed at the end and has a dartlike point.
Zones of the figure are painted red and black, and the
ears are perforated.

89. Warrior or Guardian

*West Mexico, Colima. Terminal Preclassic, 200 B.C.–
A.D. 300*
*Brown earthenware with red and negative-black paint (See color
plate)*
Purchase, 131:1956; H. 33.5 cm.

Like the previous Jalisco effigy, this Colima figure either
depicts an armed warrior or a left-facing tomb guardian.
The broken prong at the front of the tied protective
headdress may have represented a shaman's horn. In
both hands he holds spherical missiles. (An alternate the-
ory is that these warrior-like figures may represent ball
players with either bats or balls.) His torso is protected
with tubular armor from which his arms protrude. On the
back is a circular, feathered "bustle," now two-thirds
missing. The arms and legs are decorated in black-nega-
tive paint. Interestingly, the mouth is suppressed. The
back of the head has a rudimentary open spout.

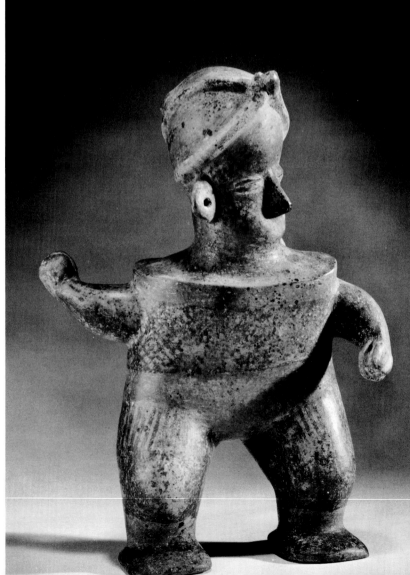

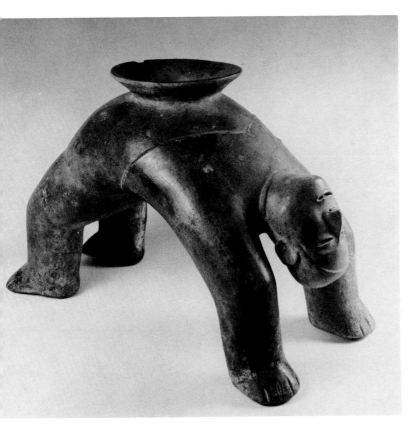

90. Acrobat Vessel

West Mexico, Colima. Terminal Preclassic, 200 B.C.–
A.D. *300*
Polished red-slipped earthenware
Gift, 325:1978; H. 24 cm., L. 37 cm.

Nude male acrobat performing an arched back bend.
The vessel is smoothly modeled, leaving V-shaped indentations following the base of the ribcage and the pubic
area. It has been suggested that the prevalent so-called
acrobat representations in Mesoamerica may actually be
ball players in action [cf. 244]. The ancient rubber ball-
game survives in West Mexico to this day.

91. Cross-Legged Dwarf with Cup

West Mexico, Colima. Terminal Preclassic, 200 B.C.–
A.D. *300*
*Polished reddish-brown earthenware with traces of red paint
and manganese oxide deposits*
Gift, 322:1978; H. 31.5 cm.

A popular theme in Colima's shaft-tomb offerings was
dwarfs and hunchbacks [93], who must have been especially revered in ancient times. The red-painted horn and
spirals on the head suggest that this one may have been
a shaman. The face is heavily wrinkled, the ribcage is
exposed, and he is shown as sexless. He drinks from an
oval libation bowl held in front of him. The vent holes
are found in the bowl where the hands join it.

92. Seated Figure Drinking

West Mexico, Colima. Terminal Preclassic, 200 B.C.–
A.D. *300*
Polished red-slipped earthenware with black manganese deposits
Gift, 334:1978; H. 38.5 cm.

This figure leans forward as he sips from an oblong cup,
which may represent a gourd. He is shown wearing a
mantle tied over the right shoulder and wrapped under
the left arm. The garment has a low-relief border and is
decorated with hatched motifs; his folded cap also is
incised. The vessel opening is at the top of the head.

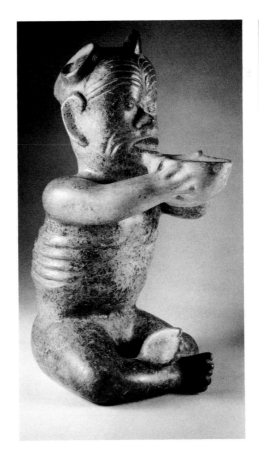
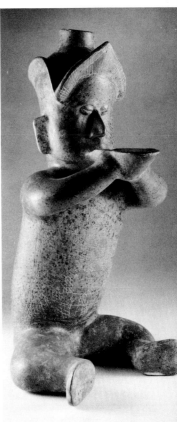

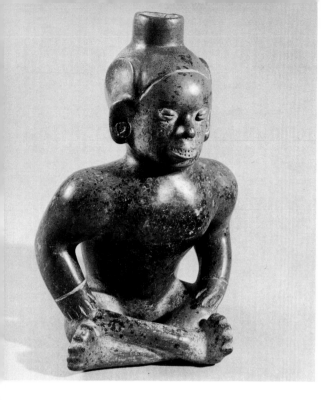

93. Cross-Legged Hunchback Dwarf

West Mexico, Colima. Terminal Preclassic, 200 B.C.–
A.D. *300*
Polished reddish-brown earthenware with red paint and manganese oxide deposits
Gift of Gail and Milton Fischmann, 181:1972; H. 28 cm.

Very comparable to the previous Colima dwarfs, this ceramic effigy has a pouring spout at the top of the head, and flanking red-painted spirals. Moreover, the upper chest is deformed forward, while the lower back protrudes as a hunchback, with an exposed vertebral column.

94. Male Seated on a Stool

West Mexico, Colima. Terminal Preclassic, 200 B.C.–
A.D. *300*
Painted buff earthenware
Gift, 150:1980; H. 52.5 cm.

A large variant of the Colima style that verges on the style of Jalisco. Red paint is selectively applied to all but the upper left quadrant of the face, the top and back of the head, the shoulder region, and the lower legs. The asymmetrical hairline falls over the unpainted quarter of the face. Cross-hatched markings on the torso are of fugitive black paint, and the base of the two-legged stool also bears black designs. There is a vent on the top.

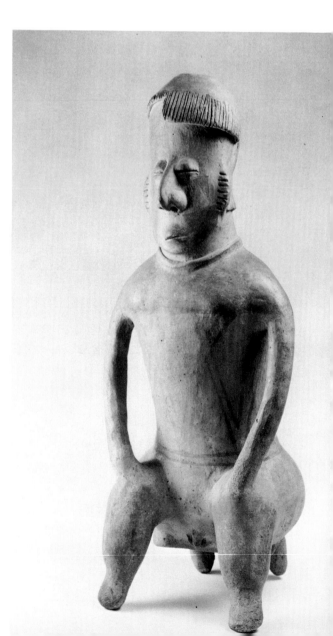

95. Male Effigy Dog

West Mexico, Colima. Terminal Preclassic, 200 B.C.–
A.D. *300*
Polished orange earthenware
*Gift of May Department Stores Co., 39:1970; L. 43 cm., H.
28.5 cm.*

Hairless dogs (called *techichi*) were fattened up for eating
as feast food in Pre-Columbian Mexico. They also were
a popular subject for ceramic sculpture in Colima [see 96
and 97]. This example is naturalistically modeled, includ-
ing the genitals and the incised whiskers at the corners
of the mouth. There is a vent in the right ear only.

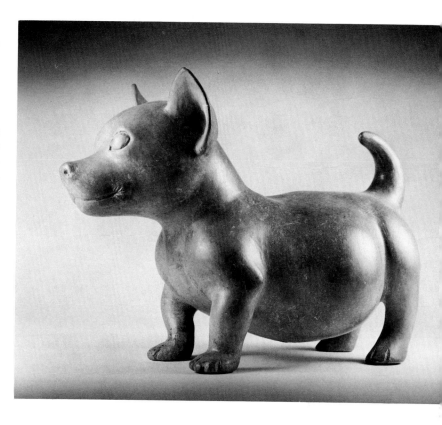

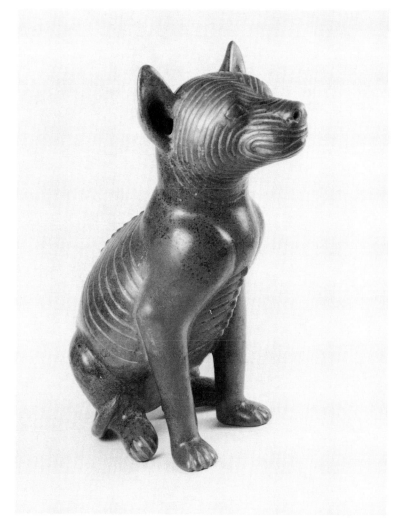

96. Large Seated Dog

West Mexico, Colima. Terminal Preclassic, 200 B.C.–
A.D. *300*
*Polished red earthenware with manganese oxide deposits (See
color plate)*
Gift, 246:1978; H. 43.3 cm.

A supremely naturalistic hairless male dog effigy. All the
ribs and the head wrinkles are emphasized by deep
grooves. The spine is shown as raised knobs and the tail
curls around the right hind leg. His nostrils and right ear
are open to serve as firing vents during the manufacture
of the hollow ceramic sculpture.

97. Anteater Vessel
West Mexico, Colima. Terminal Preclassic, 200 B.C.–
A.D. *300*
Red earthenware with black manganese deposits
Gift, 163:1980; H. 6.5 cm., L. 25 cm.

This apparently represents an anteater grasping a rotted
log in which his long snout is buried. Its hairy crest is
depicted along the back. The vessel's pouring spout is
placed on the right side.

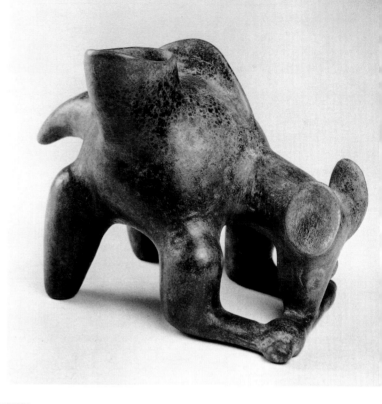

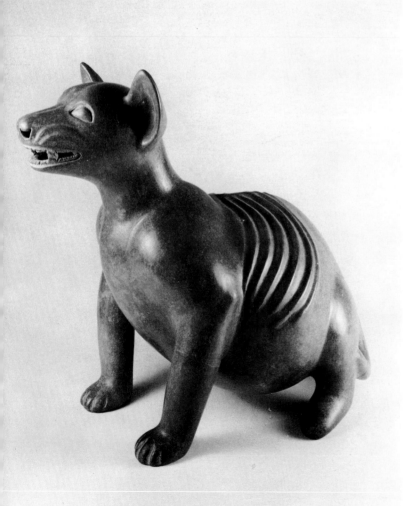

98. Fat Dog
West Mexico, Colima. Terminal Preclassic, 200 B.C.–
A.D. *300*
Polished red earthenware
Gift, 146:1979; H. 32.5 cm., L. 35.5 cm.

A modeled, crouching dog with his belly practically
dragging on the ground. His ribs are exposed and his
short tail curls around the left leg. The exposed teeth and
wrinkles on the snout give him a growling, snapping
visage. The mouth and the nostrils are open to the inte-
rior.

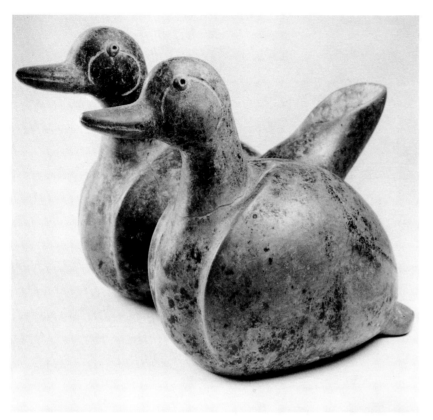

99. Double Duck Vessel

West Mexico, Colima. Terminal Preclassic, 200 B.C.–A.D. *300*
Reddish-brown earthenware with red paint and manganese oxide deposits
Gift, 151:1980; H. 18.5 cm., L. 28 cm.

Among the more appealing of naturalistic fauna modeled in Colima effigy vessels are the ducks (see 11 and 12 for prototypes). This vessel shows a joined pair with a long pouring spout emerging between them. The spout and the ducks' bills are painted red. Note the wedgelike tails, incised head markings, and the wing outlines.

100. Duck and Fish Effigy Vessel

West Mexico, Colima. Terminal Preclassic, 200 B.C.–A.D. *300*
Polished reddish-slipped earthenware with surface deposits
Gift, 316:1978; H. 22 cm., Diam. 24.5 cm.

This modeled jar depicts a pair of ducks as well as a pair of fish mounted on a round-bottomed jar with a wide-lipped opening at the top. The fish languish on their sides around the shoulder of the vessel, while the wide-billed ducks firmly plant themselves above, with their three-toed feet resting on the fish. Their flat tails protrude behind.

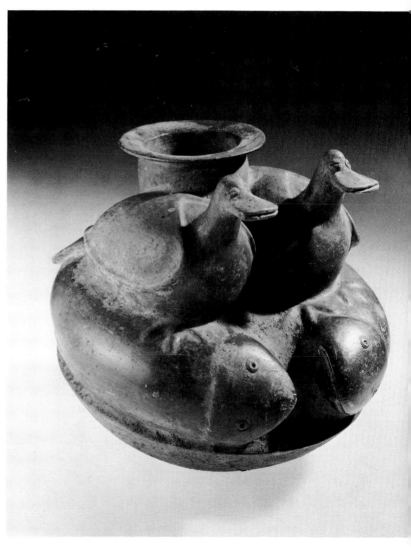

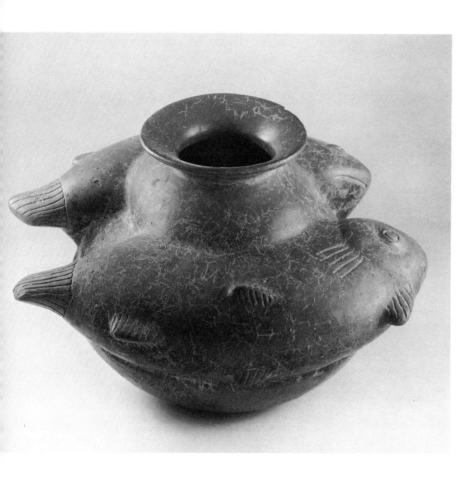

101. Jar with Two Fish

West Mexico, Colima. Terminal Preclassic, 200 B.C.–
A.D. *300*
Polished red earthenware
Gift, 164:1980; H. 18 cm., Diam. 30 cm.

A pair of realistically modeled fish encircle the shoulder of this compound silhouette, wide-mouthed jar. Their eyes, mouths, gills, fins, and tails are incised. The surface of the vessel is covered with root marks from centuries of burial.

102. Three-Fish Vessel

West Mexico, Colima. Terminal Preclassic, 200 B.C.–
A.D. *300*
Polished orange-red earthenware
Gift, 155:1980; H. 28 cm.

The epitome of naturalistic modeling in the repertoire of Colima tomb sculpture. A trio of downward-facing fish create flanges on a constricted, flat-based container. The vessel opening consists of narrow gaps on the tops of the three tails. The details of scales, fins, and gills are engraved into the surface of this unusually high-fired ceramic.

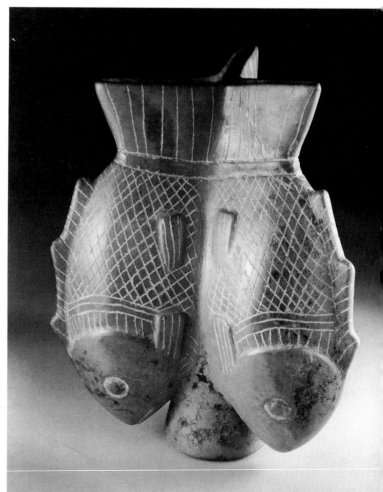

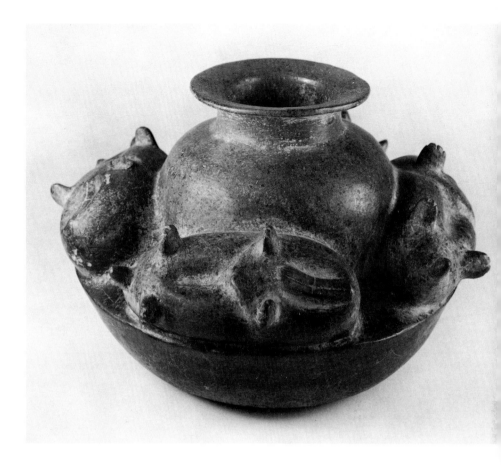

103. Jar With Four Moles

West Mexico, Colima. Terminal Preclassic, 200 B.C.–
A.D. *300*
Red earthenware with black manganese deposits
Gift, 161:1980; H. 18 cm., Diam. 29.5 cm.

A composite silhouette vessel, modeled as though a globular jar were resting in a round-bottomed bowl. Around the shoulders are four mole effigies lying upside down with their legs and snouts pointing upward—either dead or "playing possum."

104. Double Armadillo Vessel

West Mexico, Colima. Terminal Preclassic, 200 B.C.–
A.D. *300*
Polished red-slipped earthenware
Gift, 314:1978; H. 14.5 cm., Diam. 27 cm.

An ingenious treatment of faunal subject matter, employing two armadillos that chase each other around the perimeter of a wide open-mouthed jar. While the photo is a top view, the vessel itself is subglobular in form, with a raised, flat-bottomed base. The animals' heads, feet, and tails are realistically modeled, while their carapaces are incised and grooved to represent their markings. (For other armadillo effigy ceramics, see 14 and 335.)

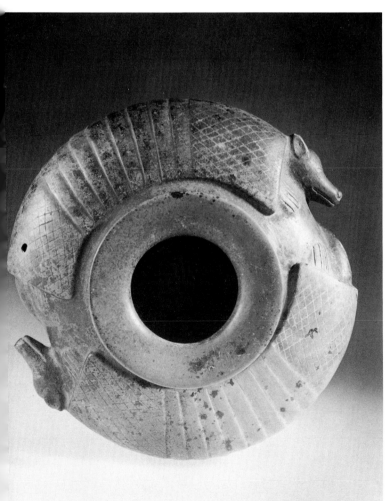

105. Jar With Ten Human Heads

West Mexico, Colima. Terminal Preclassic, 200 B.C.–
A.D. *300*
Polished red earthenware
Gift, 144:1980; H. 20.5 cm., Diam. 29.5 cm.

Another jar in the same basic form as the previous exam-
ple. This one displays ten replicated human heads, each
with a tight-fitting crested helmet, arranged around the
shoulder. Faint negative-painted dots, surrounded with
black pigment, cover the lower section of the vessel.

106. Jar With Cacti

West Mexico, Colima. Terminal Preclassic, 200 B.C.–
A.D. *300*
Burnished black earthenware
Gift, 313:1978; H. 19 cm., Diam. 24 cm.

A wide range of plants and vegetables are modeled in
Colima ceramics, in addition to the human and animal
subject matter. The six grooved protuberances around
the top of this round-bottomed jar represent a variety of
cactus common to the semiarid regions of West Mexico.

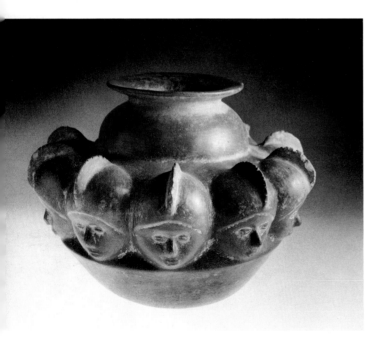

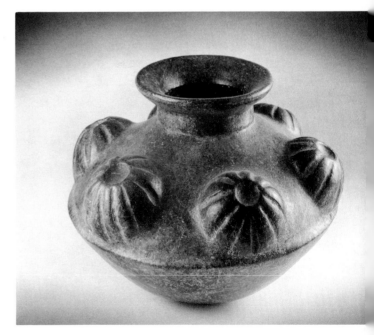

107. Jar With Cacti

West Mexico, Colima. Terminal Preclassic, 200 B.C.–
A.D. *300*
Polished red-slipped earthenware
Gift, 319:1978; H. 17.5 cm., Diam. 28 cm.

Jar with tall, lipped neck and six modeled, vertically
grooved cacti resting in the bowl-like base. (While not
yet botanically identified, the cactus attribution of the
plant forms seems certain.) The base of this vessel is
further decorated with incised and hatched rhomboid
motifs.

108. Tripod Vessel With Fruit

West Mexico, Colima. Terminal Preclassic, 200 B.C.–
A.D. *300*
Reddish-brown earthenware with red paint
Gift, 317:1978; H. 19.5 cm., Diam. 28 cm.

Another jar modeled as though a shallow bowl, sup-
ported by three solid conical legs, contains a quantity of
ovoid fruits. The rounded base, only, sustains red paint
and has cross-hatched rhomboids.

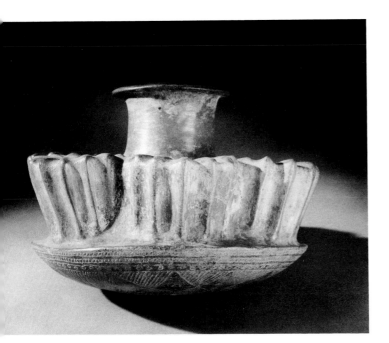

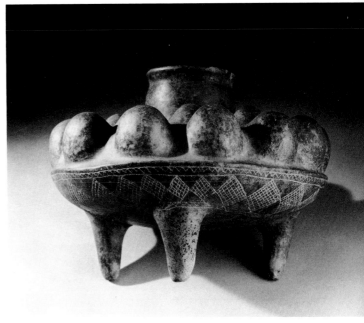

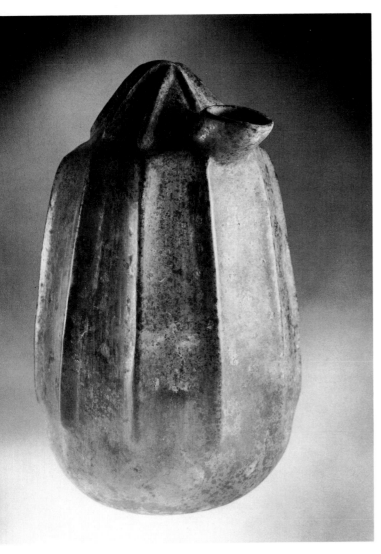

109. Squash Effigy Vessel

West Mexico, Colima. Terminal Preclassic, 200 B.C.–
A.D. *300*
Polished red earthenware with black manganese deposits
Gift, 330:1978; H. 35 cm., Diam. 21.5 cm.

This form obviously is modeled after a variety of indigenous squash, with its vertical ridges and stem cap. A pouring spout is provided near the top of the large container.

110. Pumpkin Vessel Supported by Three Dwarfs

West Mexico, Colima. Terminal Preclassic, 200 B.C.–
A.D. *300*
Polished red-slipped earthenware with manganese oxide deposits
Gift, 312:1978; H. 23 cm., Diam. 29.5 cm.

Effigy tripods on jars are another common theme in Colima shaft-tomb vessels. Here, three "atlantean" dwarf figures bear the weight of the large, deeply grooved pumpkin form. Each dwarf has a rudimentary "horn" or top knot, and a loincloth. The jar culminates in a wide-rimmed neck.

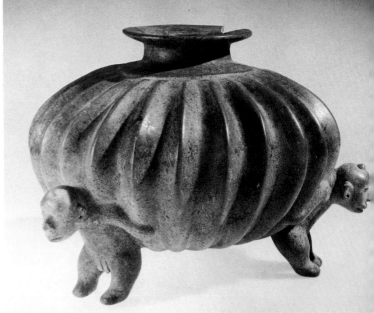

111. Tripod Lizard Vase

West Mexico, Colima. Terminal Preclassic, 200 B.C.–
A.D. *300*
Reddish-brown earthenware with red paint
Gift, 176:1980; H. 35.5 cm. (Illustrated: Von Winning, 1968, item 114)

An elegant and ingenious form of tall vase, supported by three lizard heads whose bodies continue in high relief up the sides, with the tips of their tails touching the expanded rim. The vertebrae of the creatures are notched, and only the spaces between them are painted red.

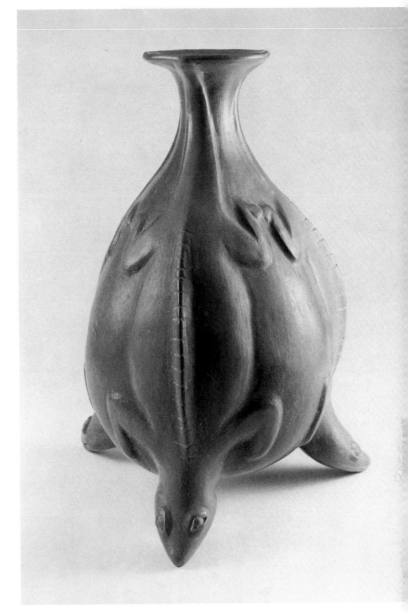

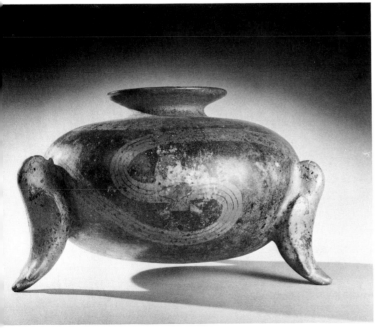

112. Parrot Tripod, Negative-Painted, Jar

West Mexico, Colima. Terminal Preclassic, 200 B.C.–
A.D. *300*
Polished red-slipped earthenware with negative-black paint
Gift, 315:1978; H. 20.5 cm., Diam. 30 cm.

Other than the globular vessels supported by human figures, those supported by parrots were equally popular. The three parrots stand on their tails, with their beaks pressing against the sides of the jar. The vessel has a wide-brimmed mouth. What is unusual about this example is its extensive, well-preserved resist- or negative-painted scene (see also the next object). Depicted in this way on three connected panels are flying parrots, whose sweeping wings flow around the vessel, joining bird to bird.

113. Low-Relief Vase

West Mexico, Colima. Terminal Preclassic, 200 B.C.–
A.D. *300*
Orange earthenware with extensive black manganese deposits
Gift, 329:1978; H. 19.5 cm., Diam. 19 cm.

Wide, flat-bottomed, cylindrical vase, with unusual relief
decoration consisting of four horseshoe-shaped panels
that actually are double-headed serpents. Two of these
enclose splayed human figures, while the opposite two
enclose tiny simplified human heads.

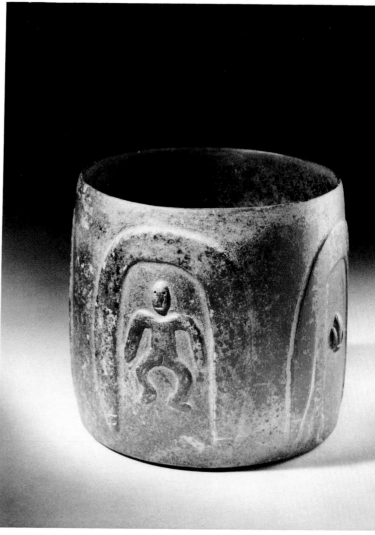

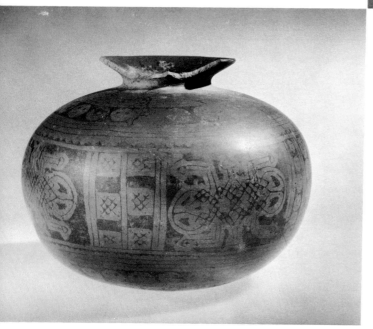

114. Negative-Painted Jar

West Mexico, Colima. Terminal Preclassic, 200 B.C.–
A.D. *300*
Polished red earthenware with black paint
Gift, 311:1978; H. 20 cm., Diam. 26.5 cm.

A simple subglobular jar, unusual for its extensive nega-
tive-painted decoration. The black paint itself is rela-
tively fugitive, and may have washed off other "plain"
Colima vessels formerly bearing resist painting. (See 441
for an explanation of the resist technique.) The black
paint was applied to surround elaborate motifs including
panels with double-headed reptilian creatures, and rows
of round faces. The rim of the jar is broken.

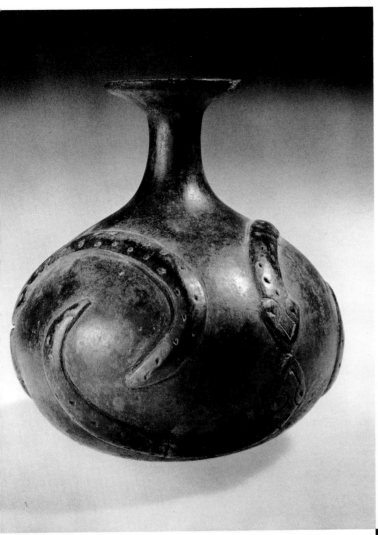

115. Serpent-Relief Bottle

West Mexico, Colima. Terminal Preclassic, 200 B.C.–
A.D. *300*
Red-slipped earthenware
Gift, 328:1978; H. 26 cm., Diam. 24 cm.

Much of the surface is evenly blackened, partly by fire-clouding and partly by heavy burial deposits of black manganese. The simple flaring-necked globular bottle is decorated with six low-relief, C-shaped serpents, which are opposed in such a way that the triangular heads of adjoining pairs meet. The snakes have punctate body markings.

116. Pyramid Model Vessel

West Mexico, Colima. Terminal Preclassic, 200 B.C.–
A.D. *300*
Polished red-brown earthenware
Gift, 154:1980; H. 16.5 cm., Diam. 29 cm.

Rare jar modeled as a three-terraced round pyramid, with four steep, balustraded staircases giving access to the flat top. To our knowledge, such a round Colima period pyramid has not yet been excavated in West Mexico. However, the Late Preclassic round pyramid at Cuicuilco in the Valley of Mexico could have served as a prototype for this form.

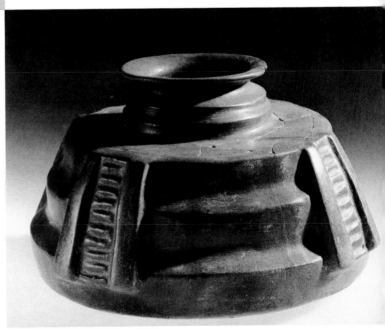

117. Yoke-Form Vessel

West Mexico, Colima. Terminal Preclassic, 200 B.C.–
A.D. *300*
Black-slipped earthenware
Gift, 175:1980; H. 14.5 cm., W. 25 cm., L. 27.5 cm.

A most unusual ceramic effigy representing the ball
player's protective waist yoke. The simple centrally
grooved form suggests the wooden prototype used in the
game. Although ball court ceramic groups exist from
West Mexico, the standard ceremonial stone yoke ar-
tifacts [cf. 266–269] are as yet unknown in this part of
Mexico. The object is unique, therefore, in that it is
perhaps the only known full-round representation of a
ball player's yoke in the area of Colima, Jalisco, and
Nayarit, even though we know a version of that pan-
Mesoamerican game was played there. On the front
curve of the vessel is a rudimentary pouring spout. Other
similar vessels are known from Colima that are C-shaped;
this, however, is decidedly U-shaped, like a ballgame
yoke.

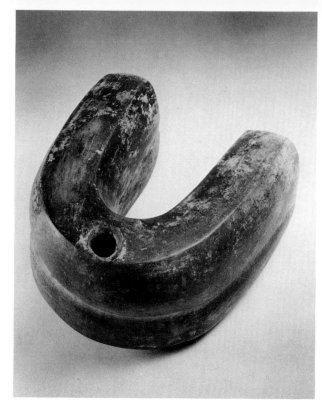

118. Tripod Bottle

West Mexico, Colima. Terminal Preclassic, 200 B.C.–
A.D. *300*
Red earthenware with black manganese deposits
Gift, 327:1978; H. 18 cm., Diam. 12 cm.

The simple, long-necked, squat flask shape of this atypical
Colima vessel may have been borrowed from earlier Tla-
tilco forms [cf. 20]. The solid tripods, however, are a
Late Preclassic innovation.

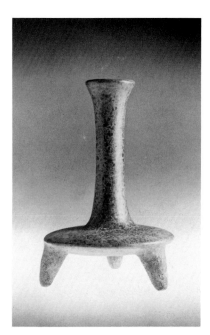

119. Sharp-Shouldered Jar

West Mexico, Colima. Terminal Preclassic, 200 B.C.–
A.D. *300*
Polished red-slipped earthenware with manganese oxide deposits
Gift, 318:1978; H. 18 cm., Diam. 35.5 cm.

A plain, low jar, with wide mouth, convex upper body,
sharp-ridged shoulder, and concave lower body that un-
dercuts the overhanging perimeter of the vessel.

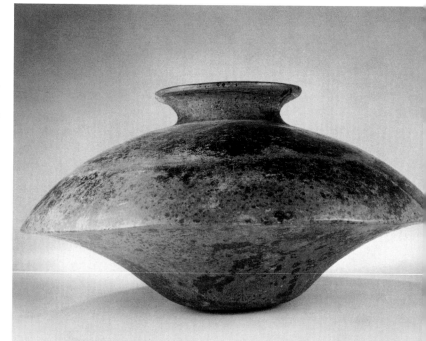

120. Solid Standing Figure With Crocodile Mouth

West Mexico, Colima. Late Preclassic, 300 B.C.–A.D. *1*
Unslipped buff earthenware
Gift, 302:1978; H. 39 cm.

A large, solid, hand-modeled figurine of the type seen in the following illustration. His fanged crocodile mouth (mask?) is an exceptional feature. Also, the feathered crest of the helmet contains a whistle in the center, with an opening on the right side. The solid cone shapes held in the hands probably represent rattles. He wears beaded armlets and necklace, while the skirt and apron are studded with clay beads. Each leg bears two disc ornaments and the feet are covered by leggings or "chaps" (as determined by the separately modeled feet underneath). He probably is a costumed dancer.

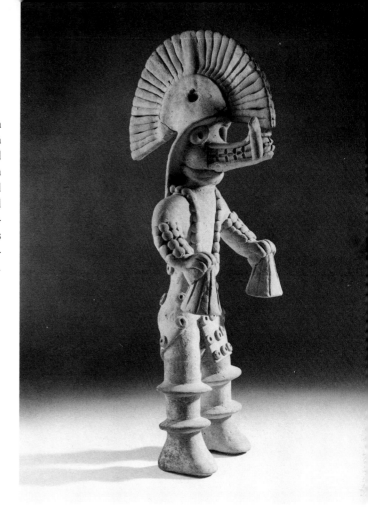

121. Two Costumed Dancers

West Mexico, Colima. Late Preclassic, 300 B.C.–A.D. *1*
Unslipped buff earthenware
Gifts, 336 and 226:1978; H. 24 and 26.5 cm. (336:1978
illustrated: Von Winning, 1968, item 63; Easby and Scott,
1970, item 90; and Wauchope, 1971, vol. 11, p. 741)

Both of these elaborate, handmade, solid figures, like the previous piece, apparently represent dancers in full regalia. The one on the left wears an enormous crested headdress, seemingly made of hollow reeds. It ends in a crocodile mouth strapped over the dancer's face. The beaded cross-bands on his torso support hollow tubes on the front and back. He wears a kilt and ringed trousers. His outstretched hands are perforated, and doubtless once had rattles or bells suspended from them. The dancer on the right has a feathered headdress pulled down to conceal his face underneath. Mounted behind is a pole-like standard, while on his back is a large fan-shaped bustle. His tunic likewise seems to be made of feathers, and under it are trousers with beaded anklets. His arms end in flat discs, the real referent for which is unknown.

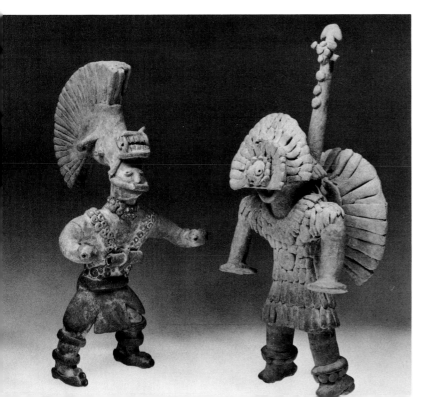

122. Circle-Dance Group With Musicians

West Mexico, Colima. Late Preclassic, 300 B.C.–A.D. *1*
Unslipped buff earthenware
Gift, 306:1978; H. 14 cm., Diam., 29.5 cm.

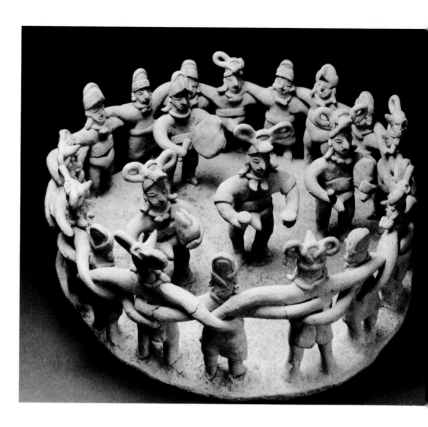

An exceptionally large and complex group of human
figurines mounted together on a flat round ceramic base.
Eighteen figures stand, arms linked shoulder to shoulder,
in a circle on the periphery. In the center are four musi-
cians: one man stands behind playing a turtle-shell reso-
nator, while three males stand in a front row. Two of
them have similar turtle-shell instruments, while the cen-
tral player carries a conical rattle in each hand. The outer
dance group consists of alternating males and females.
With two exceptions, the women stand on their partner's
right side. The nine females wear wrap-around skirts,
banded headdresses, and necklaces. The males, however,
are of several types. Five of them wear looped and
horned headdresses, waist belts, and what appear to be
penis sheaths (like the three front musicians). Two others
are identical but without the penis sheaths, and the re-
maining two males wear visored headgear and waist-
bands like the rear musician. All the males in the scene
have necklaces, pronglike ear ornaments, and double
flaps at the rear of their waistbands.

123. Grouping of Twelve Hand-Modeled Figurines

West Mexico, Colima. Late Preclassic, 300 B.C.–A.D. *1*
Unslipped buff earthenware
Gifts, 431, 434, 438, 442, 443, 445, 446, 450, 451, and
453:1955; Purchase, 299:1951 (warrior with shield) and
300:1951 (litter); H. 10.5 to 17.5 cm.

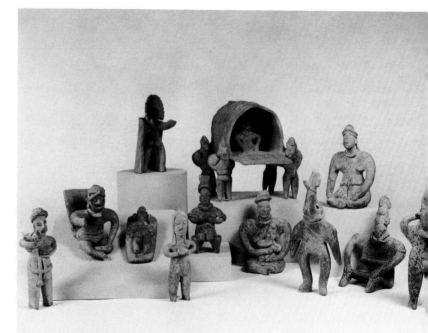

An artificially arranged group, showing a typical variety
of solid Colima clay figurines, mostly with "coffee bean"
eyes. At the top of the "hill" is a model of a palanquin,
or litter, being carried by four male bearers. Comfortably
seated inside the arched canopy is some dignitary. To the
left in the photo, a naked male warrior stands behind his
tall, curved shield. He wears a fan-shaped headdress that
contains a whistle. In the center of the scene lies a female
figure strapped to a platform. (This theme, though com-
mon in Colima and elsewhere, has several unconfirmed
explanations: one idea is that it represents a baby on its
cradle board, another suggests a sick or demented person
being secured, and a third argues for a dead person on
his funeral bier.) To the left is a helmeted figure leaning
against a tripod back rest. The other arrayed figures in-
clude a seated woman holding a child in her lap, a female
seated upon a four-legged "throne," and a group of men
and women in various postures. One carries a bowl and
a dog over her shoulder.

Seen in quantity, these little figurines are clearly anecdo-
tal and can tell us much about ancient customs, costumes,
and daily life. Colima figurines, often called the "ginger-
bread" style, may be considered a variant of a wide-
spread Late Preclassic inventory [see 61–70].

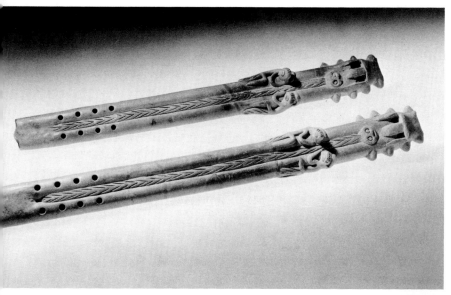

124. Pair of Double-Chambered Flutes

West Mexico, Colima. Terminal Preclassic, 200 B.C.–
A.D. *300*
Polished red-slipped earthenware with fire-clouding
Gifts, 143:1979.1 and .2; L. 52.5 and 52 cm.

Two mouthpieces, two whistle stops, two parallel chambers, and two rows of four finger stops characterize each of these matched flutes. A pair of appliqué iguanas or lizards straddles each flute. Xipe-like [see 154] faces, with long, trailing hairbands, fill the grooves between the chambers. Both objects had been broken in several places and are repaired. Musical instruments in pairs or sets are not unexpected in Mesoamerica, but seldom are kept together in collections. Colima flutes of this type have not been confidently dated, but presumably belong to the general shaft-tomb culture.

125. Hollow Female Figure

West Mexico, Jalisco, Toltec style. Early Postclassic, A.D. *900–
1200*
Unslipped red earthenware
Gift, 320:1978; H. 59.5 cm.

When this bold, expressionistic style came to light relatively recently, it was difficult to place in the repertoire of Mesoamerican ceramic sculpture. However, on analysis, the bland face style and headdress type resemble known flat Toltec figurines from Central Mexico. There are vent openings in the bottoms of the feet and at the elbows.

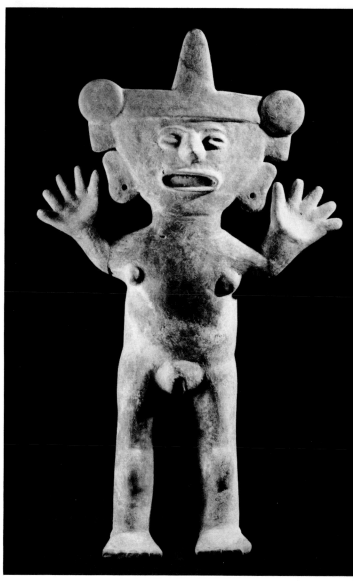

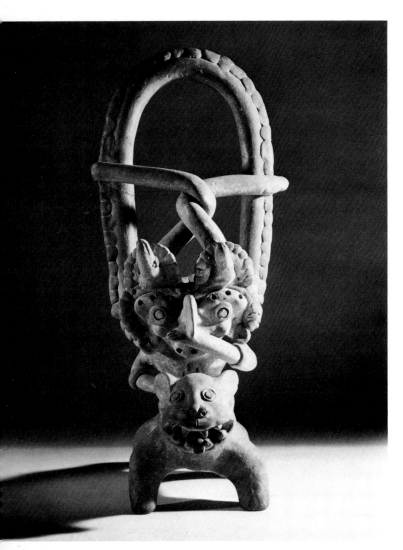

126. Loop-Handled Effigy Incense Burner

West Mexico, Colima. Postclassic, A.D. *900–1400*
Unslipped reddish-buff earthenware
Gift, 157:1980; H. 44 cm.

These unique and imaginative censers are peculiar to Colima and seem to conform to the Postclassic period in Mexico. A double Tlaloc figure (the rear face does not show in the photo) contains the burning bowl and is mounted on the back of a snarling male jaguar. One arm of the front figure is held under the long-beaked nose, as if stifling a sneeze. The back-to-back Tlalocs have separate legs and male genitals. A pair of intertwined serpents is applied to the tall loop handle, and their heads penetrate the headdress of the forward face. The combination of the rain god Tlaloc, serpents, and jaguar appropriately symbolize rain, earth, and fertility, all of which relate to the function of incense burning in Mesoamerica. There is some evidence that these were included in the Terminal Preclassic shaft tombs; if so, our dating is incorrect.

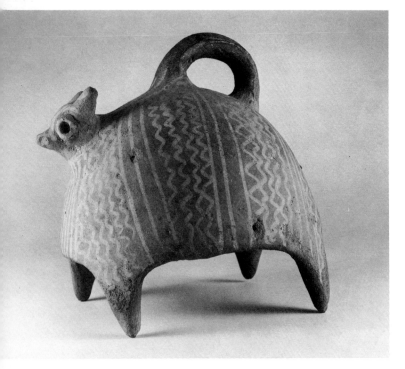

127. Incense Burner Cover

West Mexico (possibly Michoacan). Postclassic, A.D. *900–1400 (?)*
Unslipped reddish-brown earthenware with white paint
Gift, 153:1980; H. 23 cm., W. 24.5 cm.

A dome-shaped object with a loop handle. The whole is adapted to the form of an animal resting on its four legs, with effigy head and small tail. The exterior is painted in white with stripes and dots. The somewhat smoked interior indicates that these objects functioned as incense burner covers. They have not yet been securely dated.

Central Mexican Highlands

We have already described some of the principal Preclassic cultures (Tlatilco, Olmec, etc.) that originated in, or impinged upon, the Valley of Mexico and the surrounding Central Highlands of Mexico. This region became the core of Highland Mexican cultural development, giving rise to a series of such prestigious Classic and Postclassic civilizations as Teotihuacan, Toltec, Mixtec, and Aztec—all of which are illustrated in this section.

Teotihuacan precociously became the first "classical" civilization of Mesoamerica, being dated between the time of Christ and the seventh century A.D. ("Teotihuacan I through IV"). We have mentioned the fact that Teotihuacan was an urban city, a political state, and at its height between A.D. 400 and 700, became a pan-Mesoamerican power. The archaeological site, located about 30 miles northeast of Mexico City, was an urban complex spread over some 8 square miles. Its long and wide "Avenue of the Dead" terminated at the "Pyramid of the Moon" and is flanked by the "Pyramid of the Sun"—the second largest pyramid in the New World (the main pyramid at Cholula in nearby Puebla, to be cited mainly in its Mixtec context, was even larger). Both the residential precincts and the ceremonial pyramids and temples in Teotihuacan style are characterized by *"talud-tablero"* ("slope-and-panel") profiles on their platforms and terraces, as well as elaborate polychrome wall frescoes [see 153]. Tenoned stone serpent heads project from stairway balustrades and from the facade of one famous building in the *"Ciudadela."* Monumental stone sculpture, however, is sparse, with the notable exception of a couple of enormous "water goddess" images (one of them so big it was never removed from its quarry until the new Mexican National Museum of Anthropology was built, when it was transported to Chapultepec Park in Mexico City). Teotihuacan was venerated in Aztec times as the "Home of the Gods." Indeed, certain fundamental Highland Mexican deities, such as Tlaloc (the "rain god"), Xipe (the "flayed god"), and Quetzalcoatl (the "feathered serpent"), made their first appearance in the sculpture and painting at Teotihuacan.

Teotihuacan did not spring from a vacuum. Other than the incipient local Middle Preclassic cultures like Tlatilco, there was a long regional Preclassic sequence given such names as Ticoman and Cuicuilco. The latter is an unusual site in the southwest corner of the Valley of Mexico known for its round terraced pyramid with frontal access ramp, which predates the Pyramid of the Sun by perhaps 500 years. The Teotihuacan III phase (ca. A.D. 250–550) was the Classic peak at the home site, and by A.D. 400 we find Teotihuacan style architecture, stone carving, and élite burial offerings as far away as Kaminaljuyu and Tikal in Guatemala. Then, around A.D. 700, the city of Teotihuacan was burned and abandoned, although we do not know how or why, thus terminating Teotihuacan's hegemony in Mesoamerica. Before the rise of the Toltecs, the Late Classic interim in the Central Mexican Highlands was filled by important sites and cultures centering at Xochicalco to the west and Cholula to the southeast.

The art of Teotihuacan is abundantly and uniquely expressed in elaborate incense burners [128], effigy "thin orange" ware [129, 130, 132], cylindrical tripod vases [131, 133, 134], *"floreros"* [137–139], a complex of clay figurines [140–145], as well as carved stone figures and funerary masks [147–152].

The Postclassic period in the Central Mexican Highlands was inaugurated by the founding of the Toltec capital at Tula, several valleys north of Teotihuacan, in about A.D. 900. The Toltecs managed to consolidate Central Mexican traditions, and until A.D. 1200 dominated much of the Mesoamerican world. Toltec architecture and sculpture included roofed and colonnaded buildings, carved stone columns (both square and full-round "atlantean" warrior types, up to 15 feet in height), low-relief stone friezes (featuring eagles, jaguars and coyotes), ball courts with tenoned rings, and reclining "Chac Mool" figures. All of these features were duplicated at their distant colony at Chichen Itza in northern Yucatan. Early pressure from the powerful Toltec realm also may have contributed to the downfall of Central Lowland Maya civilization. Wherever the Toltecs traded or colonized, we find their specialized glazed "plumbate" pottery [156, 157], as well as other stylistic traits such as the feathered serpent-bird-man, or Quetzalcoatl.

After the Toltec regime ran its course, and before the Aztec peoples settled in the Valley of Mexico, another culture came into prominence—the Mixtec. It was influential between A.D. 1200 and 1400, and in some regions, notably Oaxaca, lasted until the conquest. The homeland of the Mixtecs actually was in northern Oaxaca, midway between the hearts of the Central and Southern Mexican Highlands. Significant outposts of their culture, however, are found at Cholula in Puebla and at Mitla in the center of the old Zapotec realm. Although the Mixtecs succeeded the Zapotecs, Mixtec objects from Oaxaca will be shown in this section.

Mixtec culture is revealed to us through its extraordinarily skilled arts and crafts [158–182] and its pictographic writing, similar in its later stages to "rebus" writing, and as such almost unrelated to Maya writing. A large

number of Mixtec painted manuscripts, or codices, have survived, allowing scholars to interpret their history, genealogies, and customs. Mixtec architecture was sometimes frescoed in a style similar to the manuscripts [see 182]. While the Mixtec art style was widespread—from West Mexico to the Gulf Coast and to the northern and southern Maya regions—this may be attributed to trading and emulation rather than to any attempt at premeditated conquest or empire building. Brightly painted pottery—in particular, the "Mixteca-Puebla" or "Cholula" polychrome [158 and 159]—a graphite-black and specular-hematite red ware [161–163], long-handled openwork incense burners [168, 169], fine lapidary and other stonework [170–173 and 181], intricate inlaid mosaic work [174–176], and metallurgy in copper and gold [177–180], all illustrate the apogee of Mixtec craftsmanship. The Aztecs derived much of their fine arts from that tradition, including narrative picture writing, some of which consisted of lists of tribute extracted from the various regions of their empire.

Working from a firm Central Mexican heritage, the Aztecs rapidly adopted Toltec tactics for empire building, and by A.D. 1400 they were the principal power in Mesoamerica. Warrior societies and professional merchants *("pochteca")* were instrumental in maintaining their networks of control. Tenochtitlan, the layout and architecture of which has already been touched upon, was founded as early as 1325 on an island of Lake Texcoco in the Valley of Mexico—the same locale where the Tlatilco peoples had buried their dead some twenty-five centuries before. More is known about the Aztecs and their dynasties than the earlier civilizations because a few Aztec noblemen, Catholic priests, and Spanish soldiers recorded their history soon after the conquest. Although they were not alone in this custom, the Aztecs were notorious in their predilection for human sacrifice, notably heart removal, to propitiate their gods. Aztec stone sculptures, which they treated as idols, mirror the Aztec pantheon of gods [185–187], many of them imparting an awesome ferocity by incorporating flayed human skins, severed heads, hands, and hearts, and writhing serpents. Aztec pottery has a sophisticated simplicity [183]; their stone carving equals the best of Mixtec craftsmanship [184]; and even normally perishable wood sculpture has survived [188], including carved drums and spear throwers *(atlatls)*.

Cortes and his conquistadores landed on the shores of Veracruz in the year 1519, slightly more than two years before they defeated Moctezuma (and consequently the Aztec empire) at his capital of Tenochtitlan. This phenomenon was partly due to Cortes's skill in enlisting the services of enemy territories and partly to the Aztecs' unfamiliarity with the horse, the crossbow, and gunpowder. But it was more a result of the fateful coincidence that Cortes arrived exactly at the forboding moment of the end of one of the Aztec calendrical cycles, as well as the prophesied year of the return of a light-skinned, bearded Quetzalcoatl from the East. Initially, Cortes was mistaken for a god.

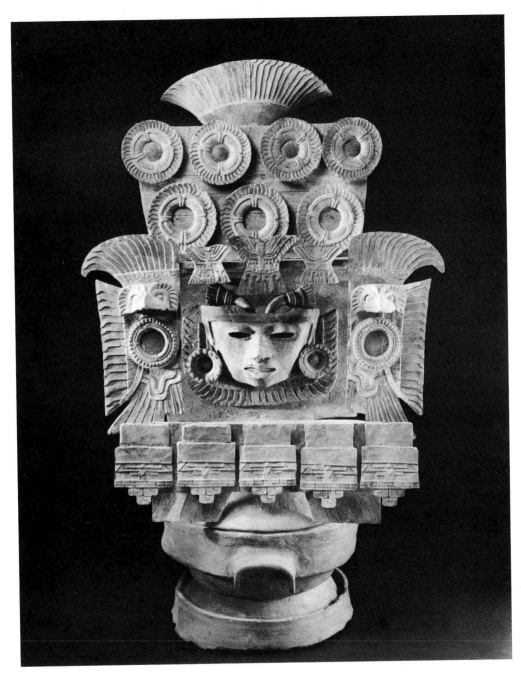

128. Composite Incense Burner

Mexico, Central Highlands, Teotihuacan III–IV. Middle Classic, A.D. *400–700*
Polychromed buff earthenware
Gift, 205:1979; Total H. 76 cm.

Elaborate incense burners such as this, with numerous applied moldmade *"adornos,"* are diagnostic of the peak period of Teotihuacan's hegemony. Similar censers have been excavated as far south as Guatemala [cf. 285], where Teotihuacan's influence spread during the Middle Classic period. The basic structure consists of two sections. First, there is a separate, hourglass-shaped incense container at the base with a pair of U-shaped handles. (The base of this object has been artificially attached to the effigy top for stability, though the top should be removable. Also, the handles of the base normally would be directed toward the sides, rather than front and back.)

The top section consists of a conical cover, from which a clay tube, or chimney, rises the full height of the back of the superstructure (concealed in the photograph). The cover supports a framework of applied clay ornamentation. The front panels create a kind of proscenium window around the central, recessed face mask. A T-shaped nose pendant, or mouth mask, identifying this image as the rain god Tlaloc, was not attached at the time of photography. The various appliquéd ornaments include plumed tassels, feathered rosettes, butterflies (above the face), owls (flanking the face), and sky emblems (the row beneath). However, we seldom can be confident that all of these moldmade *adornos* have been correctly assembled in the inevitable restoration of such a fragile object.

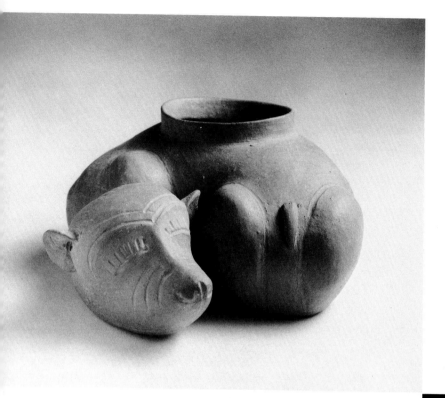

129. Sleeping Dog Vessel
Mexico, Central Highlands, Teotihuacan II–III. Early to Middle Classic, A.D. *200–600*
Orange earthenware ("thin orange")
Gift of Mr. and Mrs. George K. Conant, Jr., 108:1966; H. 9 cm., W. 19 cm.

This technologically fine, thin ware was extensively imported and exported by merchants of Teotihuacan [cf. 130,132, and 286]. Its center of manufacture is purported to be in the state of Puebla. The naturalistic dog form itself suggests some kind of stylistic interchange with the potters of Colima [see 95–97]. (Highland Mexican "thin orange" ware, indeed, has been found in a West Mexican shaft tomb, proving contact with Teotihuacan in the latest phase of the former culture.) A half dozen thin orange dog effigies are known, one of which was excavated in a Middle Classic, Teotihuacan-influenced tomb at Kaminaljuyu in Highland Guatemala. The details of our modeled example are grooved, and the legs are shown in low relief under the head. There is a wide, rimmed vessel opening in the back of the curled dog.

130. Seated Woman Holding Bowl
Mexico, Gulf Coast (?), Teotihuacan style. Early to Middle Classic, A.D. *200–600*
Orange earthenware ("thin orange")
Gift, 303:1978; H. 26 cm.

An unusual effigy in the generally distributed Teotihuacan ceramic ware termed "thin orange." The provenance of this one is purportedly Veracruz, which is well within the realm of possibility. The vessel is supplied with a long, thin, bridged spout, which joins the figure at the base of the back. The female sits with bent legs in a long dress and shoulder cape. Fine-incised lines decorate the waistband as well as the bowl she carries in front of her. The latter is open to the interior of the torso. This effigy has a small amount of restoration.

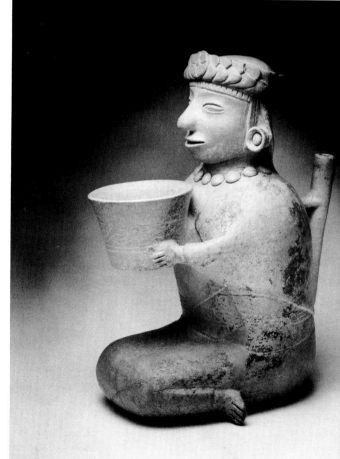

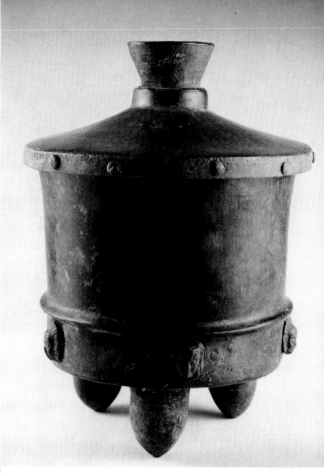

131. Cylindrical Tripod Vase With Cover

Mexico, Central Highlands, Teotihuacan III. Early to Middle Classic, A.D. *300–600*
Polished black-brown earthenware
Gift, 81:1980; H. (with cover) 19.5 cm., Diam. (vessel rim) 14 cm. (Ex-coll. George Pepper)

A classical Teotihuacan vessel, complete with the lipped sloping cover. Its handle is hollow and the lip has applied pellets. The cylindrical vase itself has a flat bottom and three hollow, rounded, "conical" feet. The banded lower border has three extant, applied moldmade heads (originally there were five). (See 305 for a comparable vessel from Guatemala inspired by Teotihuacan.)

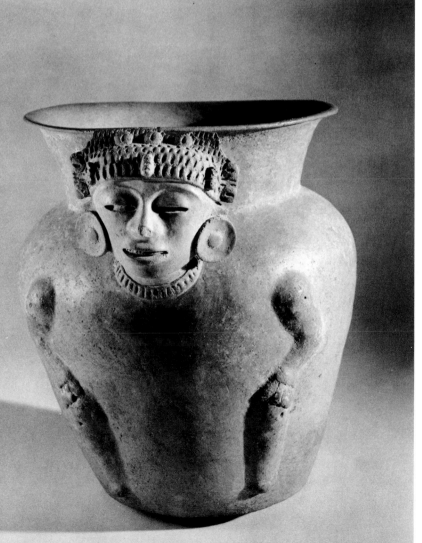

132. Jar With Appliquéd Figure

Mexico, Central Highlands, Teotihuacan II–III. Early to Middle Classic, A.D. *200–600*
Orange earthenware ("thin orange")
Gift, 229:1978; H. 34.5 cm., Diam. 31 cm.

A very large example of "thin orange" with Classic Teotihuacan morphological features. The hollow head has been appliquéd to the shoulder of the jar, as were the half-round arms and legs. The eyes are perforated on either side of the pupils and the limbs have tiny holes as well. The vessel rests on short nubbin tripods, and the surface has calcareous deposits.

133. Cylindrical Tripod Vase
Mexico, Central Highlands, Teotihuacan III. Early to Middle Classic, A.D. 300–600
Polished black-brown earthenware
Gift, 80:1980; H. 11.5 cm., Diam. 16.5 cm. (Ex-coll. George Pepper)

A vertical-walled, flat-bottomed vase, with three hollow slab feet. Each foot is grooved on the sides and has two vertical slits. The inner edge of the rim is beveled. The vessel walls were deeply engraved after firing and retain vestiges of white pigment. The iconography consists of three scrolled trapezoidal "rain" motifs on one side, and a "reptile eye" glyph on the other (see drawing). The latter is more explicit than usual in that it includes the fanged mouth on the left and a scroll trailing off the eye to the right.

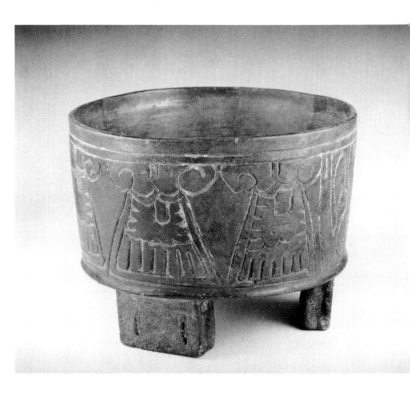

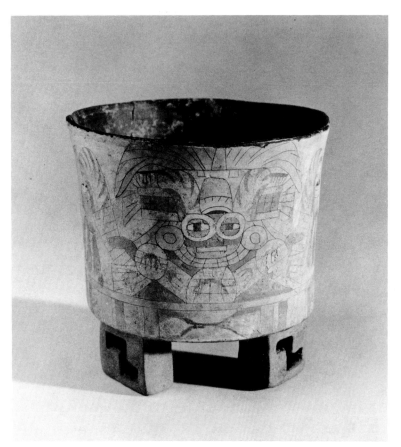

134. Frescoed Cylindrical Tripod Vase
Mexico, Central Highlands, Teotihuacan III. Early to Middle Classic, A.D. 300–600
Brown earthenware with polychromed lime plaster (See color plate)
Gift, 338:1978; H. 13.5 cm., Diam. 14.5 cm.

In addition to thin orange ware, this uniquely Teotihuacan pottery form, normally including a cover [see 131 and 305], was widely traded and copied throughout Mesoamerica in the period of Teotihuacan expansion, from approximately A.D. 400 to 600. The most elaborate examples are frescoed, here utilizing black-outlined red and light green paint over a thin coating of white plaster. The painted iconography features two frontally displayed variations of the rain god Tlaloc. Each deity holds in either hand sacrificial knives, to which are appended heart symbols dripping with trilobed blood motifs. The interior of the vase is slipped or smudged black, while the flat base is supported by three hollow slab feet pierced in front with stepped frets.

135. Double-Chambered Cylindrical Vase

Mexico, Central Highlands, Teotihuacan II. Early Classic,
A.D. *100–300*
Brown earthenware with specular-hematite red paint
Gift, 79:1980; H. 14 cm., L. 20 cm. (Ex-coll. George Pepper)

An unusual vessel form for Teotihuacan, consisting of
two concave-sided cylindrical vases connected by a solid
strap and a hollow tube. Each chamber has two nubbin
feet, and one has a sealed lid with a monkey effigy. The
latter holds one hand over his nose. The vessel walls are
incised, one of them showing three winged, trefoil, scroll
motifs, and the other with a single interlaced scroll pat-
tern in a diagonal panel.

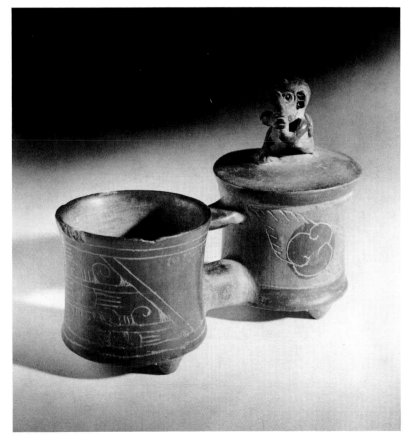

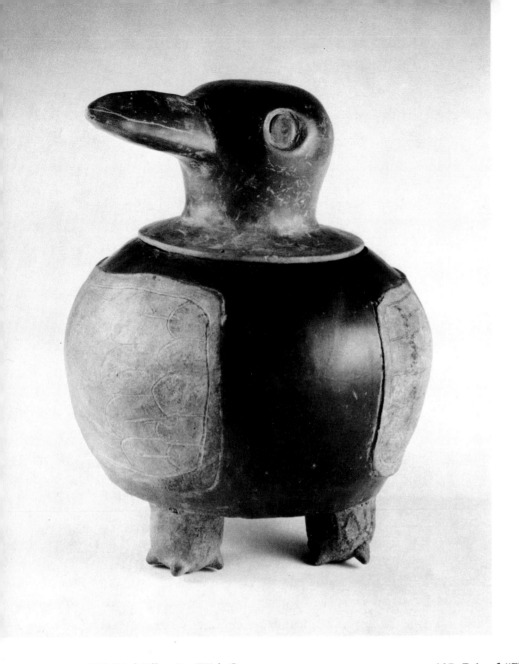

136. Bird Effigy Jar With Cover

Mexico, Central Highlands, Teotihuacan II. Early Classic,
A.D. *100–300*
Polished brown earthenware
Gift, 75:1980; Total H. 26.5 cm., Diam. 21 cm. (Ex-coll.
George Pepper)

This unique vessel is modeled as a bird's body with a
removable bird's head cover that rests on a recessed lip
in the mouth of the jar. The flat bottom is lifted on
hollow tripod, oven-shaped, feet, and the front pair is
fitted with four claws. The side wings taper back to a
point, and tail feathers are shown in a rectangular panel
at the rear. The wings and tail are raised from the surface
and have incised feathers. Only the zones between these
features, and the cover, are burnished.

137. Pair of *"Floreros"* (Facing page)

Mexico, Central Highlands, Teotihuacan II–III. Early Classic,
A.D. *200–600*
Polished black-brown earthenware
Gift, 78:1980.1,.2; H. 9.2 cm., Diam. 7 cm. (Ex-coll. George
Pepper)

This miniature pair represents another diagnostic
Teotihuacan vessel form labeled a *florero*. The mouths
have expanded lips over tall necks and bulbous bases.
The latter are lightly scored, while the flaring rims are
decorated with a series of groove-outlined, unpolished
lobes.

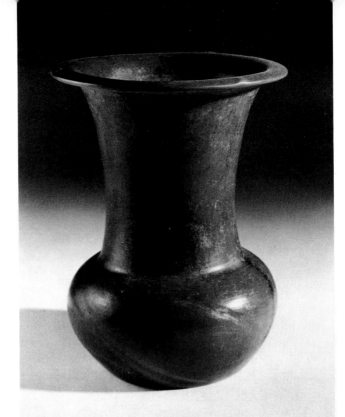

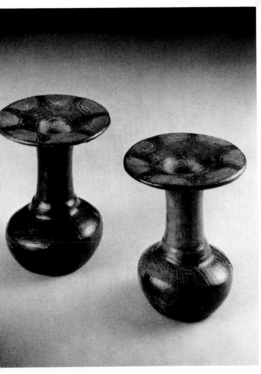

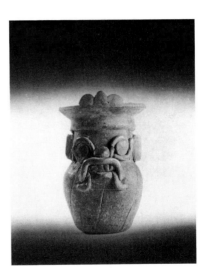

139. Miniature Tlaloc Effigy Vase
Mexico, Central Highlands, Teotihuacan III. Middle Classic,
A.D. *400–600*
Black earthenware
Gift, 77:1980; H. 7.5 cm. (Ex-coll. George Pepper)

A *florero*-shaped vase with the applied features of an early
version of the Central Mexican rain god Tlaloc. Note the
"goggle" eyes, fanged, inverted U-shaped mouth, and
trefoil lobes on the rim—all diagnostic elements of this
primary deity. The body of the vase is diagonally scored.
These Teotihuacan Tlaloc vases, as well as the *florero*
form, are widely distributed in Mesoamerica.

138. Composite Silhouette Vase
Mexico, Central Highlands, Teotihuacan II. Early Classic,
A.D. *100–300*
Polished earthenware with specular-hematite red slip
*Gift, 76:1980; H. 18 cm., Diam. 14.5 cm. (Ex-coll. George
Pepper)*

A large *florero* vase. This example has wide diagonal
grooves around the expanded body and three low nub-
bins on the rim. The deep red slip covers the vessel walls
and rim.

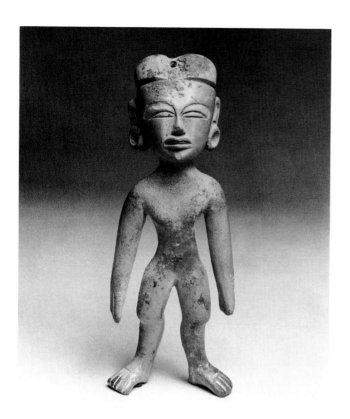

140. Standing Figurine

Mexico, Central Highlands, Teotihuacan III. Early to Middle Classic, A.D. 300–600
Polished orange earthenware
Gift, 273:1978; H. 21.2 cm.

Although the facial features of this solid, handmade figurine are more or less standard Teotihuacan style, the highly polished orange slip and the gangly body proportions are atypical. Apparently, however, this aberrant type is being found in one sector of the site of Teotihuacan. The zones of high luster are limited to the face, arms, and legs. The headdress is set apart by a deep groove, and the top is perforated. The fingers, toes, and face are incised.

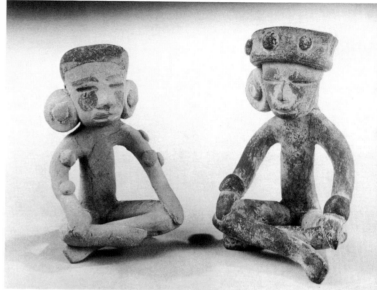

141. Seated Figurines

Mexico, Central Highlands, Teotihuacan II–III. Early Classic, A.D. 200–400
Yellow-slipped earthenware
Gifts, 234 and 235:1978; H. 6.5 and 7.5 cm.

Two typical hand-modeled, cross-legged Teotihuacan figurines. That on the left has black paint on the head crest and black spots on the cheeks. The one on the right has an appliquéd headband (its left ear spool is missing).

142. Matched Pair of Seated Figurines

Mexico, Central Highlands, Teotihuacan II–III. Early Classic, A.D. 200–400
Unslipped buff earthenware
Git, 82:1980.1,.2; H. 6.5 and 6.2 cm. (Ex-coll. George Pepper)

Solid, slit-eyed Teotihuacan figurines, apparently in tunics, and with appliqué straps for arms. Earplugs are attached, as well as beaded turbans with large bow knots to one side. Only one retains yellow paint on the face and the projecting feet.

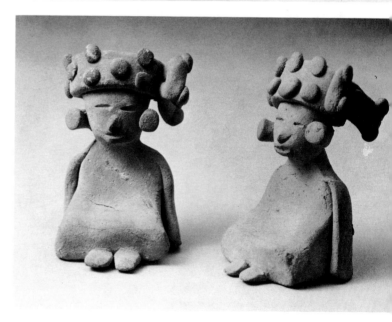

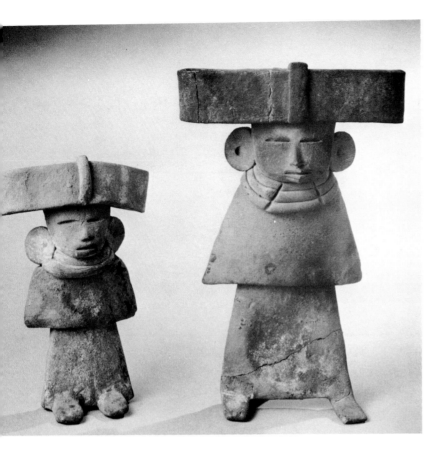

143. Two Solid, Flat Figurines

Mexico, Central Highlands, Teotihuacan II. Early Classic,
A.D. *100–300*
Unslipped buff earthenware with traces of yellow and white paint
Gifts, 232 and 233:1978; H. 10.5 and 14.5 cm.

Similarly executed figurines with slablike bodies. They are supported in a standing position by a strap armature behind. They are shown wearing capes and skirts, necklaces, and earplugs. And both have horizontally exaggerated turbans made as looped bands.

144. Jointed Dolls

Mexico, Central Highlands, Teotihuacan III–IV. Middle Classic, A.D. *400–700*
Unslipped buff earthenware with yellow, white, and red paint
Gifts, 231 and 308:1978; H. 17 and 16 cm.

Not uncommon at Teotihuacan are solid figurines with separate, movable arms and legs. These have been restrung through the perforated bodies to show the limbs as they were originally assembled. The doll on the left is handmade, with an asymmetrical headdress. The exposed hair on the left side is painted white, while the body is stained yellow ochre. The head and body of the doll on the right are moldmade. The wavy hairline and the necklace are painted red, while the rest is yellow.

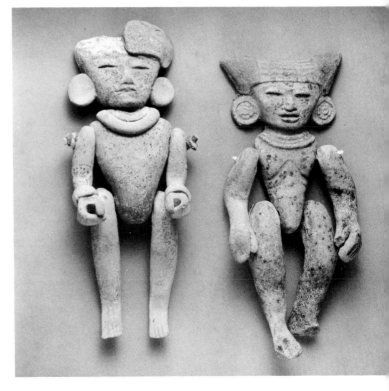

145. Jointed Figurine Fragment With Open Body Cavity

Mexico, Central Highlands, Teotihuacan IV. Middle Classic,
A.D. *600–700*
Buff earthenware with traces of yellow, red, white, and blue-green paint
Gift, 230:1978; Present H. 20 cm. (Ex-colls. Billy Pearson and Robert Woods Bliss) (Illustrated: Von Winning, 1968, item 216)

Once considered rare, this extraordinary type of mortuary doll is now appearing in far-flung localities in Mesoamerica. Its open-backed, yellow-painted head was apparently pressed in a mold. The pierced shoulder sockets demonstrate that it formerly had movable arms (and probably legs). We know from other complete examples that the hollow body cavity once had a cover. Typical of this class of dolls is the applied, moldmade supplementary figure concealed inside the torso; others may have been attached to the missing cover.

146. Pair of Ear Spools

Mexico, Central Highlands, Teotihuacan IV. Middle Classic,
A.D. *600–700*
Orange earthenware with traces of white paint
Gift, 236:1978.1 and .2; Diam. 3.5 cm., D. 1.7 cm.

A pair of thin and delicate, concave-sided ear spools, with inset moldmade panels. The latter portray faces with feathered headdresses. Such ear ornaments are frequently depicted on Teotihuacan effigy figurines [cf. 140]. Molded ceramic technology apparently was invented at Teotihuacan and became common throughout Mesoamerica during the Middle Classic and subsequent eras.

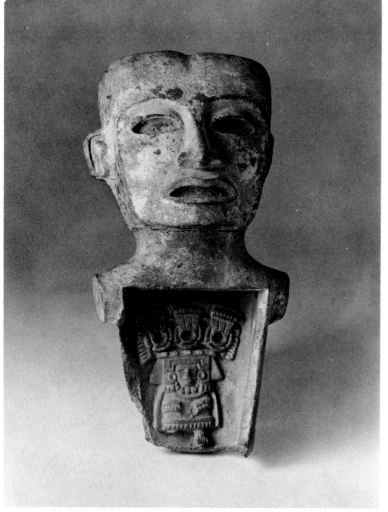

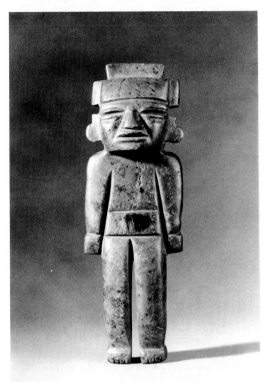

147. Standing Figure

Mexico, Central Highlands (?), Teotihuacan II–III. Early Classic, A.D. *200–600*
Deep green jadeite
Gift, 264:1978; H. 19.3 cm.

These portable stone figures in Teotihuacan style do not necessarily come from the type site; they also are found far to the west in Guerrero. Miguel Covarrubias (1957, p. 110), in fact, suggested a typological sequence of carved stone figures in West Mexico itself, from Olmecoid (cf. 52–53 this collection), to proto-Teotihuacan, to the Classic Teotihuacan style. This example has a sawed separation between the legs, and deep straight grooves delineating the front and back of the arms. The backs of the knees are notched, as though slightly bent, and reminiscent of Preclassic stone figures.

148. Standing Figure

Mexico, Central Highlands, Teotihuacan II–III. Early Classic, A.D. *200–600*
Polished green serpentine
Gift, 365:1978; H. 28 cm.

A large, rigidly stylized, carved stone figure with flat back, in the Classic Teotihuacan tradition (compare the stone masks, 149–151). The legs are separated by a V-shaped notch, the navel has a deep drilled depression (once inlaid?), and the head juts out sharply from the body.

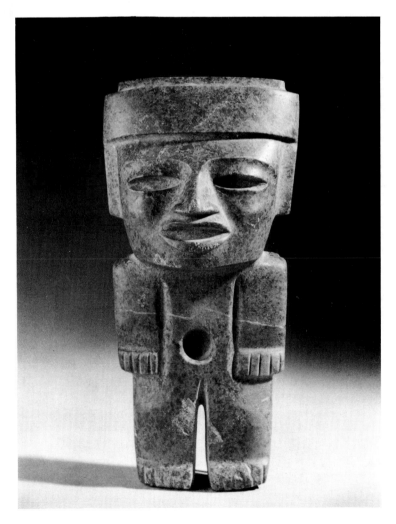

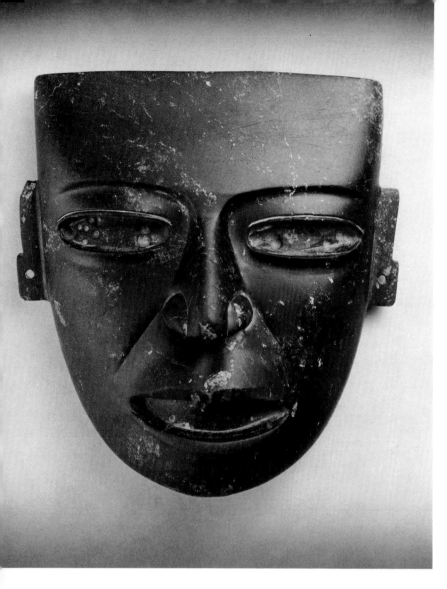

150. Inlaid Funerary Mask (Facing page)

Mexico, Central Highlands, Teotihuacan III. Early Classic,
A.D. *300–600*
Polished green serpentine with white shell and iron pyrite (See color plate)
Gift, 287:1978; H. 18.5 cm., W. 17.5 cm., D. 9.5 cm.

A unique Teotihuacan stone mask, both for its front-to-back depth and for the preservation of all its inlays. The eyes and mouth are set with white shell and the mouth is scored to represent teeth. The pupils of the eyes are shimmering discs of iron pyrite. One other Teotihuacan mask in the Mexican National Museum is in similarly pristine condition (most lack their original inlays), but also has an extensive mosaic overlay (Disselhoff and Linne, 1960, p. 36). The earlobe and suspension holes are distributed as on the previous mask, though the upper perforation on this one is drilled through to the front surface. The reverse has a deep troughlike cavity with a large conical depression behind the nose. The nostrils, in addition, are pierced. (The bottom of the left ear is missing.)

151. Funerary Mask

Mexico, Central Highlands, Teotihuacan III. Early Classic,
A.D. *300–600*
White onyx (tecalli)
Gift, 265:1978; H. 10 cm., W. 12 cm., D. 6 cm.

A thick stone mask of less than face size. The back is moderately hollowed out and the upper rear corners have biconical perforations for attachment. The corners of the eyes and mouth show the usual drill pits, as do the earlobes. The eyelids and nostrils have been outlined with incisions.

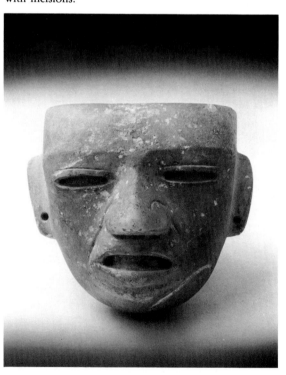

149. Funerary Mask (Above)

Mexico, Central Highlands, Teotihuacan III. Early Classic,
A.D. *300–600*
Polished black basalt
Purchase, 5:1948; H. 20 cm., W. 19.8 cm., D. 8.5 cm.

These Classic Teotihuacan stone masks are assumed to be funerary, though none of the known examples have been professionally excavated, *in situ,* in graves either at Teotihuacan or elsewhere. The deeply cut eyes and mouth once held inlays [cf. 150]. Pits from the original drills can be seen in the corners of these orifices. The nostrils are also drilled and the lobes of the flangelike ears are perforated. The back of the mask has been hollowed out to lighten it, leaving vertical string-saw marks. Five biconical holes penetrate the edges for attaching the heavy face mask—two on each side and one on the top.

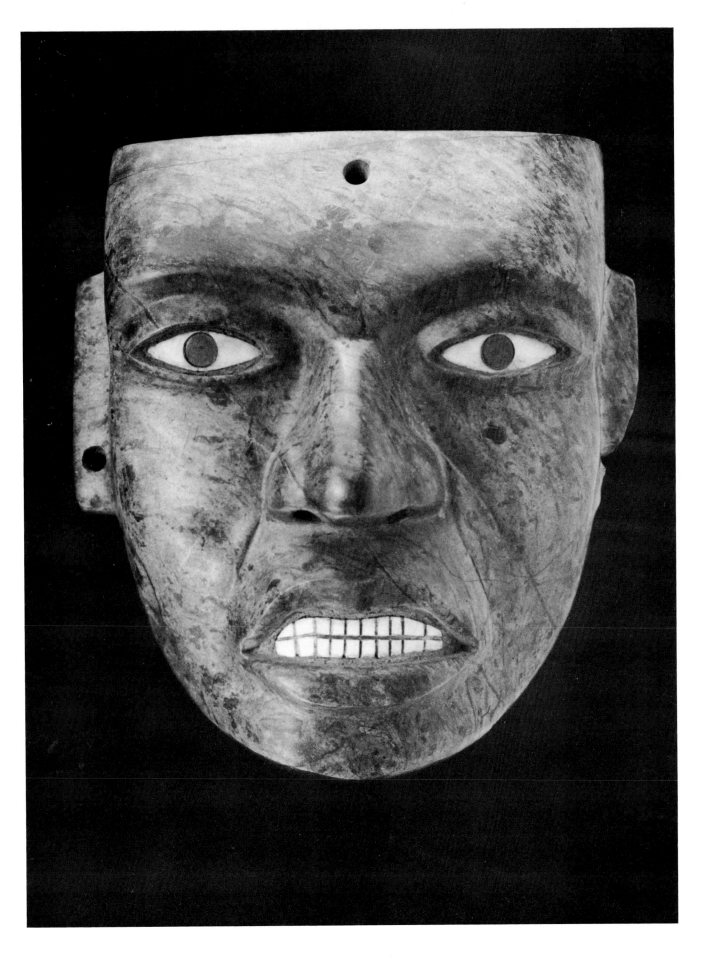

152. Seated "Old Fire God" With Brazier

Mexico, Central Highlands, Teotihuacan III. Early Classic,
A.D. *300–600*
Gray volcanic stone
Gift, 206:1979; H. 43.5 cm., Diam. 46 cm.

The fire god, Huehueteotl, is a frequent subject for stone and ceramic effigy braziers in the Teotihuacan culture. The hunched, cross-legged old man with forward-turned earplugs supports a deep, flat-bottomed, incense-burning basin on his head and shoulders. The hands have squared depressions as if to hold objects now missing. The sculpture is cut out between the arms and back, open between the legs, as well as under the head and behind the earplugs.

153. Fresco Mural Fragment (Facing page)

Mexico, Central Highlands, Teotihuacan III. Early Classic,
A.D. *300–600.*
Adobe, lime plaster, and specular-hematite red paint (See color plate)
Gift, 237:1978; ca. 73 × 97 cm. (Ex-coll. Billy Pearson)

One of the spectacular features of the great site of Teotihuacan, from which this fragment doubtless came, is the technique of fresco painting on the walls of temples and élite residential rooms. Unfortunately for the preservation of the site, certain outlying districts were looted over a long period and appeared on the world art market. Their exact provenance at Teotihuacan generally is not yet known. This fragment is similar to several others in this country and, in fact, sections extracted from the same room apparently exist in other collections.

Our section probably came from the basal frieze of a wall, and includes a single figure from a procession of related figures moving toward the right (the rear of the next one is visible on the far right). The frieze is bordered with human footprints heading in the same direction (the bottom border may have been identical). The ornately costumed personage in the center wears the guise of one of the rain gods—an aspect of the Central Mexican Tlaloc (note the identifying "goggle" eye). In addition, most of the incorporated motifs relate to water and vegetation. The broad feathered headdress, rear plumed shield or bustle, jade bead necklace, and incense bag in the right hand all are typical accouterments. Another diagnostic feature of the rich Teotihuacan iconography is the massive flowered "speech scroll" issuing from the mouth. This element contains shell and jade bead (water-drop) motifs. This fresco is painted in three shades of red—from deep hematite red to pink and reddish white.

155. Cache of Eccentric Obsidian Blades (Above)

Mexico, Central Highlands, Valley of Mexico (Cuauhtitlan).
Early Classic, A.D. *200–600*
Greenish-black obsidian (volcanic glass)
Gift, 135:1980.1-.58; Largest, 15.5 cm., smallest, ca. 2 cm.

An extraordinary group of miniature chipped obsidian figures, blades, and points. The obsidian is of the type found locally in Central Mexico. Apparently all fifty-eight were found together as a cache in a burial, though the circumstances of the find and their dating are uncertain. They probably belong to the Teotihuacan period; in fact, a cache of such obsidian human effigy figures was excavated in the Pyramid of the Sun at that site. "Eccentric flints" (i.e., flaked in naturalistic or purely abstract shapes) are far more common in Maya area caches of the Classic period, where they are normally of much larger size. But whether of flint or obsidian, they represent a *tour de force* of the stone knapper's craft. This group includes twenty-one pieces in simplified human outline and fourteen in abstract, pronged, serpentine form—all of them finely flaked on both faces. Also included in the cache are eight simple blade knives and fifteen chipped projectile points.

154. "Xipe" Architectural Ornament

Mexico, Central Highlands, Teotihuacan or Toltec culture.
Classic or Postclassic, A.D. *400–1200*
Porous red pumice
Gift, 217:1978; H. 31 cm., W. 38 cm., D. 13 cm.

A lava block carved in a conventional, abstract, facial image of the flayed god, Xipe. The three round eye and mouth perforations and the continuous, closed U-frame identify this deity in Mexican Highland art. (The nick at the base is recent damage, not an integral part of the frame.) Although this manner of depicting Xipe is precisely duplicated in Teotihuacan figurines, the stone block itself can just as well be visualized in association with Toltec architecture. Miscellaneous stone sculpture at Teotihuacan is relatively scarce, though this could be one rare example. Be that as it may, many features of the Teotihuacan art style were inherited and elaborated upon in the later Toltec culture in Central Mexico. Unfortunately, the exact provenance of this object is unknown.

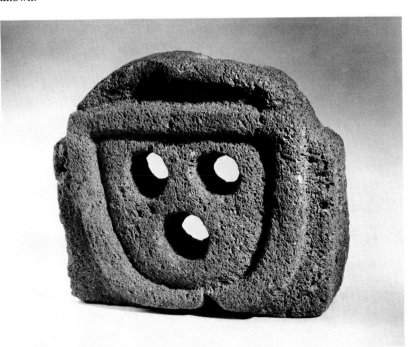

156. Deer Effigy Vessel

Mexico, Gulf Coast, Toltec culture. Early Postclassic, A.D. *900–1200*
Glazed earthenware mottled red and leaden gray ("plumbate")
(See color plate)
Gift, 122:1980; H. 18 cm., L. 23.5 cm.

This is an example of the only true hard-glazed pottery produced in Pre-Columbian America, which is termed "plumbate ware" (though the fired silica glaze does not contain lead), and is widely distributed in Mesoamerica during Toltec times. It has been suggested that the actual objects were manufactured in one region (western Guatemala) and traded to all major Toltec sites, from Tula to Chichen Itza. The incised decorations on the deer include a collar, an *atlatl* (spear thrower) on each side of the body, and a dart on the underside. The head and legs are hollow, with openings on the bottom.

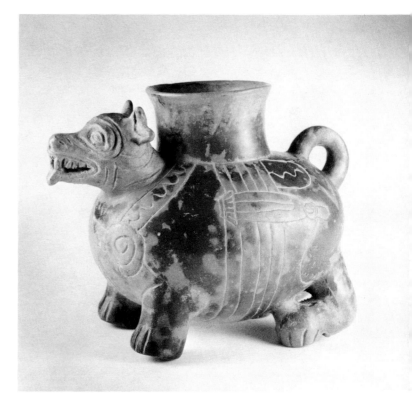

157. Animal (Coyote?) Effigy Jar

Mesoamerica, Maya area, Toltec culture. Early Postclassic, A.D. *900–1200*
Glazed gray and mottled orange earthenware ("plumbate")
Gift, 211:1979; H. 14 cm., L. 18.5 cm.

The various anatomical features of this animal are rather crudely grooved. The head and front legs are hollow, with openings below, but not to the interior of the open-mouthed vessel.

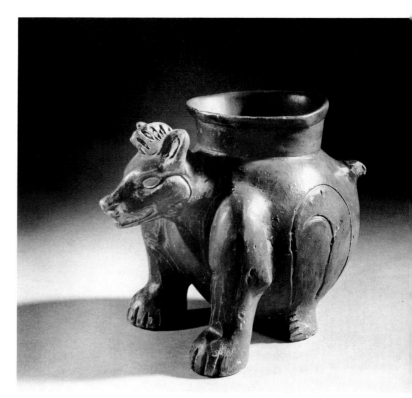

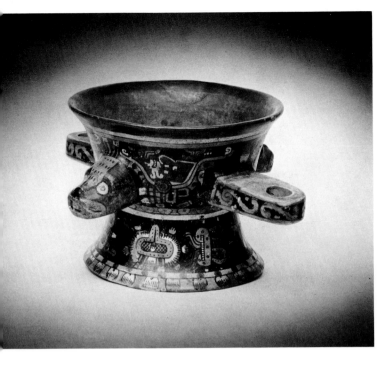

158. Effigy Incense Burner

Mexico, Central Highlands (probably Puebla), Mixtec culture.
Postclassic, A.D. *1200–1400 or 1500*
Polychromed reddish-brown earthenware ("Mixteca-Puebla" polychrome)
Purchase, 86:1950; H. 11 cm., Maximum W. 22.5 cm.

This complexly polychromed ware (termed "Mixteca-Puebla" or "Cholula" polychrome) is painted in the fashion of the Mixtec pictorial manuscripts, or codices. The ware apparently centered around the great site of Cholula in Puebla, and it is recognized as one of the finest ceramic wares produced in ancient Mesoamerica. The colors are said to be applied in a lacquer technique, here employing orange, red, beige, black, gray, and white. Painted on the upper sides, between the projections, are four heads lying horizontally in serpent-jawed "earth bowls." Around the base are other alternating Mixtec symbols. The vessel itself is of complex construction, consisting of an upper bowl resting on an open-bottomed pedestal. On opposite sides are a pair of hollow handles with walled holes, and also a pair of hollow animal (jaguar?) effigy heads. All of these contain rattles.

159. Polychrome Plate

Mexico, Central Highlands (probably Puebla), Mixtec culture.
Postclassic, A.D. *1200–1400 or 1500*
Polychromed reddish-brown earthenware ("Mixteca-Puebla" polychrome) (See color plate)
Purchase, 85:1950; Diam. 23 cm.

Comparable in style and technique to the previous example, this is in a simple plate form, and is painted orange, red, yellow, gray, black, and white. The principal motif in the slightly depressed center of the plate is an open-mouthed, scroll-cornered serpent head. A forked tongue falls from the rear corner, there is a single molar tooth in the center, and three plumes emerge from the top of the mouth. Attached to the "nose" is a feathered tassel. This central motif is surrounded by a simplified sky band, while the outer border features a series of Mixtec day signs, including "flint knife," "reed," and "eagle." The underside of the somewhat raised rim is painted orange with six black scroll motifs.

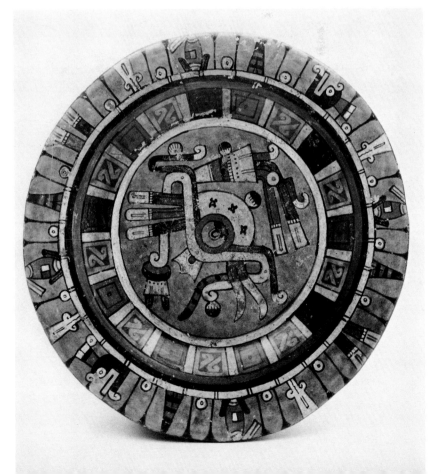

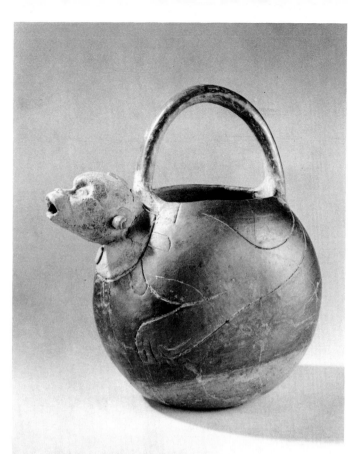

160. Pitcher With Monkey Spout

Mexico, Central Highlands, Mixtec culture. Postclassic, A.D. 1200–1400
Orange-slipped earthenware with specular-hematite red and graphite-black paint
Gift, 281:1978; H. 24.5 cm.

Zoomorphic pitcher of the same type and ceramic ware as the previous example. This vessel is ovoid in cross section, with a loop handle over the opening, and a pouring spout through the applied monkey head. The animal's forelegs and collar were outlined by deep scoring before the vessel was polished. The leg zones were painted red and surrounded with black, with the orange slip showing below. The handle likewise is red and black. The monkey head, however, was left unslipped.

161. Animal-Spouted Pitcher

Mexico, Central Highlands, Mixtec culture. Postclassic, A.D. 1200–1400
Orange-slipped earthenware with specular-hematite red and graphite-black paint
Gift, 280:1978; H. 30 cm.

Tall, spouted pitcher forms are limited to Mixtec and Aztec times [cf. 183] in Mexico. The use of graphite-black paint, however, identifies the Mixtec mode [cf. also 160 and 163]. The deep red and black paint is applied in alternating bands (black being on the shoulder and rim). Opposite sides of the vessel body have notched lug projections, and a graceful strap handle bridges the tall neck and body. The pouring spout is modeled, in unslipped clay, as an open-mouthed animal (coyote?) head.

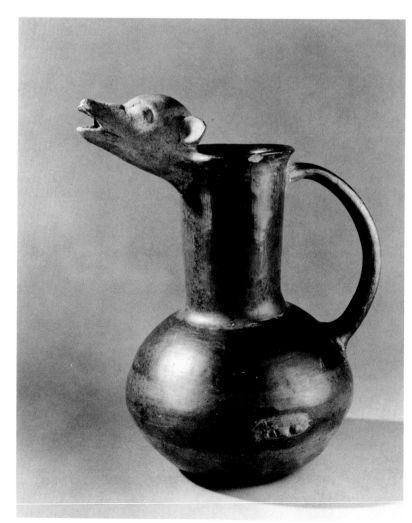

162. Polychrome Urn

Mexico, Central or West Highlands, Mixtec culture. Postclassic, A.D. *1200–1400*
Orange-slipped earthenware with red, orange, cream, and dark brown paint
Gift, 162:1980; H. 32.5 cm., Diam. 37.5 cm.

A polychrome urn similar in size and form to the last, with a pair of small loop handles. The photo captures a pair of painted panels that are repeated three times around the vessel wall. Incorporated motifs emphasize the iconography of water. The cursive rendering of these motifs and the lack of intensity to the colors suggest the possibility of a provenance some distance from the center of Mixtec polychrome ware at Cholula (possibly Michoacan).

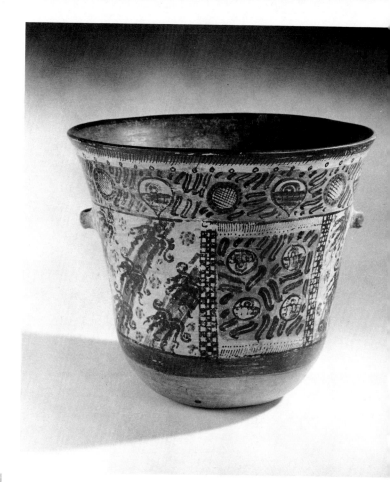

163. Decorated Urn

Mexico, Central Highlands or Gulf Coast, Mixtec culture. Postclassic, A.D. *1200–1400*
Orange-slipped earthenware with specular-hematite red and graphite-black paint
Purchase, 87:1953; H. 37 cm., Diam. 37.5 cm.

A large version of a characteristic Mixtec pottery ware. This urn has two small loop handles and two repeated motifs decorating opposite sides. These figurative motifs are outlined with incised lines and are filled with graphite-black paint, surrounded by the deep red background. The basic orange slip is exposed on the bottom and the interior below the rim. The decoration consists of a serpentine creature laid out in double U-shaped loops. Growing from the tail are four long feathers. The serpent body is formed of a series of opposing volutes, with attached flint knife motifs at irregular intervals. The head is that of a rabbit rather than a serpent. Note the ring collar around the neck. Two long, flowing, feathered scrolls issue from the mouth of this composite creature.

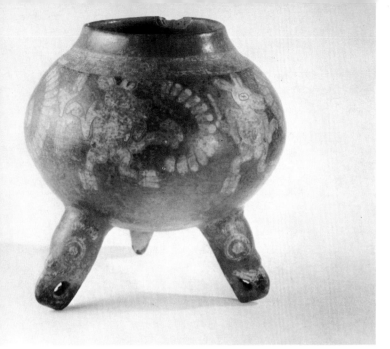

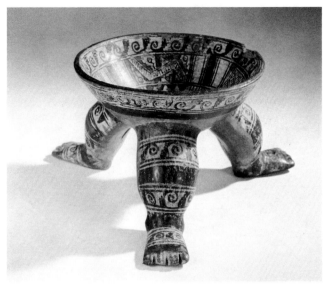

164. Tripod Jar
Mexico, Central or West Highlands, Mixtec culture. Postclassic, A.D. *1200–1400*
Polished, orange-slipped, earthenware with cream paint
Gift, 350:1978; H. 22 cm., Diam. 22 cm.

Like the previous urn, this vessel was probably manufactured away from the Cholula center. (See 158 and 159 for true Mixteca-Puebla polychrome.) The hollow tripods are modeled as raptorial birds. Such effigy legs are particularly prevalent in Postclassic ceramics. Repeated five times around the vessel walls are incised-outlined dancing opossums, framed by semicircular fanlike motifs. The opossum "gods" hold either staffs, fans, or rattles in either hand. The bordering band below the constricted rim consists of incised fret motifs.

165. Tall Tripod Bowl
West Mexico (possibly Michoacan), Mixtec culture. Postclassic, A.D. *1200–1400*
Orange-slipped earthenware with black and cream paint
Gift, 230:1979; H. 11.5 cm., Diam. 18.5 cm.

The hollow supports on this bowl are modeled as human legs with feet—an unusual variation on the typical human or animal head tripods. The outer surface of the legs, an exterior rim band, and the interior of the bowl are painted with black and cream geometric patterns, including the characteristic Mixtec spiral step-fret motif.

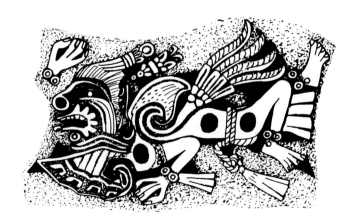

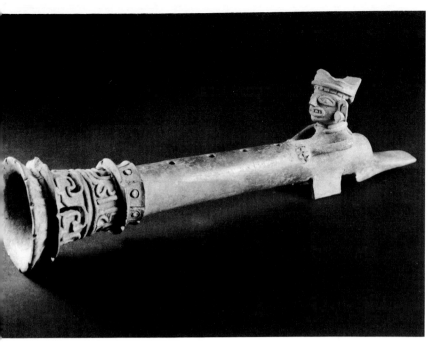

166. Effigy Flute

Mexican Highlands, Puebla or Oaxaca, Mixtec culture. Post-classic, A.D. *1200–1400*
Brown earthenware with specular-hematite red paint
Gift, 190:1979; L. 37 cm.

A hollow, trumpet-shaped flute with four finger stops and a mouthpiece, and an air hole below the chamber. When not in use, the flute rests on two rectangular flanges below the effigy human figure who rides on one end. The other end of the flute expands in an elaborate openwork design around filleted step frets. The body of the instrument and the mouthpiece, only, are painted red.

167. Tripod Openwork Vase

Mexican Highlands (possibly Oaxaca), Mixtec culture. Post-classic, A.D. *1200–1400*
Gray earthenware with polished graphite-black paint
Gift, 125:1980; H. 9.5 cm., Diam. 10 cm.

A remarkably intricate little vase, with modeled petal-shaped mouth and three curved flanges for feet. Curiously, each foot has a perforation at the bottom. The side of the vessel has the background carved to reveal three similar flying human figures in horizontal positions. They apparently have wings on their backs, or are shown swimming, with fishlike dorsal fins. The composition is punctured in many places to give an openwork effect. Each figure shows a bent arm and leg, as well as an isolated hand and foot above. A number of feathers, beads, and tassels are attached. The background bears evidence of having been dusted with red hematite. (The photograph shows the head of one individual to the right, and the rear of the next individual to the left; but see the drawing of one complete figure.)

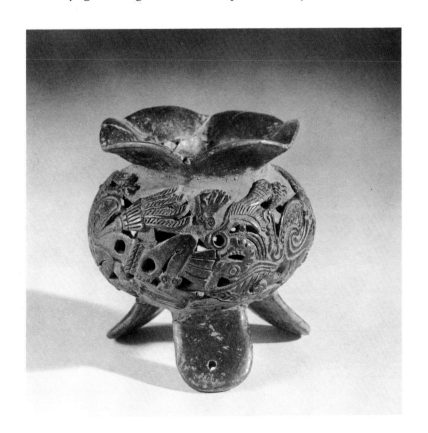

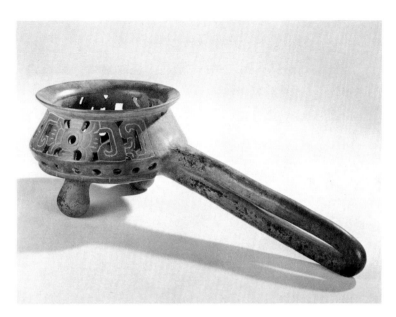

168. Openwork Ladle Censer

*Mexico, Central Highlands (Valley of Mexico), Mixtec culture.
Postclassic,* A.D. *1200–1400*
Orange-brown earthenware with red paint
Gift, 228:1978; H. 10 cm., L. 32 cm.

Long-handled, ladle-type incense burners are diagnostic of the Mixtec horizon wherever that influence was felt in Mesoamerica. This example has a looped handle and two supports containing rattles under the bowl. Its openwork perforations accent flower and scroll motifs, with the Mexican "A-O" year symbol on the side opposite the handle. These motifs are carefully scored with incisions. The red paint is applied to the end of the handle and on the sides and rim of the incense bowl.

169. Ladle Censer With Long Handle

Mexico, Central Highlands, Mixtec culture. Postclassic, A.D.
1200–1500
Whitewashed buff earthenware with specular-hematite red paint
Gift, 257:1978; L. 70 cm., Diam. 23 cm.

As mentioned, these ladle censers are characteristic of the Mixtec period in Mexico and continuing into Aztec times. Although the photo views the decorated bottom of the bowl-like incense container, the top of it, of course, is open. The bowl has triangular perforations, four spiked projections on the rim, as well as ridged and nubbined zones which indicate that it was pressed in a mold. The inner circle on the bottom bears the dark red paint. The long hollow handle has five tiny holes (for firing vents), and the end terminates in a flat serpent head, facing up. Next to it is an applied, moldmade plumed ornament.

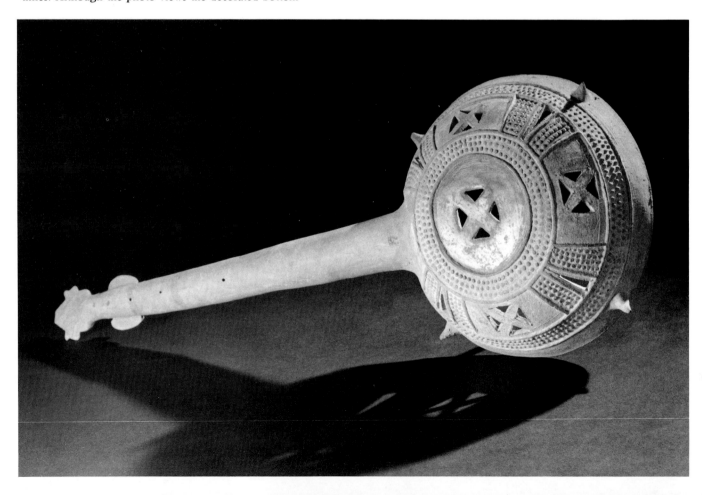

170. Plaque-Pendant

Mexico, Oaxaca (Monte Alban V), Mixtec culture. Postclassic, ca. A.D. *1200*
Light green jadeite
Gift, 290:1978; H. 11.5 cm., W. 5 cm.

A flat pendant, grooved to depict a full standing human figure in a rather rigid early Mixtec style, although this one resembles Zapotec Monte Alban IV examples [cf. 237, 238]. Perforations are found at the rear corners of the ear spools. The back side shows the central vertical ridge, left by string-sawing off the jade matrix.

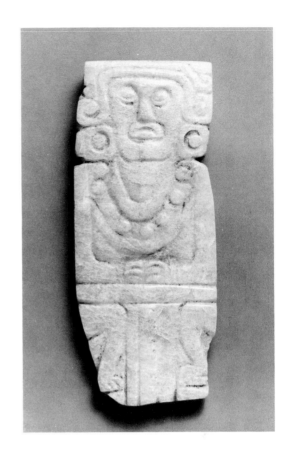

171. Human Effigy Pendant

Mexico, Southern Highlands (location unknown), Mixtec culture. Postclassic, A.D. *1200–1400*
Light green jadeite
Gift, 225:1979; H. 5 cm., W. 4.5 cm.

The front of this small flat pendant is grooved to represent a grimacing human image in typical Mixtec style. Note, for example, the reed-drilled eyes, earplugs, and headdress bead. The back is polished perfectly smooth. Suspension holes are found on the sides at shoulder level.

172. Seated Cross-Armed Pendant (Lower right)

Mexico, Oaxaca (Monte Alban V), Mixtec culture. Postclassic, A.D. *1200–1400*
White marble
Gift of J. Lionberger Davis, 175:1950; H. 14 cm.

Abstract, blocky, stone figurines functioning as pendants are prevalent in the Southern Mexican Highlands during the Mixtec period. Even more common than these larger figures are the miniature stone amulets. The flat back of this object has a pair of drilled suspension holes. Features of the figure are either string-sawed in straight lines or drilled in circular lines by hollow tubes. The headdress depicts a double-headed serpent.

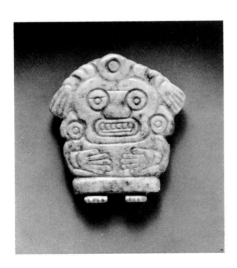

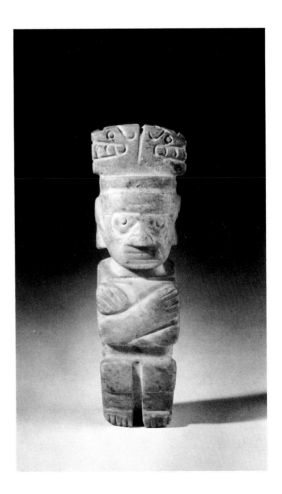

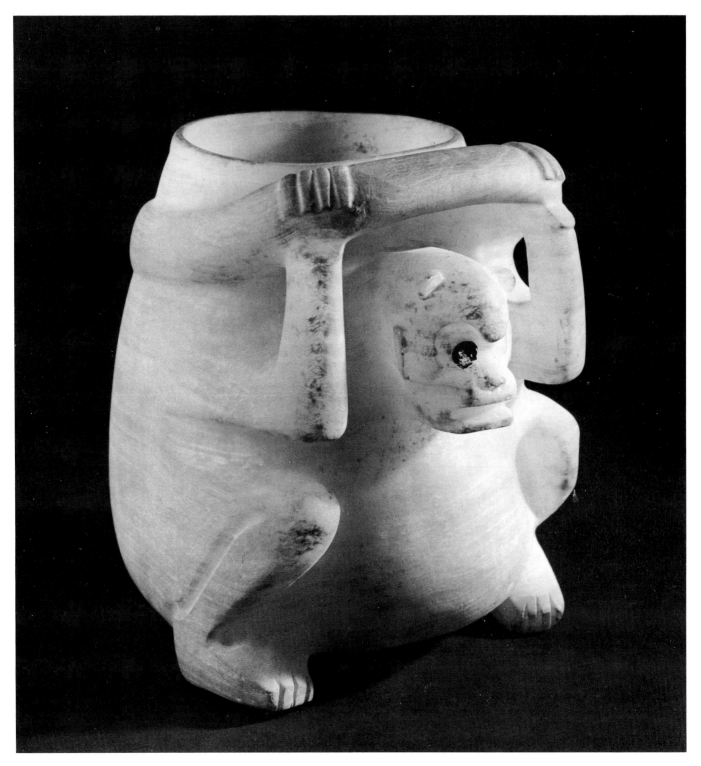

173. Spider Monkey Vase

Mexican Highlands (Oaxaca?), Mixtec culture. Postclassic,
A.D. *1200–1500*
Banded greenish-white marble, or onyx (tecalli) *(See color plate)*
Gift, 219:1978; H. 20 cm., Diam. 19.5 cm. (Ex-coll. Museum of Primitive Art, New York)

An expertly carved effigy vase, of the sort identified with Mixtec craftsmanship. Other very similar effigy marble vases are known; this one purportedly was found in Oax-aca. The cylindrical interiors were laboriously hollowed out with tubular drills, and then polished smooth. The exterior has a low-relief tail, and high-relief arms, legs, and head. The arms of the monkey are separated from the vase to hold above the head what, in fact, is his own long tail. (It continues in low relief around the monkey's left side, where the tip curls. From the front, however, the tail appears to be a tumpline.) One drilled eye retains black resin, indicating former inlays. Parts of the stone vessel are red-stained.

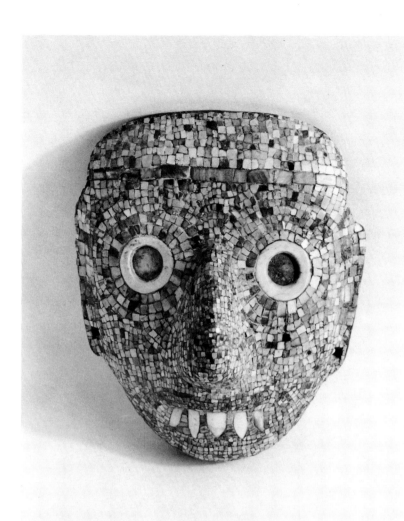

174. Mosaic Stone Mask of Tlaloc

Mexican Highlands (Puebla or Oaxaca), Mixtec culture. Post-classic, A.D. *1200–1500*
Stone with turquoise, shell, and coral inlay (See color plate)
Gift, 96:1968; H. 14 cm., W. 11.5 cm., D. 6.2 cm.

Stone funerary masks have a long tradition in Mexico [cf. 149–151], but few have survived completely inlaid on the surface with intricate mosaic work. The back of this large-nosed mask is slightly hollowed, and drilled suspension holes may be found at the bottom and top of the flangelike ears. Most of the front is inlaid, in concentric rows, with tiny facets of light green turquoise. There is a headband consisting of bits of orange coral and square zones on the ears of the same material. The eyes are ringed with white shell (with turquoise insets) and shell also forms the five pointed teeth. The visage of Tlaloc is subtly completed by means of a scroll-cornered upper lip created by inlaid dark green turquoise. (There may have been a small amount of expert restoration on the mosaic; but the inlays are more than 90 percent original.)

175. Shell Pectoral

West Mexico, Lake Chapala, Mixtec culture. Postclassic, A.D. *1200–1500*
Shell, travertine, and slate
Purchase, 86:1953; Diam. 10.7 cm.

A late period breast medallion from the Tarascan area of West Mexico. The design and manufacture is quite unusual. White triangles, and greenish-black "Tau"- and ax-shaped designs, were first sawed out of the matrix of the concave shell. Pieces of travertine were inserted in the triangular zones, while pieces of slate were fit into the inner zone. The polished central circle is incised with a Tlaloc mouth motif, which has an adjacent perforation for suspension. There are traces of red pigment in the outer dots and other interstices. (One of the cut-out frets on the perimeter is broken.)

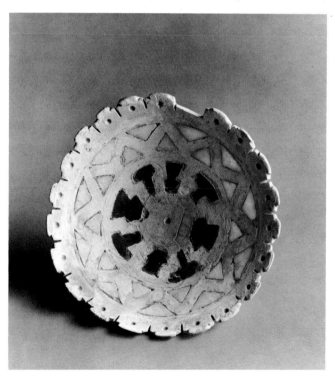

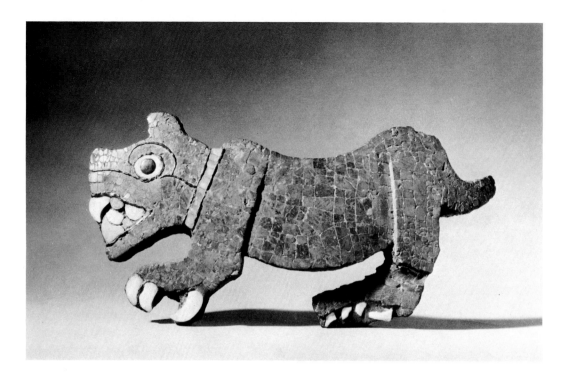

176. Mosaic Jaguar Pectoral

Mexico, Central Highlands (Puebla), Mixtec culture. Postclassic, A.D. *1200–1500*
Stone and shell inlays on wood (See color plate)
Gift, 163:1979; L. 16.5 cm.

Rare, perishable, wooden objects such as this are sometimes preserved in dry caves in the highlands. The naturalistic feline effigy is convex on the surface and has two suspension holes drilled diagonally on the upper edge. The tightly fit mosaic inlays are remarkably intact. (The broken rear leg may have been repaired in Pre-Columbian times.) The entire body is faceted with tiny pieces of green turquoise; the eye is of black jet, the collar and tongue of orange coral; while the eye ring, the fanged teeth, and claws are of white shell.

177. Copper Tweezers (Lower left)

West Mexico, Tarascan region (Michoacan), Mixtec culture.
Postclassic, A.D. *1200–1500*
Corroded green copper
Gift of Gail and Milton Fischmann, 232:1972; H. 7 cm.

Bells, ax-shaped knives, and other ornaments of copper became very prevalent in the Postclassic period of Mexico, beginning with the Toltec horizon. Tweezers—presumably for removing facial hair—were not as common here as they were in the Central Andes, however. This article was cut from one piece of sheet copper and folded over at the top. The working, crescent-shaped ends were hammered convex. Embellishments in the form of cut spirals decorate the sides of this functional cosmetic instrument.

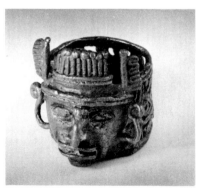

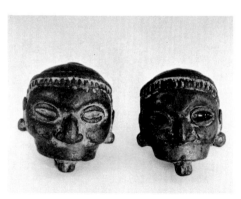

178. Filigreed Ring (Facing page)

Mexico (location unknown), Mixtec culture. Postclassic, A.D. 1200–1500
Cast copper
Gift, 223:1979; H. 1.6 cm., Diam. 2.9 cm.

Metallurgy in copper was popular in Mixtec times, though that culture excelled in gold work [cf. 180]. This finger ring was cast by the lost-wax method in the form of a human face and an openwork band with three eagle panels.

179. Pair of Miniature Masks (Facing page)

West Mexico, Tarascan region, Mixtec (or Aztec) culture. Post-classic, A.D. 1200–1500
Cast copper
Gift, 276:1978.1 and .2; H. 3 cm., W. 2.3 cm.

Hollow, open-backed copper maskettes, cast by the lost-wax technique. Added to the backs are crossed straps of copper, suggesting that these were meant to be sewn to a costume (and probably from a larger series yet to be located). The masks are jawless and deathlike, with projecting front teeth.

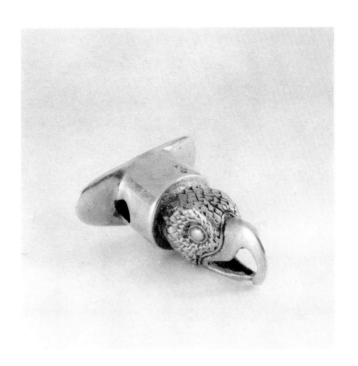

180. Labret With Eagle

Mexican Highlands (Puebla or Oaxaca), Mixtec culture. Post-classic, A.D. 1200–1500
Cast gold (See color plate)
Gift, 275:1978; L. 3.8 cm., W. 2.9 cm. (Illustrated: Wardwell, 1968, item 127)

The Mixtecs, and the Aztecs after them, were skilled goldsmiths. The art of gold working did not reach Mesoamerica from Central America until late in the Classic period, and the earliest gold ornaments are found in Yucatan and Guatemala. Gold did not become at all prevalent, however, until the Toltec and Mixtec periods. Jade was always more highly valued in ancient Mesoamerica than gold, to the disappointment of the conquistadores. (This is the only example of Mesoamerican gold in the collection.)

Labrets are ornamental plugs that fit into a slit in the lower lip. Note the expanded flange, which holds it in place behind the lip so the eagle would project on the outside. (See the next illustration for lip plugs of other materials.) This example was cast in high carat gold by the lost-wax method. The eagle's head shows extremely detailed feather markings. The object is hollow, with openings through the beak, under the head, and on either side of the cylindrical projection. (The left hole is plugged with gold as a result of breaking it from the mold when it was poured.)

181. Four Lip Plugs (Labrets)

Mexican Highlands (provenance unknown), Mixtec culture. Postclassic, A.D. 1200–1500
Obsidian, turquoise, and red chert
Gifts (left to right): 141, 139, 140, and 138:1980; 1976. 162, 159, 161, and 1957; L. 2.7, 3.2, 4.2, and 4.1 cm.

These delicate ornaments were used like the previous object. Drilled and ground from fine-grained stone and volcanic glass, they are marvels of Pre-Columbian lapidary technology—the finest examples appearing to us as though they were "machined." The labret on the far left is made of red chert, and the other three are of thinly ground obsidian. The one at the top, in addition, has inlaid turquoise in the projecting tubular disc.

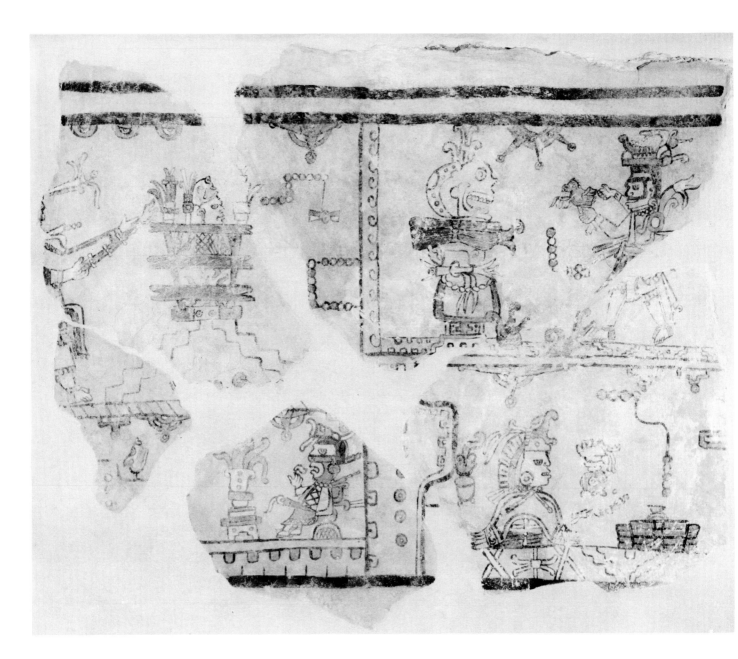

182. Frescoed Mural Fragment

Mexico, Oaxaca-Veracruz border region (?), Mixtec culture.
Postclassic, A.D. *1200–1400*
Polychrome paint on lime plaster (See color plate)
Gift, 94:1968; Assembled perimeter, 95 × 120 cm.

Five sections of a much larger wall painting remounted in their original order. The top edge is outcurving, revealing the edge of the ceiling of the room from which it came. The plaster is about 4 centimeters thick, with a coating of white lime. The polychrome fresco painting is executed on a powdery light blue background, with double black bands framing the top and a single band on the bottom of this register of the assumed room. Black-outlined components of the scene are painted in two shades of red and a deteriorated greenish-yellow. The narrative pictorial subject matter is identical to contemporary Mixtec manuscript paintings, such as the Vienna and Nuttall codices. But whereas the latter have been amply interpreted, the incomplete nature of this mural fragment prevents thorough analysis. Some of the obvious Mixtec elements include star motifs dependent from upper borders, strings of numerical dots associated with personages (identifying their birth days, such as "12-*Olin*," or "motion," in the upper left), and a possible city or place glyph (in front of the seated figure, lower right).

Featured in the upper left panel is a captive, sacrificial victim, or even an élite person, being burned or cremated in a rack. The upper right panel shows a standing death figure or deity confronting a person holding a bird. In the lower left we see a seated individual in front of a flaming altar, and there is a parallel scene in the lower right. The whole extant composition seems to refer to funerary ceremonies.

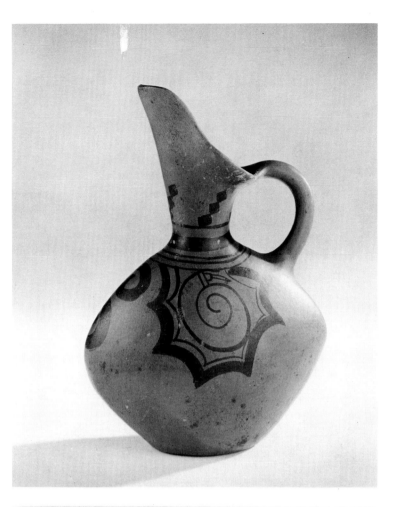

183. Pitcher

Mexico, Central Highlands, Aztec culture. Late Postclassic,
A.D. *1400–1521*
Polished red earthenware with black paint (See color plate)
Gift, 135:1979; H. 20 cm.

Although the deep red and black paint, as well as the pitcher form, relate this to the Mixtec ceramic tradition [cf. 160, 161], this particular type of handled, spouted vessel is diagnostically Aztec. Cross-section shell motifs are painted on either side, with an S-spiral on the front. The pitcher is oblong, being flattened from side to side.

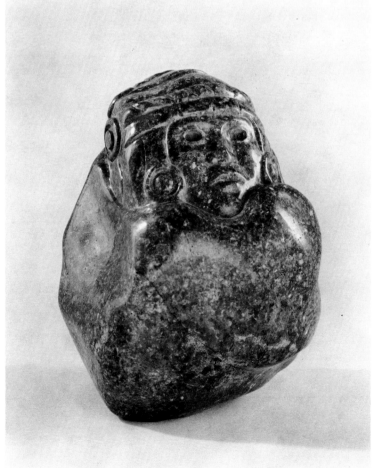

184. Jade Sculpture With Double Image

Mexico, Central Highlands, Aztec culture. Late Postclassic,
A.D. *1400–1521*
Polished, mottled, dark green jadeite
Gift, 394:1978; H. 16 cm., Diam. 13 cm.

An unusual sculpture, utilizing the maximum colored surface of a large nodule of jadeite. While the head is carved, most of the sculpture retains the highly polished natural contours of the green stone, giving the effect of a figure huddled in its mantle. The face has drilled eye sockets and circular earplugs, whereas the back of the head is carved with a notched band, circle medallions, and a trapezoidal tassel. When the object is turned sideways, however, this headdress, coupled with the amorphous body, connote a frog. The decorative medallions then become eyes and the headband a broad mouth.

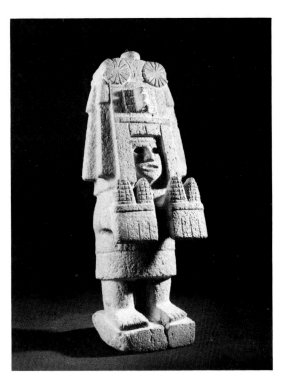

185. Sculpture of the Corn Goddess, Chicomecoatl
Mexico, northern Gulf Coast, Aztec style. Late Postclassic, A.D. *1400–1521*
Gray-buff sandstone with traces of red pigment
Gift, 291:1978; H. 37 cm.

This relatively stiff, rigid style is characteristic of much of the late period, highland-originating Aztec stone sculpture, although this object comes from the Huastec region. Other Aztec sculptures are starkly realistic. This idol is carved integrally with a square, flat base and holds out two pairs of tasseled corn cobs. (The corn goddess is one of the more common themes for portable Aztec sculpture.) Her vertically tiered headdress has two scored medallions on the front and back, and a short cylindrical projection on top.

186. Seated Old Man Sculpture
Mexico, northern Gulf Coast, Aztec style. Late Postclassic, A.D. *1400–1521*
Consolidated buff-colored sandstone
Gift of Ben Heller, 153:1965; H. 76 cm.

A blocky carving of a wrinkled old man, perhaps representing the fire god. He is seated on his haunches, with his arms folded across his knees. In the mid-torso are two conical depressions, with a knotted bow tassel below. A tied belt is shown on the flattened back. While this sculpture probably came from the Huastec region [cf. 283, 284], the style more closely resembles highland Mixtec or Aztec. On the other hand, it has been suggested that the Aztecs themselves borrowed aspects of their sculptural style from the Gulf Coast.

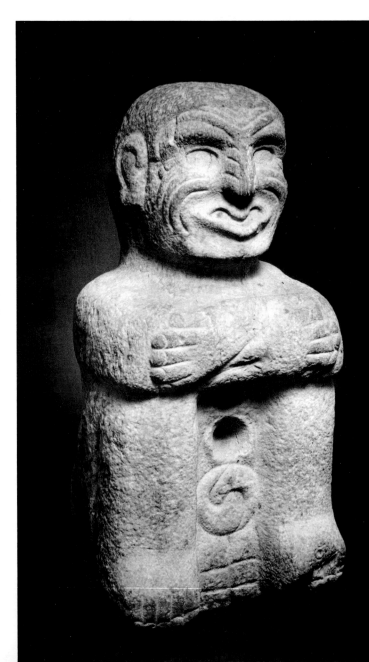

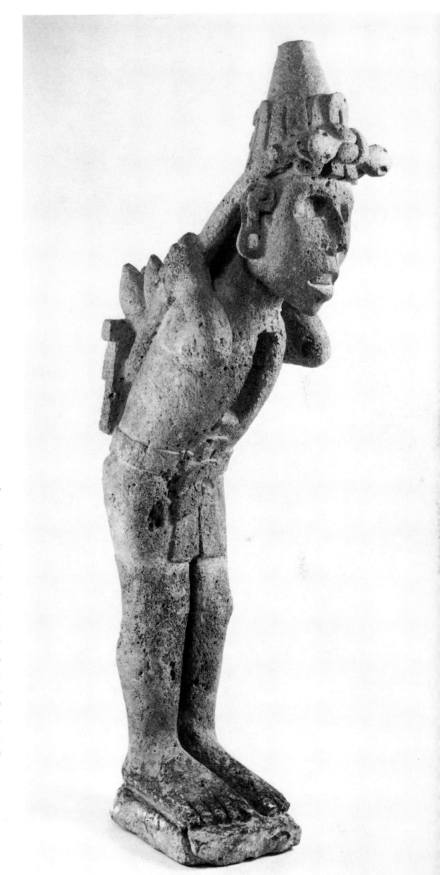

187. Merchant or Slave

Mexico, Central Highlands, Aztec culture. Late Postclassic,
A.D. *1400–1521*
Dark gray basalt with traces of polychrome paint (See color plate)
Gift, 304:1978; H. 75 cm.

An Aztec stone sculpture of a merchant or slave, bent under a load of corn or cactus fruit carried in a frame on his back. The figure's bent arms grip a tumpline that is tied as a double forked-tongued serpent across the forehead. The sculpture has distended, perforated earlobes, and is undercut, or slit, between the bends of the arms, under the tumpline, and between the legs. He wears the Aztec conical cap surrounded by tight loops ending in a divided tassel behind. The waist is girdled by a loincloth with a large tied knot in front. A rectangular depression in the chest may once have held an inlay of jade or obsidian, symbolic of the heart. The stark, staring, semi-realistic features of the face are typically Aztec [cf. 188]. Traces of red, yellow, and blue pigment adhere to the surface of the stone.

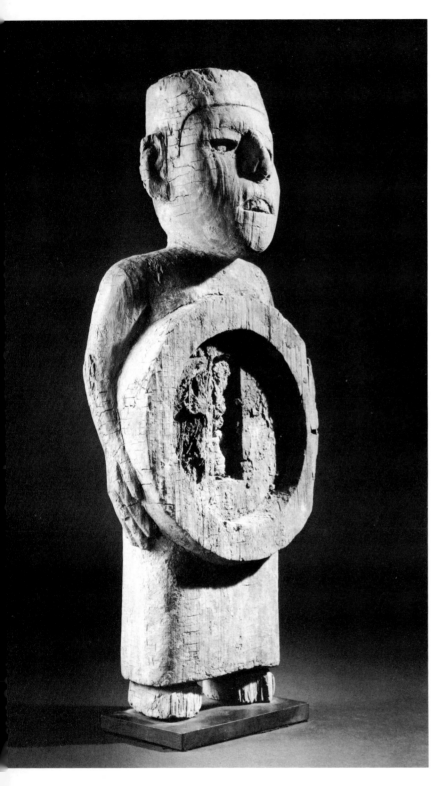

188. Standing Female Idol

Mexico, Central Highlands (Lake Texcoco), Aztec culture. Late Postclassic, ca. A.D. *1400*
Wood with encrustations and traces of paint
Gift, 381:1978; H. 53 cm. (Published: Nicholson and Berger, 1968)

Pre-Columbian wood sculpture seldom survives, due to the poor conditions of preservation in Mesoamerica, so this piece is a rare example. (It, and another like it, have been thoroughly discussed and analyzed by Nicholson and Berger.) The standing, skirted woman holds a large medallion over her midriff. The rimmed disc has a cavity and oblong slot with chunks of adhering resin. Obviously this originally held some kind of inlay—perhaps a pyrite or obsidian mirror, or possibly a mosaic of stone and shell. Similarly, the eyes and mouth probably had been inlaid. Patches of blue and black pigment, especially on the skirt and headdress, indicate that the sculpture also was painted. The sharply delineated headdress retains three blue bands, with traces of five painted circles on the front and a bow knot on the back. There are suggestions of black patches on the cheeks. From the iconography, Nicholson identifies this image as Chalchiuhtlicue ("possessor of precious jade skirt"). She was an important Aztec goddess of water, and of life-promoting moisture and fertility. A small sample of wood from this idol was submitted for radiocarbon age determination, which yielded the reasonable result of A.D. 1375± 60 years.

Southern Mexican Highlands (Zapotec Culture)

◇

Our last region of Highland Mexico encompassed, in Pre-Columbian times, the territory that is now the state of Oaxaca. Its cultural history is largely the history of the Zapotecs, who built their home site at Monte Alban in the central Valley of Oaxaca. The Zapotecs progressed continuously for fifteen centuries, from 500 B.C. to A.D. 1000 ("Monte Alban I through IV"), remaining relatively independent of surrounding cultures, though some interchanges with Teotihuacan may be perceived in the middle of that sequence. Middle Preclassic Olmec presence recently has been discovered in Oaxaca, but the great hilltop ceremonial center of Monte Alban was founded in post-Olmec times, at the beginning of the Late Preclassic era (the Monte Alban I phase is now dated from about 500 to 200 B.C.). Monte Alban IIIA and IIIB correspond to Classic Zapotec culture (A.D. 300–900). The prolific gray-paste "funerary urn" complex, depicting the many Zapotec deities, and found in subterranean stone tombs at Monte Alban and elsewhere, is the best known component of the regional Zapotec art style, though the ceramic urn tradition began in the very first phase. While most of these figure urns are modeled around cylindrical containers, they did not contain bones or ashes; instead, they probably were filled with food and drink as offerings to the dead.

In the tenth century A.D. the Zapotecs shifted southward to the site of Mitla, and in the thirteenth century ("Monte Alban V" phase) the Mixtecs infiltrated from northern Oaxaca, leaving their mark in stone-mosaic architecture, polychrome murals, and fabulous tomb offerings, such as the famous gold-filled "Tomb 7" at Monte Alban. (Postclassic Mixtec art has been treated separately in the Central Highland section.) One object [189] represents a newly defined middle period culture from northern Oaxaca called Ñuiñe.

The Monte Alban I phase [objects 190–196] has been incorrectly labeled Olmec by some, but the term "Olmecoid" is more appropriate. Its many so-called *danzante* low-relief wall panels have dynamic figures of captives with puffy features that may be derived from the earlier Olmec style, but

are a discrete post-Olmec style in themselves. From 500 to 200 B.C. at Monte Alban we also find examples of some of the earliest known bar-and-dot calendrical notations, as well as hieroglyphic writing in a proto-Zapotec system. These accompany the *danzante* stone panels on a primary Monte Alban architectural platform. The funerary ceramics from this first phase also demonstrate Olmecoid features, such as the braziers [190] with fat-lipped faces derived from the Olmec were-jaguar image but here comprising an early version of the Zapotec rain god, Cocijo. Other Monte Alban I urns and bottles also show prototypes for later Zapotec deities or relate to widespread post-Olmec stone carvings [192–195].

The Monte Alban II phase (200 B.C.–A.D. 200) [objects 197–206] is equivalent to the Terminal Preclassic stage in Mesoamerica. One Zapotec bridged-spout bottle [206] shows specific Izapan iconography borrowed from the Pacific Coast of Chiapas. The angular observatory structure at the Monte Alban site, with its low-relief stone panels, and the site of Dainzu to the south, with its ball player stone panels, both equate to the Izapan horizon. The same also applies to a unique carved shell in the collection [236]. Funerary urns from this phase and other effigy pottery [197–205] are particularly expressive; note the double-chambered whistling vessel [205].

A transition phase designated Monte Alban II–III (A.D. 200–300) [objects 207–211] shows the presence of most of the evolved Zapotec deities in its lively, realistic funerary urns. Unusual in this collection are two sets of five matched urns from the same tomb [210 and 211].

Monte Alban IIIA, then, is the full Early Classic Zapotec cultural phase, A.D. 300–600 [212–223]. We encounter such stylized deities, modeled in clay, as Pitao Cozobi (the maize goddess), Cocijo (the rain god), and the "God with the Mask of the Serpent," as well as more naturalistic human effigy urns often called companions. (The names given to most Zapotec deities perceived in the iconography are arbitrary descriptive terms, rather than names extrapolated back from proto-historic times.) Monte Alban IIIB and IV (A.D. 600–900 or 1000) [224–235] covers the final Late Classic phase of Zapotec development in a continuous evolution of the funerary urn tradition.

We also illustrate a few nonceramic Zapotec artifacts in addition to the carved shell [236]: two miniature stone carvings [237 and 238], a carved stone tomb ornament [239], and two sculptural tile friezes that decorated the cornices of architectural platforms [240].

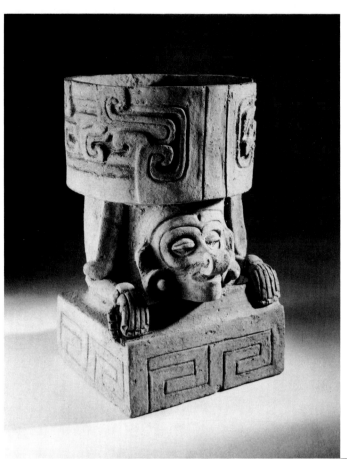

189. Effigy Brazier
Mexico, northern Oaxaca, Ñuiñe culture. Middle Classic, A.D.
500–700
*Gray-orange earthenware with red, yellow, and blue-green
paint (See color plate)*
Gift, 134:1980; H. 23.5 cm., Diam. 15.5 cm.

An important example of the recently defined Ñuiñe
culture of northern Oaxaca, which is a quite distinct local
style only vaguely related to the Zapotec farther south.
The object features a seated old man effigy, with "gog-
gled" eyes, a scrolled upper lip, and a basin on his head.
In Central Mexican iconography, this would be the old
fire god (see the incense burner from Teotihuacan, 152).
The square base is open below, with the figure applied
to a cylinder over the platform, and with an open-bot-
tomed incense bowl over his head. Three sides of the
square base bear incised stepped frets, while the walls of
the basin have deeply carved, interlocking scroll panels.
The style of the latter seems to have been derived from
the Classic Veracruz tradition on the adjacent Gulf Coast
[cf. 271]. An unusual amount of preserved red, yellow,
and blue pigment is distributed over the well-defined
zones of decoration.

190. Brazier in Form of Human Head
*Mexico, Oaxaca, Zapotec culture (Monte Alban I). Late Pre-
classic, 500–200* B.C.
Buff earthenware with traces of whitewash
Gift, 178:1979; H. 27 cm., Diam. 19.5 cm.

A cylindrical incense burner from the first phase of the
Zapotec culture at Monte Alban. The broad relief on the
front has Olmecoid, "baby face" features, with an accen-
tuated, inverted U-shaped upper lip, and narrow per-
forated eyes. In the center of the headband is a trefoil
emblem, which is a prototype for later Zapotec glyphs.
Like 193, this image prognosticates the iconography of
the Zapotec rain god. The top basin is floored 6 centime-
ters below the rim, while the bottom of the cylinder is
open.

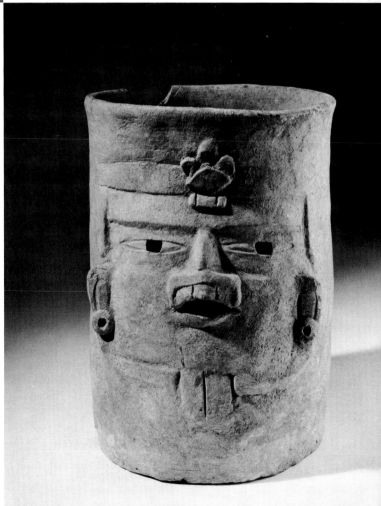

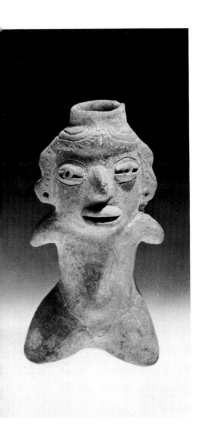
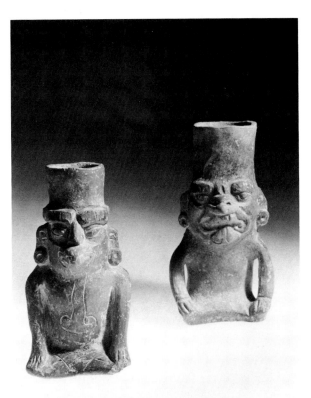
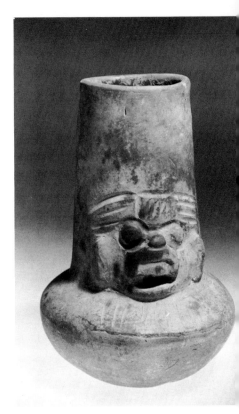

191. Figurine Vessel

Mexico, Oaxaca, Zapotec culture (Monte Alban I). Late Preclassic, 500–200 B.C.
Gray earthenware
Gift, 301:1978; H. 12.5 cm.

A seated human effigy with vessel spout at the top. The slit "coffee bean" eyes with central-punched pupils relate this sculpture to innumerable other Late Preclassic figurines, both solid and hollow, in Mesoamerica [cf., e.g., 62], and assure that this belongs to the earliest phase of Monte Alban. The vessel form also may be considered a prototype of the Zapotec urn tradition. The headdress is scored and incised, and the earlobes are perforated. Encrustations of lime adhere to the surface.

192. Two Miniature Effigy Urns

Mexico, Oaxaca, Zapotec culture (Monte Alban I). Late Preclassic, 500–200 B.C.
Gray earthenware
Gifts, 300 and 298:1978; H. 12 and 12.5 cm.

Both of these are full-round effigy urns of basically cylindrical form (note the openings on top), representing early versions of seated Zapotec deities. The one on the left is the "goddess with the projecting mask of the serpent." (And note the incised forked tongue on the torso.) That on the right depicts the Zapotec rain god Cocijo, with his feline mouth and forked tongue.

193. Bottle With Mask of Cocijo

Mexico, Oaxaca, Zapotec culture (Monte Alban I). Late Preclassic, 500–200 B.C.
Gray earthenware
Gift, 296:1978; H. 16.5 cm.

Simple, tubular-necked bottle forms are common to the Preclassic horizon in Mesoamerica [e.g., 20]. This early period Monte Alban example has modeled on one side a generalized, proto-Cocijo, rain god mask. Note the inverted, U-shaped upper lip, which is a diagnostic feature of this fundamental deity [cf. 217]. There is an incised collar or bib on the vessel below the mask. The derivation of Cocijo may be traced back to the features of the Olmec were-jaguar [52].

194. Fat Human Effigy Jar (Lower left)

Mexico, Oaxaca, Zapotec culture (Monte Alban I). Late Pre-classic, 500–200 B.C.
Gray earthenware
Gift, 297:1978; H. 13.3 cm.

A jar modeled as a fat human figure. The way the arms are placed over the belly, and the legs wrapped around the base, reminds one of the contemporary "potbelly" stone monuments on the Pacific Coast of Guatemala (Parsons and Jenson, 1965), as well as an Olmecoid style of stone figurine [cf. 56–59].

195. Face-Neck Jar (Lower right)

Mexico, Oaxaca, Zapotec culture (Monte Alban I). Late Pre-classic, 500–200 B.C.
Gray earthenware
Gift, 118:1980; H. 12 cm., Diam. 12 cm.

This little composite silhouette jar has a squat face on the neck. The ears, nose, and mouth are in relief, while the C-shaped eyes (or tear bands) are incised. Suggestions of arms are stick-burnished on the globular body.

196. Duck Bowl

Mexico, Oaxaca, Zapotec culture (Monte Alban I). Late Pre-classic, 500–200 B.C.
Dark gray earthenware
Gift, 119:1980; H. 5.5 cm., L. 11.5 cm.

Miniature bowl contained by a naturalistic duck effigy. The tail is fashioned as a pouring spout, and punctated flanges on the sides represent the wings. Fine-incised lines follow the rim. Comparable duck bowls are not uncommon in the earlier Preclassic inventory of Tlatilco [cf. 12]—perhaps the inspiration for this early Monte Alban example.

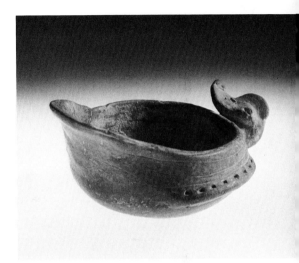

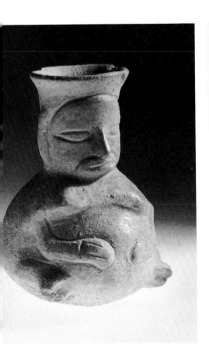

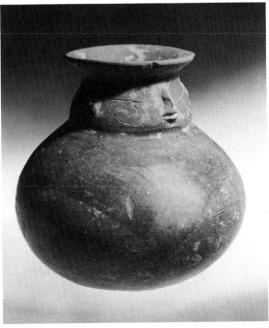

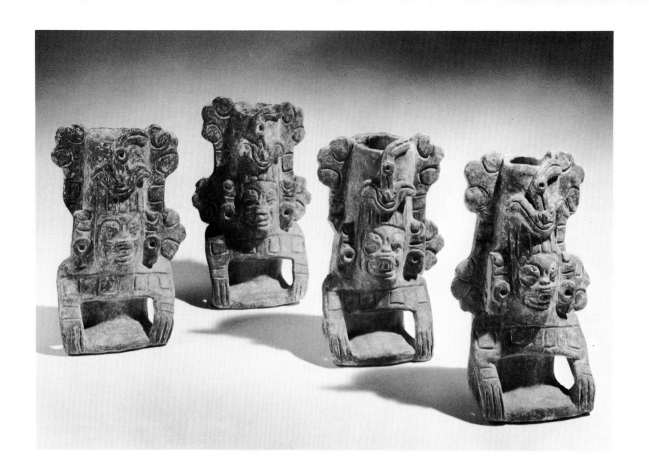

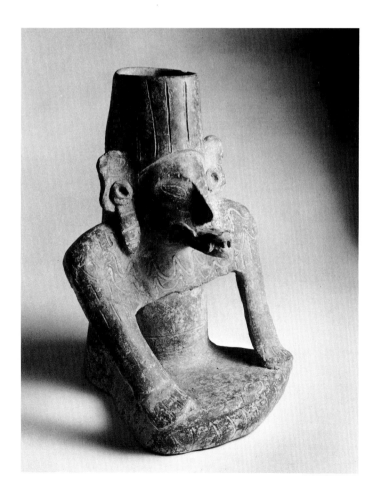

197. Set of Four Small Urns
Mexico, Oaxaca, Zapotec culture (Monte Alban II). Terminal Preclassic, 200 B.C.–A.D. 200
Gray earthenware with red paint
Gifts, 293, 294, 295, and 504:1978; H. 22.5, 23.5, 24, and 23 cm.

Although less than handsome, this is a matched set of hand-modeled urns made for the same tomb. The effigies portray the rain god Cocijo. Deep grooves defining the features are filled with red pigment. As with most of these urns, the figures are attached to cylindrical containers. Two of the urns are missing their right side flanges. (See 210 and 211 for other urns in matched sets.)

198. Urn With Mask of the Serpent
Mexico, Oaxaca, Zapotec culture (Monte Alban II). Terminal Preclassic, 200 B.C.–A.D. 200
Gray earthenware with remains of red pigment
Gift, 177:1979; H. 33 cm.

A rather crudely modeled effigy urn of Monte Alban's second epoch. The flat-bottomed container tapers to the opening at the top of the headdress. The broad shoulders are bolstered by tubes behind, while the arms are convex straps of clay. The skirted lap is open underneath. Details of decoration on this serpent mouth-masked deity are executed with grooves filled with red.

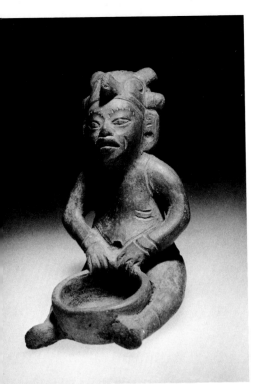

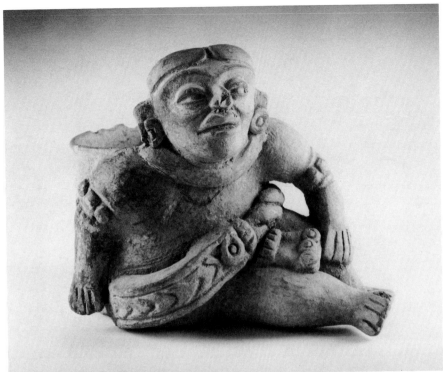

199. Hollow Seated Figure With Bowl
Mexico, Oaxaca, Zapotec culture (Monte Alban II). Terminal Preclassic, 200 B.C.–A.D. 200
Gray earthenware with traces of red cinnabar
Gift, 136:1979; H. 12.5 cm.

An expertly modeled miniature ceramic sculpture. Note the expressive face and the incised details, such as stomach and cheek wrinkles. He wears a birdlike helmet and holds a bowl between his legs. There are vent holes in the bottom and head.

200. Ball Player Vase
Mexico, Oaxaca, Zapotec culture (Monte Alban II). Terminal Preclassic, 200 B.C.–A.D. 200
Gray earthenware
Gift, 171:1979; H. 12.5 cm., Vase diam. 9.5 cm.

A modeled figure applied to a small cylindrical vase. The head and arms are solid, while the extended legs are hollow. The distinctive feature of accouterment is the U-shaped waist yoke tied on with a cord, demonstrating that this is a ball player (see 266–269 for ceremonial stone yokes). This is a relatively early representation of the ball player's yoke in Mesoamerican art (but see 65). It should be noted that the contemporary carved stone panels at the site of Dainzu in the Valley of Oaxaca also depict ball players. At least one other very similar Zapotec effigy vase is illustrated in the literature.

201. Bat Effigy Bowl
Mexico, Oaxaca, Zapotec culture (Monte Alban II). Terminal Preclassic, 200 B.C.–A.D. 200
Gray earthenware
Gift, 251:1978; H. 16 cm., L. 30.5 cm.

A bent-rimmed effigy bowl of fine-paste clay. The fanged bat head modeled on the rim is an integral part of the bowl, and is open in back. Note the appliquéd bat's claws and the incised markings in the round ears. This vessel apparently has been extensively restored.

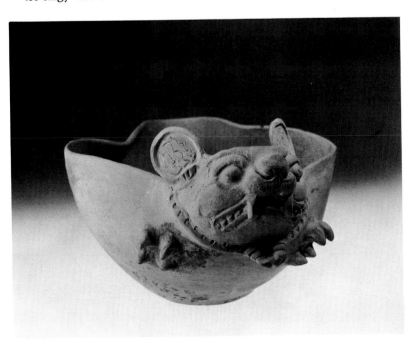

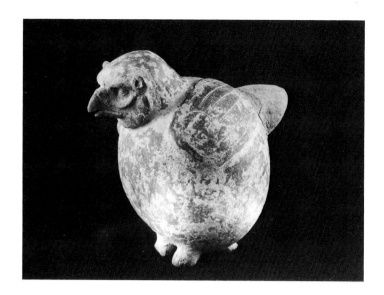

202. Hollow Owl Effigy
Mexico, Oaxaca, Zapotec culture (Monte Alban II). Terminal Preclassic, 200 B.C.–A.D. 200
Gray earthenware
Gift, 117:1980; H. 11.5 cm.

Globular vessel with vent hole underneath the appliquéd tail feathers. It has a modeled owl head, tripod supports, and low-relief wings with incised scroll-wing markings.

203. Bridged-Spout Owl Effigy Jar
Mexico, Oaxaca, Zapotec culture (Monte Alban II). Terminal Preclassic, 200 B.C.–A.D. 200
Polished black earthenware
Gift, 130:1980; H. 19 cm.

A compound lobed jar with lateral vertical spout (the tip of the spout is missing). As is typical of this form and time period, the tall spout is attached to the neck of the jar by a flat bridge. The neck is modeled as an owl's head, with the suggestion of arms and legs on the body. Details are added by means of grooved lines.

204. Bridged-Spout Effigy Jar
Mexico, Oaxaca, Zapotec culture (Monte Alban II). Terminal Preclassic, 200 B.C.–A.D. 200
Gray earthenware
Gift, 299:1978; H. 16 cm., Diam. 15 cm.

The relief arms and legs of this fat effigy figure are pressed out from inside the vessel and outlined with grooves. The hollow human head is applied to the rim.

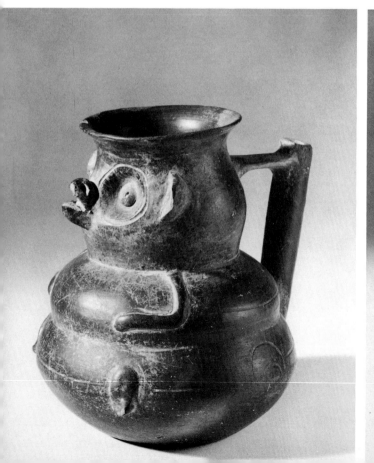

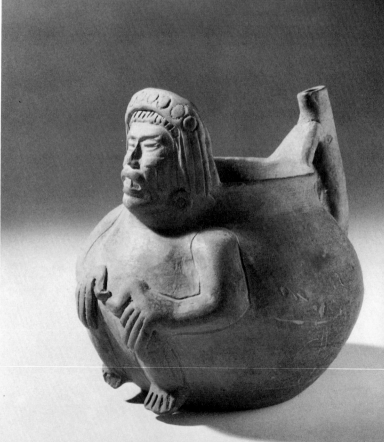

205. Double-Chambered Whistling Jar With Bridged Spout

Mexico, Oaxaca, Zapotec culture (Monte Alban II). Terminal Preclassic, 200 B.C.–A.D. 200
Gray earthenware with traces of red paint
Gift, 129:1980; H. 21 cm., L. 27 cm.

An exceptionally fine and complex effigy jar. The rear open-mouthed chamber has the vertical bridged spout and is connected to the front anthropomorphic chamber by a passage at the bottom and a flat strap at the top. At the juncture of the strap and the effigy head is a whistle opening, through which air can be forced out when liquid in the vessel is tipped forward. The modeled and incised human figure on the front has a crested bird's head. The posture of the body is curiously asymmetrical, and red pigment adheres to the eyes and mouth. Double-chambered whistling vessels are common on the North Coast of Peru during the same time period (but are rare in Mesoamerica). Therefore, they may represent another example of Pre-Columbian contact with South America.

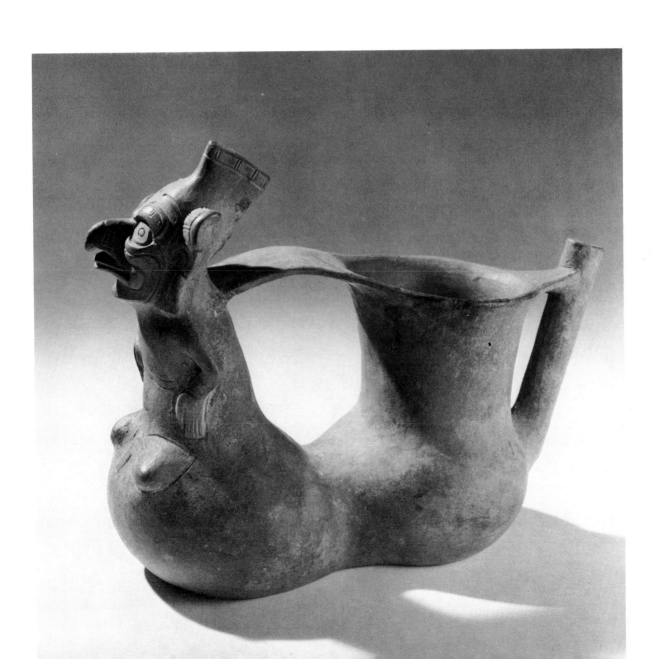

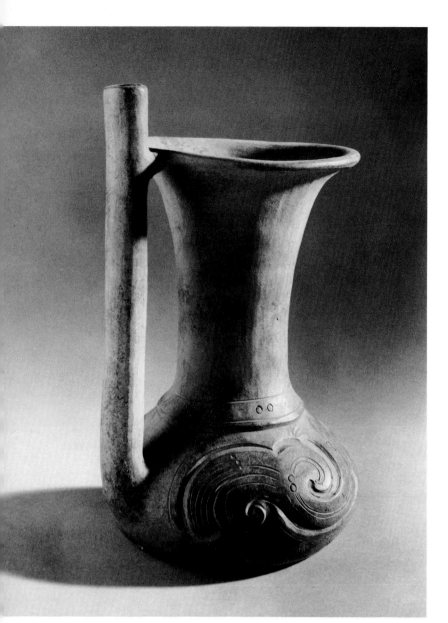

206. Bridged-Spout Vase

Mexico, Oaxaca, Zapotec culture (Monte Alban II). Terminal Preclassic, 200 B.C.–A.D. *200*
Gray earthenware with residue of red pigment
Gift, 134:1979; H. 25.5 cm., Rim diam. 13.5 cm.

Although the bridge-spouted, tall-necked, vase form is diagnostic of the Monte Alban II period, this graceful example is unique for its carved design around the sub-globular base (see rollout drawing). The scrolled motifs, with the profile "dragon" head, demonstrate inspiration from the contemporary Izapa style on the Pacific Coast of Chiapas, near the Guatemalan border. The Terminal Preclassic Izapan art style profoundly influenced all of southeastern Mesoamerica and prognosticated much of Classic Maya art as well. However, evidence of direct Izapan influence in highland Oaxaca is relatively rare (see the "Zegache" vase from Monte Alban; Easby and Scott, 1970, item 77).

Note the central dragon head in right profile, with exposed teeth, tubular eye, and comma-shaped "horn." Its scrolled body ends in a saurian claw motif at the left, while scrolls leading to the right, from the snout, end in a wing motif. This stylized celestial monster seems to be dependent from an incised sky band. The head and scrolls are outlined by deeply carved grooves, while details are lightly incised.

207. Small Urn (Lower left)

Mexico, Oaxaca, Zapotec culture (Monte Alban II–III). Early Classic, A.D. 200–300
Gray earthenware with red paint
Gift, 240:1978; H. 23.5 cm.

Transition period (Monte Alban II–III) Zapotec urns tend to be more lifelike and delicately modeled than urns of other epochs. This one represents the "god with the headdress of the bird with a broad beak." Various appendages are broken off, including the crossed legs. Interestingly, the applied human pectoral mask shows stylistic influence from the Teotihuacan II period in Central Mexico [cf. 143].

208. Urn Figure With Mouth Mask of the Serpent

Mexico, Oaxaca, Zapotec culture (Monte Alban II–III). Early Classic, A.D. 200–300
Painted buff earthenware (See color plate)
Gift, 131:1980; H. 23.5 cm.

A very naturalistic seated figure open at the top as an urn. The projecting serpent mouth mask with forked tongue is broken on the right side, now revealing the figure's realistic mouth (out of view in this photograph), over which that iconographic feature had been applied. Note the slanting eyes, shoulder cape and necklace, and the relatively simple headdress. (The trefoil flange on the left is missing.) This object retains extensive areas of powdery red paint as well as white details.

209. Urn With Mask of Cocijo in the Headdress

Mexico, Oaxaca, Zapotec culture (Monte Alban II–III). Early Classic, A.D. 200–300
Gray earthenware with traces of red pigment
Gift, 170:1979; H. 22.5 cm.

A diminutive urn showing perfection of form and detail. The seated skirted figure wears a broad cape, forward-facing ear spools, and a complex headdress, in this case showing the stylized mask of the rain god. The latter has a projecting and curled upper lip, framed eyes, and a superimposed Glyph C medallion.

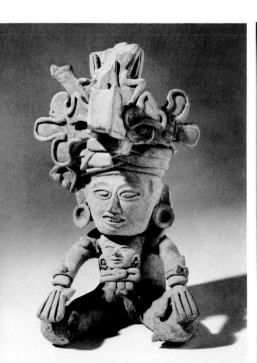
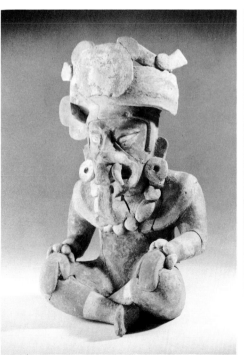
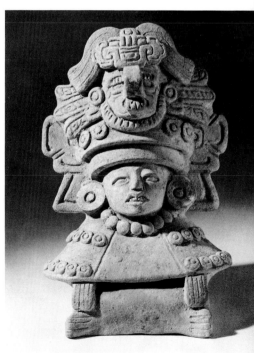

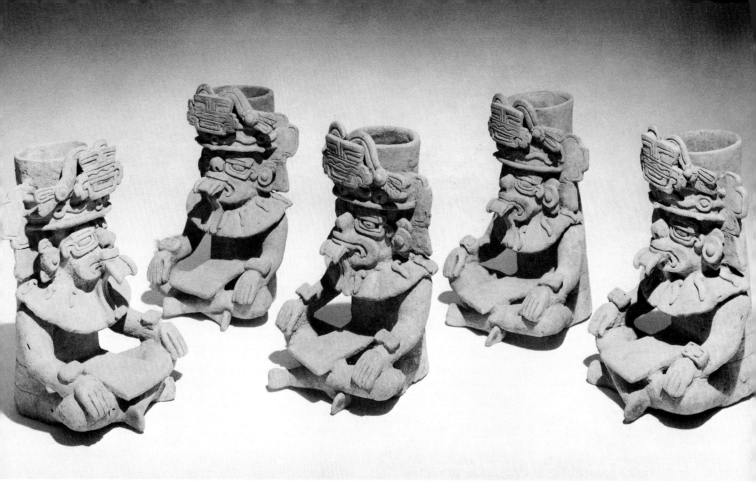

210. Set of Five Matched Urns

Mexico, Oaxaca, Zapotec culture (Monte Alban II–III). Early Classic, A.D. 200–300
Gray earthenware with traces of red paint
Gift, 249:1978.1–.5; H. 41 to 42.5 cm.

This and the following companion set of matched Cocijo urns are exceedingly rare in surviving tomb offerings from the transitional Monte Alban II–III epoch. This set of five nearly identical, handmade urns is more elaborate than the next in having intact Glyph C medallions on the headdresses—an emblem traditionally associated with the rain god in Zapotec iconography. The effigy figures are built around wide, cylindrical, flat-bottomed urns. The hollow arms and legs are pierced for air vents. They are seated cross-legged, with their hands on their knees. The loincloth aprons are plain, and they wear collars with appliquéd squiggle motifs. The headdresses are flanked by trefoil flanges, and the masks of Cocijo consist of scrolled and terraced eyes, platformed upper lips with projecting fangs, and double tongues.

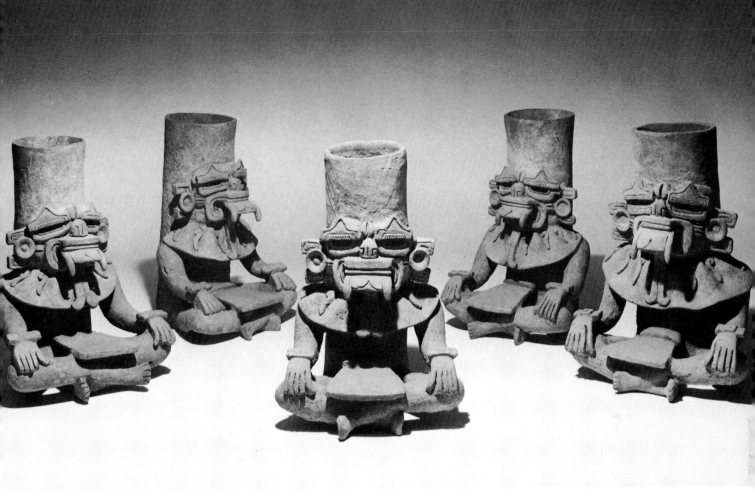

211. Set of Five Matched Urns

Mexico, Oaxaca, Zapotec culture (Monte Alban II–III). Early Classic, A.D. 200–300
Gray earthenware with traces of red paint
Gift, 250:1978.1–.5; H. 39.5 to 41 cm.

This set of five Cocijo urns is similar in construction to the former, with the exception of the plain upper cylinders lacking headdresses or medallions (as though they were unfinished). The rain god masks also differ in detail; note the peaked eye surrounds, broader platform mouths with down-turned corners, and the long forked tongues. They probably came from the same tomb offering as the previous group.

212. Large Hollow Figure: "God of Glyph L"

Mexico, Oaxaca, Zapotec culture (Monte Alban IIIA). Early Classic, A.D. 300–600
Unslipped red earthenware
Gift, 238:1978; H. 54 cm., W. 52 cm., D. 36 cm.

An urn of exceptionally large size (and note that the entire superstructure of the headdress is missing). However, the base of a clay corn cob may be seen in the upper left—one of the identifying features of Pitao Cozobi ("God of Glyph L"), or the Zapotec maize goddess. It also has the projecting, curled mouth mask and comma-shaped attachments over the eyes. The pupils are perforated. Note, too, the forward-facing earplug flares, the shoulder cape, and beaded necklace. The seated figure holds an *olla* or jar in its hands (compare this urn with 224). There are a number of repairs on the object and some of its appliquéd elements are gone. The *olla* may not be original, and the sculpture may be better classified as Monte Alban IIIB.

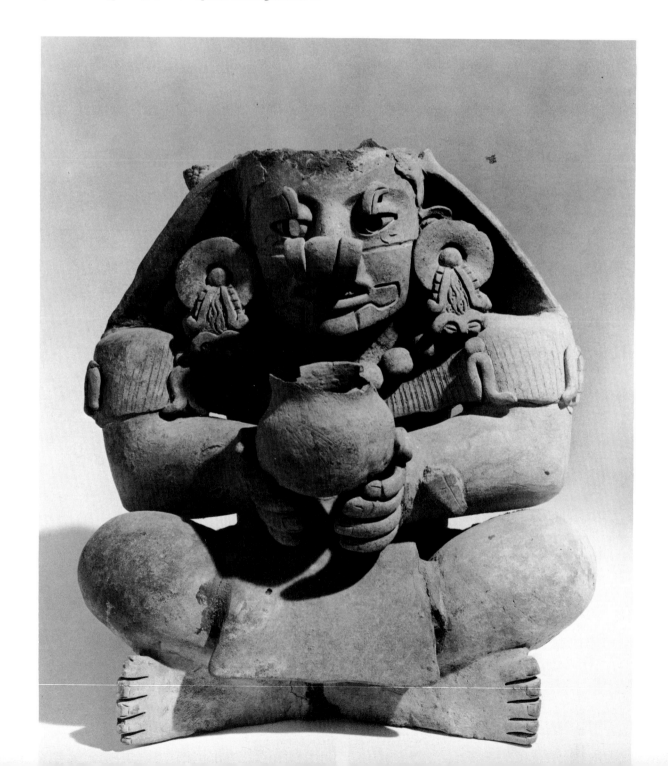

213. Urn With Seated Female

Mexico, Oaxaca, Zapotec culture (Monte Alban IIIA). Early Classic, A.D. 300–600
Gray earthenware (See color plate)
Gift, 305:1978; H. 36.5 cm., W. 32 cm.

A masterpiece of Early Classic Zapotec ceramic tomb sculpture. The realistic full-round female figure is attached to a wide, vaselike container. She is depicted with a simple, bordered *quechquemitl* or shoulder cape, and a type of wrapped yarn turban that is still worn by the Yalalag Indians of Oaxaca today. The pupils of the eyes are open to the interior of the ample hollow figure, which is also open on the bottom.

214. Standing Figure With Urn

Mexico, Oaxaca, Zapotec culture (Monte Alban IIIA). Early Classic, A.D. 300–600
Gray earthenware with specular-hematite red and traces of yellowish-white paint (See color plate)
Gift, 180:1979; H. 48.5 cm.

A uniquely complex and asymmetrical skirted figure on a flat square base. The back rounds out to a cylindrical vase, which is supported by a strap attached to the platform. The unusual headdress consists of a profile (facing left in the photo), "jeweled" deer head with two different flanges off to the side. The figure's eyes are bisected by "tear bands," which normally symbolize the deity Xipe. On the torso is an applied, foliated glyph plaque, while four carved spheres (one missing) serve as a necklace. The left arm and tapered earplug are missing, as well as the top of an object held in the right hand. Note the shell motif on the intact arm. Areas of paint are outlined by deep incisions.

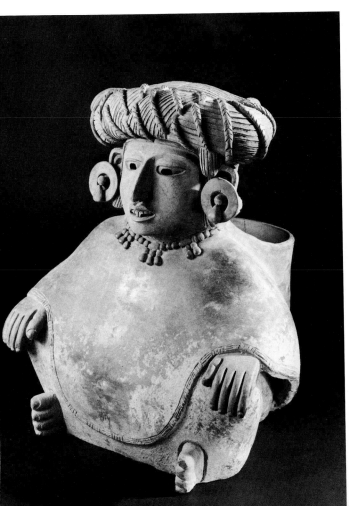

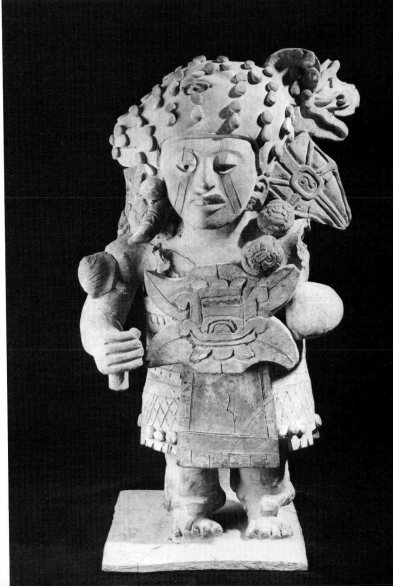

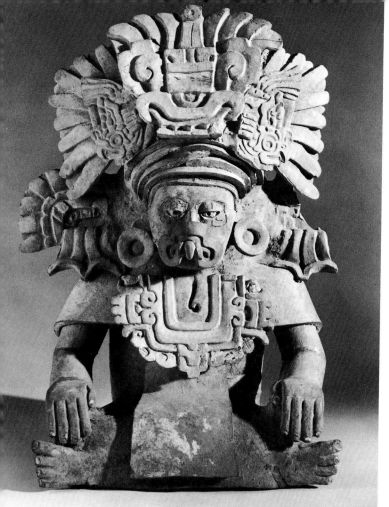

215. Urn With Mask of the Serpent

Mexico, Oaxaca, Zapotec culture (Monte Alban IIIA). Early Classic, A.D. 300–600
Gray earthenware with traces of red, yellow, and white pigment
Gift, 133:1980; H. 44 cm.

A precisely modeled, seated figure, formed around a cylindrical urn. Note the Glyph C plaque in the headdress, the serpent's projecting mouth mask that identifies this deity, and the elaborate breast medallion. Flanking the Glyph C emblem are two "diving" owl plaques, while the eyes are crossed with incised scrolls. The plumed flange on the left side of the head is missing, marring the symmetrical construction of the original urn.

216. Brazier Depicting "God With Mask of the Serpent and Bow Knot in the Headdress"

Mexico, Oaxaca, Zapotec culture (Monte Alban IIIA). Early Classic, A.D. 300–600
Gray earthenware with red (and traces of white) paint
Gift, 179:1979; H. 42 cm.

An elaborate construction fronting a two-part, hourglass-shaped incense burner with vent holes in its lower section. The deity wears a turban-like headdress featuring the bow knot, and with four appliquéd circular *adornos* in the manner of certain Teotihuacan censers [cf. 128]. Note the raised scrolls about the eyes and the fact that parts of the shoulder cape and apron are missing.

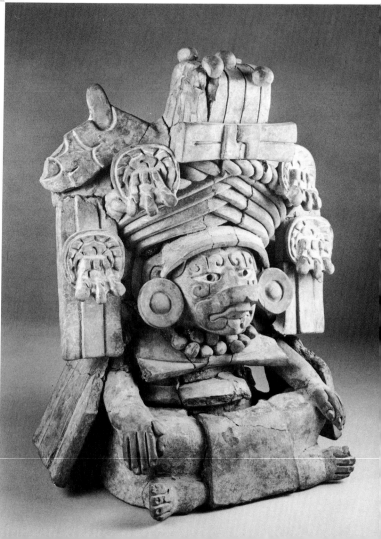

217. Funerary Urn Depicting Cocijo

Mexico, Oaxaca, Zapotec culture (Monte Alban IIIA). Early Classic, A.D. 300–600
Gray earthenware with remains of red paint
Gift, 176:1979; H. 32.5 cm.

A classical Zapotec representation of the local rain god, Cocijo (see 193 for an earlier version). The upturned mouth has the pendént forked tongue of a serpent, the eye plaques have the terraced top and scrolled bottom sections, and the headdress bears the emblematic Glyph C. The cape and headdress also have various applied squiggles with watery symbolism. Unfortunately, fragments of the superstructure, apron, and left foot are broken on this urn.

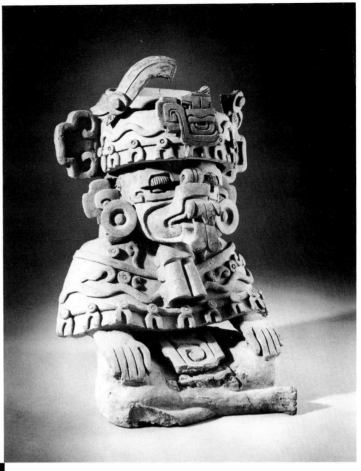

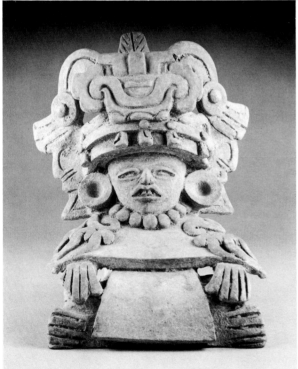

218. "Companion" Urn With Glyph C in Headdress

Mexico, Oaxaca, Zapotec culture (Monte Alban IIIA). Early Classic, A.D. 300–600
Buff earthenware with red cinnabar on front surface
Gift, 169:1979; H. 23 cm.

A well-preserved, relatively simple human effigy urn surrounding a cylindrical container. Slabs of clay are applied for the shoulder cape and the loincloth apron. The only symbolic identifying feature is the headdress containing a Glyph C medallion.

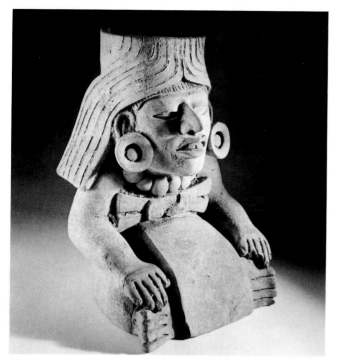

219. Seated "Companion" Urn

Mexico, Oaxaca, Zapotec culture (Monte Alban IIIA). Early Classic, A.D. 300–600
Gray earthenware
Gift, 168:1979; H. 23 cm.

Plain human effigy urns of this type, with a parted and striated hairdo around the opening of the cylinder, are usually termed "companions." They often were made in sets and placed as guardians near the entrance of a tomb, with the iconographically more complex urns clustered toward the rear of the chamber. The face of this naturalistic figure is especially large and bold.

220. Miniature Urn With Mouth Mask of the Serpent

Mexico, Oaxaca, Zapotec culture (Monte Alban IIIA). Early Classic, A.D. 300–600
Gray earthenware
Gift, 167:1979; H. 10.7 cm.

This resembles the previous plain "companion" urn with its scored hairdo. However, it also wears the symbolic element of the serpent mouth mask. The Zapotec numeral "1" is carved on the loincloth apron.

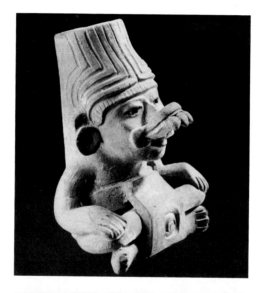

221. Anthropomorphic Tray

Mexico, Oaxaca, Zapotec culture (Monte Alban IIIA). Early Classic, A.D. 300–600
Whitewashed red earthenware
Gift, 123:1980; H. 9.5 cm., L. 22 cm., W. 9.5 cm.

An unusual shallow rectangular tray form, with applied human head, hands, feet, and "tail." The crouching figure wears a serpent-snouted headdress.

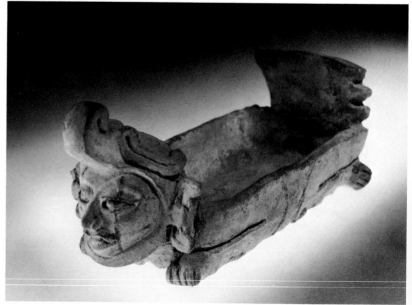

222. Pair of Cups With Glyphs

Mexico, Oaxaca, Zapotec culture (Monte Alban IIIA). Early Classic, A.D. *300–600*

Gray earthenware

Gift, 227:1978.1 and .2; H. 14 and 13.5 cm.

Each vessel is deeply carved with a hieroglyph on one side. The left cup bears the Zapotec glyph called "2 J" and the right, Glyph "1 Tiger" (the U-shaped motifs under them have unit numerical value). Pairs of cylindrical cups or vases frequently occur with these same two glyphs [cf. 223], though their meaning is not known other than that they may be among the twenty Mexican day signs.

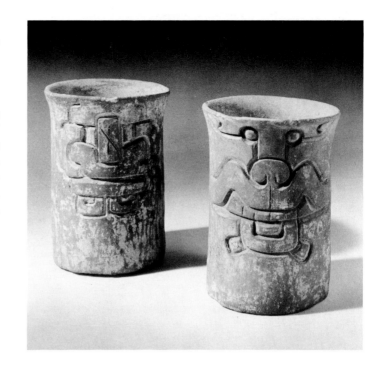

223. Joined Vases

Mexico, Oaxaca, Zapotec culture (Monte Alban IIIA). Early Classic, A.D. *300–600*

Buff earthenware

Gift, 353:1978; H. 11.5 cm., W. 13.5 cm.

This pair of carved vases was joined after being separately manufactured. Like the previous two, the carved emblems show the mating of the glyphs "1 Tiger" and "2 J."

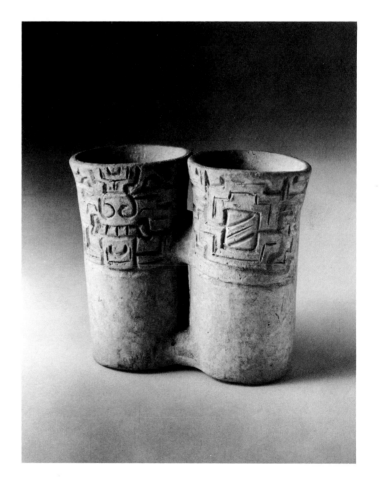

224. Urn Featuring the "God of Glyph L"
Mexico, Oaxaca, Zapotec culture (Monte Alban IIIB). Late Classic, A.D. *600–900*
Dark gray earthenware with traces of red pigment
Gift, 380:1978; H. 62.5 cm.

A large and impressive funerary urn, bearing the iconography of Pitao Cozobi, the benign maize deity. The expanding, open-topped headdress is engraved with Glyph C. The curled upper lip or nose attachment is a special feature identifying this god. The modeled seated figure holds a jar containing symbolic flowing water.

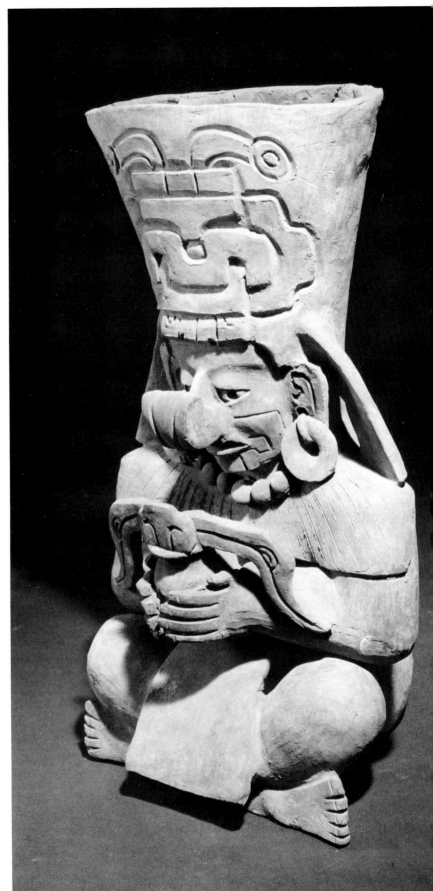

225. Effigy Bottle With the "Mouth Mask of the Serpent"

Mexico, Oaxaca, Zapotec culture (Monte Alban IIIB). Late Classic, A.D. *600–900*
Gray earthenware
Gift, 239:1978; H. 22 cm.

An "urn" variation with a figure modeled over a globular, tall-necked bottle form. In addition to the serpent mouth mask, the effigy has a moldmade Glyph C on the head, a cape, and a breast medallion. Tiny perforations along the hairline and on the ear spools are unusual.

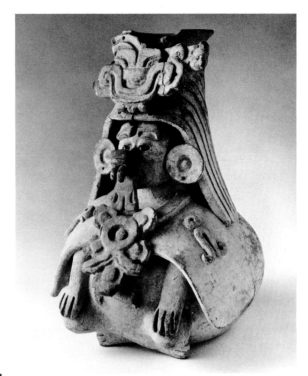

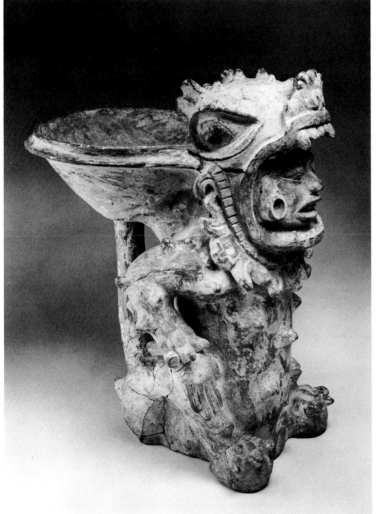

226. Brazier With Jaguar-Costumed Figure

Mexico, Oaxaca, Zapotec culture (Monte Alban IIIB). Late Classic, A.D. *600–900*
Gray earthenware with whitewash and traces of red
Gift, 175:1979; H. 37.5 cm.

The hollow effigy carries on its back an incense-burning bowl supported by the "tail" of the jaguar costume. Note the gaping feline helmet revealing the face of the figure, the exposed human hands, and the crouching legs. The costume is studded with thornlike spikes instead of jaguar spots.

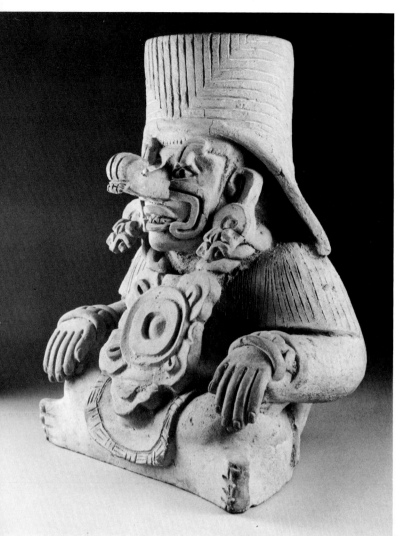

**227. "Companion" Urn With "God of Glyph L" At-
tributes**

*Mexico, Oaxaca, Zapotec culture (Monte Alban IIIB). Late
Classic,* A.D. *600–900*
Buff earthenware with trace of red paint
Gift, 114:1980; H. 35 cm.

Scored-turbaned effigy urn with open top. The project-
ing, curled mouth mask indicates Glyph L, an attribute
of the corn god. Also note the ear ornaments, incised
shoulder cape, medallion, and fringed apron.

228. Urn With Seated "God of Glyph L"

*Mexico, Oaxaca, Zapotec culture (Monte Alban IIIB). Late
Classic,* A.D. *600–900*
Gray earthenware with traces of red pigment
Gift, 116:1980; H. 34.5 cm.

This deity includes features of Pitao Cozobi, the god of
the cornfield. Its pelleted horizontal headdress, however,
is atypical. A former crest (a continuation of the plumed
penache) is missing. The figure holds out a presumed
incense bag rather than a bowl. Attached hollow bosses
at the elbows and shoulders are another peculiar feature
of this effigy urn.

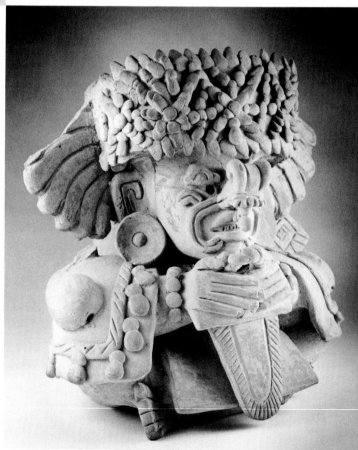

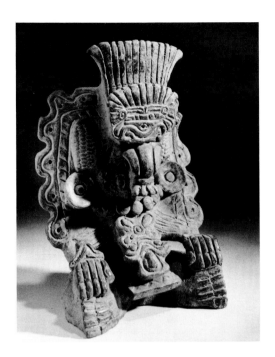

229. "God of the Cornfield" Urn

Mexico, Oaxaca, Zapotec culture (Monte Alban IIIB–IV). Late Classic, A.D. *600–900*
Dark gray earthenware with traces of red pigment
Gift, 115:1980; H. 27.5 cm.

A more literate depiction of the "God of Glyph L," with actual corn cobs modeled at each side of the headdress. It also has an applied, moldmade Glyph C emblem. The curled nose ornament practically obscures the face of this late, rather crudely modeled urn.

230. Matched Pair of Urns Representing the "God of Glyph L"

Mexico, Oaxaca, Zapotec culture (Monte Alban IIIB). Late Classic, A.D. *600–900*
Gray-brown earthenware
Gift, 279:1978.1 and .2; H. 36 and 35.5 cm.

While matched pairs and matched series of urns were routinely made for Zapotec tombs, they are seldom kept together in collections. The May Collection, however, includes a number of such sets [cf. 197, 210, 211, and 231]. The openings for this pair of urns are located behind the feathered headdresses. Unfortunately, the projecting mouth-mask elements are broken off on both urns. Unusual features in the extensive applied details include profile human heads peering down from either side of the headdresses.

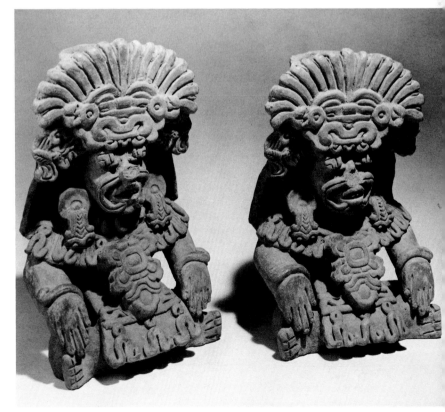

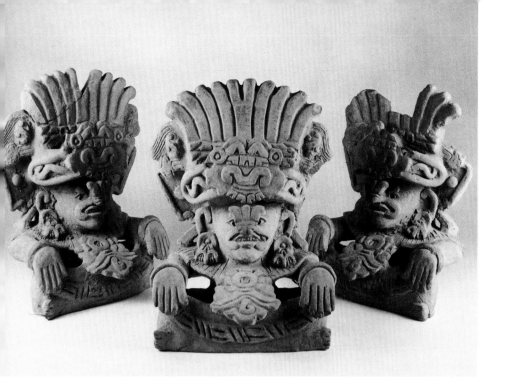

231. Set of Three "God of Glyph L" Urns

Mexico, Oaxaca, Zapotec culture (Monte Alban IIIB). Late Classic, A.D. *600–900*
Gray earthenware with red pigment
Gifts, 141, 142 and 140:1979; H. 37, 37, and 35 cm.

Another matched set probably from the same tomb offering. These urns are typically constructed in frontal fashion around cylindrical containers at the rear. These examples all have their trefoil mouth masks, but the feathered crests are incomplete on two. Traces of red cinnabar remain on the Glyph C medallions in the headdresses. The oval elements, with diagonal bands and dots, flanking these are symbolic of corn cobs.

232. Cylindrical Urn With Anthropomorphic Bat Effigy

Mexico, Oaxaca, Zapotec culture (Monte Alban IIIB). Late Classic, A.D. *600–900*
Gray earthenware
Gift, 127:1980; H. 20 cm.

The modeled frontal figure on this little urn is a conventional, relatively naturalistic representation of a bat-headed creature. Note the oversized ears and hooked forehead element. (The right arm is missing.)

233. Bat Claw Vase

Mexico, Oaxaca, Zapotec culture (Monte Alban IV). Late Classic, A.D. *600–1000*
Polished black earthenware
Gift, 252:1978; H. 14.5 cm., L. 18.5 cm.

Bat claw effigy vases are characteristic of the late Zapotec art style. The four front claws are naturalistically outlined, with a fifth rear claw on the right side.

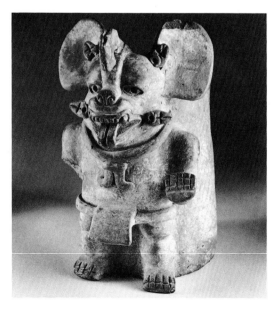

234. Moldmade Urn of the God Cocijo

Mexico, Oaxaca, Zapotec culture (Monte Alban IIIB). Late Classic, A.D. *600–900*
Reddish-gray earthenware with traces of red paint
Gift, 113:1980; H. 15.5 cm.

The front of this small late period urn was entirely pressed from a mold, in the manner of some contemporary Zapotec figurines. The use of molds in pottery manufacture did not become popular until the Middle and Late Classic period. This effigy is attached to a standard cylindrical container. Due to the technique of manufacture, the iconography is not as sharply defined as the handmade urns. The Glyph C headdress, and the eye and mouth configurations, identify this as the Zapotec rain god.

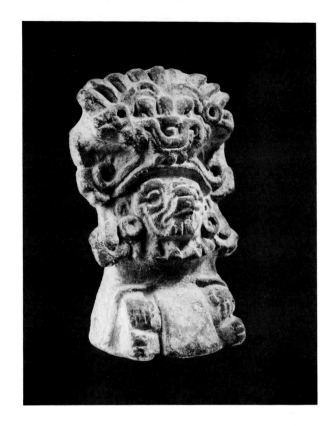

235. Deep Dish With Carved Scene

Mexico, Oaxaca, Zapotec style (Monte Alban IIIB–IV). Late Classic, A.D. *600–900*
Gray earthenware
Gift, 147:1979; H. 10 cm., Diam. 15 cm.

A flat-bottomed, straight-walled dish with a carved scene that resembles certain contemporary moldmade bowls from the Gulf Coast and Campeche—possibly the inspiration for this unusual vessel. The photographed side displays a shield emblem surrounded by scrolls and U-motifs. The drawn side shows a standing figure confronting a dragon monster. A number of filler motifs occupy gaps in the scene. The human figure has a "speech scroll," and water, or maize kernels, drop from his hand. The toothy "dragon" has a forked tongue, convoluted body, and crenulated tail.

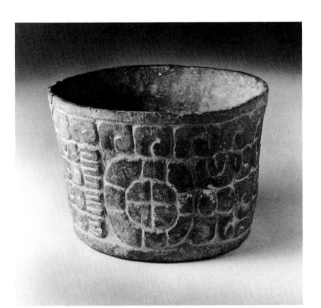

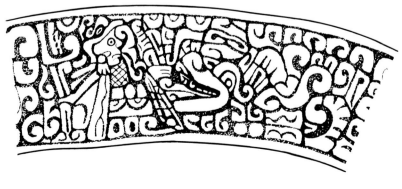

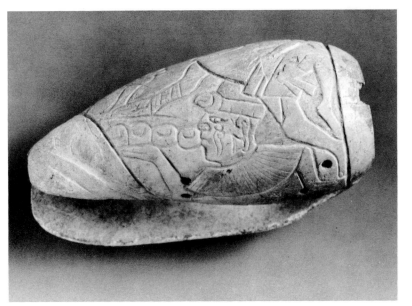

236. Carved Shell Ornament

Mexico, Oaxaca, Zapotec culture (Monte Alban II). Terminal Preclassic, 200 B.C.–A.D. 200
Buff-colored olive shell
Gift, 288:1978; L. 11.5 cm., Diam. 6.5 cm.

This worked seashell bears a unique carved scene with incised borders (the top border is sawn through to the hollow interior). There is one perforation at the narrow end (for suspension?) and seven others at the bottom of the scene. The composition is executed by a combination of excising and engraving. Represented are two dynamic half figures on the left and a full figure on the right (see drawing). The free, calligraphic style, the simplicity of accouterments, and the various filler motifs (serpent tail with feather above, trefoil flower in the center, and four numerical dots, with U shapes, issuing from the lower figure's mouth) all suggest a transitional, post-Olmec to Terminal Preclassic, Zapotec period equivalent to Monte Alban II.

While unparalleled in known artifacts, this object is obviously important for iconography and doubtless fits the Izapan-contemporary period in Oaxaca, even though it lacks Izapan style scrolls [cf. 206]. The style of the figures and associated motifs also resembles certain low-relief carved stone panels on the observatory structure at Monte Alban itself, and at the site of Dainzu in the Valley of Oaxaca. The carving at the latter site emphasizes ball players and, indeed, the figures on this shell could also be engaged in a ballgame.

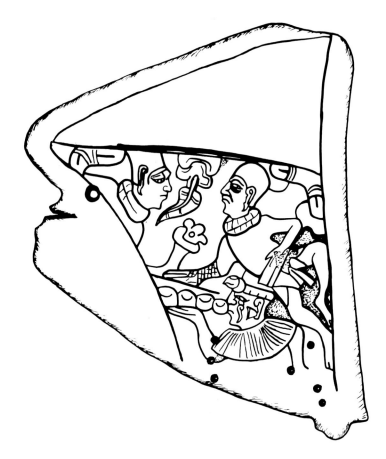

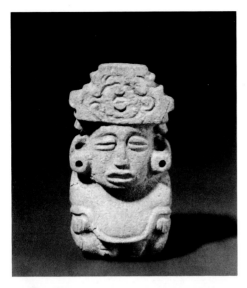

237. Seated Female

Mexico, Oaxaca, Zapotec culture. Early Classic, A.D. *300–600*
White stone (probably onyx)
Gift 121:1980; H. 7.2 cm.

Small stone effigies are less common in the Zapotec period than the Mixtec [cf. 170–172]. Zapotec stone carvings show more rounded and curvilinear treatment, though the back of this figure is flattened. She wears the standard *quechquemitl* tunic and a stepped headdress displaying a poorly defined Glyph C. The ear spools are drilled.

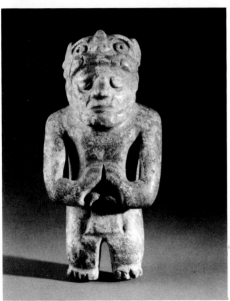

238. Person With Jaguar Head Mask

Mexico, Oaxaca, Zapotec culture. Late Classic, A.D. *600–900*
Mottled white-to-gray-to-green jadeite
Gift, 120:1980; H. 11.5 cm.

An unusual full-round jade carving of a standing individual, with the fingertips joined over the abdomen. On the head is a half jaguar mask. A loincloth is depicted, and the arms are separated from the body. Incised on the back is a small profile death's-head glyph or emblem resting in a "bowl" drawn as a human bone. ("Death" is one of the twenty day signs in the pan-Mexican calendar.)

239. Tenoned Serpent Head

Mexico, Oaxaca, Zapotec culture. Early Classic, A.D. *300–600*
White limestone
Gift, 284:1978; L. 40.5 cm., H. 16.5 cm., D. 10.5 cm.

Architectural ornaments such as these were tenoned into the entrance walls of tombs flanking the doorways. The style of the stone carving is relatively rectilinear, unlike contemporary sculpture in clay. The serpent or "dragon" has an upturned snout, U-framed eye, a bow knot motif over the eye, as well as fang and tongue volutes. Both sides are carved the same way. This stylized creature has been identified as the Mexican earth monster Cipactli. (See Easby and Scott, 1970, item 166, for a discussion of nearly identical examples.) Prototypes for this monster are prevalent in Izapan art [cf. 206].

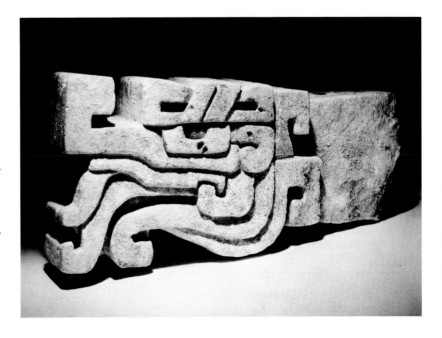

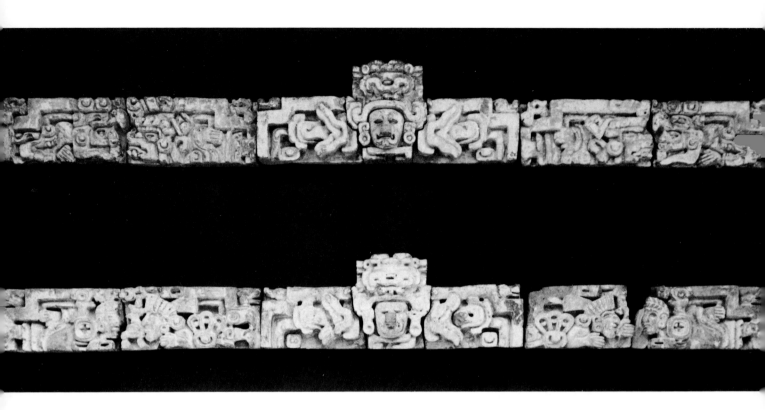

240. Two Sculptured Tile Friezes

*Mexico, Valley of Oaxaca, Zapotec culture. Late Classic, A.D.
600–900*
Gray terra cotta with whitewash and buff pigment
*Gift, 351:1978; Average H. 19 cm., D. 8 cm., Assembled
lengths ca. 250 cm. (Published: Boos and Shaplin, 1966)*

In the Zapotec region, both tomb facades and building
platforms were occasionally decorated with sculptured
clay or stucco tiles inlaid as continuous friezes. These two
sections have been reassembled in their presumed, but
not necessarily correct, order from fourteen individual
tiles. More than likely these came from the cornices of
architectural platforms in public patios, rather than
tombs, and represent the terminal Classic Zapotec pe-
riod. "Keystoned" in the center of each *tablero* is a larger,
and higher-relief, stucco head of the "god with the
mouth mask of the serpent," with Glyph C in the head-
dress. Flanking tiles include a number of profile Zapotec
deities, associated with day-name glyphs and numerals.
Many of them are framed in the stepped-"hill" glyph, a
presumed place name. Prominent are the jaguar and old
man deities. They are arranged in pairs so that each god
faces a goddess.

Gulf Coastal Lowlands

Veracruz, along the Gulf Coast of Mexico, spans the northern sector of the extended region we are calling the Coastal Lowlands. (The southern Pacific Coastal sector will be treated with the southern Maya here, owing to a paucity of objects from the Chiapas-Guatemala-El Salvador coast in this collection. On the other hand, the rubber ballgame complex is covered in this section, and some of the associated objects do come from the Pacific Coastal region.) The Coastal Lowlands were the primary source of the coveted rubber tree as well as the cacao (chocolate) tree, and as a result were the focus of many trade routes and the passage of many peoples. Having dealt with the Preclassic Olmec and Izapan cultures elsewhere—both of which had their homelands here—we may now concentrate on the Classic and Postclassic cultures of this coastal corridor.

The Classic period on the Gulf Coast is best termed "Classic Veracruz," but incorporates such specific cultures and entities as "Remojadas," "El Tajin," and some of the most elaborate stone ballgame paraphernalia. The contemporary Classic period culture on the Pacific Coast is called Cotzumalhuapa, outstanding for its monumental stone sculpture as well as its ballgame paraphernalia. Another cultural region in far northern Veracruz, in the vicinity of the Panuco River, is the Huastec; this is best known for its Postclassic pottery and sculpture. The Postclassic phase in Veracruz reflects highland Mixtec and Aztec influence, and is associated with the historic Totonac Indians.

Collectors of Pre-Columbian ceramic sculpture are familiar with a Classic period culture and art style from south-central Veracruz known as Remojadas (the name of a particular archaeological site, although objects in closely related styles actually come from a number of different sites in Veracruz). Remojadas ceramic figures and effigies, in a bewildering variety and exuberance comparable to the tomb sculptures of West Mexico, span the entire Classic period from A.D. 200 to 900 [241–258]. The earliest object illustrated

is also one of the most extraordinary: an enormous toad effigy burial or storage container [241]. Some Remojadas objects show Teotihuacan influence [e.g., 263 and 264], and others show Mayoid traits [247], but the regional tradition is linked by the frequent use of natural black bitumen pigment and a stylized realism. Many of the hollow ceramic figures are unusually large [242, 253, and 254], and the later objects were often made in molds [255–257]. The latter comprise a popular substyle dubbed "laughing boys."

Another style, more concentrated around the large site of El Tajin (the name of the local rain god) in north-central Veracruz, is expressed primarily in the stone architecture of the site itself ("Temple of the Niches," paneled ball courts, etc.) and in the complex of ceremonial ball player equipment to be described below [266–280]. This is the epitome of "Classic Veracruz" art, also dated from A.D. 200–900, and it features the device of interlaced scroll motifs (see the unique bone object, 262), which in turn may have been derived from the earlier scrolled Izapan style.

Several Postclassic objects from Veracruz are included here: a large Xolotl effigy ceramic sculpture [260]; a polychrome plate from the Isla de Sacrificios [261]; and a stone head of Xipe [265]—all demonstrating Mixtec and Aztec penetration to the coast.

The ballgame was one of the universal integrating complexes of Pre-Columbian Mesoamerica—from the earliest civilizations to the latest, and in every major geographical region. Rubber was discovered by the Olmecs and solid rubber balls weighing approximately 5 pounds were made for enacting a game with rules resembling, in our experience, modern soccer. Although the specifics of the game differed from region to region and from time period to time period, normally the ball was not allowed to come into contact with the hands or feet, but was kept in motion with the elbows, knees, and hips. In the Preclassic and Classic periods it was a deadly serious affair, and the outcome may have been ritually predetermined. The game probably symbolized the movement of the sun and moon between the celestial and terrestrial spheres. After the "game," selected players (possibly the winners rather than the losers) were ceremonially decapitated or otherwise sacrificed to the gods to maintain the cosmic cycle. Only in Postclassic times did the game approach a competitive team sport as we know it.

Architectural ball courts throughout Mezoamerica are variable in size and profile, but most have an I-shaped playing court, vertical side walls, and sloping benches for deflecting the ball. Only some late courts had hoops set into the side walls; scoring was achieved more frequently when the ball struck stone markers in the playing alley, or tenoned heads in the sides.

Ball players wore protective padding over the head (helmets), around the waist (belts or "yokes"), and on one arm and one leg for striking the heavy ball (and sometimes gloves or "hand-stones"). The costumed Late Preclassic ball player figurines [65 and 200] show some of these accouterments. For actual play, leather, quilted cotton, basketry, and wooden devices were probably worn. However, elaborately carved stone replicas of ballgame

equipment also were produced [266–280] for pre- and post-game rituals and for burial in votive caches. Ceremonial ballgame equipment is most characteristic of the Classic Veracruz style region, with a significant extension into the Pacific Coast Cotzumalhuapa region [278–280]. Prototypes for these objects are also evident in the Preclassic period, both on the coast and in the Mexican Highlands [e.g., 117]. U-shaped "yokes" were worn sideways on the waist [266–269]; stone yokes weighed between 40 and 50 pounds, but their hardwood counterparts probably used in the game were nearly as heavy. Thin, ax-shaped objects, beautifully carved on both faces (called *hachas,* or "thin stone heads"), were apparently lashed to the front side of the yokes [273–280], and are so depicted in many figurines and relief panels. The early *hachas,* however, were more in the form of full-round heads. During the Late Classic period, the *hacha*-type yoke attachments were elongated into ornamental palm- or fan-shaped objects, called *palmas* [269–272]. The carved iconography on the yokes emphasizes toads and reptilian creatures (the underworld), the *hachas* feature trophy heads, and the *palmas* highlight details of human sacrifices; while the ball itself symbolized the celestial world.

One other Gulf Coast regional style remains to be shown—the Huastec. We have only a single figurine from the Classic period there [281]. Postclassic Huastec effigy pottery is black on cream with the addition of red details [282]. The late period stone sculpture from the region, however, is especially dramatic, as in the dualistic old man figure [283] and the monumental slab figure [284]. In addition, almost pure Aztec style stone sculpture was carved in the Huastec region [185 and 186].

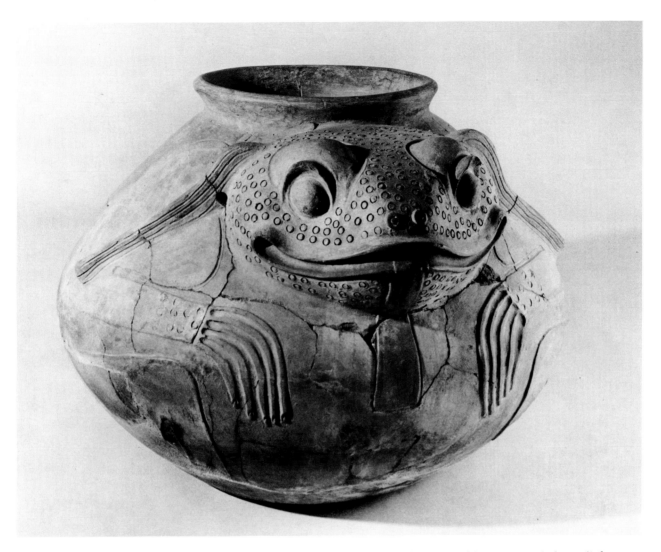

241. Toad Effigy Vessel

Mexico, Gulf Coast, southern Veracruz. Proto-Classic, A.D. *1–200 (?)*
Orange-brown earthenware with red paint
Gift, 97:1968; H. 55 cm., Diam. 83 cm.

Giant ceramic effigies are rare, and this jar is unique in representing a toad. The style and size remind one of the toad effigy stone altars at Kaminaljuyu in southern Guatemala, which are dated between 200 B.C. and A.D. 200. The toad's arms and legs are seen in low relief on the front. The head and wrists bear circular markings impressed with a tubular instrument. Two flowing motifs emerge from the back of the head. Only the mouth and the incised-outlined tongue are painted red. This vessel reportedly came from a mound near the famous site of Cerro de las Mesas. Although broken and repaired, most of the restoration is on the back and bottom.

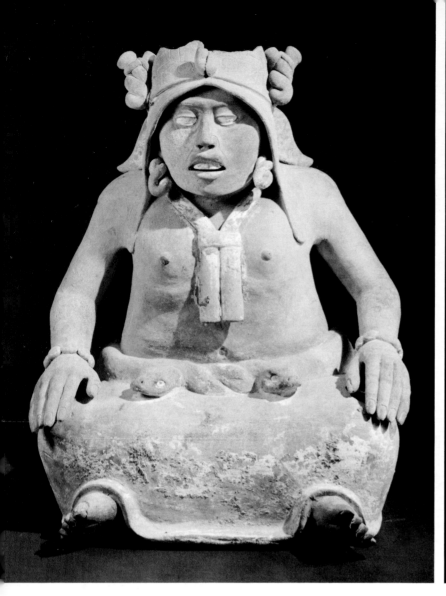
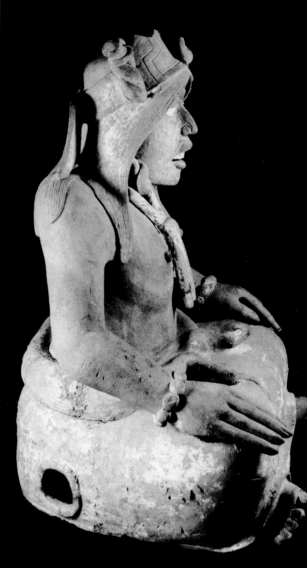

242. Heroic-Sized Seated Female

Mexico, central Veracruz, Remojadas culture. Late Classic,
A.D. *600–900*
*Reddish-buff earthenware with traces of lime plaster and red
paint (See color plate)*
Gift, 212:1979; H. 94 cm., W. 80 cm., D. 63 cm.

A hollow figure of monumental proportions, possibly
representing an earth goddess. The placement of vent
holes and the fact that the bottom is open suggest that this
clay sculpture may have functioned as a cover for incense
burning. A pair of holes, with raised borders, is found on
either side of the skirt. Also the mouth is open and other
vents are located in the knees under the palms of the
hands, in the right elbow, the armpits, in the middle of
the back, and in the top of the head. The figure wears a
wrap-around skirt tied with a double-headed serpent
belt. The bare feet protrude under the skirt and the
fingers are held out. The hair falls in tresses over the
shoulders and back. (Only the front crest of the head-
dress is missing.) A coating of white lime adheres to
portions of the sculpture, with overlying traces of red
pigment. (A mate to this unusual object is owned by the
Musées Royaux d'Art et d'Histoire in Brussels, another
is in the Mexican National Museum of Anthropology,
and two others are known in private collections.)

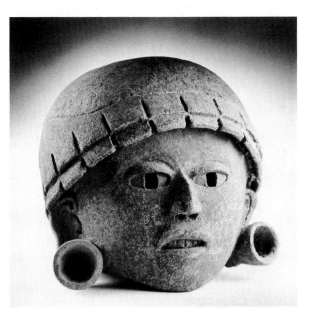

243. Life-Sized Human Head

Mexico, Veracruz, Remojadas culture. Late Classic, A.D. *600–900*
Coarse buff earthenware
Gift, 193:1979; H. 20.5 cm., W. 20.5 cm.

This hollow head had been broken at the neck from a life-sized ceramic sculpture (comparable to the previous piece). It is notable for its plain, stylized realism. Its eyes and ears are perforated; note the hollow conical earplugs.

244. Relief-Decorated Cup

Mexico, Veracruz. Early Classic, A.D. *300–600*
Polished brown earthenware
Purchase, 85:1953; H. 16 cm., Diam. 12 cm. (Illustrated: Von Winning, 1968, items 270, 271)

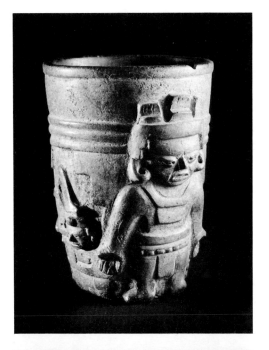

An unusual thick-walled vase, with carved low-relief figures and horizontal bands on the surface. On opposite sides are two large, frontally displayed figures with squared headdresses and yokelike belts. In the intervening spaces are two "acrobat" figures (with their legs turned over their heads) resting on footed thrones. The latter panels are framed by stepped niches. There is a good possibility of ballgame references on this carved vase. In addition to the waist yokes, the acrobat figures may well be ball players "diving" for a retrieve.

245. Figurine on Scaffolding

Mexico, Veracruz, Remojadas culture. Early Classic, A.D. *200–400*
Unslipped buff earthenware
Gift, 258:1978; H. 22 cm., W. 14 cm., D. 7 cm.

A hand-modeled flat figurine straddling a scaffold with crossed bars in back and a platform below. The applied cape and kilt do not wrap around the figure. Not readily apparent in the photo is a plaquelike lower face mask typical of this sort of object. One wonders if this may be a Mesoamerican version of the arrow sacrifice ritual of the Late Mississippian culture of the southeastern United States, where victims were similarly tied to racks.

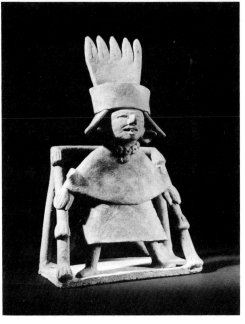

246. Seated Female

Mexico, Veracruz (El Faisan). Middle Classic, A.D. 400–700
Polished, cream-slipped earthenware with black and red paint
Gift, 326:1978; H. 45 cm. (Illustrated: Von Winning, 1968, item 243)

A hollow, big-hipped figure with holes at the navel, nipples, and in the hairdo. The black details and the loincloth are painted with the local natural bitumen, while the punctated necklace and hair zone are painted red. This southern Veracruz substyle has been confused with the northern Huastec style, but the provenance of this piece is well established [cf. 248]. (The sculpture has been restored.)

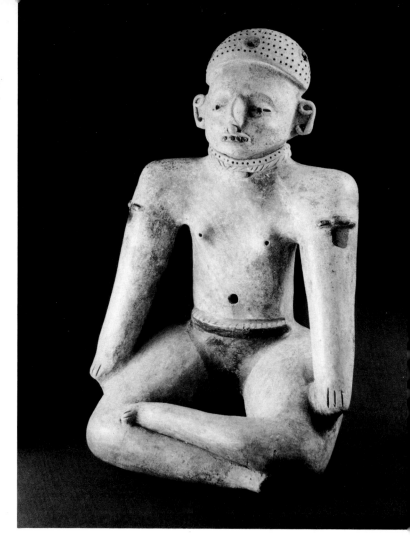

247. Hollow Seated Figure

Mexico, southern Veracruz (Tres Zapotes region). Middle to Late Classic, A.D. 400–900
Unslipped orange earthenware
Gift, 344:1978; H. 30 cm.

Identical orange ware sculptures have been excavated at the site of Tres Zapotes and the type seems to be limited to that region. The female figure wears a *quechquemitl* upper garment, while the legs are crossed under the skirt. (The toes and fingers on the right side are missing; also, straplike projections from the shoulders are broken.) The flat base is closed with a slab of clay, and there are vent holes in the back and behind the head. A subtle Mayoid stylistic influence may be noted in this sculpture, and is even more evident in ceramic effigies from the southern Veracruz site of Nopiloa.

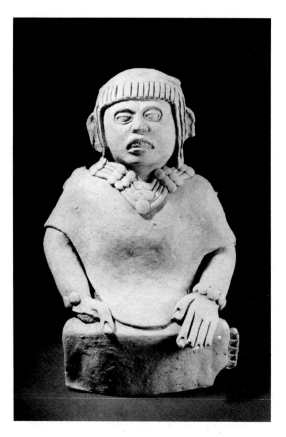

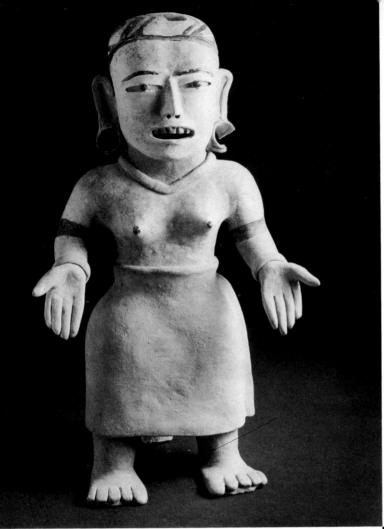

248. Hollow Standing Female

Mexico, Veracruz (El Faisan). Middle Classic, A.D. *400–700*
Polished, cream-slipped earthenware with black and red paint
Gift, 362:1978; H. 51 cm.

This object is stylistically identical to the previous one, with its cream slip, black bitumen details, as well as red paint (on the legs, neck, and ears). The mouth is open and the whole figure is supported by an extra slab leg behind. Note the tubular "napkin ring" ear spools.

249. Seated Female Figure

Mexico, Veracruz, Remojadas culture. Early Classic, A.D. *300–600*
Buff earthenware with red and black-bitumen paint
Gift, 386:1978; H. 44.5 cm.

A relatively flat, hollow figure, with open bottom and circular vent holes at the navel and behind the head. The red paint covers the upper armbands, collar, sides of the face, and headband. Black bitumen is applied to the mouth, earplugs, pupils, and the eyes of the animal heads flanking the headdress.

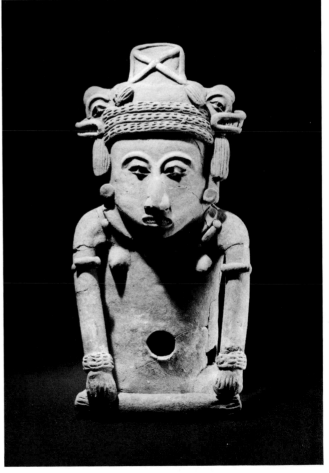

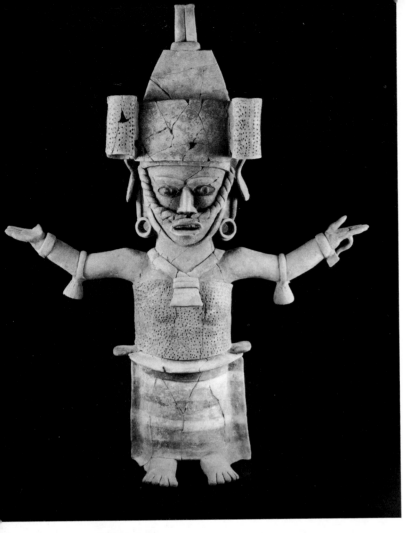

250. Displayed Female Figure

Mexico, Veracruz, Remojadas culture. Middle Classic, A.D. *400–700*
Polychromed buff earthenware (See color plate)
Gift, 292:1978; H. 71 cm.

An elaborately dressed woman with imposing headgear. The figure is open-bottomed, the mouth is open, and there is a vent in the back. Her belted skirt is striped red, black, and white, and she wears a punctated bodice. The ornaments at the elbows probably represent bells. The headdress is held on by both a chin strap and a cord passing under the nose. At the side of the headband are hollow tubes and at the rear is a raised plaque (out of view in the photo). She probably represents Cihuateotl, the "goddess of women who die in childbirth" [cf. also 254].

251. Standing "Priestess"

Mexico, Veracruz, Remojadas culture. Middle Classic, A.D. *400–700*
Unslipped buff earthenware with black-bitumen paint
Gift, 161:1979; H. 45 cm.

Skirted female in a conventional Remojadas "arm-outstretched" posture. Curiously, her upper garment is cut out in the breast areas and filled with bitumen pigment. There also is a black patch over her mouth. Note the bird perched on the headdress. The bottom of the figure is open, and there is a rectangular vent behind the head.

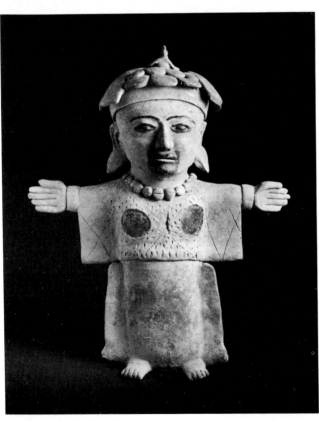

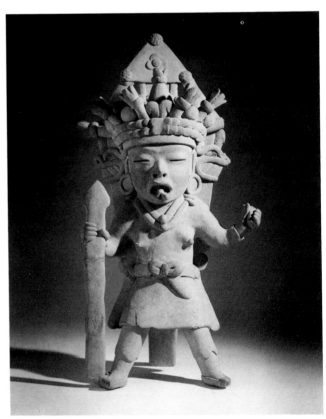

252. Tripod Effigy of Xipe Totec

Mexico, Veracruz, Remojadas culture. Late Classic, A.D. *600–900*
Unslipped reddish-buff earthenware
Gift of Mr. & Mrs. Milton Tucker, 333:1962; H. 50.5 cm.

An iconographically complex representation of Xipe, the god of growth and vegetation (see the flowers in the headdress), and the one who wears the flayed skin of a sacrificial victim. Note the serrated edges of the overlaid female skin costume at the calves and wrists [cf. 265]. There is also a skirt and belt over the flayed skin. Other significant features include the dart in the right hand and a broken object, probably a rattle, in the left; the conical hat; and the bead in the mouth (customarily placed on the tongues of the dead). The figure is bolstered by an extra slab leg at the rear.

253. Large Standing Male

Mexico, Veracruz, Remojadas culture. Late Classic, A.D. *600–900*
Buff earthenware and bitumen paint (See color plate)
Gift, 355:1978; H. 100 cm.

The entire surface of this effigy, except for the whites of the eyes, is covered with *chapopote* or black bitumen—a frequently used pigment in the oil-rich Gulf Coast region. Oversize hollow figures with realistic proportions are more common in the Postclassic period, though the facial features of this one relate it to the Late Classic Remojadas complex. The "pouting" lip gives it a particularly commanding expression. The fingers are curled as if to hold objects now missing. He is simply adorned with bracelets, necklace, and breechcloth. Openings in the bottom of the feet and back of the head, as well as slits behind the thighs, allowed for safe firing of the object.

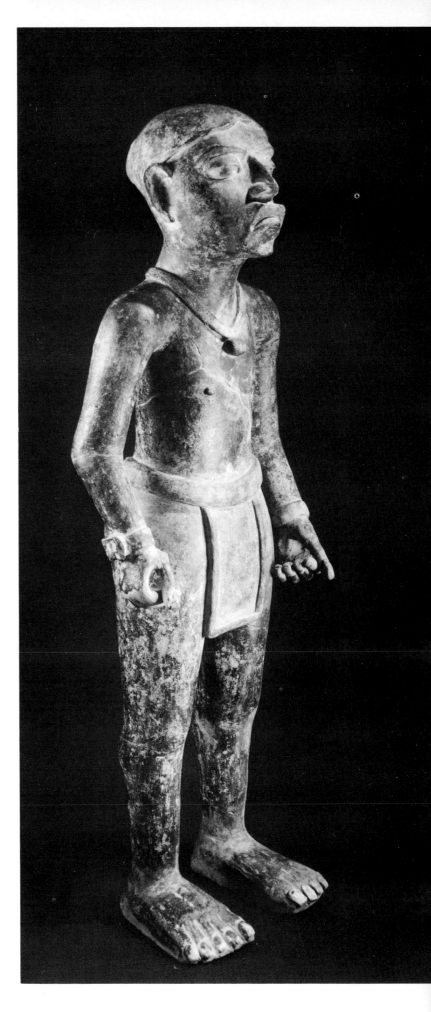

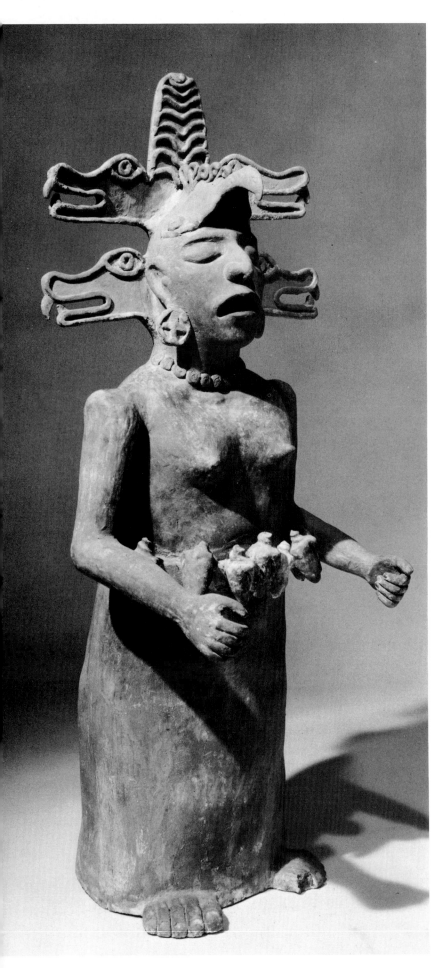

254. Oversize Standing Female
Mexico, Veracruz, Remojadas culture. Late Classic, A.D. 600–900
Buff earthenware with red, white, and blue-green pigment
Gift, 172:1979; H. 122 cm.

An unusually large, hollow effigy figure, probably representing Cihuateotl, the "goddess of women who die in childbirth." The base of the figure and the mouth are open, and there is a square vent behind. The eyes are shown closed. Iconographic features include the bird-beak headdress, the pair of double-headed serpent flanges, the serpent-tail crest, and the modeled sea-shell belt on the full skirt. (This sculpture has been rather extensively restored.)

255. Moldmade Laughing Figure (Facing page, lower left)
Mexico, central Veracruz. Late Classic, A.D. 600–900
Unslipped buff earthenware
Gift, 307:1978; H. 31.5 cm.

These famous smiling figures were known to us a quarter century ago almost exclusively by their broken heads. Since then a great number of complete examples have come to light [cf. also 256 and 257]. Laughing portrayals are rare in Classic Mesoamerican cultures; it has been suggested that this Gulf Coast type represents ritual intoxication. Both the fronts of the hollow heads and the bodies were pressed in clay molds (some of which have been excavated). The backs were then enclosed with slabs of clay, leaving holes in the feet and back for escape of air during firing. The headdresses often have mold-impressed animals or patterns; this object presents an exquisite crane and fish motif. The geometric details of the (embroidered or brocaded?) tunic are particularly sharp.

256. Displayed Figure With Rattles

Mexico, central Veracruz. Late Classic, A.D. 600–900
Unslipped buff earthenware with traces of red cinnabar
Gift, 208:1978; H. 58.5 cm.

An especially restrained version of the "laughing boy" complex. On this the face, only, has been pressed from a mold. He is draped with a plain robe hanging to the toes. The two hollow clay rattles held out in his hands are types that have been found archaeologically. The smooth-crested headdress is decorated with twisted coils of clay. Red pigment is found there and on the ears. The bottom of the effigy and the top of the headdress are open; small holes penetrate the palms of the hands, and a vent occurs in the middle of the back.

257. Two "Laughing Boy" Effigies

Mexico, central Veracruz. Late Classic, A.D. 600–900
Unslipped buff earthenware (left), and red-slipped earthenware
with white-painted detail (right)
Gifts, 212 and 211:1978; H. 42 and 44 cm.

Like the previous figure, the fronts of these figures were manufactured in molds (the side seams are still apparent). They depict standing nude boys wearing only decorated chest bands, necklaces, ear ornaments, and trapezoidal turbans. That on the left carries a rattle in his left hand, while that on the right holds his left hand to his open mouth. Attached to his wrist is a bell.

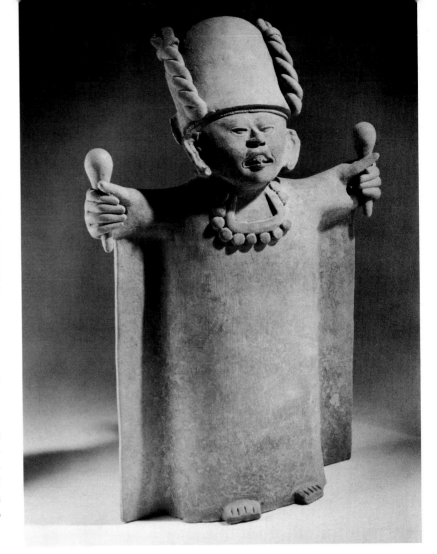

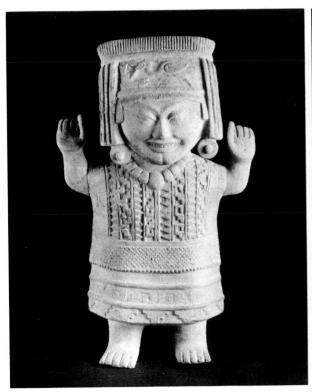

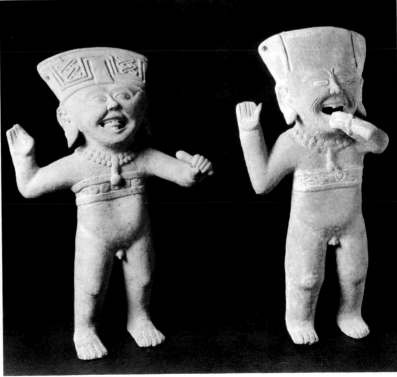

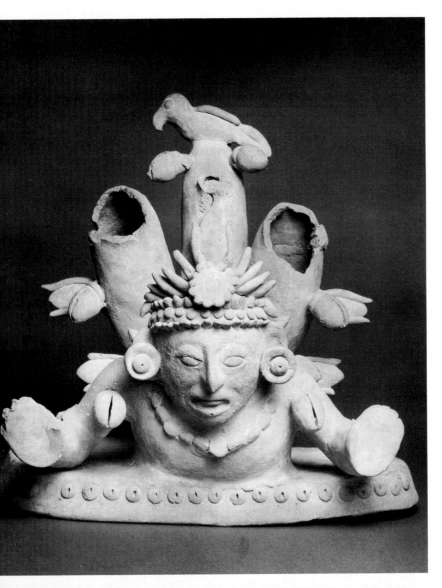

258. Incense Burner Cover With "Diving God"

Mexico, southern Veracruz. Late Classic, A.D. 600–900
Unslipped buff earthenware
Gift, 160:1979; H. 31 cm., W. 32 cm., D. 17 cm.

An unusual hollow modeled figure, mounted on a lipped, ovoid lid that must have fit over a container for burning incense. The missing forelegs at the top of the figure formerly turned forward, positioning him in the standard "diving" posture with hands held out at the bottom. Diving gods are not uncommon in the Coastal Lowlands and the Yucatan peninsula in both Classic and Postclassic times. This example has a number of applied leaves and flowers sprouting from his limbs. A cactus-like prong rises between the upturned legs, with attached blossoms (one missing), and bird on top. Birds are also missing from the elbows. It would be worthwhile identifying the plant motifs and speculating on the meaning of the iconography, as the diving god complex has not been fully interpreted in Mesoamerica. One possibility is a ballgame association [cf. 244].

259. Ladle Censer

Mexico, Gulf Coast, Veracruz. Late Classic to Postclassic, A.D. 700–1400
Buff earthenware with cream slip
Gift, 84:1980; L. 27.5 cm. (Ex-coll. George Pepper)

Ladle-form incense burners are primarily associated with the Mixtec period [cf. 168 and 169], but sporadically occur earlier. This sample is unusual in that the hollow rattle handle was mold-impressed in the realistic image of a human arm and hand, with bracelet. The style reminds one of the molded, cream-slipped, Late Classic figurines from Nopiloa in southern Veracruz (not represented in this collection).

260. Xolotl Effigy

Mexico, Veracruz-Oaxaca border region (?), Mixtec culture.
Postclassic, A.D. 1200–1400
Unslipped reddish-buff earthenware with whitewash and red paint
Gift, 333:1978; H. 77.5 cm.

Large, hollow effigies with open bottoms such as this may have functioned as incense burner covers in the Postclassic "Xantil" tradition. Escape holes were left on both sides of the ribcage, and the eyes; the nostrils and mouth also are open to the interior. Xolotl is the Mexican dog-headed "guide of the sun to the underworld," and is represented here seated on his haunches with leg ornaments, collar, and ear pendants. The shoulders, elbows, and knees have rounded protuberances backed by folds of clay, which seem to indicate exposed bones at the joints. The ribcage also is accentuated, both to connote death and the conventional aspect of the dog in Mexican iconography.

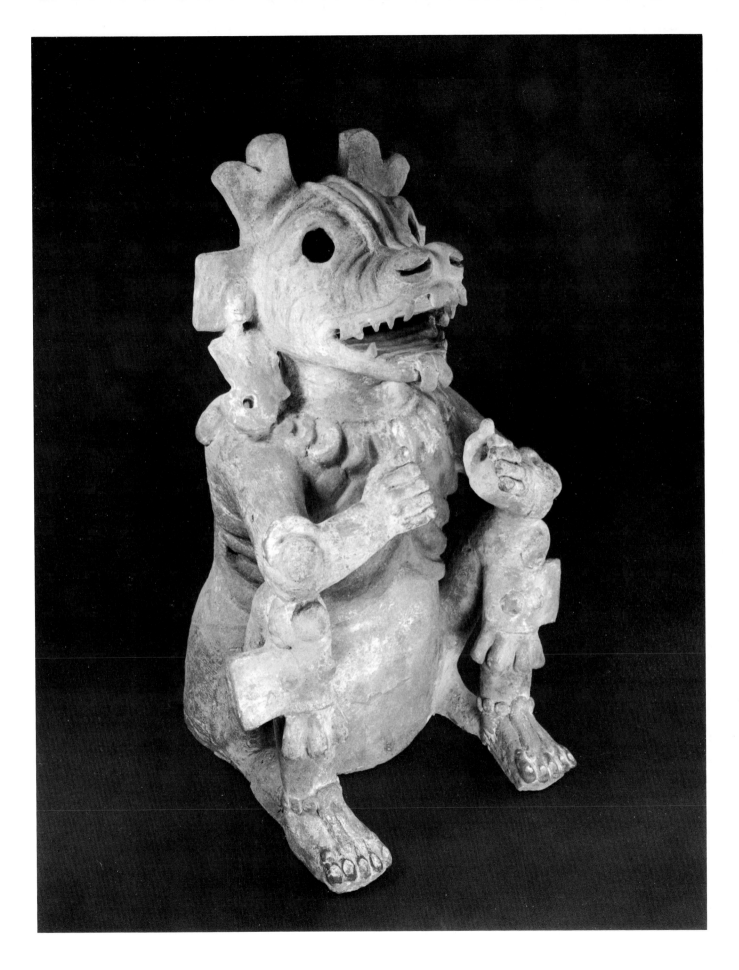

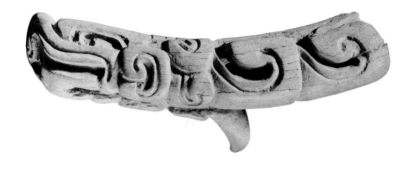

261. Polychrome Plate (Below)

Mexico, Gulf Coast (Isla de Sacrificios), Mixtec style. Postclassic, A.D. 1200–1500
Orange-slipped earthenware with cream, red, and black paint
Gift, 83:1980; H. 5.5 cm., Diam. 30 cm. (Ex-coll. George Pepper)

This ware is relatively scarce in collections. Its center of distribution is assigned to Isla de Sacrificios in southern Veracruz, where it was first reported. The style of painting, however, relates to the general Mixtec period in

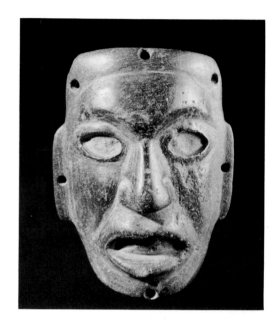

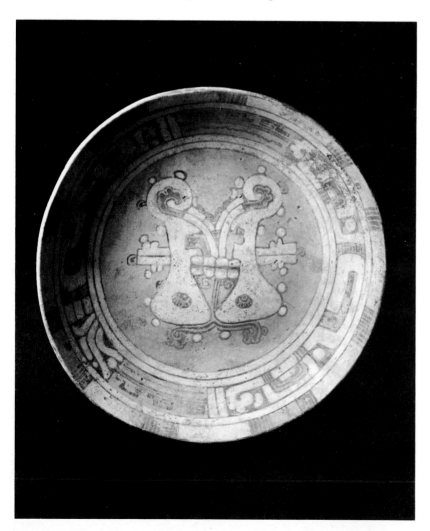

Mexico. The center of this plate features a variation of the Mixtec "earth bowl" motif, with the toothy open jaws of the saurian earth monster in Mexican mythology. The side panels include abstract versions of the profile serpent. The distinctive colors used include a light orange background, with painted areas in cream and brown-black outlining (with touches of orange-red). The exterior of the rim has bands of cream and red.

262. Serpent-Form Wand or Atlatl Fragment (Upper left)

Mexico, Gulf Coast, Classic Veracruz style. Middle Classic, A.D. 400–700 (or earlier)
Deer antler
Gift, 309:1978; L. 13.5 cm.

This intricate carved fragment may have been the handle of a spear thrower (note the projecting grip). The carving terminates in a serpent head with upturned snout facing left. The surface of the shaft is decorated with a series of Tajin (or Classic Veracruz) style C-shaped and interlaced scroll motifs, which in turn may derive from the earlier Izapan tradition [cf. 206]. Openwork separates the two rear scrolls, and a circular perforation is located at the base of the prong.

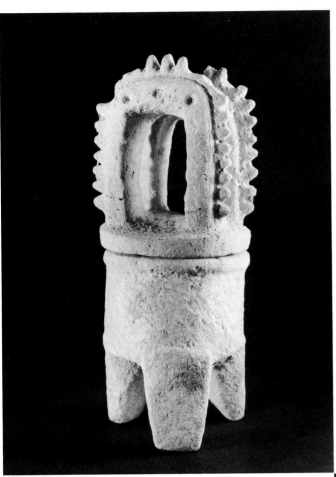

surfaces have conical depressions—three on one side and nine on the other. The tripod vessel form identifies the piece as belonging to the Teotihuacan epoch in Mesoamerica, when this mode was widespread [see 133 and 305]. The double loop-handled cover, however, is unique, though it calls to mind some of the ballgame "hand stones."

265. Head of Xipe, the "Flayed God"
Mexico, Veracruz, Mixtec or Aztec style. Postclassic, A.D. *1200–1500*
Volcanic stone with red paint
Gift, 159:1979; H. 26 cm.

The intent of this sculptural fragment (it is broken from a lifesize figure) is best seen on the reverse side, where the serrated, flayed over-layer of human skin is realistically depicted. The sacrificial skin is tied onto the head of the priest wearing it by means of low-relief knotted cords (see 252 for a fuller explanation of Xipe). The gaping outer skin mouth reveals the real mouth underneath it. Stark realism such as this is characteristic of the Late Postclassic in Mexico. All of this image except the face is stained red.

263. Maskette (Facing page)
Mexico, Gulf Coast, Teotihuacanoid style. Middle Classic, A.D. *400–700*
Specular diorite
Gift, 289:1978; H. 11.2 cm., W. 8.5 cm.

A very similar miniature stone mask illustrated by Easby and Scott (1970, item 114) is identified as coming from eastern Puebla. The style of the face, at any rate, is a cross between Teotihuacan and Remojadas conventions. The reverse is concave, and the eyes and mouth are deeply excised as though to hold inlays. Six biconical perforations are found around the perimeter.

264. Cylindrical Tripod Vessel With Loop-Handled Cover
Mexico, probably Gulf Coast, Teotihuacanoid style. Middle Classic, A.D. *400–700*
Light gray limestone
Gift, 85:1980; Total H. 24 cm., Vessel H. 12 cm., Diam. 10 cm. (Ex-coll. George Pepper)

This strange stone vessel has three slab feet and a cover with a pair of U-shaped handles. The cover has a disclike ledge, which fits into the mouth of the vessel. The perimeters of the loop handles are spiked, while the outer

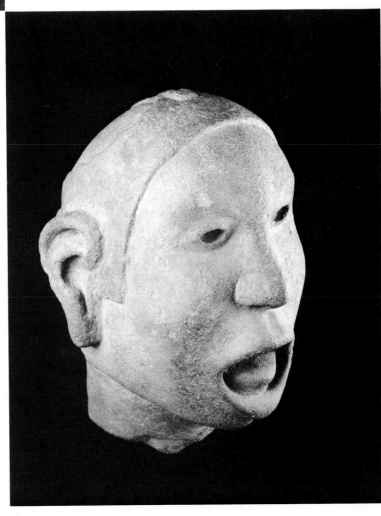

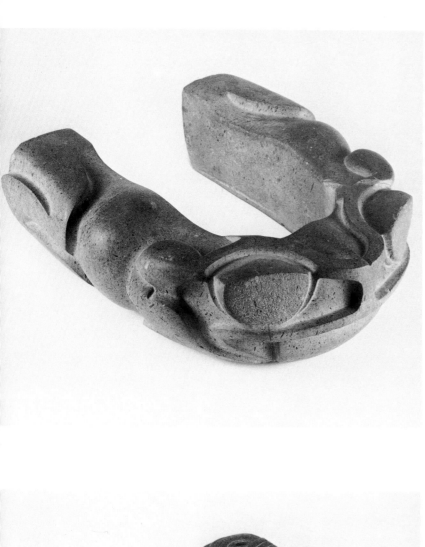

266. Toad Effigy Ballgame Yoke

Mexico, Gulf Coast, Classic Veracruz style. Early Classic, A.D. 300–600
Polished greenish-gray granite
Gift, 383:1978; L. 42 cm., W. 38 cm., H. 13.5 cm.

Ballgame yokes carved as stylized toads are among the more common of the known inventory of these objects. It is believed that this relatively naturalistic subject matter, adapted in-the-round to the U shape of the yoke, is early in the sequence of development of Classic Veracruz ballgame paraphernalia. It is deeply carved, the ends are plain, and the inner edge is unpolished. Note the eyes and broad mouth on the front, and the bent legs on the sides.

267. Carved Ballgame Yoke

Mexico, Gulf Coast, Classic Veracruz style. Late Classic, A.D. 600–900
Polished dark green granite (See color plate)
Gift, 86:1980; L. 40.5 cm., W. 36 cm., H. 11.5 cm. (Ex-coll. George Pepper)

This example is as elaborate as these exquisitely carved stone yokes can be, although, unlike some others, the ends of the arms are plain. It illustrates the Classic Veracruz ("Tajin") outlined, interlaced scroll motifs, but in addition is extraordinary for its asymmetrical front figure, whose long-snouted head overlaps the top border of the stone. This creature is crouching with his haunches to the right and the head facing left. One bent arm can be seen on the left, while the other is raised behind the head. On the rear corners are similar long-snouted "dragon" heads, while the spaces between these figures are filled with interlaced scrolls.

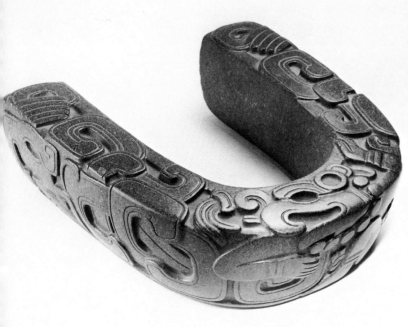

268. Ballgame Yoke (Facing page)

Mexico, Gulf Coast, Classic Veracruz style. Late Classic, A.D. 600–900
Polished, speckled green granite
Gift, 356:1978; L. 40 cm., W. 33 cm., H. 11 cm.

This finely carved object, like the previous one, represents the ultimate of Classic Veracruz stonework in commemoration of the ballgame. Typically, the top and outer surfaces as well as the ends of the arms are carved with a design that, as redrawn, is a complete reptilian representation. (The inner and bottom edges are ground smooth.) The limbs of the crouching reptile are shown on the sides and the broad head is on the front of the yoke. Within its mouth is a human head, while folded around the ends of the yoke are supplementary long-snouted monster heads.

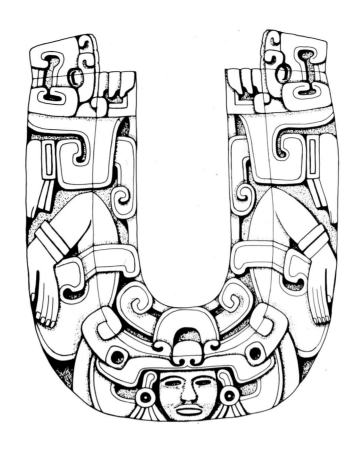

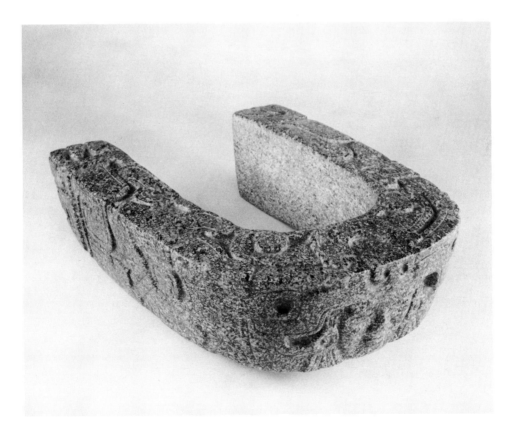

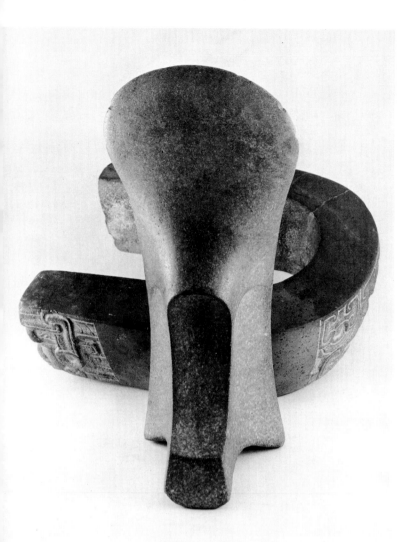

269. Yoke and *Palma*

Mexico, Gulf Coast, Classic Veracruz style. Late Classic, A.D. *600–900*

Green granite

Gifts, 331 and 332:1978; H. 12.5 cm., L. 40.5 cm., W. 8 cm. (yoke); H. 42 cm., W. 21 cm. (palma) (332:1978 illustrated: Von Winning, 1968, items 301, 302)

According to the original dealer, these two objects were found together in the same cache. Although yokes and *palmas* functionally belong together, instances of their being buried together are rare. While the greenstone raw material may be the same in the two objects, the curved bottom of this *palma* is not designed to fit the angular top edge of this particular yoke, as it should. (These stone objects, in any case, probably are ceremonial replicas of the actual wooden ones used in the game.)

The fan-shaped stone *palma* has smooth-polished surfaces. Its back is slightly convex, and expands to a broad crest at the top. The lower half of the front surface has three, pecked, concave facets. The stone yoke has polished outer and upper surfaces, whereas the bottom and inner surfaces are rough. The three low-relief carved panels on the side demonstrate the local classic interlaced scrolls. The front panel features an abstract serpent (or toad) head, with a human face revealed in its open mouth. The reptile's nostrils may be seen above and its scrolled eyes on either side. The rear corner panels show human heads, with one profile on the outer surface and the other profile on the end surface.

270. Carved *Palma*

Mexico, Gulf Coast, Classic Veracruz style. Late Classic, A.D. *600–900*

Dark gray volcanic stone

Gift, 364:1978; H. 40 cm.

Characteristic Tajin style ballgame *palma* with projecting curved base, designed to fit onto the side of a yoke facing forward, and directed upward at an angle (as yokes and *palmas* are illustrated being worn together in some of the extant bas-relief ball court panels at El Tajin and Chichen Itza). Both sides are precision-carved, highlighting masses of interlaced, outlined scrolls. The symbolic significance of the convex back is not obvious, except for the central eye motif; the front features a high-relief Xipe face, closed eyes, and a composite feathered headdress.

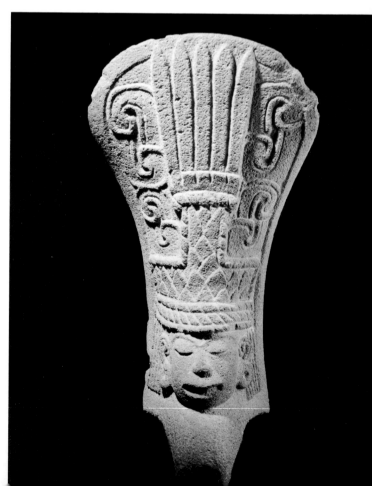

271. *Palma*

Mexico, Gulf Coast, Classic Veracruz style. Late Classic, A.D.
600–900
Gray volcanic stone
Gift, 213:1978; H. 51 cm.

Another *palma,* this one carved only on the front surface.
Amid outlined "cloud" scrolls, with comma-shaped ap-
pendages, is an ascending anthropomorphic figure with
scrolled eye frames and human nose. His left arm grasps
a volute at the side, while his right arm is suppressed. His
knees are sharply bent, with the feet raised laterally.

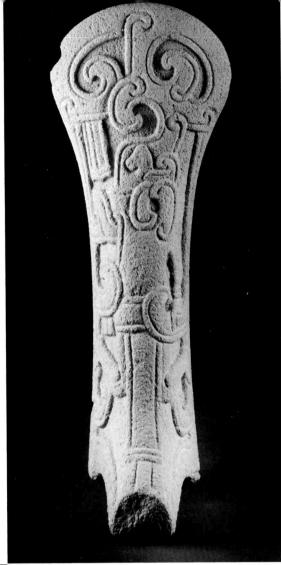

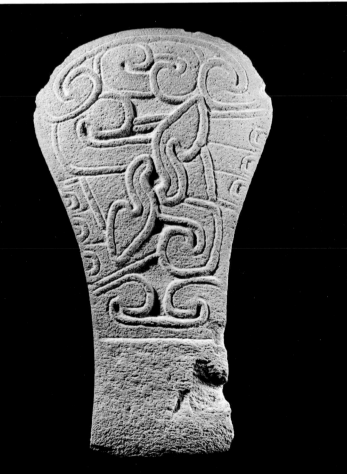

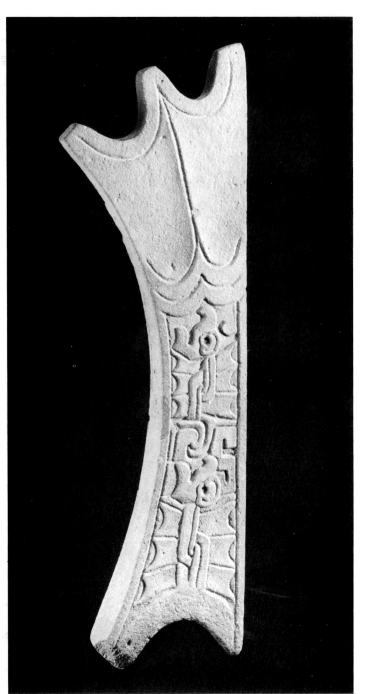 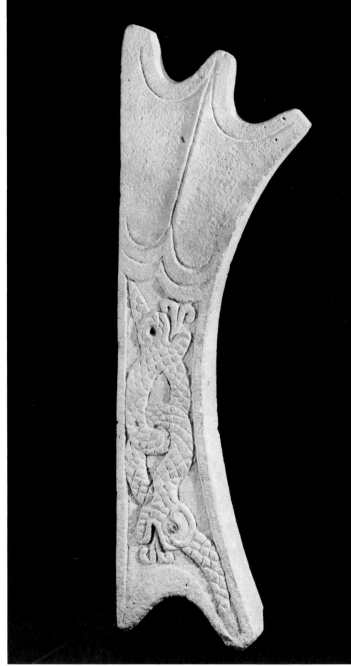

272. Tall *Palma*

Mexico, Gulf Coast, Classic Veracruz style. Late Classic, A.D.
600–900
Gray volcanic stone
Gift, 385:1978; H. 61 cm.

A fan-shaped *palma,* flattened from side to side, with
differently carved low-relief panels on either surface.
One side contains two bats; the other is carved with two
interlocking serpents. The drilled eye of the lower ser-
pent retains its obsidian inlay.

273. Mosaic *Hacha* in the Form of a Death's Head

*Mexico, Gulf Coast, Classic Veracruz style. Early Classic, A.D.
300–600*
*Black pumice with stone and shell inlay, lime stucco, and paint
Gift, 310:1978; H. 18.5 cm., W. 14 cm.*

Although in poor condition, this is an extraordinary object. While full-round carved stone *hachas* are common to the Early Classic period on the Gulf Coast [cf. 274–276], this is the only mosaic inlaid example known to this writer. The stone used for the head is a porous volcanic pumice. The entire front surface was originally overlaid with clay and lime stucco, as well as inlaid with areas of white shell, green jade, black obsidian, and orange coral; intervening zones of lime stucco were painted red, or left white.

Much of the mosaic work is presently missing. However, the left eye contains a ring of jade surrounded by smaller pieces of the same material. The nasal bridge bears a triangle of jade. Bits of jade also are set along the upper lip, the cheek line, and in the tooth row. Coral remains at the right corner of the gaping mouth. Obsidian is found on the right forehead, with squares of shell on the temporal crest. The carved stone head features a scored tongue, sagittal and temporal crests, as well as a rectangular tenon projecting from the back—confirming that this object was a ballgame *hacha*, sculptured as a dead "trophy head." *Hachas* were attached to the sides of yokes in the same functional position as the *palmas*.

274. Full-Round Head *Hacha*

*Mexico, Gulf Coast, Classic Veracruz style. Early Classic, A.D.
200–400*
*Dark gray volcanic stone
Gift, 377:1978; H. 15.5 cm.*

While one might be tempted to call this carving "Olmecoid," it in fact represents a version of the prevalent "fat god," with a prominent crest on its forehead. Full-round head *hachas* nevertheless are relatively early in the developmental sequence of the form, with the "thin stone head" variation appearing later [see 277]. The back of the *hacha* is flattened and has a rectangular tenon (for fitting into a wooden yoke?). The earlobes are biconically perforated.

275. Full-Round *Hacha*

*Mexico, Gulf Coast, Classic Veracruz style. Early Classic, A.D.
200–400 (or earlier)*
*Cream-colored marble, with remains of red paint
Gift, 158:1979; H. 15.5 cm.*

A superbly carved *hacha*, featuring a monster head with bulbous crest, tongue descending from the prominent upper lip, rounded scrolls at the sides of the head, and upward-projecting scrolled ears. The back has a shallow notch for attachment to a yoke. It illustrates an early developmental stage of Tajin scroll forms which, in turn, probably evolved from the Izapan art style [206].

The ultimate intention of this sculpture (as of the previous one) may well be the trophy head. The custom of attaching human head forms to belts (whether ballgame or not) is prevalent in Mesoamerican iconography, especially Maya. This may recall a primary, archaic, New World trait of trophy head collecting, and the display of them on the belt. In some versions of the ancient ballgame, human heads were sacrificed at the conclusion. (Note also the stone ball player, with trophy head, from Costa Rica, 351.)

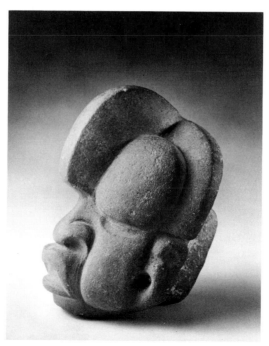

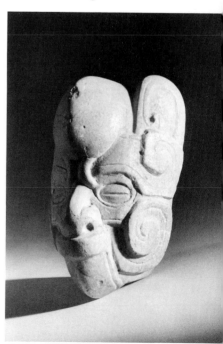

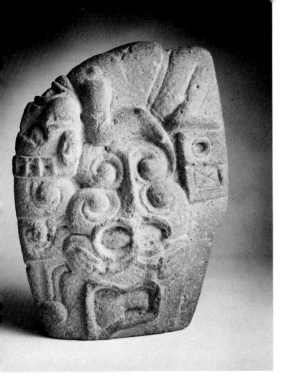

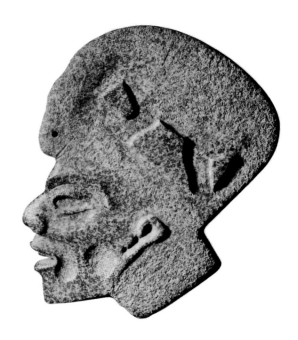

276. *Hacha*
Mexico, Gulf Coast, Classic Veracruz style. Middle Classic,
A.D. *400–700*
Dark gray volcanic stone
Gift, 366:1978; H. 24.5 cm.

An elaborately carved *hacha,* with the identical design on
both faces. It has the expected shallow notch at the rear,
but the cross section is more rounded and thicker than
normal. Laid across the top is a sacrificial victim with bent
legs; its fat face is similar to another *hacha* in the collec-
tion [274]. Occupying the sides is what may be intended
as a double-eyed parrot (vulture?) head, from which Ta-
jinoid scrolls emerge.

277. Tenoned *Hacha* (Thin Stone Head) (Upper right)
Mexico, Gulf Coast, Classic Veracruz style. Middle Classic,
A.D. *400–700*
Mottled green granite
Gift, 395:1978; H. 25 cm., W. 19 cm., D. 3.5 cm.

A profile human effigy, carved in mirror image on both
sides of the "thin stone head." Only the face and the
raised trapezoids in the headdress are polished, suggest-
ing that the latter forms are negative fillers for a previous
animal effigy overlay in a different material. The head of
this now obscure animal hangs over the forehead and
contains an eye perforation. The nostrils of the human
face are also drilled, and the cheeks have concavities. The
tenon is located in the neck position.

278. *Hacha* (Thin Stone Head) (Below)
*Guatemala, Pacific Coast, Cotzumalhuapa style. Middle to
Late Classic,* A.D. *400–900*
Gray volcanic stone with remains of red cinnabar
Purchase, 38:1960; H. 28.5 cm., W. 22.5 cm., D. 5.5 cm.

Head effigy *hacha,* probably representing a monkey. The
bilobed, raised facial area and the bulging forehead
confirm this identification. As with all of these "thin

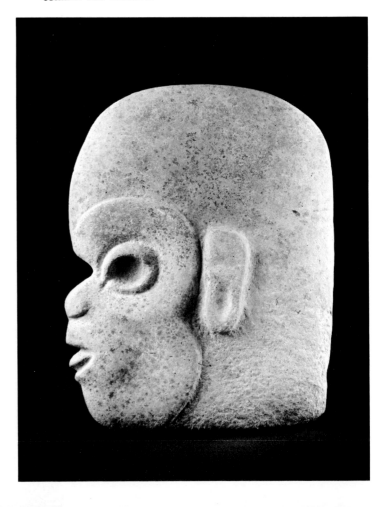

stone heads," both flat faces of the stone are carved in identical profile, with top and front forming a sharp edge, and bottom and back flattened at the maximum thickness. The squared-off rear corner, lacking a notch or tenon, is characteristic of Pacific Coastal Lowland *hachas*. While the stylistic features of yokes and *hachas* from this region differ from the Veracruz prototypes, we know that the complex of stone ballgame paraphernalia diffused from the Gulf Coast to the Pacific Coast as far south as El Salvador during the Middle Classic period.

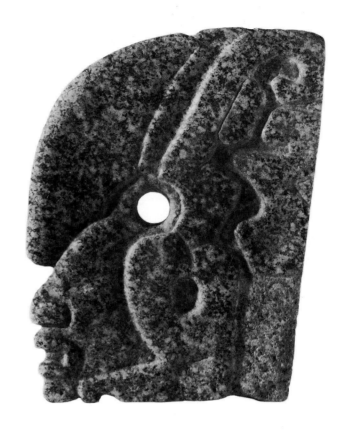

279. Ballgame *Hacha*
Mexico, Pacific Coast of Chiapas, Cotzumalhuapa style. Middle to Late Classic, A.D. 400–900
Polished greenstone with traces of red cinnabar (See color plate)
Gift, 98:1968; H. 30.5 cm., W. 23 cm., D. 4 cm.

Another "thin stone head" with a squared lower rear corner manufactured in the southern Coastal Lowlands. Like the previous one, it was inspired by the Gulf Coast complex; but here is a component of the general Pacific Coast Cotzumalhuapa culture of the Classic period. Carved on both faces is a long-beaked bird monster carrying a human head in its open mouth. The circular eyes of the bird are deeply indented, and there is a complementary round perforation at the base of the beak.

280. Thin Stone Head
Guatemala or Chiapas, Pacific Coast, Cotzumalhuapa style. Middle to Late Classic, A.D. 400–900
Polished black basalt with traces of red cinnabar
Gift, 256:1978; H. 34 cm., W. 25 cm., D. 3.5 cm.

Another ballgame *hacha* of the same basic style and pattern as the previous one. This is perforated in the top center, and in front of the human face. Also the lower rear corner has a shallow notch more in the fashion of Gulf Coast *hachas*. It represents, in double profile, a parrot head containing a human head in its mouth. The long beak of the bird descends in front of the face and its eyes are surrounded by double scroll motifs. (The circular eyes of the bird had been pecked, but at some point in the history of the object they were filled and patched.) Either they were intended to be inlaid with another material; or a complete perforation, like the circular hole above, was started and abandoned. A serpent rises from the upper eye scroll, follows the front crest, and ends in a scroll-eyed head. (The notch behind the serpent's head was caused by recent damage to the object.)

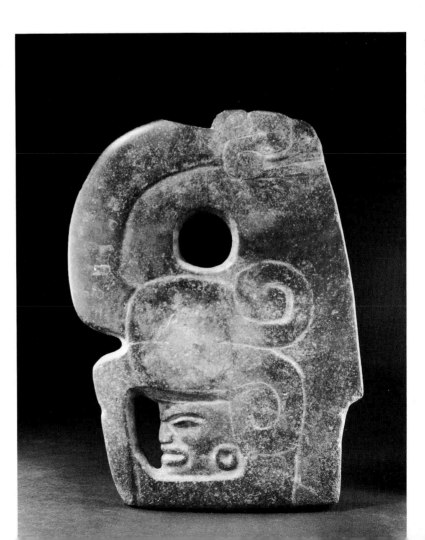

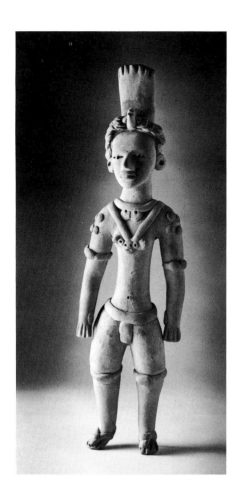

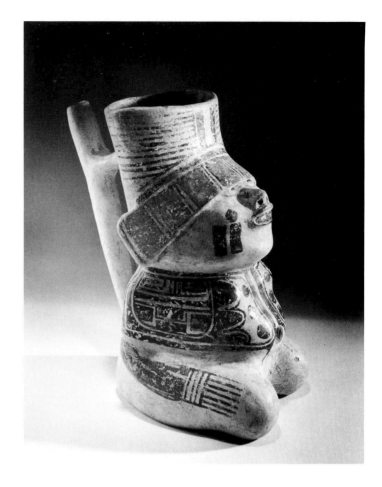

281. Large Solid Figurine

Mexico, northern Gulf Coast, Huastec culture. Early Classic,
A.D. *300–600*
Buff earthenware with traces of black paint
Gift, 244:1978; H. 36.5 cm.

Although many of the Huastec style figurines portray ball
players, this object does not clearly do so. It has double
knee pads and elbow ornaments, and a simple loincloth,
rather than the yoke and single knee and elbow pads that
Pre-Columbian ball players normally wore. Huastec figu-
rines are usually tall and linear, like this type piece, and
have horizontal slit eyes with central punctations.

282. Human Effigy Vessel

Mexico, northern Gulf Coast, Huastec culture. Postclassic, A.D.
1200–1500
*Cream-slipped earthenware with red and black paint (See color
plate)*
Gift, 207:1978; H. 21 cm.

A classical example of late Huastec style ceramics from
northernmost Veracruz in the region of the Panuco
River. This open-mouthed, modeled vessel has a vertical
spout connected to the neck by a bridge. The explicit
details of decorative painting on the compact figure are
applied in both red and black paint.

283. Old Man Leaning on Staff

Mexico, northern Gulf Coast, Huastec culture. Postclassic, A.D.
1200–1500
Gray sandstone with traces of red paint
Gift, 361:1978; H. 57.5 cm., W. 31.5 cm., D. 6.4 cm.
(Illustrated: Von Winning, 1968, item 329)

A flat, openwork figure, with a short vertical tenon below
the feet (not shown in these photos). This sculpture illus-
trates the pervasive Mexican dualistic representation of
life and death, or youth and old age, on two sides of the
same object. Similar concepts are depicted on clay masks
from Tlatilco 2,000 years earlier. One side is fully
fleshed, while the other shows a wrinkled old man's face,
and exposed ribs and leg bones. Red paint adheres to the
eyes, mouth, and face wrinkles. (Two original breaks in
the stone have been repaired so as not to be visible.)

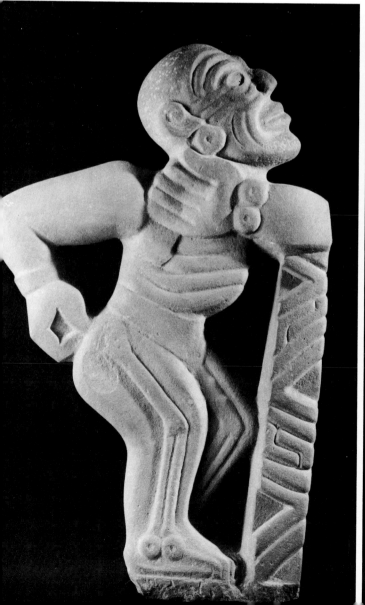 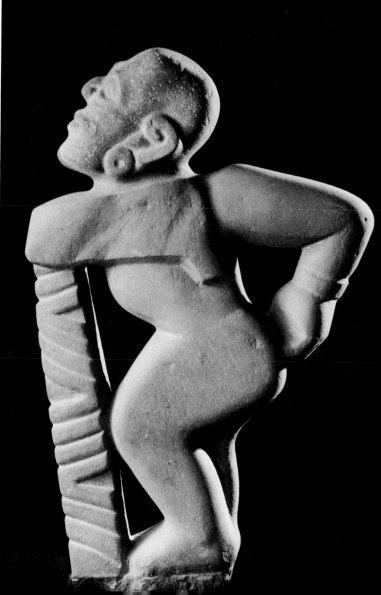

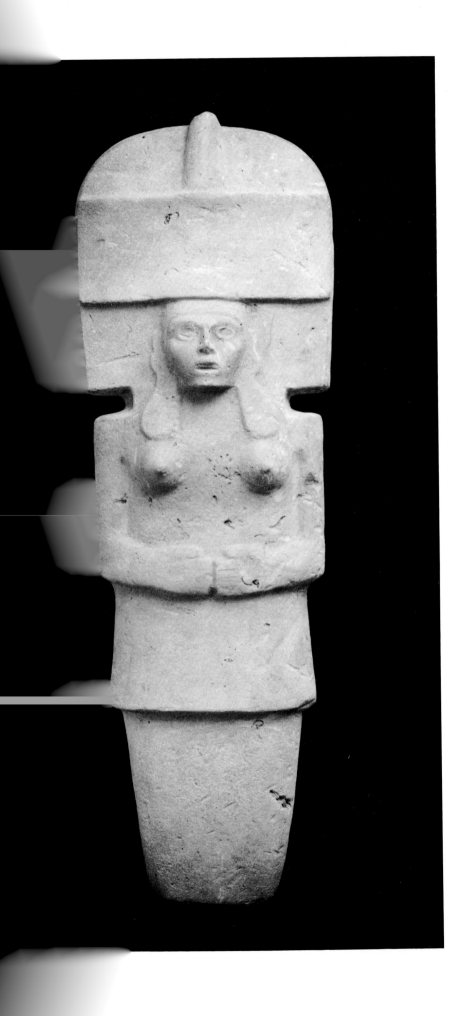

284. Carved Stone Monument

Mexico, northern Gulf Coast, Huastec culture. Postclassic, A.D.
1200–1500
Buff-colored sandstone
Gift, 270:1978; H. 160 cm., W. 52.5 cm., D. 20 cm.

Large slablike stone figures carved in fairly low relief are
common to the Postclassic Huastec culture. This one is
minimally carved, with a restraint that recalls ancient
Egyptian sculpture. It depicts a standing, skirted female
figure with a plain banded headdress and a conical center
ornament. The back of the flat monument is smoothed
but undecorated. A number of other examples are more
elaborately carved, often with dualistic images on both
front and back. (Two other stone sculptures from the
Huastec region, in Aztec style, were illustrated in a previ-
ous section, 185 and 186.)

Maya Area

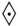

In the seemingly forbidding rain forest area of Guatemala and neighboring territory, there emerged during the Classic period the most splendid and advanced civilization of the New World. This area was occupied from Early Preclassic times onward, and villages or ceremonial centers were established, and grew, throughout the entire Preclassic period. However, most of the features we associate with Maya civilization—such as vaulted architecture, stone sculpture, and writing—did not become evident until the Terminal Preclassic (the earliest carved monument with a calendrical date does not show up in the Maya area, at Tikal, until the end of the third century A.D.). We attribute much of the developed nature of Maya art, sculpture, and writing to the peripheral coastal Izapan culture—and its extension at Kaminaljuyu in the highlands, outside of modern Guatemala City—that flourished around the time of Christ. Izapa's innovations, in turn, built upon Olmec cultural foundations.

Therefore, when talking about Maya civilization, we are primarily referring to the Early and Late Classic Maya, A.D. 300–900. The peak of the Maya achievements is encountered in the Central Lowlands at such spectacular ceremonial centers as Palenque, Tikal, and Copan. However, ramifications of this civilization, with regional differences, are found both in the Southern (Guatemala) Highlands and the Northern (Yucatan) Lowlands. While Maya civilization disappeared in the Central Lowlands by the tenth century A.D., Postclassic survivals of Maya culture lasted to the time of the conquest in the other two geographical regions.

Before embarking on the specific art styles of the three Maya subregions, two general subjects that characterize Maya civilization as much as the luxury material goods found in museum collections should be mentioned: writing and architecture.

The foremost intellectual achievement of man in the New World was realized in southeastern Mesoamerica—a system of hieroglyphic writing and

an accurate calendar. Hieroglyphs and calendars were intimately related to religious concepts, and each graphic element featured deities or sacred symbols. The ancient Olmecs possibly invented writing in the first millennium before Christ, and both the Zapotec and the Izapan cultures inscribed some of the first calendrical monuments; but the Classic period Maya perfected the hieroglyphic system. Inscriptions were carved on stone monuments and also drawn on screen-fold books of deerskin or lime-coated bark paper. (Only three or four of these Maya books, or codices, survived the ravages of time and the purges of the first Spanish missionaries.) Other systems of writing evolved in Mesoamerica, such as those of the Mixtec and Aztec peoples. Many Postclassic period manuscripts in these systems have been preserved, but they display a more simplified picture writing, and their calendars are nonspecifically recorded, primarily by the use of the twenty basic signs for the days of the month.

Not much more than 20 percent of the Maya hieroglyphs have yet been deciphered, and most of the securely translated glyphic characters pertain to the calendar. Well over 400 discrete Maya hieroglyphs are known. They are basically ideographic (pictures representing units of meaning), but also have attached phonetic elements (expressing linguistic sounds). Other than the calendrical content of the inscriptions, most are straightforwardly historical, and some are esoterically religious.

The basic calendrical notations were probably invented in Preclassic times in order to predict the seasonal cycles for the benefit of agriculture. The Maya elaborated them into an exceedingly complex ritual system. Other calendars were used in Mesoamerica, but all have the following elements in common: the bar (for 5) and dot (for 1); vigesimal counting (by 20s); a solar year (18 "months" of 20 days, plus an unlucky 5-day period to equal 365 days); a simultaneous "sacred year" of 260 days (the same 20 day names in 13 revolutions); and a 52-year "calendar round" (the interlocking solar and sacred calendrical cycles, which both mesh and start over again on the same day once every 52 years). The Maya are credited with using the concept of the zero before it was invented in the Old World. The Maya also had accurate supplementary Lunar and Venus calendars, as well as tables of eclipses. These calculations necessitated advanced mathematics and sophisticated astronomical observations. The calendar in common use in Mesoamerica when Cortes arrived was astronomically more precise than the Julian calendar then available to the Europeans.

The Maya were fascinated by time, and recognized patron deities for each of the twenty named days and the eighteen named months of the solar year, as well as years grouped in multiples of twenty. Each unit was represented by a compound glyph portraying the mythological patron deity, often with a bar-and-dot number. Each calendrical date was recorded in a so-called Initial Series or Long Count. This consisted of five positions. As an example, the notation 9.17.5.0.0 calculates, from the arbitrary starting point of the calendar, the elapse of:

9 *Baktuns* (9 × 400 years of 360 days)
17 *Katuns* (17 × 20 such years)
5 *Tuns* (5 years)
0 *Uinals* (no additional months of 20 days)
0 *Kins* (no additional days)

Inscriptions are normally ordered in two vertical columns read from left to right, top to bottom [see 325]. The accepted correlation of the Maya calendar to the Christian calendar places the "year 1" at 3113 B.C. Following the formula above, the typical inscription, 9.17.5.0.0., then translates to A.D. 775.

The development of Maya architecture was indigenous to the Central Lowlands. The fundamental invention of the inverted, V-shaped corbeled vault for spanning interior space appeared in the first centuries before Christ at Tikal. Even in the Late Preclassic period, the basic Maya pattern of palaces on platforms and temples on stepped pyramids, arranged around open courts, was established. In the Classic period, Maya architectural styles varied discernibly from site to site and from region to region. Common to most was the desire for a sense of height. False facades and decorated "roof combs," or crests, which adorned the tops of temples, increased the effect. Pyramids were usually tall and steep-sided, and they supported stonemasonry temples with two or three narrow, vaulted, inner galleries. Surfaces were a veneer of cut limestone, while the hearting was of rubble. Lime mortar and plaster were used extensively. Such structures at Tikal measure as much as 200 feet from base to summit. Painted frescoes (best known from Bonampak), modeled stucco work, low-relief wall panels, and carved doorway lintels, all lent extra embellishment to the architecture.

The Late Classic architecture of the Northern Maya Lowlands—especially in the Puuc region of Yucatan and such sites as Uxmal and pre-Toltec Chichen Itza—differs in its emphasis on low-ranging buildings with plain lower registers and stone-mosaic upper registers, as well as doorways framed by mammoth serpent mouths. The architectural sculpture here often features the Maya rain god Chac, with his long, curled upper lip (this prevalent image, in fact, may more specifically refer to the supreme Maya deity, Itzamna). A unique round structure at Chichen Itza, the Caracol, functioned as an astronomical observatory for sighting the equinoxes and solstices.

A dominant attribute of most Maya ceremonial centers, especially in the central area, was the custom of carving commemorative stone stelae, usually combined with round altars. These were set up in front of buildings and in the plazas. The faces of these monuments were carved with the images of ceremonially garbed élite personages, and their sides and backs were inscribed with hieroglyphic texts telling of the reigns of the rulers depicted, accompanied by pertinent calendrical dates.

The first two objects [285 and 286] come from the Pacific Coastal Lowlands of Chiapas and Guatemala, and actually are representative of the extended region beginning on the Gulf Coast of Mexico; they are culturally

non-Maya. (In the previous section we illustrated several ballgame *hachas* from this same region.) These particular two ceramic sculptures demonstrate Teotihuacan presence in the south during the Middle Classic period. The next group of ceramics [287–291], however, illustrates the Maya subregion of southern Guatemala, which is limited to the inland Chiapas-Guatemala volcanic highland zone. The site of Kaminaljuyu dominated this region in the Preclassic and Early Classic periods, until it reached its culmination with the takeover as a foreign colony of Teotihuacan. A number of Classic period Maya ceramic styles are found in the central and western highlands, which are not often illustrated in popular literature [287–290]. The highland Maya also continued to exist here in the Postclassic period (see the late incense burner, 291), until their fortified hilltop capitals of Utatlan and Iximche succumbed to Cortes's captain, Alvarado, in the year 1524.

Before examining the center of Maya civilization, let us look at its extension in the Northern Maya Lowlands. In the flat limestone Yucatan peninsula, Preclassic and Early Classic Maya remains are scanty. However, the Late Classic period (A.D. 700–950) paralleled the Central Lowlands in a superlative regional expression of Maya art and architecture, in which the impressive sites of Uxmal, Kabah, Sayil, Labna, and early Chichen Itza are vividly called to mind. Orange-slipped and gray-paste ("slate ware") ceramics are particularly diagnostic of this time and place [292–294]. Unlike the Central Lowlands, the northern region continued to flourish after the Classic period. The Mexican Toltecs dominated Yucatan (especially at Chichen Itza, which they colonized) in the Early Postclassic era, A.D. 950–1250, though much of the art of this period shows a fusion of the Maya and Toltec styles [see 295 and 296]. At Chichen Itza we find such edifices as the great Ball Court, the Temple of the Warriors, and the Castillo—all of which show the local Maya style modified and remodeled with Tula-Toltec conventions. (It was customary, in any case, for major Pre-Columbian buildings to be added to periodically, with new architectural shells, throughout their history.) After the demise of Toltec power, late Maya civilization reemerged weakly in the following centuries at such sites as Mayapan and at Tulum on the east coast of Yucatan. Incense burners (resembling 291 from southern Guatemala) survive from this period, often found in sacred caves. The first European landfall in Mesoamerica occurred here with the Cordoba expedition in 1517, when the Maya were "discovered" but not "conquered."

Illustrated next is a group of Late Classic Maya modeled clay figurines [297–304], all presumably from cemeteries on the Island of Jaina off the west coast of the Yucatan peninsula. We consider them the epitome of Maya ceramic sculpture in their extreme sensitivity and realism, whether or not we wish to associate them with the northern or central Maya regions (comparable figurine types are also found in the more southern regions).

The tropical region (the Central Maya Lowlands), spreading from the Gulf of Mexico to the Gulf of Honduras, and focusing in the rain forests of the department of El Peten in northern Guatemala, nurtured the richest

development of Classic Maya civilization. The great Maya ceremonial centers here experienced a brief Teotihuacan-influenced interlude in the Middle Classic period [see 305], but Maya civilization easily weathered that interruption to reach its culmination in the Late Classic years, A.D. 600–900. We illustrate only one Early Classic, Tzakol phase, Maya object [306], while the remainder represent the Late Classic, Tepeu phase [307–331]. Maya polychrome, figure-painted, "orange-gloss" ware, funerary pottery [307–313, 326–330], as well as carved and modeled wares [314–316], survive to remind us of this once opulent civilization. Modeled lime-stucco heads from the architecture [317–322], carved jade [323, 324], and monumental and small stone sculptures [325 and 331] also increase our awareness of the range of Classic Maya art. (Objects 326–331 came from the Honduras-El Salvador southern periphery of the Central Maya Lowlands.)

The ninth century witnessed the downfall and abandonment of most major Central Lowland Maya ceremonial centers, for reasons not completely understood. Early Mexican, Toltec-related, inroads (invasions?) have been observed at sites like Seibal in the Peten, but one wonders whether the élite Maya social and religious system itself did not finally break down, with the masses doubting and mistrusting the divine authority of the priests and rulers, who by then may have become very involuted and self-serving. Could there have been massive popular revolts? In any case, once the rulership was deposed, the intellectual dimension of the culture was gone; monuments ceased to be carved, and the grand ceremonial centers no longer served a useful purpose other than as disintegrating shrines to some past glory. During the Postclassic period there was only minor activity in the Central Maya Lowlands. When Cortes himself traversed the Peten territory in 1525, he found but a shadow of former Maya existence there. The peasant farmers continued to populate the rain forest area, retained vestiges of their religion and mythology, and survive today in such almost extinct Maya groups as the Lacandon Indians of lowland Chiapas. Maya-speaking Indians also survive to this day in Yucatan and in the highlands of Chiapas and Guatemala.

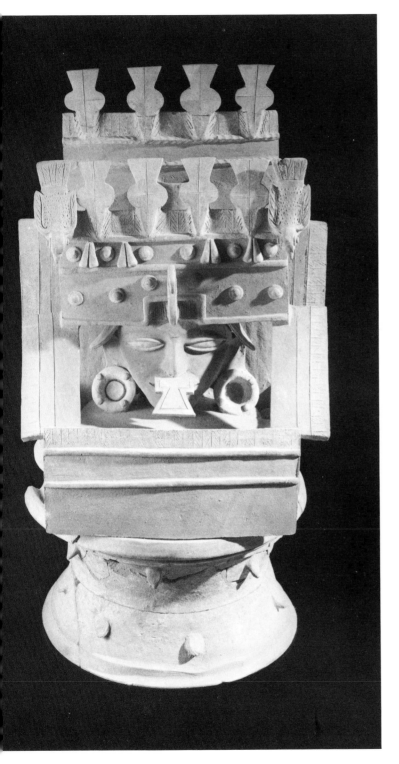

285. Composite Incense Burner

Guatemala, Pacific Coast (probably Escuintla), Teotihuacan style. Middle Classic, A.D. *400–700*
Polychromed buff earthenware
Gift, 174:1979; Total H. 56 cm., H. of base 13 cm., Diam. 26.5 cm.

Elaborate appliquéd incense burners of this type originated at Teotihuacan in Central Mexico (see 128 for the prototype). About ten years ago, a great number of them turned up along the coast of Guatemala in mounds being bulldozed by the landowners. These objects are among the most incontrovertible evidence for the physical presence of Teotihuacan traders and colonists on the southern Pacific Coast and adjacent highlands. The censer has a separate hourglass-shaped base for holding the incense. Its bowl is supported by a pedestal, and the exterior is whitewashed. The prongs apparently represent the thorns on the native *amatle* tree—the tree utilized for making bark cloth (shredded bark cloth was occasionally burned as incense, as well as the resin called *copal*). The effigy portion rests on an inverted bowl form, which serves as a cover for the hourglass base. The whole decorative superstructure surrounds a clay chimney through which the smoke was released. Two handholds are provided on either side for lifting the cover.

Placed in the center of the rectangular framework is a Teotihuacan style face mask, with its trapezoidal nose pendant symbolizing the rain god Tlaloc. Projecting from the hairline is a scrolled serpent-snout element. Appliquéd on the top are two bird effigy *adornos,* and double rows of abstract birds. It is painted in zones of white, yellow, and red.

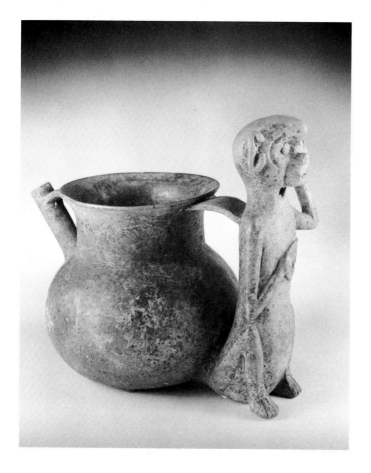

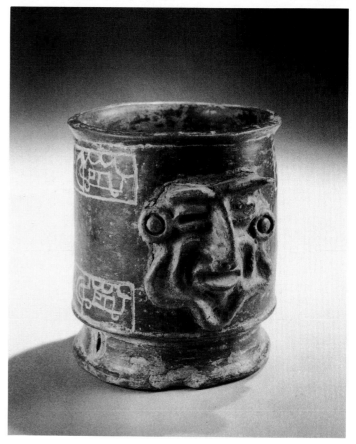

286. Bridge-Spouted Whistling Vessel With Monkey

Mexico, Chiapas, Teotihuacan style. Early to Middle Classic,
A.D. *200–600*
Orange earthenware ("thin orange")
Gift, 227:1978; H. 17 cm., L. 18.5 cm.

Thin orange ware was extensively distributed in
Mesoamerica during Teotihuacan times. This unusual ex-
ample was collected in Chiapas [cf. also 129, 130, 132].
Modeled on the front is a hollow monkey effigy, cupping
his left ear. He is connected to the bridge-spouted vessel
by a strap of clay, and there is an opening at the base of
the container joining the monkey so that liquid can flow
into his body and force air out of the whistle located in
his neck. (See 205 for an earlier whistling vessel in
Mesoamerica.)

287. Pedestal Vase With Appliquéd Face

*Guatemalan Highlands, Alta Vera Paz, Maya culture. Late
Classic,* A.D. *600–900*
Polished red-slipped earthenware
Gift, 225:1978; H. 15.5 cm., Diam. 13.5 cm.

There is a great deal of unfamiliar, sparsely published,
pottery from the Southern Highland region of the
greater Maya area. This piece is thick-walled, has a
unique closed-bottomed pedestal containing rattles and
slit openings. A rather crude old man face has been ap-
plied to one side of the cylindrical vase. Two rows of
incised, repetitive, glyphlike elements surround the top
and bottom of the vessel.

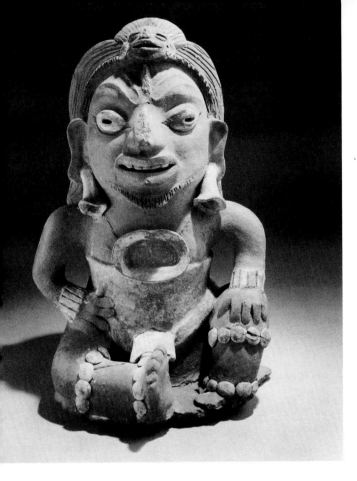

288. Hollow Effigy Figure

Guatemalan Highlands, El Quiche, Maya culture. Late Classic, A.D. 600–900
Orange-slipped earthenware with white, black, and yellow paint
Gift, 354:1978; H. 40.5 cm., W. 26.5 cm. (Illustrated: Von Winning, 1968, items 437, 438)

This large painted figure is actually a fragment from a far bigger object. It sits on a flat broken base that must have extended as a hemispherical cover for an urn. Such covered effigy urns in the style of this fragment, and from 4 to 5 feet in total height, have been recovered from graves near Nebaj in the department of El Quiche, Guatemala (see the next item for a smaller example). The body of the seated figure is orange; the eyes, teeth, and many of the accouterments are painted white. The grooved hair is yellow, while the headband and beard are stained black. The strange, limp, trumpet-shaped ear ornaments appear to represent the white datura blossom, the seeds of which are known to be hallucinogenic. If so, this could represent a Pre-Columbian shaman.

289. Effigy Incense Burner

Guatemalan Highlands, El Quiche, Maya culture. Late Classic, A.D. 600–900
Painted red earthenware
Gift, 358:1978; H. 29.5 cm., Diam. 37.5 cm.

A prevalent style of large incense burner from the department of El Quiche in western Guatemala. It is of slightly flaring cylindrical form, raised on a low annular base. It has vertical side flanges, an applied hollow human head on the front, and an everted rim with "pie crust," finger-indented, edge. The wide-eyed bucktoothed head has a vent below its chin. This type of censer often had a domed effigy lid as well. The soft red clay is whitewashed, with restricted areas of decoration painted black, red, and an unusual blue-green.

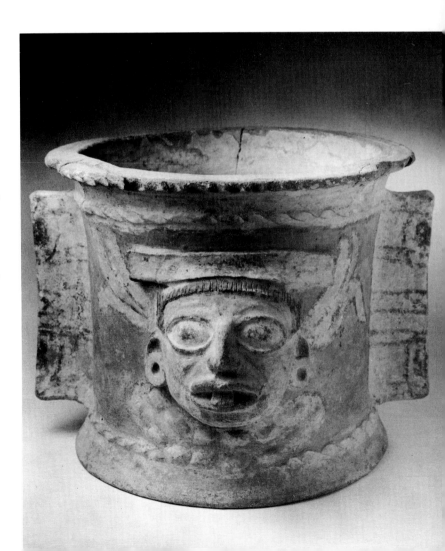

290. Strap-Handled Incense Burner

Guatemala, Western Highlands, El Quiche (?). Early to Middle Classic, A.D. *200–600*
Painted red earthenware
Gift, 137:1980; H. 23 cm.

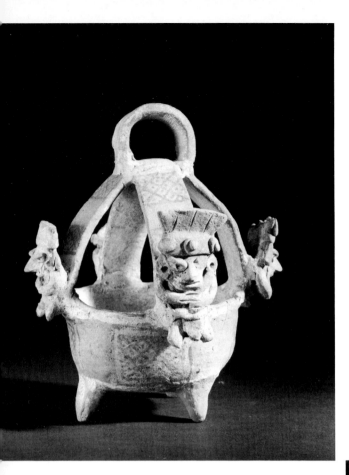

While "basket"-handled incense burners are known in other styles from other parts of Mesoamerica [see 126], this type is difficult to classify. The purported provenance is West Mexico. However, the clay, the specific colors, and the "feel" remind one more of Highland Guatemala. (Also, identical strap handles with loops have been excavated at the site of Nebaj.) The bowl is supported by solid tripods and culminates in four straps with a loop handle above. Attached to the base of each strap is a hand-modeled figurine. In addition to areas of white-wash, rectangular geometric panels are black-outlined, with a blue-green filler color (comparable to the previous object). Typical for everyday incense burners, which may have been mass-produced for use in a kind of folk cult, it is poorly fired and rather crudely modeled. The only clue to dating is the style of applied figurines. The closest parallel seems to be the Early or Middle Classic figurines of Teotihuacan [cf. 141]. Despite these observations, the dealer's provenance of Michoacan could still prove correct.

291. Incense Burner With High-Relief Figure

Guatemala (or Chiapas), Western Highlands, late Maya culture. Postclassic, A.D. *1200–1500*
Whitewashed buff earthenware with traces of blue and red paint
Gift, 173:1979; H. 38 cm., Diam. 28 cm.

A variety of censer common to the highlands of Chiapas, Mexico, and across the border in Guatemala. (The style of the high-relief applied figure also resembles the contemporary full-round effigy censers from the Mayapan area of northern Yucatan.) The incense-burning container is slightly flaring at the top, round-bottomed, and has a pedestal base. The upper walls have narrow flanges with a series of paired tabs (two are broken). These frame a button-eyed being with arched, serrated mouth. The center of this mouth projects as a broad jaguar "helmet," floating over the head of the human effigy figure (which seems to be contained in the mouth of the feline monster). His mouth is perforated through to the vessel so he would appear to exhale incense vapor. The scored beads at the corners of the mouth are difficult to interpret, unless they represent the jade pieces placed in the mouth of a dead person [cf. 252]. The hands on the hollow arms are curled as though to grasp some object. His cape is covered with braided elements and fringed with what may be intended as copper bells.

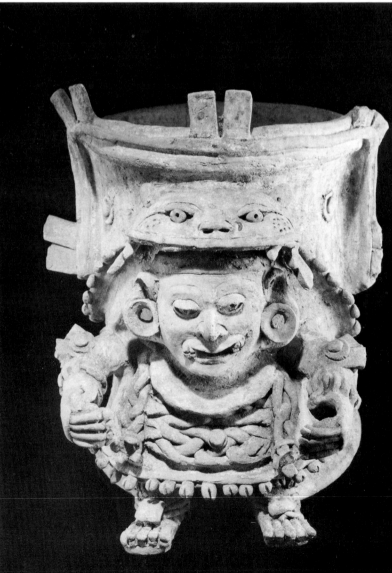

292. Appliquéd Vase and Lid

Mexico, northern Campeche (Puuc region), Maya culture. Late Classic, A.D. *700–900*
Polished orange earthenware
Gift, 201:1979; H. (without lid) 21 cm., Diam. 16 cm.

A thick-walled vase with a wide neck, and an annular base with four perforations. While the inner rim is chamfered, the thick lid that fits it is a perfectly flat disc. Both the rim and the edge of the cover are painted reddish-brown. Applied to the body of the vase is a full-front Moan bird image (a god of darkness and the underworld), complete with projecting beak, spread wings, and pendent legs. Its mouth is framed by scrolls and its eyes are done as spirals. The relief mask on the lid may represent Itzamna, the supreme Maya celestial deity, with rain god features about the mouth.

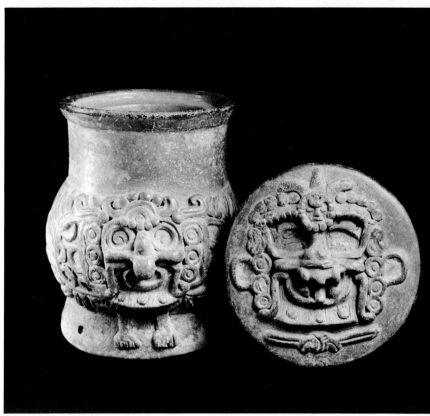

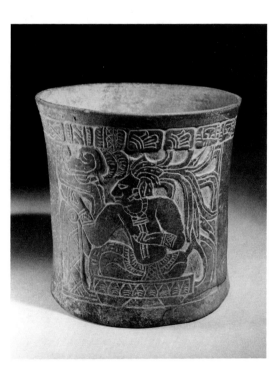

293. Carved Vase

Mexico, northern Campeche (Puuc region), Maya culture. Late Classic, A.D. *700–900*
Thin gray earthenware
Gift, 363:1978; H. 14.5 cm., Rim diam. 15 cm.

This Yucatan ceramic type is termed "thin slate ware" by archaeologists. The vase has a flat bottom, concave walls, and two related carved rectangular panels on opposite sides. A band just below the rim displays a series of pseudo-glyphs. The background of the narrative panels is deeply cut away, while the surface details are engraved. The panel viewed in the photo shows a dignitary seated on a low throne. He holds out a long-snouted monster head with draping elements below. The figure's long feathered headdress fills the right side of the scene. The opposite panel (see drawing) depicts a similar figure, seated at ground level and gesturing in the direction of a different grotesque head. This person is backed by a vertical profile "dragon."

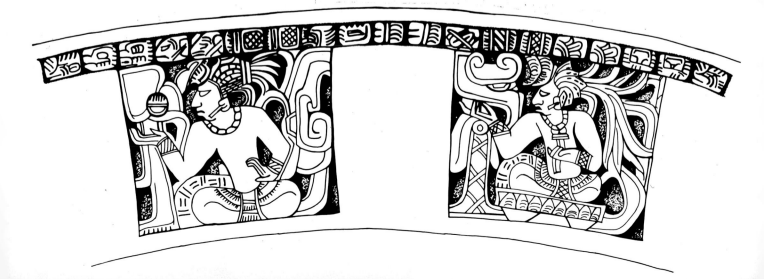

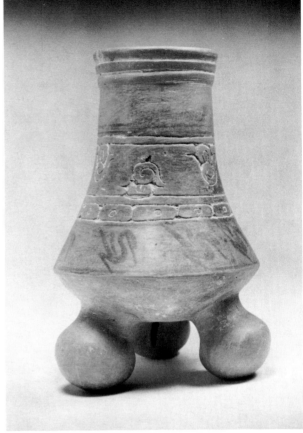

294. Tripod Dish
Mexico, Yucatan (Puuc region), Maya culture. Late Classic,
A.D. *700–900*
Gray earthenware with orange paint
Purchase, 33:1976; Diam. 24 cm., H. 6.5 cm.

A prevalent variety of northern Yucatan ceramic referred to as "thick slate ware." Decoration apparently was achieved by dribbling orange paint on the interior before firing, with no attempt to create a meaningful pattern. The present condition of the vessel imparts an unintended effect, due to the black burial deposits laced with root marks. The low tripods are trapezoidal and the flaring sides are expanded at the rim.

295. Tripod Pyriform Vase
Mexico, probably Campeche, Maya-Toltec culture. Early Post-classic, A.D. *900–1200*
Orange-slipped earthenware with black paint ("fine orange")
Gift, 124:1980; H. 19.5 cm.

During the hegemony of the Toltecs in Mesoamerica, certain pottery wares, forms, and subject matter became hallmarks of any area influenced by those Central Mexican peoples. In southern Mesoamerica, "fine orange" ware is one of these "markers." This vase, with its three bulbous, hollow, rattle feet, is another. The form also was duplicated in Toltec "plumbate ware." The central register is engraved with curvilinear motifs, while the band above the shoulder is painted in black with cursive long-beaked birds. White lime adheres to the recesses.

296. Seated Figure With Rear Tenon
Mexico, northern Yucatan peninsula, Maya-Toltec culture. Terminal Late Classic to Early Postclassic, A.D. *800–1200*
White limestone with surviving lime plaster and paint (See color plate)
Gift, 95:1968; H. 63.5 cm., W. 38 cm., D. (with tenon) 43 cm.

Although the archaeological site from which this stone sculpture came is unknown, the horizontal tenon on the middle of the back indicates that it once functioned as an architectural ornament on the facade of a building (such as those seen at the famous restored sites of Uxmal and Chichen Itza in northern Yucatan). The rather stiff style of the sculpture suggests the period of Toltec occupation of this Maya region—in fact, its face and "pill box" cap resemble the well-known Chac Mool sculptures. The surface has been coated and redecorated more than once, reflecting the practice of replastering buildings periodically. Where the heavy outer coating of lime has been peeled, there is evidence of a thin undercoating with preserved red pigment (especially about the fringe of the shoulder cape). A touch of blue pigment remains on the right cheek.

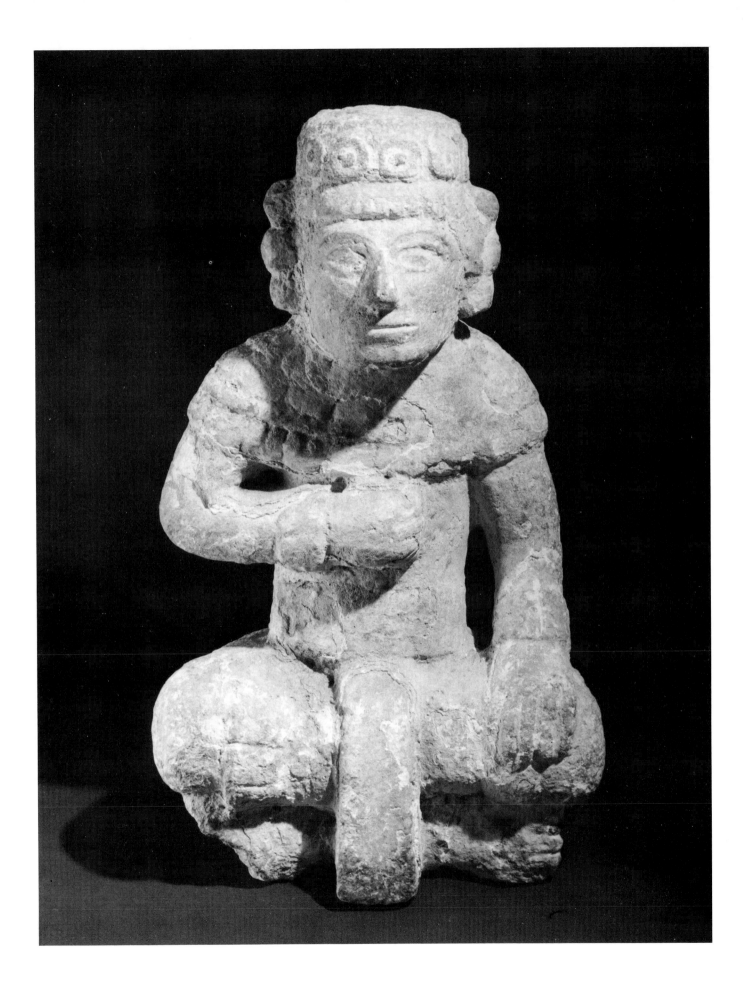

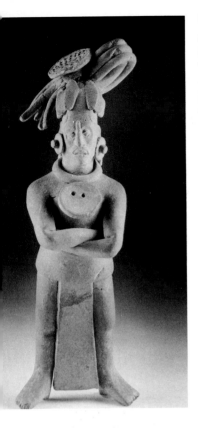
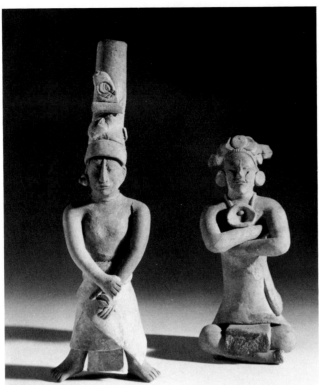
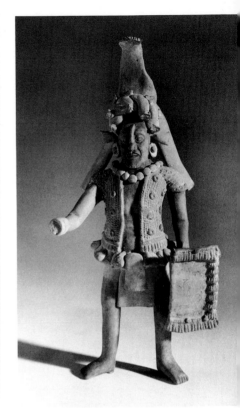

297. Figurine Portraying Standing Dignitary

Mexico, Campeche (Island of Jaina), Maya culture. Late Classic, A.D. *600–900*
Reddish-buff earthenware with traces of red, yellow, and blue paint
Gift, 157:1979; H. 20.5 cm.

An imposing, hand-modeled male figure with lavish looped headdress. He also is adorned with ear spools, necklace, and chest medallion, as well as a wide belt and long apron. Jaina figurines represent the height of Classic Maya art in ceramic sculpture, emphasizing a sensitive realism and concentration on detail.

298. Two Skirted Figurines

Mexico, Campeche (Island of Jaina), Maya culture. Late Classic, A.D. *600–900*
Buff earthenware with red and black paint
Gifts, 137 and 138:1979; H. 23 and 16.5 cm.

Both of these hand-modeled figures have wrap-around skirts with aprons underneath, but they do not necessarily represent females. The seated, cross-armed figure on the right has applied cheek plates and a small goatee. It also has a special headdress, earplugs, and a breast medallion. Black is painted on its skirt and apron, and a whistle is located in its right shoulder. The figure on the left is distinguished by a tall tubular headdress, and its body is perforated through the waist.

299. Warrior With Rectangular Shield

Mexico, Campeche (Island of Jaina), Maya culture. Late Classic, A.D. *600–900*
Buff earthenware with red and blue paint
Gift, 139:1979; H. 25.5 cm.

An elaborate figurine with hollow body (and slits on the sides). At the back of his turban is an upended deer head (visible from behind). He wears a decorated vest and apparently a shell belt. The body is stained red, while the feather-edged shield and the wings of the headpiece are painted "Maya blue." The extended right hand of this figure is missing.

300. Standing Dignitary
Mexico, Campeche (Island of Jaina), Maya culture. Late Classic, A.D. *600–900*
Buff earthenware with traces of red, blue, and white paint
Gift, 502:1978; H. 22.5 cm.

A handmade figure with hollow body; the head, however, is moldmade. His face apparently is tattooed and mustached. He holds a bent tubular object in both hands in front of him. Over the shoulders is a short feathered cape, and he has a tight vest over a short kilt, with apron in front. Other features of his adornment may be perceived in the photograph.

301. Seated Female Figure
Mexico, Campeche (Island of Jaina), Maya culture. Late Classic, A.D. *600–900*
Buff earthenware with remains of red paint
Gift, 342:1978; H. 22 cm.

A hollow figurine with a disproportionately small moldmade head. There is a whistle mouthpiece in the right shoulder, with its outlet in the back. The off-the-shoulder cape, the necklace, and the bracelets have been applied to the skirted figure. Curvilinear red designs can be seen on one side of the cape, as well as on the shoulders and headdress.

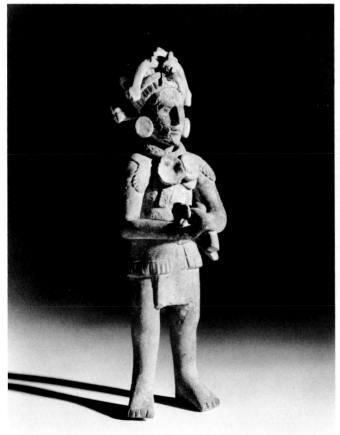

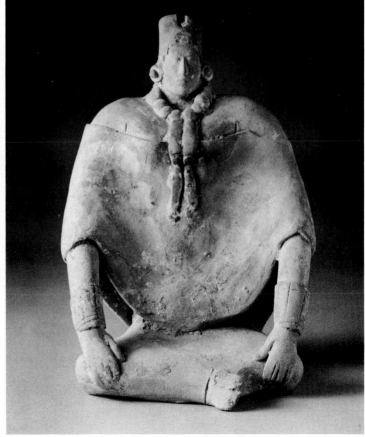

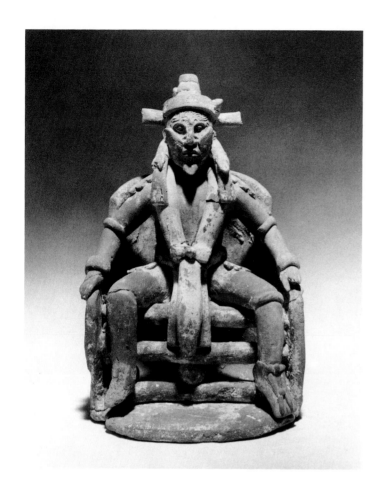

302. Nobleman Seated on Throne

Mexico, Campeche (Island of Jaina), Maya culture. Late Classic, A.D. *600–900*
Buff earthenware with traces of red, yellow, and white paint
Gift, 343:1978; H. 18.7 cm.

Hand-modeled figure seated on a cribbed seat within a round-backed, flat-bottomed chair. There is a hollow tube extending up the back inside the chair. The figure wears a pronged hat, oversized ear ornaments, a long neckpiece and belt, as well as leaf-shaped epaulets on his shoulders and thighs. His forehead shows intricate tattooing, while his face has applied cheek plates and a goatee.

303. Moldmade Female Figurine (Lower left)

Mexico, Campeche (Island of Jaina), Maya culture. Late Classic, A.D. *600–900*
Buff earthenware with traces of red paint
Gift, 352:1978; H. 24.5 cm.

The front of this hollow effigy was pressed in a mold, while the back was enclosed with a smooth piece of clay. The royal lady portrayed has a notched rectangular headdress and a long flowing gown. This object has rattles inside and perforations on both sides of the body for suspension, suggesting that such rattle effigies were meant to be worn.

304. Warrior in Full Regalia

Mexico, Campeche (Island of Jaina), Maya culture. Late Classic, A.D. *600–900*
Reddish buff earthenware with whitewash
Purchase, 53:1948; H. 26.5 cm.

Hollow moldmade figurines were as common as the hand-modeled types during the Late Classic Jaina tradition. Like the previous figure, the front half of this one, with all the detail of costume, was formed in a half-section mold, and the back enclosed with a slab of clay. This class of figure functioned secondarily as either a rattle or whistle. This object has a whistle mouthpiece on the side of the round shield. The latter, interestingly, bears an incised visage of the Mexican rain god Tlaloc. The warrior wears a cape with a stepped-fret design and a fringed collar. His head is covered with a helmet, a tall feathered penache, and a projecting animal plaque.

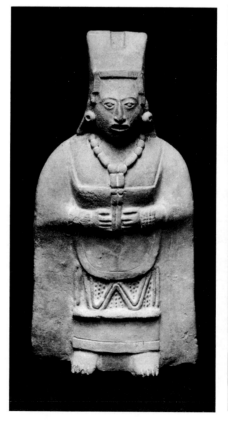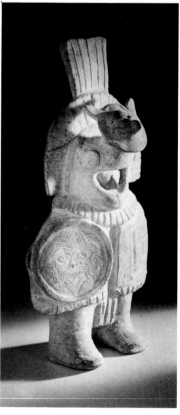

305. Cylindrical Tripod Vase With Effigy Cover

Guatemala, Central Lowlands (El Peten), Teotihuacanoid style. Middle Classic, A.D. *400–700*
Polished black-brown earthenware
Gift, 153:1979; Total H. 23 cm., Rim diam. 14.5 cm.

These particular Teotihuacan-inspired vessel forms [cf. 132] appeared in burials at sites throughout the Maya area during a limited time period when the Teotihuacan hegemony was far-reaching. These contacts from the Mexican Highlands must have involved more than trade; there is evidence of substantial presence of Mexican élite at major Maya ceremonial centers (such as Tikal) during the Middle Classic period. This vessel was probably manufactured in the Peten in the Teotihuacan mode, rather than being carried there by merchants from Mexico. The hollow effigy human head, which serves as a handle for the scutate cover, is more in the Maya style, while the tripod cylindrical vase form (and lipped cover) is uniquely Teotihuacan. This ceremonial vessel is plain except for the modeled head and the pierced, hollow, slab feet.

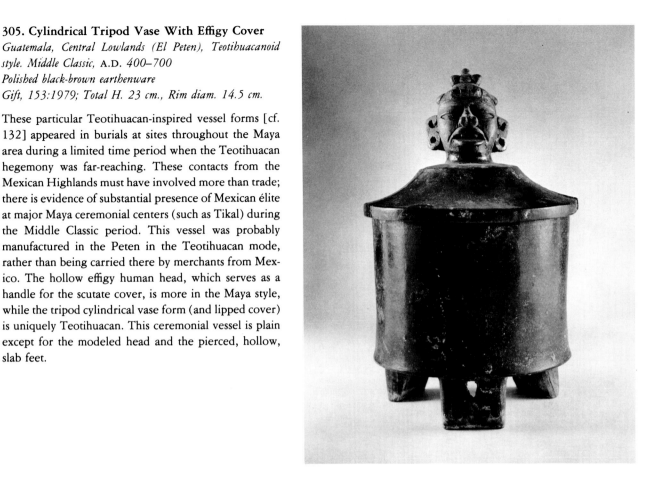

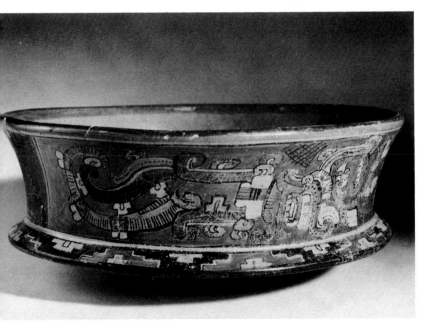

306. Basal-Flanged Bowl

Guatemala, Central Lowlands, Maya culture. Early Classic, A.D. *300–600*
Polychromed orange-gloss earthenware
Gift, 286:1978; H. 14 cm., Diam. 38 cm.

A large bowl characteristic of the Early Classic (Tzakol phase) in the Peten. The flaring-sided, round-bottomed vessel rests on a low ring base and is encircled by a broad flange. The polished orange slip is painted red, orange, black, and cream. The basal flange has a series of stepped-fret motifs, while the walls have two opposite rectangular zones containing abstract, elongated, serpent-head motifs. They are separated by square black panels. The serpent's curled snout can be seen facing left, the jaw in the center, and its scroll-crested head to the right. It should be noted that these bowls were made with a low conical cover, missing from this example.

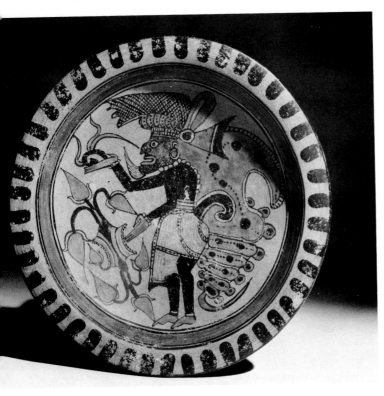

308. Tripod Dish

Mexico, Campeche, Maya culture. Late Classic, A.D. 600–900
Polychromed orange earthenware
Gift, 340:1978; H. 8 cm., Diam. 33 cm.

Another dish with everted rim and hollow, "oven-shaped" feet. The rim and interior are painted in red, orange, and black. The floor of this vessel contains a feathered and scrolled Moan bird—a Maya mythological symbol of darkness and the underworld. The inside walls have two stylized feathered-serpent motifs. The center also has a "kill hole" to release the object's power. The surface was clouded with lime deposits (now removed).

307. Painted Tripod Plate

Mexico, Campeche, Maya culture. Late Classic, A.D. 600–900
Polished orange-slipped earthenware with polychrome paint
Gift, 210:1979; H. 7.5 cm., Diam. 31 cm.

The diagnostic Late Classic (Tepeu phase) ceremonial pottery from the southern part of the Yucatan peninsula and throughout the Central Maya Lowlands is "orange gloss ware." Tripod plates and dishes are particularly profuse, and feature skillfully hand-painted mythological figures on the interiors. These are known to have been produced in matched sets for particular burials. This one depicts a black-painted figure carrying an oversized shell on his back. He probably portrays the Maya merchant god, Ek Chuah. In front of him are plant motifs, which may well be cacao pods (commercial chocolate was intimately associated with this deity). The colors are black, gray, and dark orange over the light orange slip. The underside of the plate is unslipped, and the three feet are of hollow conical form.

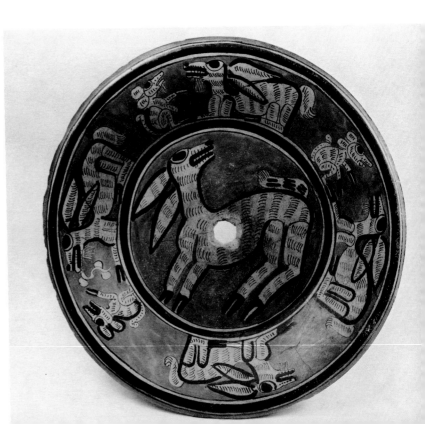

309. Large Tripod Dish (Facing page, bottom)

Mexico, Campeche, Maya culture. Late Classic, A.D. *600–900*
Polished orange-slipped earthenware with dark orange and black paint
Gift, 215:1979; H. 11 cm., Diam. 41.5 cm.

This example is painted with a group of rather naturalistic deer images. Three of the four crouching deer around the inner walls confront seated companions. While the deer itself was a symbol of death in Maya mythology, this scene has no particular esoteric reference. The underside of this vessel is unslipped and is supported by three hollow conical feet. An unusual feature of this grave object is the pre-burial "kill hole" through the deer in the center.

310. Painted Cylindrical Vase Depicting the Ballgame

Guatemala, Central Lowlands (possibly Belize), Maya culture. Late Classic, A.D. *600–900*
Orange-slipped earthenware painted in five-color polychrome (See color plate)
Gift, 216:1979; H. 23 cm., Diam. 17.5 cm. (Illustrated: Hunter, 1974, pp. 200, 201)

While figure-painted vases with realistic narrative scenes are prevalent among élite Maya grave goods, explicit ballgame scenes are rare. This is one of the most elaborate of the known depictions of the subject. The rubber ballgame was pan-Mesoamerican, and every major archaeological site boasted at least one architectural ball court. The grid of parallel red lines in the background on the vase represents seven steps of the side walls on such a court. In the foreground, on a base line, are five costumed ball players engaged in the game. An oversized black rubber ball is captured in motion in left center. The fallen player has no doubt just made this play in the direction of the two standing figures of the opposing team. All of the players have strapped-on waist yokes over wrapped padding and kilts; they also wear protective wrist and knee padding. Each player has an emblematic animal headdress. On the side steps behind the ball is a possible umpire as well as two spectators in heated debate. All of the eight figures are accompanied by rows of hieroglyphs, which relate to the vertical column of glyphs dividing the scene (far left in the rollout photograph). This large polychrome vase had been broken, but has been expertly repaired.

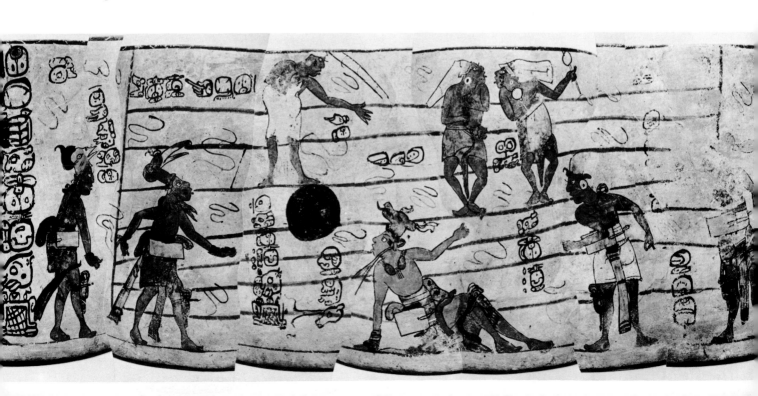

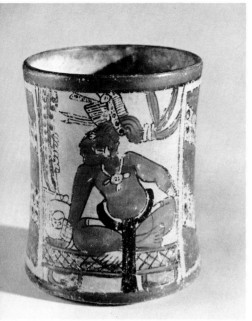 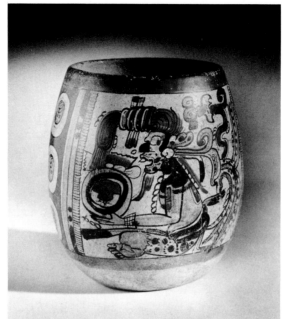

311. Concave-Sided Polychrome Vase

Mexico, Campeche, Maya culture. Late Classic, A.D. *600–900*
Orange-slipped earthenware with dark orange, brown, and black paint
Gift, 209:1979; H. 13 cm., Diam. 10.5 cm.

Vase with two matching figure-painted panels separated by two "jaguar pelt" columns. Both panels show seated Maya dignitaries on thrones, and facing a glyphlike element that emits a rising stream. The cross-legged, leaning posture is conventional for Classic Maya rulers represented both on pottery and on low-relief stone sculpture.

312. Painted Barrel-Shaped Vase

Mexico, Campeche, Maya culture. Late Classic, A.D. *600–900*
Polished orange-slipped earthenware in five-color polychrome
Gift, 202:1979; H. 15 cm., Rim diam. 11 cm.

Another vase with two nearly identical painted panels, here interspersed with columns of three matching glyphs for the day sign "Ix" (jaguar). Each panel portrays a profile seated figure with jaguar-skin kilt and a jaguar mask. A trailing penache of feathers fills the space to the right, while a knotted hairdo flows to the left over a tau-shaped "Ik" (wind) glyph held in his hand.

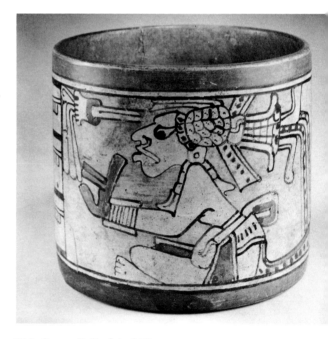

313. Squat Cylindrical Vase

Guatemala, Central Lowlands (Motagua Valley), Maya culture. Late Classic, A.D. *600–900*
Polished orange-slipped earthenware with dark orange and black paint
Gift, 388:1978; H. 14.5 cm., Diam. 16.5 cm.

Vase with two similar panels painted with sure, almost calligraphic, strokes of the brush. The expressive seated figures, with outstretched orange hands, each face a decorative column of three glyphlike characters. This particular substyle of polychrome pottery may be pinpointed to the Upper Motagua Valley of southeastern Guatemala.

314. Carved Incurved Bowl

Mexico, Campeche, Maya culture (Chochola style). Late Classic, A.D. *600–900*
Polished brown-black earthenware
Gift, 341:1978; H. 12 cm., Maximum diam. 15.5 cm.

An intricately carved bowl, with two quite different panels displaying profile serpent monsters (or what have been dubbed "bearded dragons"). These panels are separated by plain polished surfaces. The backgrounds are deeply cut away, while the surface details are carefully incised. The two serpents face one another with wide-open jaws and with differing "effluvia." The one on the right in the drawing has a naturalistic serpentine body, but with a possible fish tail and, interestingly, a spear penetrating its side. The other may be construed almost as a double monster with its unique crustacean tail. This also has a cartouched cross in the mouth, a tied bundle in the center, and a fish-and-lily motif in the top center. According to Michael Coe's recent iconographic studies of Classic Maya pottery, these bearded dragons fit into some specific underworld, as well as underwater, myth not yet completely understood.

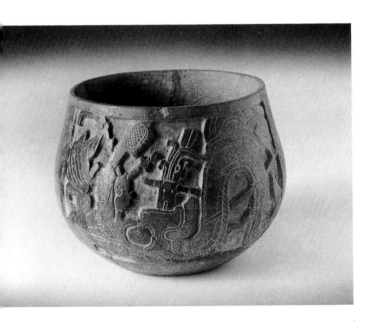

315. Flanged Cylinder With Relief Personage

Mexico, lower Usumacinta region, Maya culture. Late Classic,
A.D. *600–900*
Red-brown earthenware with traces of blue paint
Gift, 376:1978; H. 54.5 cm., W. 31.5 cm., D. 15 cm.

This sort of object—built around a cylinder and with flat
side flanges bearing appliquéd ornamentation—is com-
mon to the general vicinity of Palenque, in Chiapas.
However, they are often larger and feature stacked series
of deity heads in high relief. This example, instead, has
an unusually elongated high-relief figure in front. (Por-
tions of its arms and legs are missing, as well as some of
its appliqué detail.) He wears a bird headdress and a
broad penache representing feathers. A medallion pend-
ént to his collar is incomplete. Designs on the flanges
include flowers and serpents. It has been suggested that
incense was burned in, or on, these objects—there are
vent holes on either side of the torso and in the back of
the cylinder.

316. Face Effigy Vase

*Guatemala, Central Lowlands (Quirigua), Maya culture. Late
Classic,* A.D. *600–900*
Painted orange-brown earthenware
*Loan, Archaeological Institute of America, St. Louis Society,
3051.95; H. 17.5 cm. (Illustrated: Kelemen, 1943, item
132a)*

This vase is in the form of a squash, with a modeled
grotesque face on one side. The base is dimpled, the
bottom is expanded, and the vertically grooved sides are
concave. The inset rim suggests that a cover was origi-
nally supplied for the vase. The face effigy has a red-
painted beard, while the upper row of teeth, earplugs,
eyes, and headband are painted white.

 This unusual vessel was excavated by the Archaeo-
logical Institute of America, St. Louis Society, during
their official 1912 expedition to the important Maya site
of Quirigua (subsequently excavated and partially re-
stored by the Carnegie Institution of Washington, and
currently by the University of Pennsylvania). This is the
only surviving documented object, from the first excava-
tion, on loan to this museum. It deserves to be a famous
Maya object, having been first published in 1943.

317. Head of a Young God

Mexico, Yucatan peninsula, Maya culture. Late Classic, A.D. 600–900
Lime stucco and polychrome paint
Gift, 272:1978; H. 56 cm., W. 40 cm.

One of a group of six modeled stucco heads [317–322] from an undisclosed site somewhere near the base of the Yucatan peninsula, where this kind of art was prevalent. They all presumably fell from the facades of buildings—their backs either are crumbled or they have preserved tenons. Modeled, lifesize stucco heads are among the high points of Classic Maya sculptural art, and often reveal true portraiture. This example retains considerable original paint: red covers the realistic face, as well as the eyes and mouths of the two surmounting headdress masks. The faces of the latter are painted blue, while the headband and upper leaf-shaped fringe are a light blue-green. The beaks or noses of the head masks are missing, making their identification problematical. The reverse side of this fragment is rough and concave.

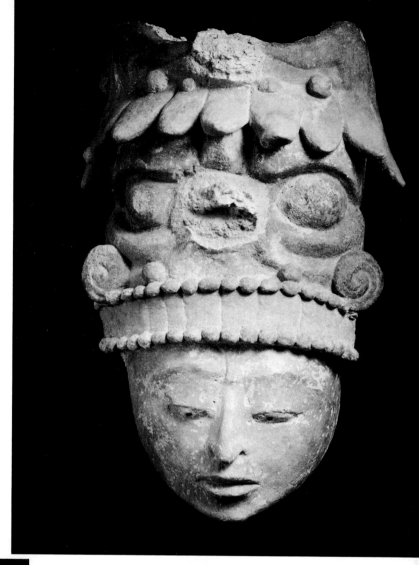

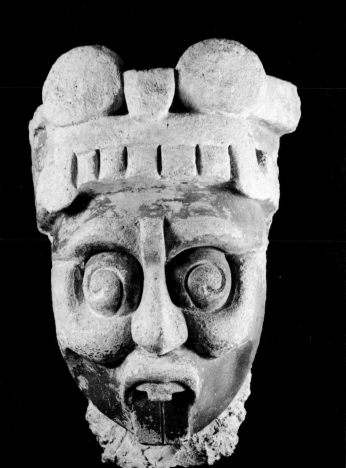

318. Head of Sun God With Headdress of Tlaloc

Mexico, Yucatan peninsula, Maya culture. Late Classic, A.D. 600–900
Lime stucco with red paint and traces of blue (See color plate)
Gift, 503:1978; H. 35 cm., W. 26 cm.

This modeled stucco head has certain features of the Maya sun god (Kin), such as the filed, tau-shaped front teeth, spirals in the bulging eyes, and a raised scroll between the brows. The headdress frontlet, however, is modeled in the manner of the Mexican rain god Tlaloc, with its large round eyes, scrolled upper lip, and exposed tooth row. (The mixture of Mexican and Maya motifs in the Late Classic period is not uncommon; see 304.) Originally the entire head was painted deep red, while traces of blue paint adhere to the eyebrows and sides of the headdress.

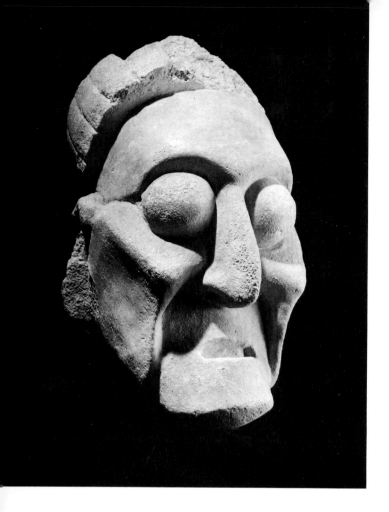

319. Old Man's Head

Mexico, Yucatan peninsula, Maya culture. Late Classic, A.D. *600–900*
Lime stucco with blue-green and red paint
Gift, 150:1979; H. 31 cm., W. 21 cm.

Another architectural fragment with well-preserved paint. The face is a light blue-green, while the eyes and the tips of the broken ears are red. This is an unusually expressive plaster model of an old man, with sunken cheeks and protruding cheekbones; receding, toothless mouth; beaked nose; and bulging eyes—perhaps the individual portrayed was a victim of goiter as well as being superannuated. A portion of a scored headband is extant, while the back of the head is rough stucco at the point of cleavage from the building off which the sculpture fell.

320. Maya Portrait Head

Mexico, Yucatan peninsula, Maya culture. Late Classic, A.D. *600–900*
Lime stucco with traces of red paint
Gift, 149:1979; H. 33 cm., W. 30 cm.

A realistic head modeled in stucco as an architectural ornament. The hairstyle, almond-shaped eyes, and artificially raised extension of the noseline, between the eyes, all are conventional ways of representing the living Maya élite. A broken spine in the parted lips suggests the depiction of a front tooth.

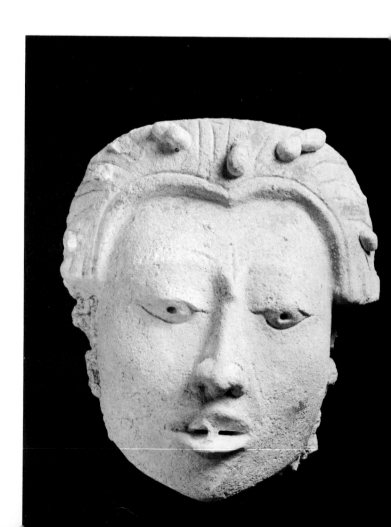

321. Portrait Head With Earplugs

Mexico, Yucatan peninsula, Maya culture. Late Classic, A.D. *600–900*
Lime stucco with remains of red paint
Gift, 151:1979; H. 27 cm., W. 23 cm.

A very sensitively modeled human portrait in the full classical Maya style. This fragment is full-round, having been broken from its matrix at the neck. The crestlike top projection is incomplete, and only two of the nine original headband prongs are intact.

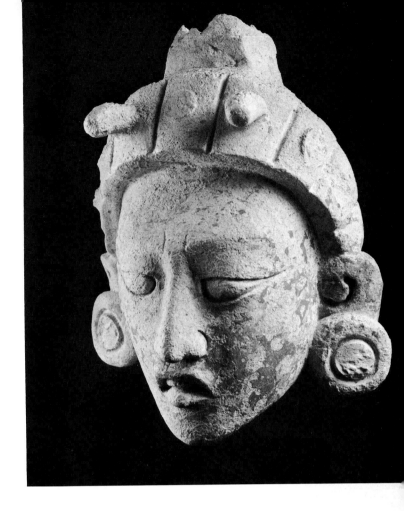

322. Portrait Head With Medallion

Mexico, Yucatan peninsula, Maya culture. Late Classic, A.D. *600–900*
Lime stucco with traces of red paint
Gift, 152:1979; H. 29 cm., W. 20.5 cm.

Another realistic representation, this time without the eye punctations seen on the last example. Again, note the artificially extended nose bridge over the forehead, which was an actual cosmetic practice of élite Maya society. This personage sports a headdress medallion in the form of a scrolled eye. The back of the head is finished stucco work, with a broken neck and a diagonal tenon.

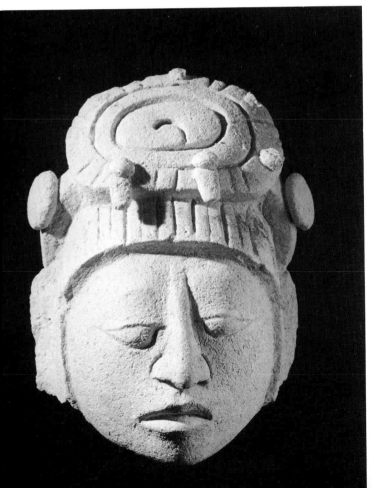

MAYA AREA 207

323. Mask-Pendant

Guatemala (?), Central Lowlands, Maya culture. Late Classic,
A.D. *600–900*
Light green jadeite
Gift, 177:1980; H. 5.8 cm., W. 4.2 cm., D. 2.7 cm.

Classic Maya portrait-style pendant. Unfortunately, we
do not know what part of the greater Maya Lowlands this
object is from. It has the stylized almond-shaped eyes,
accentuated upper nose and browline, and sensitive lips
characteristic of the best of Maya art (as seen in the stucco
heads). There also is a pair of fine-incised lines emanating
from either side of the mouth. The top of the head and
the back are flattened. The jade pendant has been drilled
horizontally through the middle for suspension.

324. Pair of Flower-Shaped Earplugs

Mexico, Yucatan peninsula, Maya culture. Late Classic, A.D.
600–900
Mottled green jadeite
Gift, 164:1979.1 and .2; Diam. 6 cm., D. 1.3 cm.

Earplugs of great variety, and often of jade, were worn
by the Maya élite [cf., e.g., 321]. This pair is funnel-
shaped, with a serrated outer rim, and a pair of opposing
perforations on the inner rim for affixing them to a back-
ing, which would hold them in the slit earlobes.

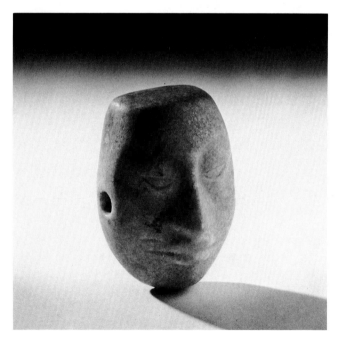

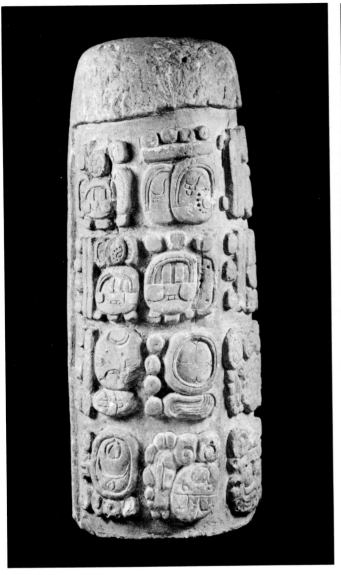

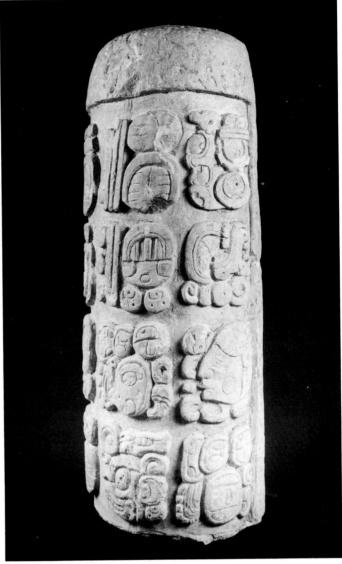

325. Cylindrical Altar With Hieroglyphic Inscription

Mexico, Chiapas, Maya culture. Late Classic, A.D. 715
Yellowish limestone with traces of red pigment
Gift, 384:1978; H. 57 cm., Diam. 23 cm. (Published: Liman and Durbin, 1975)

Inscribed monuments in cylindrical form are practically unique in the Maya area. This sculpture has a complete hieroglyphic inscription, in four columns of sixteen glyphs. The first glyph on the upper left introduces a Maya "long count" calendrical date, which has been read by Liman and Durbin as 9.14.3.8.4; 2 Kan, 17 Zotz. This transcribes to the Christian calendar at April 30, A.D. 715, in the Thompson correlation. The standard five-position notation can be read simply from the bar-and-dot affixes (each bar denotes 5 and each dot 1) to the five time period glyphs which follow the introductory glyph (arranged in two columns proceding from left to right, top to bottom). Among the more obscure hieroglyphs in the double column to the right, Liman has recently perceived two "emblem glyphs," referring to the names of particular Maya sites: Bonampak and Tonina. She suggests that the monument may have been carved in the region of Tonina, Chiapas, though its actual provenance is not known to us. The Tonina emblem glyph, if Liman's reading is correct, is located in the far lower right corner —the expected location of a glyph identifying the place where a monument was carved, and where the date commemorates some event.

The crisply preserved glyph blocks are deeply carved in a panel that covers two-thirds of the circumference of the stone. The rest of the surface is plain. The base of the column has been cut off, so we do not know whether or not there was a shaft below for erecting the monument, or perhaps supporting legs for a semiportable "altar." While Liman and Durbin define the object as a "stela," this writer believes that a free-standing "altar" classification is more appropriate. (A pair of proto-Maya carved monuments from Kaminaljuyu in the Guatemala Highlands, of similar size and form, have tetrapod legs.)

326. Polychrome Bowl

El Salvador (Soyapango), Maya culture. Late Classic, A.D.
600–900
Orange-slipped earthenware with red and black paint
Gift, 221:1978; H. 11 cm., Diam. 18.5 cm.

Another vessel of this Ulua Polychrome group. It too is
relatively thick-walled and has a dimpled base (painted
red). Below the scroll-fret designs on the rim is a band
of alternating pseudo-glyphs. On the walls are two black-
painted anthropomorphic creatures, with spider monkey
bodies and tails, and human hands and faces. Dividing
these images are broad red scroll motifs.

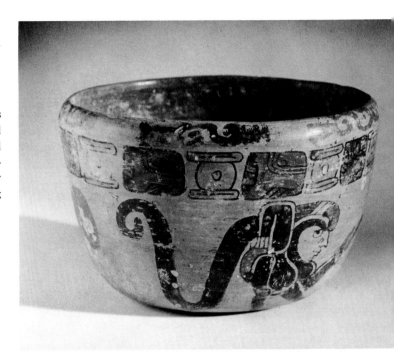

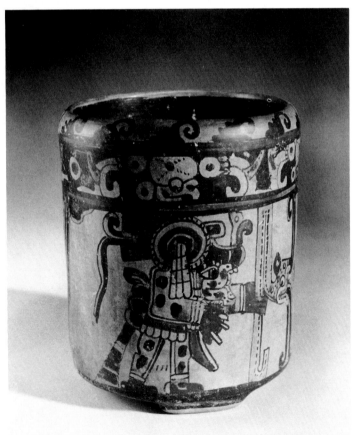

327. Cylindrical Tripod Polychrome Vase

El Salvador (Soyapango), Maya culture. Late Classic, A.D.
600–900
Orange-slipped earthenware with red and black paint
Gift, 222:1978; H. 20 cm., Diam. 17.5 cm.

One of four polychrome ceramics in the collection [326–
329] said to have come from the same grave in the Soya-
pango district of El Salvador. They are of the general
type known as "Ulua Polychrome," which was dis-
tributed throughout western Honduras and El Salvador,
in the southeasternmost Maya Lowlands. The vessel walls
are relatively thick, and the flat base is raised on three
stubby rectangular feet. The figure painting on the vessel
walls features a series of three similar individuals wearing
jaguar costumes. Note the feline head, clawed "glove,"
and black spots. The hooked staff held forward also ter-
minates in a jaguar's head, from whose mouth flow black
scrolls. As with so much of Maya polychrome pottery,
this scene probably depicts a mythological event in the
underworld. The upper band features a repetitive series
of glyphlike heads, topped by a band of stepped frets.

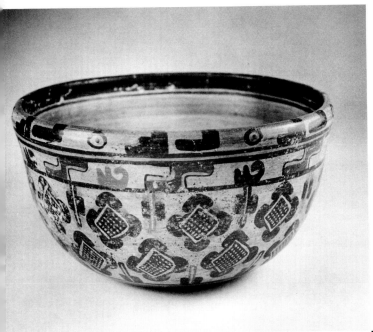

328. Polychrome Hemispherical Bowl

El Salvador (Soyapango), Maya culture. Late Classic, A.D. *600–900*
Yellowish cream-slipped earthenware with orange, red, purple, and brown paint
Gift, 223:1978; H. 10.5 cm., Diam. 20 cm.

Part of the grave lot of four vessels, although the background slip is lighter than the first two. This offering has geometric fretlike motifs below the rim, and the body is patterned with dotted quatrefoil designs.

329. Tripod Polychrome Bowl

El Salvador (Soyapango), Maya culture. Late Classic, A.D. *600–900*
Yellowish cream-slipped earthenware with orange, red, purple, and brown paint
Gift, 224:1978; H. 9.5 cm., Diam. 19 cm.

This example is painted in the same way as the previous one. The straight walls have an everted rim, while three low slab feet support the flat bottom. Two opposite painted panels contain rather rectilinear seated human figures, separated by narrow zones with S-shaped scrolls. The rim and one-third of the interior are decorated with banded squiggles.

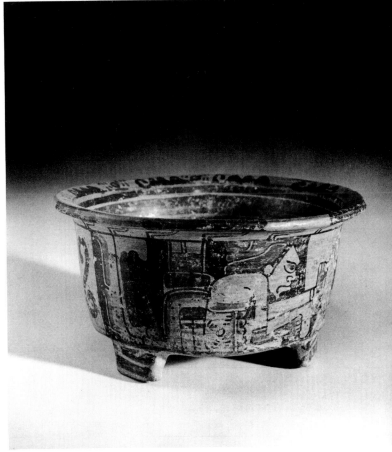

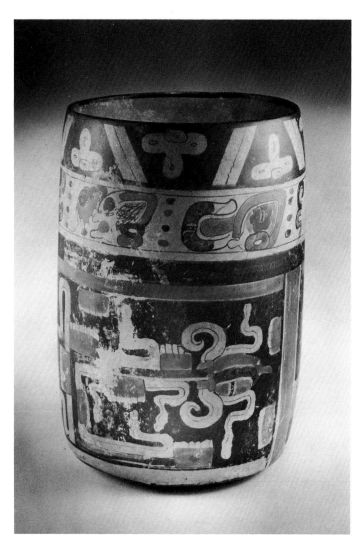

330. Polychrome Cylindrical Vase

Western Honduras, Maya culture. Late Classic, A.D. *600–900*
Light orange-slipped earthenware with orange, red, and black paint
Gift, 339:1978; H. 19.5 cm., Diam. 14 cm.

The walls and bottom of this vase are somewhat convex. It is painted in a variation of Ulua Polychrome ware, with an unusual amount of background space devoted to black (including the bottom of the vase). (In that respect, there is a comparable vase from Copan, Honduras, in the Peabody Museum at Harvard.) Opposite sides feature nearly identical profile serpent-head motifs, facing left. They have scroll-and-comb appendages, and in the far left (out of view in the photo) is a water lily motif. The rim is decorated with trefoils and diagonal bands. The register between contains six different pseudo-glyphs divided by vertical rows of four dots.

331. Carved Tripod Vase

Western Honduras, Ulua Valley, Maya culture. Late Classic, A.D. *600–900*
White marble (tecalli)
Gift, 213:1979; H. 11 cm., Rim diam. 18 cm.

These rare carved stone vases had a restricted region of manufacture in the Ulua Valley, but were occasionally traded to the Central Maya Lowlands, and even Costa Rica, during the Late Classic period. The particular style of low-relief scrolled decoration (with high-relief animal effigy handles) seems to relate to the Gulf Coast, Classic Veracruz, tradition [cf. 267]; and yet it is unique. (Trans-Pacific contact from China has also been suggested as inspiration for this style.) The central frieze of scrolls contains a monster mask in the center and is bordered by overlapping scale motifs above and below. The effigy handles depict long-snouted, fanged creatures (the snout on the left handle is broken). The hollowed-out stone vase is cylindrical, with three low cylindrical feet.

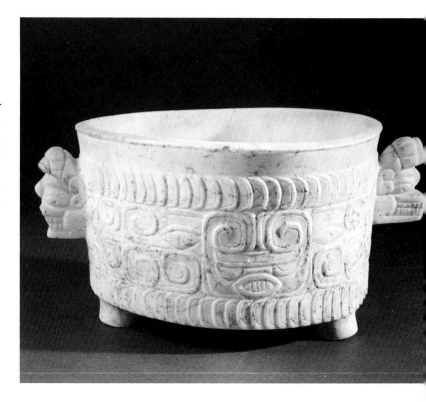

INTERMEDIATE AREA

Lower Central America and the Northern Andes—the "Intermediate Area"—formed a transitional link between the centers of Pre-Columbian civilization to the north and south, and participated in both traditions. This is the land stretching from Honduras across the Isthmus of Panama all the way to Ecuador (see map in color section following page). We mentioned in the Introduction that aspects of advanced civilization from both the Central Andes and Mesoamerica diffused into the Intermediate Area, and that that area did not rise to the same heights. Some of the earlier cultures excelled in jade working, the later cultures excelled in gold working, and the stonework and funerary ceramic production rivaled that of any Pre-Columbian area. The megalithic stone sculpture found here is particularly impressive. Significantly, the earliest ceramic complexes of the New World have been unearthed in the Northern Andes. However, in the spheres of political and social structure, as well as public architecture, we seem to be witnessing elevated "chiefdoms" rather than dynastic "states" or complex civilizations. While there has been systematic archaeological work, and important discoveries, during the last few decades in Costa Rica and Ecuador, less is known and published about the cultural history of this whole area than the neighboring areas of high civilization. Popularly, we still tend to think only of some of the highlights in reference to the Intermediate Area—such as the beautiful jade from Costa Rica, Cocle and Veraguas gold from Panama, Quimbaya gold, and the perplexing site of San Agustin in Colombia—rather than of a total picture of cultural growth and diversity. (The chronological chart on p. 214 gives a simple ordering of the principal known cultures.)

Closely associated with the Intermediate Area were certain less advanced Pre-Columbian cultures located on the islands of the Caribbean. We are justified in including a Caribbean subarea for Pre-Columbian America since those cultures, such as the Taino on Hispaniola, also relate to northern South America, Mesoamerica, and even the southeastern United States. A version of the Mesoamerican ballgame complex developed in the islands, complete with playing courts and variants of the stone paraphernalia.

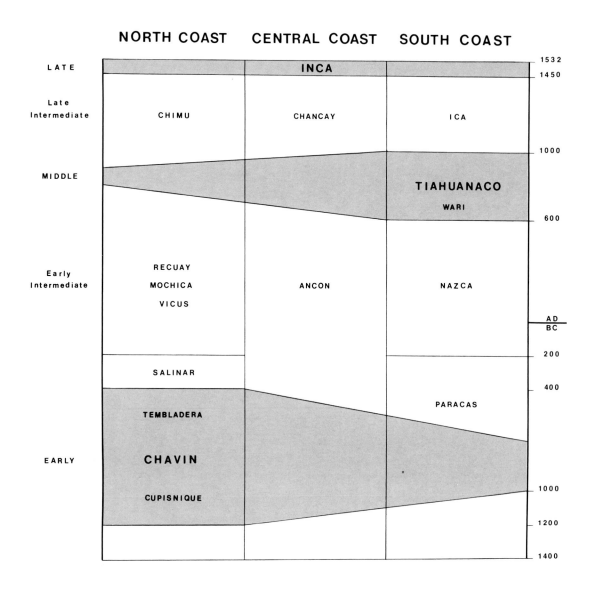

NORTH COAST **CENTRAL COAST** **SOUTH COAST**

| LATE | INCA | | 1532 / 1450 |

Late Intermediate: CHIMU — CHANCAY — ICA — 1000

MIDDLE — TIAHUANACO / WARI — 600

Early Intermediate: RECUAY MOCHICA VICUS — ANCON — NAZCA — AD / BC — 200

EARLY: SALINAR — 400 — TEMBLADERA — CHAVIN — CUPISNIQUE — PARACAS — 1000 — 1200 — 1400

CHRONOLOGICAL CHART OF INTERMEDIATE AREA

Lower Central America
(and Caribbean)

The countries south of Guatemala, including eastern Honduras, Nicaragua, Costa Rica, and Panama, comprise the northern sector of the Intermediate Area. Most of the Pre-Columbian objects in this collection come from the last two countries, though we illustrate one superb, and rare, Taino wood carving from the Caribbean region [332], and one effigy corn-grinding stone from Honduras [333]. Nicaragua is not represented at all, although its southeastern Rivas Province is closely related to the Guanacaste Province (Nicoya peninsula) of Costa Rica, which is amply represented here. (Further, since the recent disastrous earthquake that leveled Managua, most of the known Pre-Columbian ceramic objects from this little-explored country were destroyed.) Monumental stone sculpture, such as the complex of "alter-ego" figures from the Lake Nicaragua region, is noteworthy, although similar sculpture is found as far south as western Panama. Elaborate small stone sculptures are also prominent in Costa Rica [349–352], and we should call attention to the famous and enigmatic, man-made stone spheres (up to 7 feet in diameter) that are strewn over the Diquis delta region there.

The pottery of Costa Rica is prolific and widely collected [334–348]. The Nicoya peninsula in the northwestern corner of the country is the home of exceptionally fine polychrome pottery, generally termed "Nicoya Polychrome." Its later styles are perceptibly influenced by the Postclassic cultures of Mesoamerica. Lapidary work in jadeite is especially characteristic of the first significant developmental stage in Costa Rica [353–358]. The early style in jade, from before 500 B.C., was Olmec-influenced, and the later style, to A.D. 500, is noted for its "ax-god" figure pendants. After A.D. 500, and up until the Spanish period, the technology of lost-wax gold casting supplemented jade carving [359–362]. This Costa Rican style closely resembles the Chiriqui and Veraguas gold work of Panama.

The principal Pre-Columbian cultures of Panama, in addition to the above two, include Cocle and Parita [363–374]. The polychrome ceramics of

Veraguas and Cocle, which feature the "alligator god" and are dated between A.D. 500 and 1500, are outstanding. However, these cultures are best known for their delicate gold work [369–374], featuring cast frog and eagle effigy pendants, as well as embossed gold discs or breastplates.

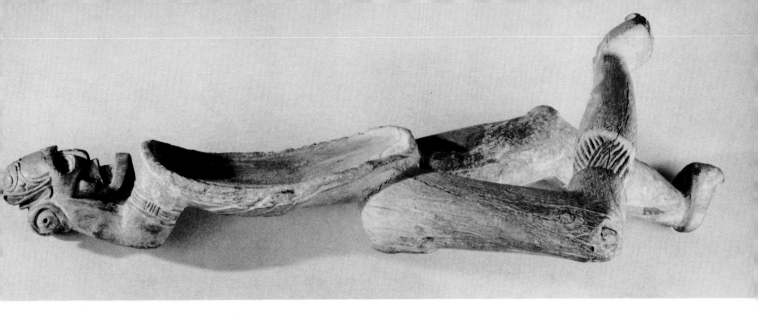

332. Male Effigy "Stool"

Caribbean, Dominican Republic, Taino culture. Fifteenth century A.D.
Eroded hardwood (Lignum vitae) (See color plate)
Loan, Missouri Historical Society, 1976.683; L. 61 cm. (Published: Fewkes, 1919)

An emaciated male figure, with long contorted legs, short arms raised alongside the head, and a concavity in the torso, which may have served as a low stool (or an offering dish, or possibly a tobacco or "snuff" tray). The figure's ribcage is carved on the back of the shallow oval tray, while the top of the deathlike head is deeply carved with a reptilian motif. Note the leg and arm ligatures, an ancient tropical South American cultural trait—the possi-

ble ultimate inspiration for this unusual Pre-Columbian style of the Caribbean. Taino wood sculptures are exceedingly rare, and those known were generally preserved in caves.

This important "curio" was presented to the Missouri Historical Society in 1876 by A. W. Kelsey, who had spent some months in Santo Domingo in the years 1867–68. The object is unusually well documented, having been published by J. Walter Fewkes in 1919, coupled with Kelsey's own account of the circumstances of its discovery in a cave. Kelsey reported that it originally had fish teeth inserted in the gaping mouth, as well as inlays in the eye orbits. Further, its male organ had been excised by the natives before he acquired the carving.

333. Tripod Effigy *Metate* With *Mano*

Eastern Honduras: Late Classic, A.D. *600–900*
Black basalt
Purchase, 2:1940; H. 21 cm., W. 32.5 cm., L. 55 cm. (L. of mano *50 cm.)*

Effigy corn-grinding stones, of somewhat different styles, occur widely in Lower Central America [cf. 350], as well as on the Pacific Coastal region of Guatemala. This one is the style of the eastern plains of Honduras, just outside the limits of the Maya area. (Grinding stones, or *metates*, in the Maya area proper are generally plain utilitarian troughs.) It has a concave, smooth-polished, grinding surface and three rectangular legs—two at the back and one at the front. Projecting from the forward edge is a pecked and incised crocodilian head. It has knobs on top and culminates in a perforated loop on the snout. The polished, round-ended, cylindrical *mano* resting on the *metate* was rolled to grind the corn, or maize. It reportedly was found with this particular grinding stone.

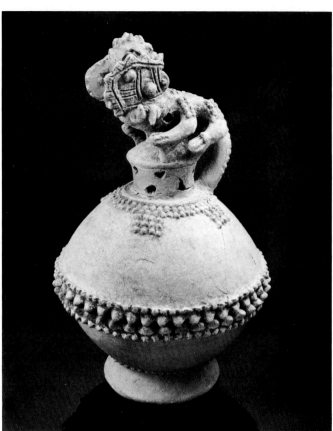

334. Two-Part Effigy Incense Burner

Costa Rica, Nicoya region. Early Polychrome period, A.D. 300–800

Unslipped red earthenware

Gift of Mr. and Mrs. Alois J. Koller, 221:1973; Total H. 33 cm., Diam. 21 cm.

Formerly this type of incense burner was not well known, but now a great number—often of larger size—have turned up. The lower burning bowl has an annular base and nubbins around the rim. The cover portion is like an inverted bowl, with a perforated chimney to allow the incense smoke to escape. Crowning the chimney is a crested, hand-modeled crocodile—one of the fundamental Lower Central American subjects for ritual expression. The crocodile (or, more properly, caiman) is hollow and also has its perforations. One may hypothesize that the concept for these two-part effigy censers was borrowed from Mesoamerica, where comparable forms were popular in the Middle Classic Teotihuacan period.

335. Armadillo Effigy Vessel

Costa Rica, Nicoya region. Early Polychrome period, A.D. 300–800

Polished black-brown earthenware

Gift, 374:1978; H. 27.5 cm., L. 37 cm.

A naturalistic, round-bottomed effigy jar, depicting by grooves and punctations the shell of the armadillo. The animal's head and forefeet project from one end, and the plated tail and hindfeet from the other. These exposed limbs grasp the head and tail, respectively. Sensitively modeled, animal effigy, monochrome pottery is unusual for Costa Rica.

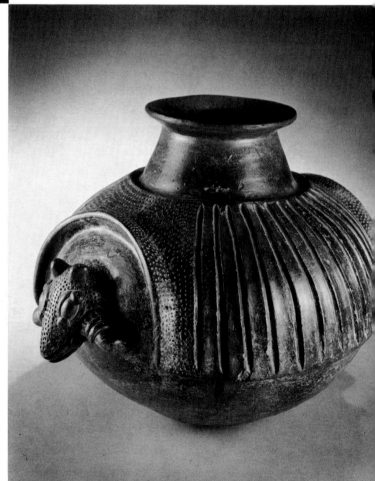

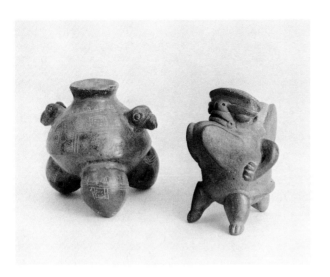

337. Tripod Bird Effigy Bowl (Below)

Costa Rica, Nicoya region. Early Polychrome period, A.D. *300–800*
Black earthenware
Gift, 274:1978; H. 13.5 cm., L. 28.5 cm.

A hollow bird's head (presumably a parrot) with three perforations is attached to the front, with a pair of wing flanges on the sides, and a tail at the rear of the rim. Four incised rectangular panels on the shoulder of the bowl contain geometric guilloche motifs. These incisions had been filled with white pigment. The bowl has three hollow legs.

336a. Miniature Tripod Effigy Jar

Costa Rica (provenance unknown). Early Polychrome period,
A.D. *300–500*
Polished red earthenware
Gift, 147:1980; H. 9 cm.

The vessel on the left has features that remind one of Terminal Preclassic pottery in Guatemala. The fine-line incised decoration on the body and tripod legs consists of meandering zigzags with attached triangles and loops, as well as punctated rectangles. The jar is supported by hollow bulbous legs with rattles. A pair of effigy bird heads is mounted on the shoulders of the jar.

336b. Tripod Effigy Ocarina

Costa Rica (provenance unknown). Early Polychrome period,
A.D. *300–500*
Brown earthenware
Gift, 166:1980; H. 9.5 cm.

Features of the horizontally compressed face, and the treatment of the top of the head, on the unusual object to the right seem early for Costa Rica. The head has zones of incising and punctation, filled with white pigment. The figure "wears" fore and aft lobes that probably indicate an extreme hunchback deformity. The ocarina (musical instrument) function is evident from a whistle stop in the rear tripod, a round mouthpiece in the center of the back, and finger stops on either side of the head.

338. Effigy Tripod Bowl

Costa Rica (provenance unknown). Early Polychrome period,
A.D. *300–800*
Brown earthenware
Gift, 173:1980: H. 16.5 cm., Diam. 23.5 cm.

The hollow tripods on this convex-bottomed bowl are boldly modeled as vulture heads (note the perforated crests on the raptorial beaks). Each effigy leg contains rattles as well as vents. The vessel walls are incised with cross-hatched triangular patterns. The bowl itself resembles Early Classic pottery from southern Guatemala.

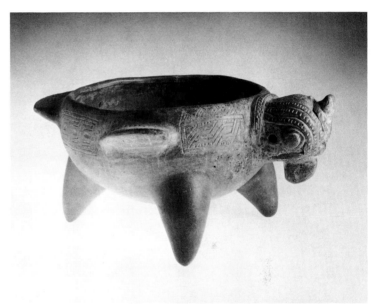

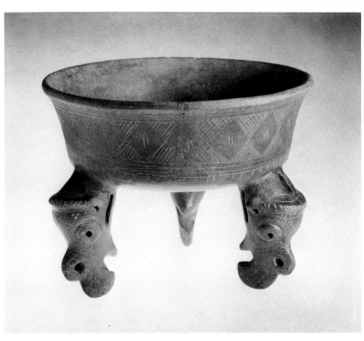

339. Hollow Kneeling Figure

Costa Rica, Nicoya region. Early Polychrome period, A.D. *300–800*
Burnished red earthenware
Gift, 393:1978; H. 21.5 cm.

A figurine vessel (note the opening on top of the head) from the second developmental phase in Costa Rica. It crouches with the hands resting on the knees (the tips of the feet are shown under the rear), and the shoulder blades are well defined. The arched eyebrows and bulging eyes are characteristic of early figurines in Costa Rica and neighboring Nicaragua.

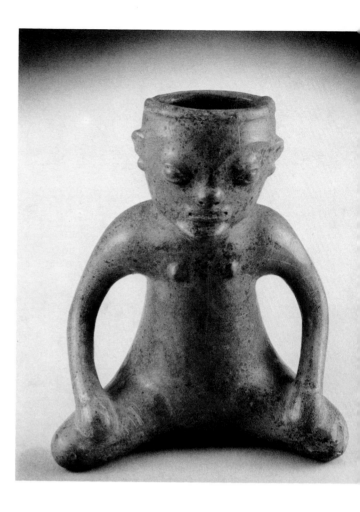

340. Hollow Whistle Figurine

Costa Rica, Nicoya region. Middle Polychrome period, A.D. *800–1200*
Red and black on light orange earthenware
Gift, 172:1980; H. 11 cm.

Fat human effigy figurines are a common component of the "Nicoya Polychrome" assemblage of ceramic production. The arms are separated from the body, and there is a perforated lug on the back of the neck. Whistle mouthpieces are found on the bottom of each leg, with an air hole in the back of the head.

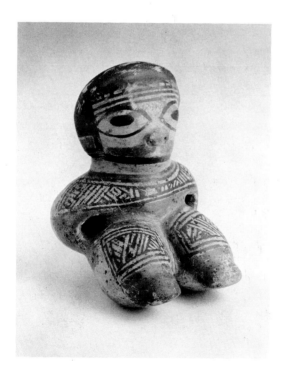

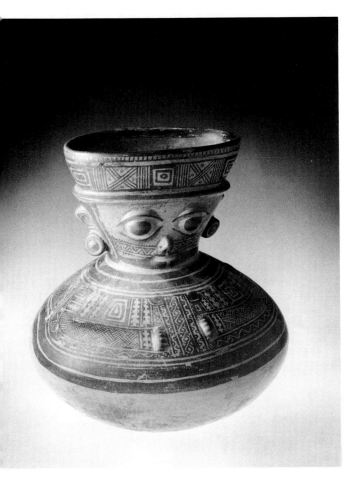

341. Face-Neck Jar
Costa Rica, Atlantic watershed region. Middle Polychrome period, A.D. *800–1200*
Reddish-brown paint on orange-slipped earthenware (See color plate)
Gift, 375:1978; H. 24 cm., Diam. 22 cm.

The brushwork on this bichrome flaring-mouthed jar is exceedingly delicate. The facial features, the arms, and even the breasts are indicated in very low relief.

342. Face Effigy Bowl
Costa Rica, Nicoya region. Middle Polychrome period, A.D. *800–1200*
Cream-slipped earthenware with black, red, and purple paint
Gift, 146:1980; H. 11 cm., Diam. 20 cm.

A hemispherical bowl of Nicoya Polychrome ware, raised on an annular base. Two wide faces are depicted in paint and raised relief on opposite sides, separated by two vertical guilloche motifs. The interior walls are decorated with red bands and rectangles.

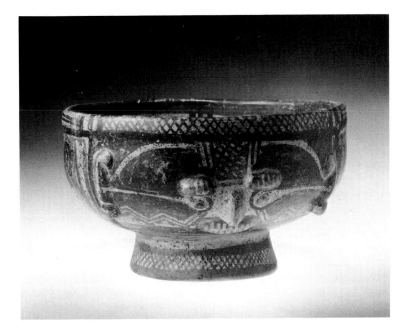

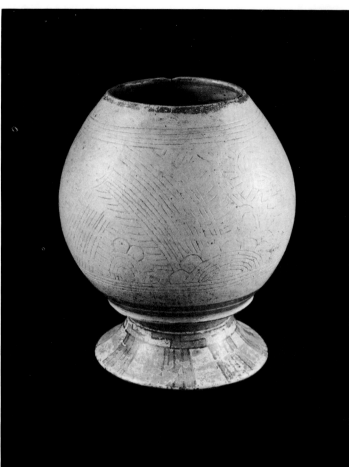

343. Pedestal-Based Vase
Costa Rica, Nicoya region. Middle Polychrome period, A.D. *800–1200*
Red, gray, black, and cream polychrome earthenware
Gift, 174:1980; H. 22 cm., Diam. 19.5 cm.

A less prevalent variant of Nicoya Polychrome, with its convex walls incised before the overall cream slip was applied. The intended representation of the intricately incised curvilinear designs is obscure, though the polychrome base is standard for these vessels.

344. Large Pyriform Vase
Costa Rica, Nicoya region. Middle Polychrome period, A.D. *800–1200*
Polychrome earthenware
Gift, 259:1978; H. 35.5 cm., Diam. 23.5 cm.

This vessel form, as well as elements of the painted decoration, was freely borrowed from the Late Maya and Toltec styles in Mesoamerica. Note the bands of stepped frets, and the pseudo-glyph panels on the neck. The base rests on a flaring pedestal base. The background is slipped orange, and the painted designs are red and black.

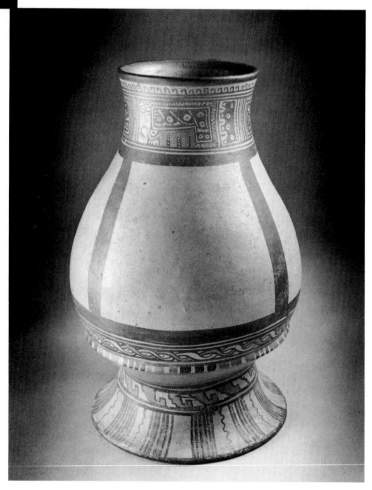

345. Hollow Jaguar Carrying Bowl

Costa Rica, Nicoya region. Middle Polychrome period, A.D.
800–1200
Polychrome earthenware
Gift, 260:1978; H. 12 cm., L. 18 cm.

Full-round animal effigy ceramics are less common here
than the plain painted vessels. This object was decorated
in four colors: red, orange, and black over a cream slip.
The bottoms of the legs are open, and eight perforations
were left in the hollow body of the jaguar. Its head
contains a rattle.

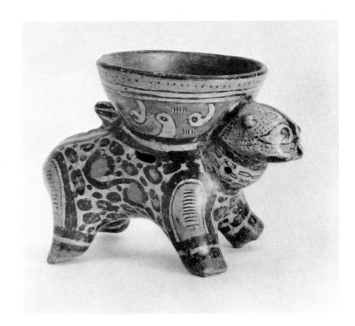

346. Bowl on Ring-Based Effigy Stand

Costa Rica, Nicoya region. Middle Polychrome period, A.D.
800–1200
Polychrome earthenware
Gift, 262:1978; H. 13 cm., Rim diam. 15.5 cm.

An unusual form in Nicoya Polychrome ware. The base
is fabricated as an open ring, which is connected to the
bottom of the bowl by three hollow jaguar bodies with
rattle heads. These contain slits, and there are oval perfo-
rations in the ring below. The vessel is painted red and
black over cream. Note the guilloche band on the base
and the pseudo-glyph panels on the sides of the bowl.
(Costa Rica did not share the Maya hieroglyphic system.)

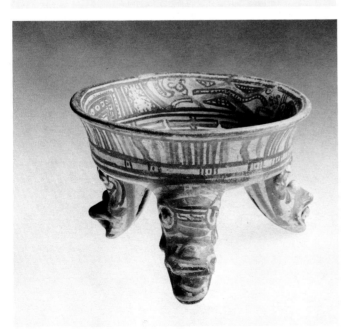

347. Tall Tripod Bowl

Costa Rica, Nicoya region. Late Polychrome period, A.D.
1200–1500
Orange and black on cream-slipped earthenware
Gift, 261:1978; H. 13 cm., Diam. 19 cm.

The hollow legs are modeled as crocodile heads and
contain rattle pellets. The sides and interior are painted
with broken-down designs (stylized birds on the floor of
the bowl), possibly derived from Mexico in its Mixtec
period.

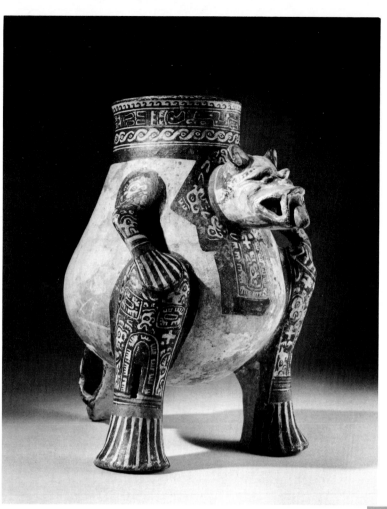

348. Tripod Jaguar Effigy Jar
Costa Rica, Nicoya region. Middle to Late Polychrome period,
A.D. *1000–1500*
Black and orange on cream-slipped earthenware
Gift, 220:1978; H. 31 cm.

A popular form of Late Nicoya Polychrome effigy show-
ing delicate, but degenerate, painted motifs stemming
from Postclassic Mexico. The jar itself is pear-shaped.
The rear leg to support the vessel is looped, and also
serves as the tail. The jaguar effigy is composed of tall
hollow legs, appended arms, and a hollow head with a
clay rattle.

349. Standing Anthropomorphic Male Figure
Costa Rica, Diquis region. A.D. *800–1500*
Buff-colored sandstone
*Gift, 357:1978; H. 38 cm., W. 22.5 cm., D. 12 cm. (Illus-
trated: Von Winning, 1968, item 517)*

This style of flat standing figure on a peg base, and with
vertical slits separating the arms and legs, is diagnostic of
the Diquis delta region of southern Costa Rica. Curi-
ously, the style also resembles both megalithic stone
sculpture at San Agustin, Colombia, and certain portable
sculpture in southern Guatemala. The stiff figure has a
wide feline mouth with crossed fangs, while a pair of
serpents issues from the mouth, and their heads rest on
each bolstered shoulder.

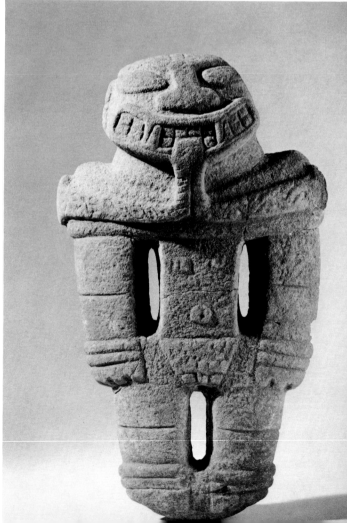

350. Ceremonial Stone *Metate*
Costa Rica, Atlantic watershed region. A.D. *800–1500*
Gray basalt
Gift, 387:1978; L. 73 cm., H. 24 cm., W. 36 cm.

Elaborate effigy corn-grinding stones were frequent offerings in burials on the Atlantic side of Costa Rica. This one has carved crocodile effigy heads on both ends, four geometrically carved animal legs, and openwork panels on either side. These panels depict pairs of anthropomorphic animals facing each other. The rectangular grinding surface is concave and polished smooth.

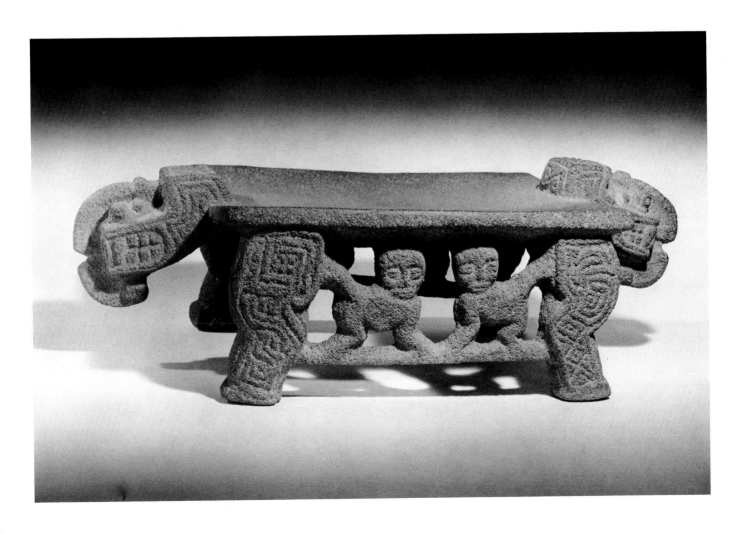

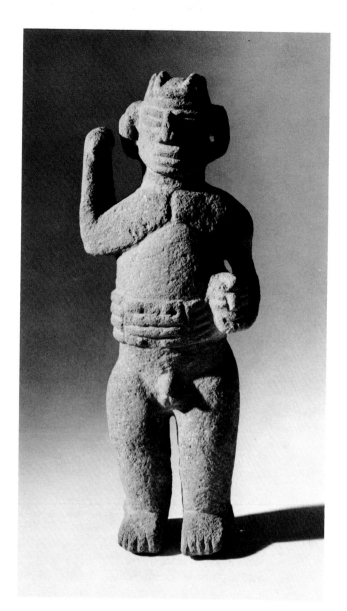

351. Male Ball Player With Trophy Head

Costa Rica, Atlantic watershed region. A.D. *800–1500*
Reddish volcanic stone
Gift, 266:1978; H. 42 cm.

Full-round portable stone sculptures are very common in
Costa Rica, especially from the Linea Vieja region of the
Atlantic slopes. A totally different style is peculiar to the
southeastern Diquis region [349]. This standing figure is
noteworthy not so much for the trophy head in his left
hand but, additionally, for the wide-grooved belt. The
latter indicates that he is a ball player (see the ballgame
stone yokes from Mesoamerica, 266–269). Note also the
headgear. This male wields a stone ax in his raised right
hand—doubtless his instrument for severing the trophy
head. Decapitation of ball players after a contest was a
prevalent custom associated with ballgame ritual in
Mesoamerica, primarily in Yucatan and the peripheral
Coastal Lowlands. The ballgame itself was circum-Carib-
bean in distribution.

352. Two Effigy Mace Heads

Costa Rica, Nicoya region. 300 B.C.–A.D. *300*
Polished granite
Gifts, 372 and 373:1978; L. 17.5 and 19.5 cm.

Ceremonial stone mace heads are among the finest of
early Costa Rican lapidary work, other than the jade
carving. Both of these pieces are pierced with cylindrical
holes to receive wooden shafts; they have effigy heads,
and conical striking ends. One (greenish granite) fea-
tures a human head with wide depressions for eyes, and
the other (reddish granite) has the head of a raptorial
bird with similarly executed eyes, as well as wing mark-
ings on the sides of the shaft enclosure.

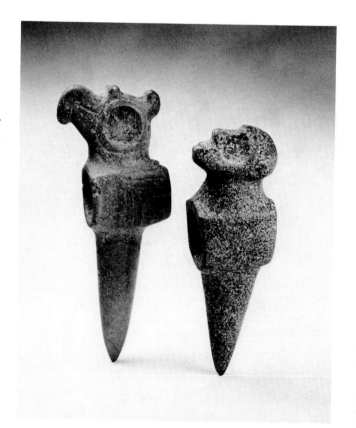

353. Long-Beaked Bird Pendant
Costa Rica, Nicoya region. 500 B.C.–A.D. 1
Dark green jadeite (See color plate)
Gift, 170:1980; H. 6.5 cm.

Costa Rica was one of the major natural sources of the coveted jade in Pre-Columbian Central America—especially the deep green and blue-green varieties, though there is a considerable range in color. Not only was jade extensively worked in Costa Rica, but trade for that raw material, and even interchanges of carved objects, took place with Mesoamerica from Olmec to Maya times. Jade working in Costa Rica was intensive from as early as the fifth century B.C. to about the sixth century A.D., when apparently the accessible deposits of jadeite dwindled. After A.D. 500, gold gradually replaced jade as the most desirable luxury material [cf. 359–362].

This polished bird pendant represents the earlier era of craftsmanship in jade, and its elegant simplicity gives it special charm. Biconical perforations at the neck allow for suspension. The eyes, also, are drilled.

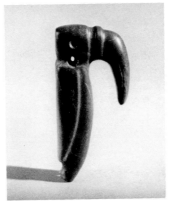

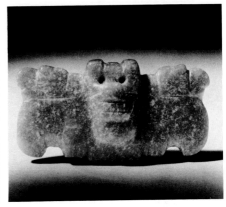

354. Bat Effigy Pendant
Costa Rica, Nicoya region. 500 B.C.–A.D. 1
Blue-green jadeite (See color plate)
Gift, 391:1978; H. 3.5 cm., L. 7 cm.

This is the type of jade the Olmecs of Mesoamerica desired, and several bat effigies in pure Olmec style actually have been found in Costa Rica. This particular pendant, however, is undoubtedly of local, post-Olmec inspiration. The eyes of the bat are drilled, and suspension holes extend longitudinally through the head. The upper corners of the wings bear profile bird heads rather than bat claws.

355. Anthropomorphic Bat Figure
Costa Rica, Nicoya region. 500 B.C.–A.D. 1
Polished white-mottled dark green jadeite (see color plate)
Gift, 169:1980; H. 11.5 cm., W. 3.2 cm.

A very unusual jade effigy, with tall winged crest, head tuft, and anthropomorphic face. It is equally carved on both faces of a wedge-shaped piece of high-quality jade. The eye is pierced.

356. Double-Headed Crocodile Pendant
Costa Rica, Nicoya region. A.D. 1–500
Gray-green jadeite
Gift, 171:1980; L. 17.5 cm., W. 2.5 cm.

An interesting bar pendant, with terminal crocodile heads and a central, low-relief, splayed monkey figure. All the eyes are drilled, and two tiny perforations on the upper border are for suspension. The double-headed concept is universal in archaic New World cultures and, in fact, may be considered circum-Pacific in distribution.

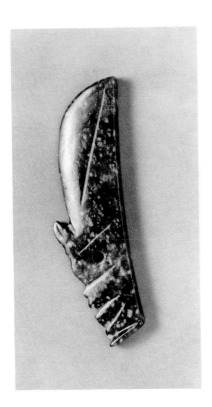

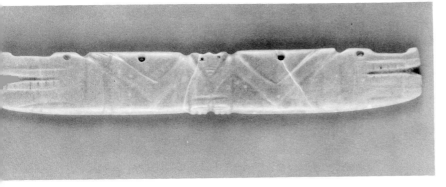

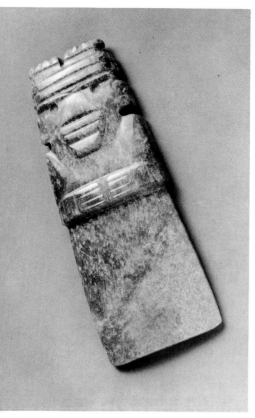

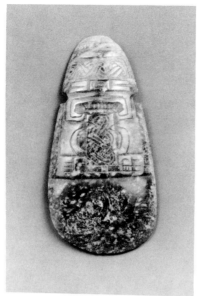

359. Filigreed Pendant

Costa Rica, Diquis style. A.D. *1000–1500*
Cast gold
Gift, 205:1978; H. 5.2 cm., W. 6.1 cm.

An exceptionally elaborate lost-wax casting, with open-work of wirelike delicacy. The flanges were probably hammered flat after breaking the whole gold pendant from the mold. A three-dimensional splayed male figure is shown with ropes (snakes?) leading from his mouth to his hands. He is flanked by four filigreed crocodile snouts at the outer corners of the composition.

357. "Ax-God" Pendant

Costa Rica, Nicoya region. 500 B.C.–A.D. *500*
Dark blue-green jadeite
Gift, 390:1978; H. 15 cm., W. 5.8 cm.

The so-called ax-god is the best known of Costa Rican jade pendants. It is carved as an abstract human figure on a thin celt-form blade. The back has been smoothed to remove the central string-sawed ridge. (The original celts were sawed into two pieces to create these carved pendants.) There is a horizontal perforation through the neck.

358. "Ax-God" Pendant

Costa Rica, Nicoya region (?). A.D. *1–500*
Transluscent, dark blue-green jadeite
Gift, 389:1978; H. 10 cm., W. 5 cm.

Another "ax-god" carved in low relief on a rounded celt-shaped stone. The back retains the longitudinal ridge where the other half was broken away. The mouth of this deity has feline aspects, while its eye region and protruding tongue are decorated with guilloche designs. It has a suspension hole through the neck. Although these are generally attributed to the Nicoya peninsula region, this object was said to have been found at Guapiles, Linea Vieja, in the Atlantic watershed.

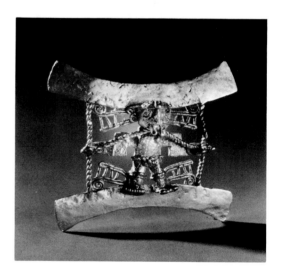

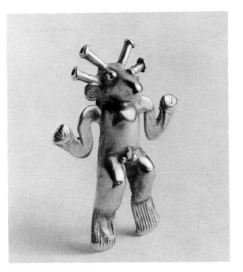

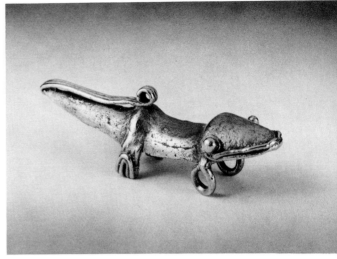

360. Frog Pendant

Costa Rica, Diquis style. A.D. *1000–1500*
Cast gold
Gift, 202:1978; L. 6.7 cm., W. 5.2 cm.

The frog was as popular as the eagle and crocodile in "lost-wax" gold pendants from Lower Central America. This example is cast leaving an opening on the bottom, and the characteristic hammered flanges behind the rear legs. Suspension loops are attached under the forelegs. Flowing from the mouth is a pair of sinuous crocodile motifs. This object reportedly came from the site of La Vaca in the Diquis region of Costa Rica.

361. Anthropomorphic Pendant

Costa Rica or Panama, Diquis-Chiriqui-Veraguas style. A.D. *1000–1500*
Cast gold
Gift, 209:1978; H. 6.3 cm., W. 5 cm.

Heavy gold casting, hollowed out behind, with a suspension loop between the shoulders for use as a pendant. This represents a composite deity, with male human body, crocodile feet, and a four-horned animal head. (A commercial gold copy of this object is available from Alva Museum Replicas.)

362. Crocodile Pendant

Costa Rica or Panama, Diquis-Chiriqui-Veraguas style. A.D. *1000–1500*
Cast gold
Gift of J. Lionberger Davis, 154:1954; L. 7.4 cm., W. 2.5 cm.

While the crocodile is frequently depicted as an anthropomorphic deity, this gold casting is relatively naturalistic, with the exception of its exaggerated looped tail. Its eyes bulge from the surface, and its forelegs are fashioned as rings for suspension.

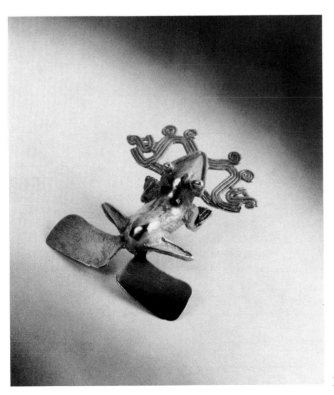

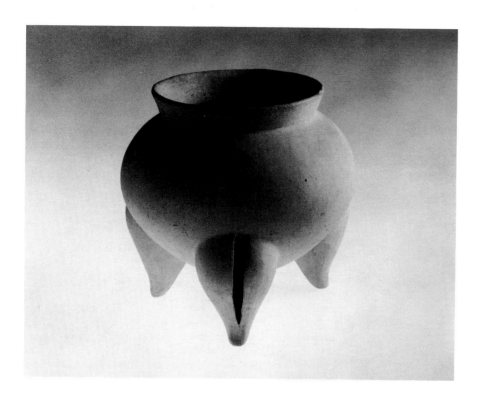

363. Tripod Bowl
Panama, Chiriqui style. A.D. *1000–1500*
Unslipped light orange earthenware
Purchase, 102:1954; H. 14.5 cm., Diam. 16 cm.

A thin ceramic, termed "bisquit ware," peculiar to the Chiriqui region of Panama and across the border into Costa Rica. The plain collared bowl is supported by three bulbous hollow legs with slits and rattles.

364. Ring-Based Shallow Bowl
Panama, Cocle style. A.D. *500–1000*
Polychrome buff earthenware
Purchase, 99:1954; H. 5.5 cm., Diam. 19.5 cm.

Painted ceramics from the Cocle region often feature simple but bold curvilinear motifs (in this case a "C" and "Y" pattern), arranged in panels. The bottom is un-slipped, while the concave bowl is painted purple, red, and black over cream.

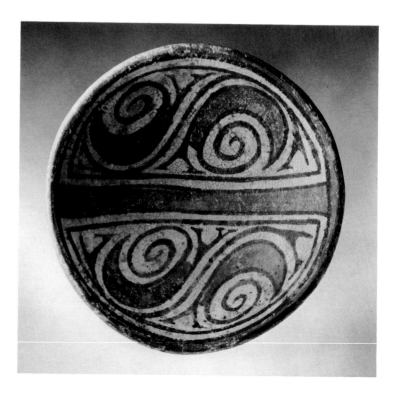

365. Tall Pedestal Plate

Panama, Veraguas style. A.D. *1000–1500*
Polychrome orange earthenware
Gift, 345:1978; H. 22 cm., Diam. 26 cm.

"Fruit stands," or tall pedestal plates, are prevalent forms for tomb offerings in the Veraguas-Cocle region. The bell-shaped open base is painted with geometric designs, while the floor of the plate is decorated with an intricate version of the "alligator god" who seems to be dancing (the head, only, is in view in the photo). The paint over the light orange slip includes dark orange, purplish red, and black. (Unfortunately, the colors on this object have been enhanced by overpainting.)

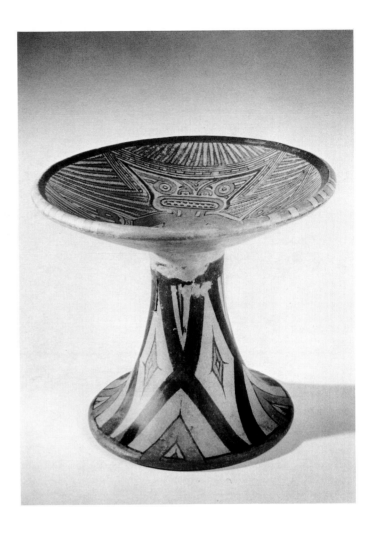

366. Painted Plate

Panama, Cocle style. A.D. *1000–1500*
Four-color polychrome earthenware (See color plate)
Gift, 226:1979; H. 6 cm., Diam. 28 cm.

An unusually complex and contorted, as well as curvilinear, version of the so-called alligator god. The crocodilian head may be seen at the top, the claws to the sides, and a serpent-headed tail at the bottom. The colors are orange, purple, black, and cream.

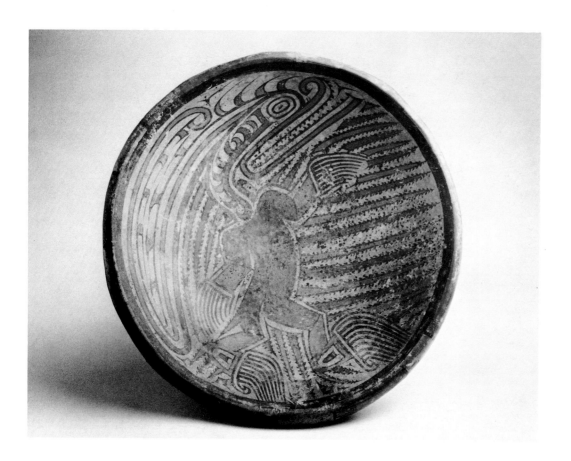

367. Pedestal Plate

Panama, Veraguas style. A.D. *1000–1500*
Polychrome orange earthenware
Purchase, 129:1952; H. 13 cm., Diam. 25 cm.

The hollow pedestal support on this example has four perforations. The bottom is unslipped, while the inside of the plate and the rim are painted purple, orange, and black over a cream ground. Featured in the design is another dancing anthropomorphic crocodile, with long swirling headdress, long thin claws, and a number of dartlike attachments.

368. Bird Effigy Bowl With Tall Pedestal

Panama, Veraguas or Parita style. A.D. *1000–1500*
Dark orange and black over light orange earthenware
Gift, 156:1980; H. 24 cm., L. 29 cm.

An elegantly modeled raptorial bird effigy bowl on a hollow pedestal base. Note the painted clawed legs and the scrolled wing motifs.

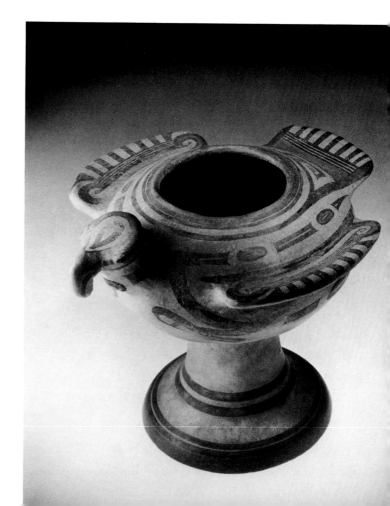

369. Hollow "Skunk" Pendant

Panama, Cocle style. A.D. *500–1500*
Cast gilded silver
Gift, 206:1978; H. 3.2 cm., L. 3.9 cm., W. 3 cm.

While the metal has not been professionally analyzed, the worn undersurface at the base of the tail appears to be silver, the rest of the surface being a coppery-gold gilt. It was cast in the lost-wax process. The bottom of this charming animal is open, with clay cores still intact in the hollow tail and head. Tiny loops on the front feet allowed for suspension of the pendant. (This type of object also has been identified as a Cebus monkey.)

370. Double "Skunk" Pendant

Panama, Cocle style. A.D. *500–1500*
Cast gold
Purchase, 104:1954; L. 2 cm., W. 2.2 cm., H. 1.6 cm.

A pair of miniature, joined, "skunk" effigies, with open bottoms and hollow tails (the heads are filled with earthen cores). Their front feet are perforated for suspension. Although this piece was collected in Costa Rica, the style is undoubtedly of Panamanian Cocle origin, like the previous one. (Copies of this object are available from Alva Museum Replicas.)

371. Necklace

Panama, Cocle style. A.D. *500–1500*
Gold
Purchase, 103:1954; Total L. 51 cm.

An elegant necklace composed of sixty-four hollow beads—some tubular, some spherical, and some elliptical —all strung on a modern cord. Accession information supports an original provenance of Sitio Conte in Panama.

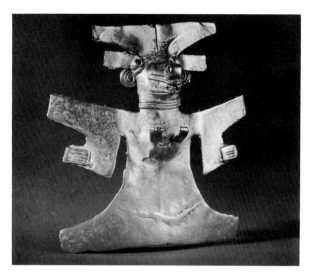

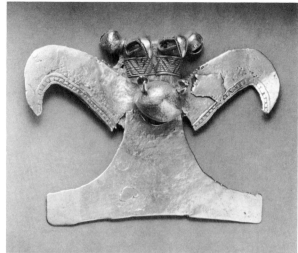

372. Bird Pendant
Panama, Veraguas style. A.D. *1000–1500*
Cast and hammered gold
Gift of Mr. and Mrs. Alvin Novak, 83:1958; H. 7.2 cm., W.
7 cm.

A composite bird creature, with a looped crocodile snout, and a suggestion of digits on the lower wing flanges. The feet are full-round projections from the abdominal cavity. Only the feet and head are open in back from the casting process. The bulk of the piece has been hammered flat, but still shows ridges and creases from an imperfect casting. A ring attachment is located behind the neck.

373. Double-Headed Eagle Pendant (Upper right)
Panama, Veraguas style. A.D. *1000–1500*
Cast gold
Gift, 204:1978; H. 9 cm., W. 12.3 cm.

Double-headed eagle pendants, sharing the same wings, are less common than simple eagles. (And this is a Pre-Columbian concept, only fortuitously resembling the European Hapsburg double-eagle crest.) This heavy gold pendant has the usual looped hook at the back, plus a bell-shaped cavity on the front, and two lateral bell-shaped eyes containing rattles. Several spots on the wings and tail show aboriginal repairs on a faulty lost-wax casting.

374. Eagle Pendant
Panama, Veraguas style. A.D. *1000–1500*
Cast and hammered gold
Gift, 203:1978; H. 14 cm., W. 18.2 cm.

An especially large eagle pendant of standard Veraguas configuration. The head is hollow through to the back, and three-dimensional feet protrude from the abdominal cavity. Judging by the color of the metal, this object appears to have appreciable copper content.

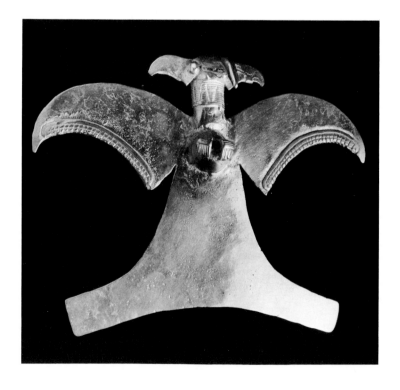

Northern Andes

The southern sector of the Intermediate Area covers the Northern Andean countries of Colombia and Ecuador. (The Caribbean coast of Venezuela is also sometimes included, though Pre-Columbian objects from there are seldom seen.) In this region the oldest fired ceramics in the New World have been discovered along the coasts, dated to before 3000 B.C. The importance of the Northern Andes has yet to be fully appreciated, but fairly recent work in Ecuador is bringing to light unexpectedly long sequences and surprisingly innovative cultures. Forty years before the conquest, the Incas penetrated the region as far north as the Ecuador-Colombia border, incorporating Ecuador into their empire.

Colombia is still poorly known archaeologically, though we have long been struck by its gold-producing cultures, which flourished from A.D. 300 to 1500. The ceramics of Colombia are as prolific as in any other Pre-Columbian region, but not as well sorted culturally or chronologically and infrequently collected. We illustrate only one Quimbaya style ceramic here [375]. The remainder of the objects display the remarkable gold work of the Muisca (Chibcha), Quimbaya, Calima, Tairona, and Darien cultures [376–386]. The sprawling site of San Agustin in the southeastern highlands of Colombia has long been recognized for its many megalithic stone sculptures (with grimacing, fanged visages that have been compared with the early Chavin sculpture of Peru), and its stone-lined passage graves. According to recent information, San Agustin was in existence between 500 B.C. and A.D. 1000. Eventually this extraordinary site will be correlated with developments to the south and north.

Our representation of the cultures of Ecuador is far from comprehensive [387–392], but no collection outside of Ecuador is. For the newly defined early cultures, the reader is referred to another work (Lathrap, 1975). The discovery of the ancient Valdivia ceramic complex in Ecuador (2500–1500 B.C.) created quite a stir in academic circles, due to claims for the introduction

of clay figurines—the oldest in the western hemisphere—and pottery styles from the contemporary Jomon culture in northern Japan. Be that as it may, even earlier indigenous ceramic complexes have since been located in the Northern Andes. In the subsequent Machalilla phase (1500–1000 B.C.), stirrup-spout vessels appear in Ecuador possibly earlier than they have been dated for the first Chavin civilization in Peru. The Chorrera phase (1000–300 B.C.) is contemporary with Chavin (and Tlatilco in Mexico), and shows unusual effigy pottery in two and three colors, some of which may have influenced Mesoamerica (such as the whistling vessel form). Then, the Bahia phase (ca. 300 B.C.–A.D. 500) is noted for roller stamps [387], a wide range of figurines [388, 389], and even ceramic house models, which again occasionally relate to Mesoamerica in about the same period. The last major cultural phase (A.D. 500–ca. 1500) in coastal Ecuador is called Manteño [390–392], and is characterized by effigy black-ware ceramics. (In the highlands there is a contemporary three-color, negative-painted, ware from the province of Carchi.) Metallurgy in gold is not absent from Ecuador. But to understand some of these Pre-Columbian styles and cultures, we must look at the Central Andes itself.

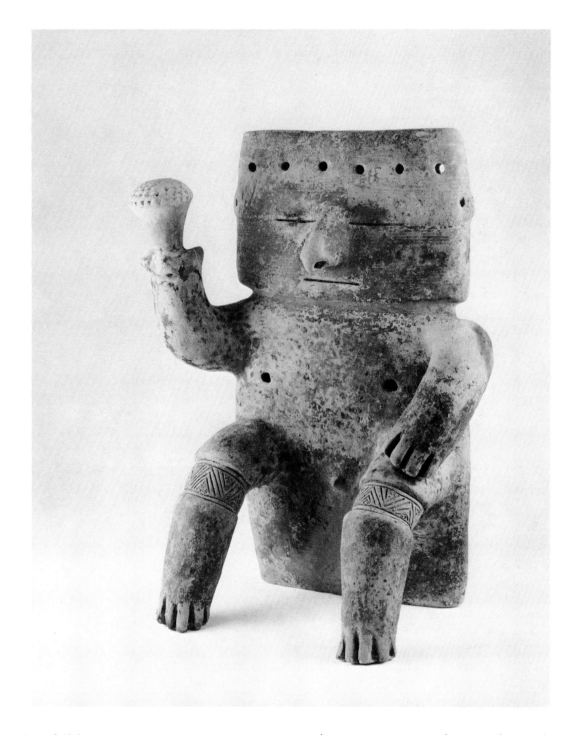

375. Seated Slab Figure

Colombia, Quimbaya region. A.D. *1000–1500*
*Unslipped orange earthenware with black patina and traces of
negative-black stripes*
*Gift, 253:1978; H. 37 cm., W. 29.5 cm. (Illustrated: La-
piner, 1976, item 808)*

While Pre-Columbian ceramics from Colombia are as
profuse as any other Latin American region, this is the
only example we have for this catalogue. This well-
known type seems to relate to prehistoric Amazonian
cultures; note the incised leg ligatures [and see 332].

The figure is constructed as a heavy rectangular slab
of clay, with a broad, flat head and projecting legs and
arms (one of which holds forth a punctated mushroom-
shaped rattle). Perforations occur at the nipples, the nose
septum (these clay figures sometimes have attached gold
nose rings), and along the top of the head.

376. Hollow Seated Man
Colombia, Muisca style. A.D. 1000–1500
Cast gold
Gift of Mr. and Mrs. Alvin Novak, 84:1958; H. 3.7 cm.

Tiny "lost-wax" figure of a crouching, turbaned man holding an object across his knees. Muisca style gold casting usually has a rougher surface feel than other contemporary styles in Colombia, and specialized in the wirelike filigree work achieved through the casting process. This example suffered some losses in the less than perfect cast, as witnessed by a number of gaps in the metal.

378. Bodkin With Acrobat Finial (Facing page)
Colombia, Middle Cauca Valley, Calima style. A.D. 300–1000
Cast gold and copper
Gift, 220:1979; Total L. 24 cm., Finial L. 3.6 cm.

A costume pin, fabricated by extremely complex technology that combines alternating areas of gold and copper. While two similar acrobat bodkins are in the collection of the famed Banco de Oro in Bogota, no other examples are yet known. The shaft of the pin consists of copper *tumbaga,* girdled with a decorated gold band on the lower third, another gold band near the top, and an expanding gold support under the finial. The last depicts an acrobat performing a handstand on the body of another supine human figure. The acrobat's body is essentially of gold, with the lower legs and belly of copper. The tiny supine figure has a coppery finish. According to Robert Sonin, who examined the object, the two component metals have been selectively fused by a combination of soldering and lost-wax casting. Objects like this deserve detailed metallurgical analysis to discover exactly how they were accomplished with "primitive" technology.

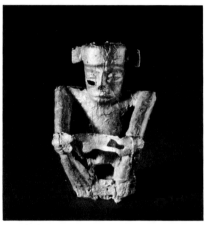

377. Human Effigy Pendant
Colombia, Quimbaya style. A.D. 500–1500
Cast gold
Purchase, 153:1944; H. 9.6 cm., W. of headdress 5.8 cm.

A lost-wax casting with hammered lower flange. It depicts a human figure with openwork crests, and is hollowed behind the head where the suspension ring is located. Loops are also attached on the front for rectangular sheet gold danglers (four of these are extant). One loop on the nose, two flanking the head, and four on the horizontal bar grasped in the figure's hands all held danglers. The gold alloy apparently has some copper content.

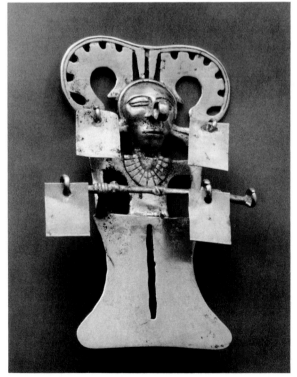

379. Knife-Shaped Pectoral

Colombia, Cauca Valley, Calima or Tolima style. A.D. *300–1000*
Hammered sheet gold
Purchase, 247:1966; H. 17.5 cm., W. 14.5 cm.

These cut and hammered objects are distinctive of a relatively early gold-working horizon in central Colombia. The stylized knife or chopper shape has a rectangular perforation, which permitted it to be suspended, presumably as a breastplate. The flat sheet metal has a coppery gold color. The object weighs 156 grams.

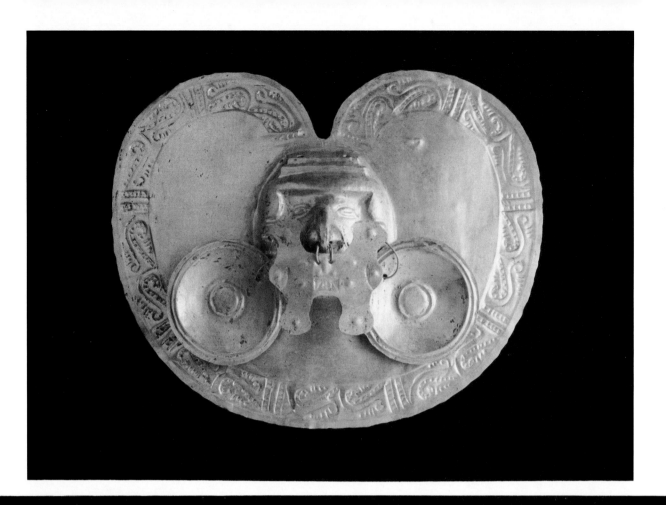

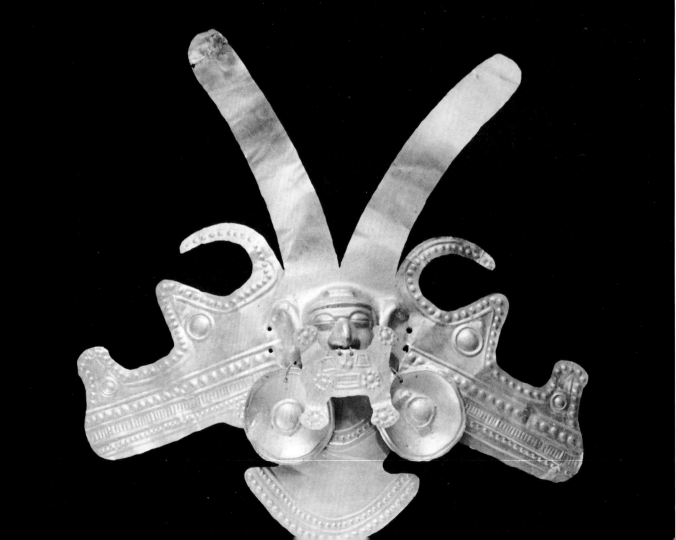

380. Breastplate

Colombia, Calima style. A.D. *300–1000*
Hammered and embossed sheet gold
Gift, 217:1979; H. 16 cm., W. 20 cm.

The heart-shaped form has been hammered from thin sheet gold, with a relief head deeply pressed out from behind. The decorated border, on the other hand, was embossed from the front. A pair of large sheet gold earrings, and a four-lobed nose pendant, have been attached by gold wires through tiny perforations. A pair of holes at the top of the head allowed for suspension of the large breastplate.

381. Breastplate

Colombia, Calima style. A.D. *300–1000*
Hammered, repoussé sheet gold (See color plate)
Gift, 218:1979; H. 29 cm., W. 29 cm.

Similar, but more elaborate than above, this breast ornament also has been cut and hammered from thin sheet gold. The surface details, however, were worked from the reverse side in repoussé fashion. The face was pressed forward and has attached earplugs and nose pendant. Two long-horned dragons emerge from either side of the breastplate, and two pairs of suspension holes flank the central face.

382. Necklace

Colombia, Tairona style. A.D. *1000–1500*
Cast gold beads
Gift, 224:1979; Total L. ca. 144 cm.

A unique necklace, with modern stringing, composed of several hundred individually cast beads. Each bead consists of eight or more minute, hollow drops of gold, and each perforated bead measures only 2 to 4 millimeters in length.

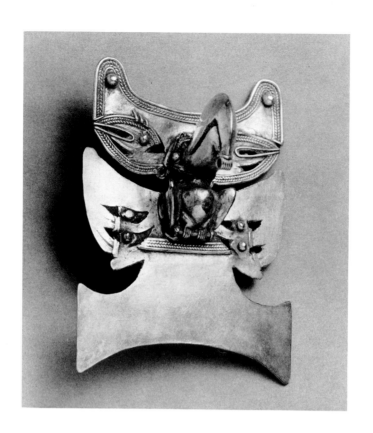

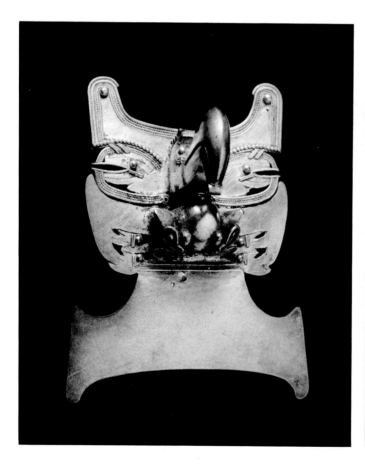

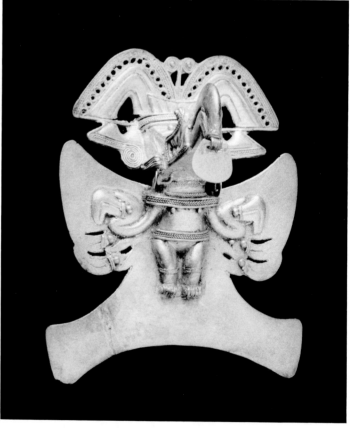

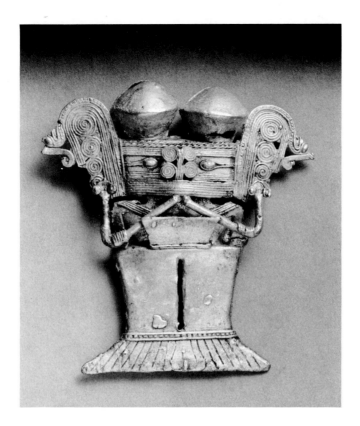

383. Bird Pendant (Facing page, top)
Colombia, Tairona style. A.D. *1000–1500*
Cast and hammered gold (See color plate)
Gift, 219:1979; H. 8 cm., W. 6.2 cm.

One of three gold pendants [383–385] of the delicately distinctive Tairona style from Colombia's north coast. A perfectly cast pendant, similar to the examples below. The large hollow beak of this bird still retains some of the clay core from the lost-wax casting process. Note the low-relief bird effigies on the upper side flanges.

384. Bird Pendant
Colombia, Tairona style. A.D. *1000–1500*
Cast and hammered gold (See color plate)
Gift, 221:1979; H. 11.2 cm., W. 9 cm.

The hollow projecting bird effigy is independently attached to the flat, cast and hammered, decorated backing. A small clip may be observed on the reverse, which served as a mechanical join before the cast bird was soldered to its symmetrical back. Two tiny suspension loops are also found on the reverse.

385. Birdman Pendant (Facing page)
Colombia, Tairona style. A.D. *1000–1500*
Cast and hammered gold (See color plate)
Gift, 232:1979; H. 10.2 cm., W. 8.7 cm.

This is the most elaborate of the three Tairona pendants, and has been cast in one piece. The standing anthropomorphic figure has arms ending in birds' heads. He sports a toothy crocodilian snout, as well as a raptorial bird's beak. The back of the body and head are open and hollow. The crests flowing from the headdress are filigreed, while loops are attached below the ears and the beak. A sheet gold ornament hangs from the beak. (The lower right flange recently was broken and repaired.)

386. Anthropomorphic Pendant
Colombia, or Panama, Darien style. A.D. *300–1000*
Cast gold
Gift, 231:1979; H. 9 cm., W. 9.1 cm.

An example of complex lost-wax casting, including two hollow bells with rattles at the top of the head. The scrolled nose, horizontal mouth band, arms, and trapezoidal element, all are raised from the surface, although the entire object evidently was cast in one piece. Two suspension loops are on the upper back. Darien was the province of northwest Colombia and now includes the southernmost sector of modern Panama.

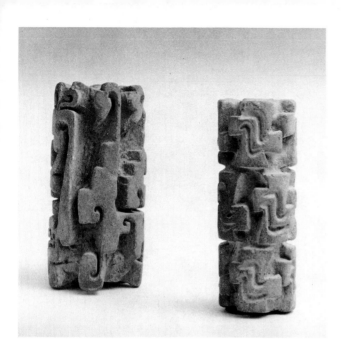

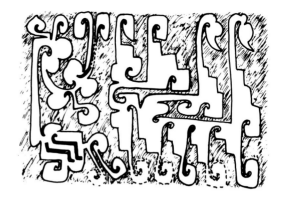

387. Two Roller Stamps

Ecuador, Pacific Coast. Bahia phase, 500 B.C.–A.D. *500*
Gray-brown earthenware
Gift, 167 and 168:1980; (right) L. 5.5 cm., Diam. 2 cm.;
(left), L. 5.8 cm., Diam. 2.5 cm.

Roller stamps or seals are standard artifacts during the
"Preclassic" periods from Ecuador to Mexico [cf. 43].
They were used to roll out pigment to create continuous
patterns (see drawings) on people's skin, and possibly on
bark cloth. These cylindrical examples from Ecuador are
solid and have deeply cut designs.

388. Hollow Figurine

Ecuador, Guayas, Guangala style. Bahia phase, 500 B.C.–
A.D. *500*
Burnished gray-black earthenware with whitewash
Gift, 245:1978; H. 27 cm.

Several substyles of figurines are common to the Bahia
phase on the Pacific Coast of Ecuador. This female effigy
has pairs of holes on the front and back, and one on the
head, which allow the object to whistle. The head and
body are burnished, while the incised skirt is white-
washed.

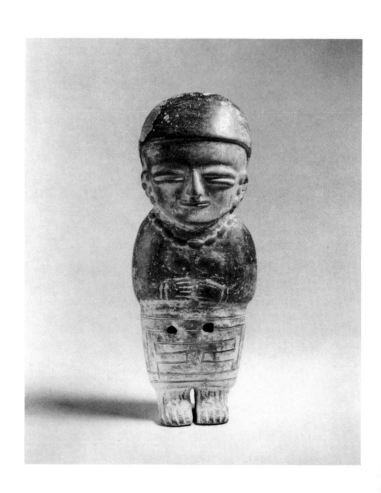

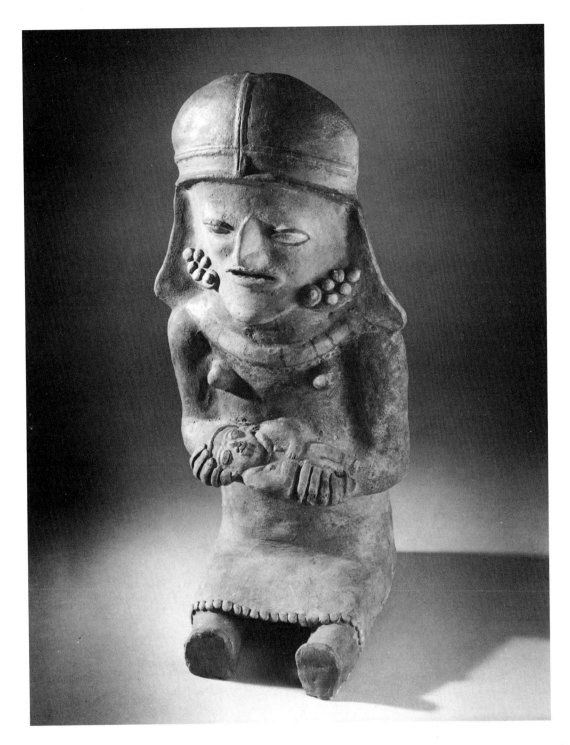

389. Large Seated Female Figure

Ecuador, Manabi (Los Esteros). Bahia phase, 500 B.C.–A.D.
500
Polychromed buff earthenware (See color plate)
Gift, 255:1978; H. 51 cm.

Many years ago, a large group of these spectacular hollow figures were washed out of a Pacific Coastal Ecuadorian site (Los Esteros) and quickly appeared on the international art market. Since then, very few of this special type have been seen outside of Ecuador. This skirted figure holds out a child in front of her, which resembles the next figurine. Most of the surface is painted red, black, and white. There is a vent hole in the top, and the mouth is open.

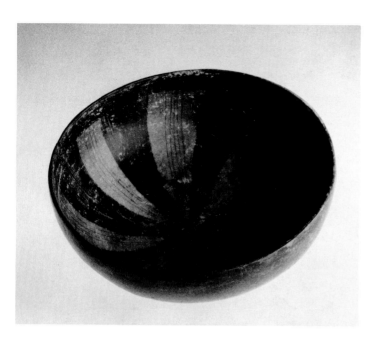

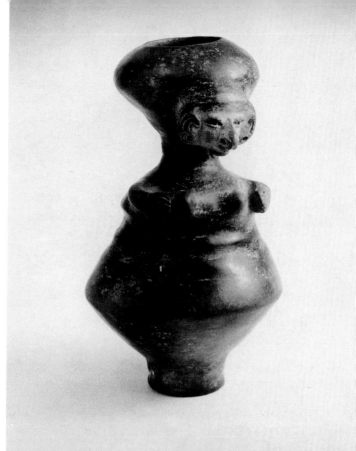

390. Hemispherical Bowl
Ecuador, Pacific Coast. Manteño phase, A.D. *500–1500*
Pattern-burnished black earthenware
Gift, 207:1979; H. 6.5 cm., Diam. 19 cm.

A simple thin-walled bowl, decorated by selective polishing. The exterior is completely burnished, while the interior is burnished in radiating triangular patterns. The unpolished zones between are decorated with stick-burnished lines.

391. Composite Jar With Female Effigy
Ecuador, Manabi. Manteño phase, A.D. *500–1500*
Polished black earthenware
Gift, 166:1979; H. 21.5 cm.

This form is peculiar to Ecuador. It has a ring-stand base and a vessel opening in the expanded top. A face is applied to the latter, with arms and breasts in relief on the shoulders. The nose is pierced as if to hold a nose ring.

392. Large Human Effigy Incense Burner
Ecuador, Manabi. Manteño phase, A.D. *500–1500*
Burnished black earthenware
Gift, 200:1979; H. 45 cm., Diam. 24.5 cm.

These impressive full-round modeled figures, with bell-shaped tops and bottoms, are common to the later period on the coast of Ecuador. The bottom is open, and there is a continuous vent through the body to the base of the upper bowl. The object was probably placed over a separate incense-burning container to allow the vapor to be emitted through the summit (and the ears and hands). The broad-shouldered male effigy is seated upon a wide concave stool (the left side is broken). His earplugs are inserted in the slit ears, as they would be in actuality. The right shoulder and torso are incised with patterns, as is a band around the chin.

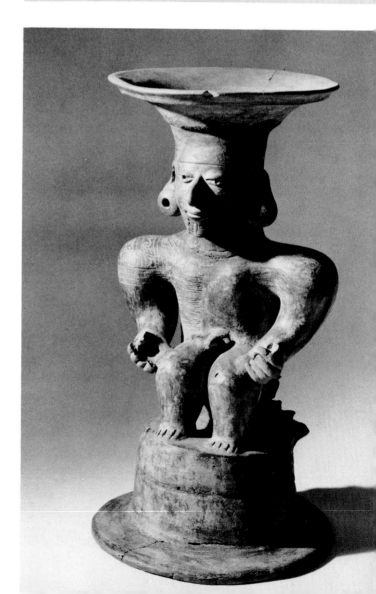

CENTRAL ANDES

The height of Pre-Columbian civilization in South America was attained in the Central Andes, which are now Peru and western Bolivia (see map in color section following page xvi). This area straddles two sharply demarcated environmental regions: the arid, narrow coastal strip, and the high Andean mountains and basins. On the Pacific Coast, which we divide into North, Central, and South cultural subregions, rainfall is to all intents and purposes nonexistent. On the better-watered North Coast, appreciable rainfall occurs about once every quarter century, when long-dormant seeds immediately germinate and bloom throughout the desert. Peoples of the desert coast therefore depended upon efficient irrigation systems to water their crops along the many river valleys that cross-cut this region, draining from the Andean mountains that loom in the background. (In some seasons even these rivers become dry arroyos before they empty into the Pacific Ocean.) In the habitable highland basins, 9,000 to 14,000 feet in elevation, peoples devised tiers of agricultural terraces on the steep mountain slopes to extend their arable land. Through the millennia, Native Indian races also adapted in physique and metabolism to the high altitudes. By A.D. 1500 the highland Incas had expanded their territory, through conquest, into the Northern and Southern Andes as well. The short-lived Inca Empire was preceded by a series of earlier civilizations, beginning with the Chavin 1,200 years before Christ (see chronological chart on p. 253).

The most important food crops in the Central Andean area were (and still are) maize (corn), quinoa (a native highland grain), potatoes (a great many varieties of "white," as well as "sweet"), manioc, beans, squash, chili peppers, and peanuts. Bottle gourds, cotton, tobacco, and coca (a narcotic leaf) also had their special uses. These all were domesticated by the Chavin period. (Except for bottle gourds and cotton, all were unknown in the Old World before Columbus.) The eastern slopes of the Andes (the *montaña*) and the upper reaches of the Amazon and its tributaries were also exploited for

tropical bird feathers, and peanuts, manioc, and the coca bush were initially domesticated in this tropical zone. We have not mentioned the native tropical fruits, but only the pineapple, avocado, papaya, and mango are generally familiar to most of us today. Abundant sea life was utilized for food, and represented in the coastal art, as well as shore birds and small land mammals, such as the highland guinea pig, still considered "feast food" among the Indians. Native American cameloids, llamas and alpacas, were the only domesticated beasts of burden in the New World; their wool was used for the prevalent art of weaving. Again, these animals are found exclusively in the Central Andes.

Whereas for Mesoamerica we could elaborate on the systems of writing and calendar, these intellectual achievements were never realized in the Central Andes. The closest approach to recording knowledge in ancient Peru was the use of assemblages of knotted cords called *quipus.* Variously colored strings with differently tied knots were used as memory aids for recording numerical quantities of material goods in the fashion of bookkeeping. They were also employed to take censuses of populations and for recording genealogies. For any particular surviving *quipu,* however, we have no way of knowing whether it was last used to tabulate llamas, potatoes, or people.

As in Mesoamerica, Andean civilizations excelled in monumental architecture. While some building complexes might be called ceremonial centers, others, as Cuzco in the South Highlands and Chanchan on the North Coast, were urban cities. The latter, which was the capital of the kingdom of Chimu, was apparently the largest city in the New World, sprawled over some 10 square miles. Buildings in the highlands were constructed of stone. Cut stonemasonry first appeared there at Chavin de Huantar, the center of the Early Horizon Chavin civilization. At that site we encounter a large stonemasonry temple with three levels of interior galleries and passages covered with stone slabs. This ceremonial temple is entered through a portal with an enormous stone lintel supported by two monolithic round columns. These are decorated with low-relief carving, as were a number of stone cornices and wall panels at the site. Full-round tenoned stone sculptures were also set into the masonry facades. By the Middle Horizon, on the south shore of Lake Titicaca in western Bolivia, we find the South Highland Tiahuanaco capital. This center, again, is an imposing complex of stone architecture, including a raised acropolis enclosed by megalithic pylons and containing the famous carved monolithic "Gateway of the Sun." There are sunken courts lined with dressed stone blocks and tenoned with full-round stone sculptures. Some structures had joined blocks clamped together by copper-filled, T-shaped grooves. Tiahuanaco is also characterized by a number of free-standing, full-round stone figures, the largest of which is 24 feet in height. Late Horizon Inca masonry—best known for the temples and civic buildings at the Cuzco capital, as well as the great surrounding fortresses (such as Sacsahuaman) and outposts (such as Machu Picchu)—is legendary for its use of massive faceted stone blocks, tightly fitted together without mortar, and for its trapezoidal door-

ways, windows, and niches. However, Inca architecture is less remarkable when we recall the history of stonemasonry in the highlands, which goes back to the first millennium B.C.

On the desert coast, where stone was not easily available and water erosion was a problem rarely encountered, buildings were constructed of sun-dried adobe bricks—often millions of them incorporated in one structure—and mud-plastered walls. Stone sculpture on the coast also is rare. Stepped mud-brick pyramids dominate the major ceremonial centers. The largest, *Huaca del Sol* ("Pyramid of the Sun") at Moche, the capital of the Mochica on the North Coast, is 350 feet square at the base and 75 feet high. It surmounts a much larger terraced platform, in itself 60 feet high. The great pyramid at Pachacamac, outside of Lima on the Central Coast, covers 12 acres. Polychrome murals on the plaster walls are preserved at some coastal sites (best seen at the Mochica site of Pañamarca). The Late Intermediate period city of Chanchan consists of a number of large walled precincts enclosing complexes of temples, élite residences, warehouses, funerary pyramids, and reservoirs dug down to the water table. The outer adobe walls are up to 30 feet in height, and the inner mud-walled structures are carved with arabesque-like reliefs.

In the late period, 30-foot-wide highways lined with low walls were built and ran for hundreds of miles across the desert. The Incas are well known for their network of roads linking distant parts of the empire. In the highlands, roads were paved with stone cobbles (still in use today, even in Ecuador), and they crossed gorges by means of stone or suspension bridges. Communication, as well as political and economic control, was implemented on these by relays of messengers, pack trains of llamas, and battalions of soldiers, facilitated by intermittent garrisons and storage houses. The lines and "pictures," miles in length, found in the Nazca Desert of the South Coast, which have received so much recent publicity, are not roads, nor are they astronomical sight lines, or even "landing strips" as one popular author tries to tell us. Rather, they are colossal "landscape art," doubtless meant to be viewed by the gods.

As we did for Mesoamerica, we will summarize the history of the Central Andes by reference to the three major integrative "horizons": Chavin, the "Early Horizon" (1200–400 B.C.); Tiahuanaco, the "Middle Horizon" (A.D. 600 or 700 to 1000); and Inca, the "Late Horizon" (ca. A.D. 1450–1532). (These are indicated by horizontal gray bands on the chronological chart.) Each of these cultures expanded during successive time horizons to temporarily unify large areas. The Chavin art style spread to the coast and as far south as the Paracas peninsula, perhaps through the emulation of a compelling religious cult; the Tiahuanaco style and culture spread throughout Highland and Coastal Peru, perhaps by means of economic trade as well as colonization (although there is very little evidence for the mechanisms responsible); while it is well recorded that the Incas gained dominion over an incredibly extensive territory (stretching 2,500 miles from northern Ecuador

to central Chile) through premeditated military conquest and an intricately organized system for empire building. Interestingly, all three of these far-reaching cultures originated in the Andean cordillera—the Chavin centering at Chavin de Huantar in the North Highlands, the Tiahuanaco in the South Highlands of western Bolivia, and the Inca at Cuzco in the South Peruvian Highlands. It also may be germane to note that it was in the highlands that the first staple crops were domesticated as early as 5000 B.C., thus partially explaining a certain precocity there.

These cultural and art style horizons are separated by long periods of local regional florescences, especially on the desert coast. The "Early Intermediate" period, 400–200 B.C. to A.D. 600–700 (popularly dubbed the "Master-craftsman" period, and actually equivalent to the "Classic" period in Mesoamerican terminology), witnessed such civilizations as the Mochica on the North Coast and the Nazca on the South Coast—both of which had cultural roots in the preceding Early Horizon Chavin civilization. After the Middle Horizon, there is another intervening stage of regional divergence known as the Late Intermediate period, A.D. 1000–ca. 1400 (popularly termed the "City Builder" period), when we see such distinctive civilizations as the Chimu on the North Coast and the Chancay and Ica on the Central and South coasts, respectively. Incidentally, the Chimu city of Chanchan was finally conquered by the Incas in 1471. We will examine the complete art style sequences in the coastal regions, including other cultures not yet mentioned, in the following sections. Here, we shall briefly characterize the three primary highland civilizations.

Peru's first civilization, Chavin, is comparable in time (1200–400 B.C.) and cultural content to the Olmecs of Mesoamerica, including the worship of the awesome tropical jaguar. We have touched upon the monumental architecture and stone sculpture found at its presumed capital at Chavin de Huantar. The Chavin are also notable for their innovations in metallurgy, especially hammered and soldered gold work, and their sophisticated black-ware pottery. Most of the known artifacts in Chavin style, including painted textiles, have been preserved in graves on the coast of Peru where Chavin influence was pervasive. Chavinoid stone sculpture and mud-relief decorated buildings have also been excavated on the North Coast, as at Cerro Sechin. What is most distinctive about the Chavin horizon is the art style itself, whether manifested in stone, pottery, metal, or cloth. The prevailing motif in its vigorous iconography is a fanged feline figure, which must have been the principal anthropomorphic deity in a forceful religious cult. In the art, the fangs always cross the upper and lower lips. Another fundamental deity is a kind of "staff-god," brandishing two different ceremonial staffs. These images usually have multiple appendages consisting of twined serpents. The style is decidedly curvilinear, employing volutes and S-shaped motifs with concentric outlines. Supplementary monster heads and mouths are worked into the fabric of the primary deities. The early Chavin civilization developed fundamental concepts in all dimensions of culture, which were then inherited and elaborated

upon by the subsequent civilizations of the Central Andes.

The middle period highland civilization originated at Tiahuanaco, far to the south. That important site (already described) was founded as early as A.D. 300, but by A.D. 600 the culture expanded northward to the South-Central Highlands of Peru, where a colony was established at the site of Wari. From Wari, the Tiahuanaco art style spread to the South Coast of Peru, and eventually as far as the North Coast. Between A.D. 600 and 1000 the Wari-Tiahuanaco style was pan-Peruvian, temporarily eclipsing the previous Nazca and Mochica cultures. The rigid, geometric Tiahuanaco style is easily recognized wherever it appears, and in whatever medium, be it low-relief stone carving, tapestry textiles, or painted pottery. It has been suggested that the art style was derived from the mechanics of weaving, transferred to stone carving as well as pottery, and possibly passed from region to region through the trade of actual textiles. A central Tiahuanaco motif, again, is a "staff-god," such as the one carved in relief on the Gateway of the Sun at the home site (also called the sun god, or Viracocha). Like the Chavin prototype, it has numerous animal-headed appendages—representing serpents, pumas, and condors. Certain features of Tiahuanaco civilization were later carried on by the Incas, just as the Aztecs borrowed from the Toltecs.

However successful the culminating highland Inca civilization was, it lasted in power for even less time than the Aztecs of Mexico. Developing in the region of Cuzco in the South Highlands of Peru, the Incas began building an empire in 1438, to be precise. (Inca history is well recorded through chronicles written after the conquest.) Their imperialism was sustained by a tight central bureaucracy and a social system that has been aptly described as "pure communism." We have mentioned their military power, their method of rapid communication by road, and their formidable civic architecture. The masses were controlled by forced labor, taxation, and tribute. Land and its produce were evenly distributed, except for the proportion claimed by the state. If a distant colony proved to be unmanageable, the inhabitants of whole villages would be moved to a pacified region, and the already pacified people transported to the unruly foreign village. Levels of political power were carefully distributed among governmental entities, but the ruling dynasties, calling themselves Incas, were considered to be "children of the sun" with divine privileges. Since the Incas devoted most of their energy to political enterprises and to public monuments and fortresses, the art of the period is perhaps less brilliant than some of the earlier civilizations. Nevertheless, the Spaniards were astounded by the opulent gold and silver work they found there in unbelievable quantity, and bronze too had come into common use by Inca times.

In 1532, when Pizarro navigated down the Pacific Coast from Panama, he already had heard of the splendors to be encountered in the land of the Inca. Like Cortes in Mexico, he fortuitously arrived on the North Coast of Peru at a most propitious time for conquest. In that same year, two Inca brothers were themselves in conflict over power; in fact, a revolution had just

taken place, with the legitimate ruler Huascar having been defeated by Atahualpa. Pizarro was not slow to take advantage of the precarious political situation. He quickly found and captured Atahualpa in the North Highlands, asked for a vast ransom in gold and silver for his release, and after only some of it arrived from distant provinces, assassinated the Inca ruler. This simple act, as with the slaying of Moctezuma in Mexico, effectively marked the collapse of the Inca Empire. The living Quechua-speaking Indians of Highland Peru are the heirs of Inca civilization; but like the surviving Maya and Mexican Indians, they have lost the cultural richness of their Pre-Columbian civilization.

LOWER CENTRAL AMERICA

NORTHERN ANDES

COSTA RICA	PANAMA	COLOMBIA	ECUADOR	
				1550
CHIRIQUI		MUISCA	INCA	1450
Late Polychrome	VERAGUAS	TAIRONA	CARCHI	
				1000
NICOYA Middle Polychrome		QUIMBAYA	MANTEÑO	
	COCLE			
Early Polychrome		CALIMA		500
		DARIEN		
			LA TOLITA JAMA-COAQUE	AD
		TUMACO	BAHIA GUANGALA	BC
Zoned Bichrome				300
		SAN AGUSTIN		500
			CHORRERA	500-1000
			MACHILILLA	1000-1500
	CHRONOLOGICAL CHART OF CENTRAL ANDES		VALDIVIA	1500-3000

North Coast

Pre-Columbian cultures on the North Coast of Peru extended from the Piura Valley near the Ecuadorian border down to about the Casma Valley, and centered in such major river valleys as the Lambayeque, Jequetepeque, Chicama, Moche, Santa, and Nepeña. Civilization began here with Chavin penetration from the adjacent North Highlands. The Chavin manifestation on the North Coast is usually called Cupisnique, after one of the important grave sites. Significant Chavin finds were made more recently at a site called Tembladera. The regional florescence on the North Coast is seen in the Mochica (or Moche) culture, which itself was preceded by the transitional, post-Chavin, Salinar and Gallinazo cultures. Mochica development was also paralleled by the relatively recently discovered Vicus culture in the north. After a very brief Wari-Tiahuanaco overlay during the Middle Horizon, the powerful Chimu civilization (terming itself the "Kingdom of Chimor") came into prominence outside of modern Trujillo, where the ruins of the city of Chanchan are located. The Chimu were conquered, with difficulty, by the Inca, who took over their kingdom for the final sixty years before Pizarro. On the North Coast there is a continuity of cultural development from the Early to the Late Horizon. Such traits as the stirrup-spout pottery form began with Chavin and persisted through Chimu. The Mochica inherited Chavin innovations, and the Chimu in turn elaborated upon the contributions of the Mochica.

The majority of surviving objects in the Early Horizon Chavin style, including the gold (much of it found at the site of Chongoyape), have been excavated in the North Coast. Chavin pottery is usually monochrome black, or sometimes bichrome red and orange (or black). Design motifs are normally surrounded with grooves (termed "zoned-incising"), or the surfaces of the ceramics are boldly textured. In fact, the general feeling of Chavin pottery is a kind of solid monumentality. The favorite shapes are single-spout and stirrup-spout vessels (an arbitrary form that served as a handle and also re-

tarded evaporation of the contents), but including some modeled effigy forms, and not forgetting, of course, the jaguar [cf. 397]. The seven Chavin ceramics shown here [393–399] are sorted into the Early, Middle, and Late phases, 1200–400 B.C.. The most unusual effigy is that of an embracing male and female couple from Tembladera [399]. Also illustrated is a miniature stone vessel in the form of a feline [400].

From the post-Chavin, Salinar-Gallinazo, period of 400–200 B.C., we illustrate some Early Vicus effigy ceramics from the Piura Valley far to the north [401–403]. At this point we encounter some of the most naturalistic ceramic modeling ever produced in the Central Andes, from llamas to cats to birds and people. The style is expressed in either monochrome black, or red-orange and cream colors, similar to the Mochica tradition that was beginning at the same time in the Moche Valley. But before we get to the Mochica sequence, we will introduce the contemporary (200 B.C.–A.D. 700) Late Vicus style from the Piura Valley [404 and 405], discovered in 1962. This is a different negative-painted tradition, with white and black-resist paint on a red ware. The forms are modeled effigies, and both the resist-painting technique and the style of modeling derive from the earlier Salinar and Gallinazo cultures to the south. In this context, we illustrate the distinctive Recuay style, also contemporary, and also featuring three-color negative painting [406]. Recuay actually centered in the adjacent North Highlands, specifically in the Upper Santa River Valley. Its ceramics are notable for narrative modeled scenes on the tops of spouted jars.

The classic Mochica sequence (Early Intermediate period, 400 B.C.–A.D. 700) has been seriated into "Mochica I through V" phases, on the basis of variations in the shape and proportions of the stirrup spouts found on much of the pottery, and it is so ordered in the ceramics illustrated [407–418]. The Mochica ceramic inventory is memorable for its realistic modeling, resulting in an almost narrative style: every aspect of human and mythological activity is portrayed, including the notorious small percentage of erotic subject matter, providing a visual encyclopedia of the Mochica way of life and religion. Realistic human portraits, and all varieties of animals and vegetables, were modeled in clay. While the early phase, Mochica I (400–200 B.C.), continued the Chavin monochrome black mode [408], it also introduced the red-orange and cream tradition [407 and 409] paralleling Early Vicus in the north, and becoming the norm for all later Mochica phases. Some Mochica pottery was made in clay molds in matched sets, especially a type with low-relief scenes on its surfaces (Parsons, 1962). Other pottery was two-dimensionally painted rather than modeled [418]. Mochica arts and crafts are found in all media— from polychrome mural painting to textiles to wood and shell to metallurgy —though their prolific ceramic tradition is best known. We illustrate one unusual painted skin fragment [419] and one gold object [420]. Certain techniques of working gold and silver were inherited from the Chavin, but the Mochica invented new techniques and alloys, and also developed processes for working copper.

We conclude the North Coast developmental sequence with the Late Intermediate period Chimu civilization. (No Inca-Chimu objects, with the possible exception of the bronze knife [466], exist in this collection.) Whereas Chimu ceramics, if anything, were more prolific than the Mochica, being mass-produced in clay molds, we have only one example in the typical Chimu black ware [421]. This particular early Chimu vessel, further, is unusual in representing Wari-Tiahuanaco influence during the Middle Horizon, A.D. 700–1000. The greater part of Chimu ceramics (A.D. 1000–ca. 1450) derived from the previous Mochica modeling tradition, but in the main were of inferior quality due to the emphasis on moldmade production. The stirrup-spout mode continued, but the style reverted to monochrome black (or red) wares. As with the Mochica, Chimu graves have revealed a wide range of well-preserved artifacts in all media, including textiles. We illustrate one mosaic-inlaid earplug on wood [422] and a group of six Chimu gold and silver ornaments [423–428]. The latter demonstrates the range of artistry and technology available in metallurgy by the late period of Central Andean civilization. Sheet gold masks placed over mummy bundles are common [424], as well as hammered gold and silver beakers [425 and 426], costume pins [423], hollow earplugs [427], and extraordinarily large silver repoussé discs [428].

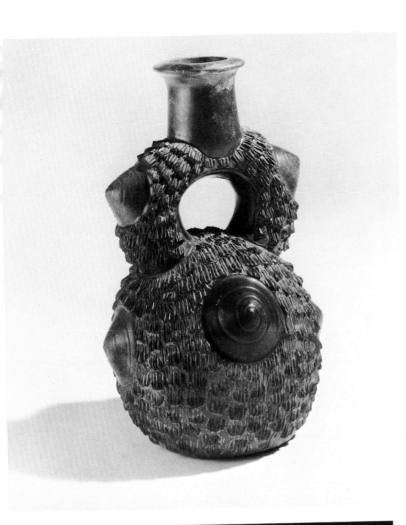

393. Stirrup-Spout Bottle
Peru, North Coast, Early Cupisnique culture. Early Horizon, 1200–1000 B.C.
Black earthenware (See color plate)
Gift, 184:1979; H. 24.5 cm.

The heavy, squat stirrup spout, and the bold, textured relief, indicate that this bottle is of the Early Chavin period. The whole imparts a particularly monumental feeling for an earthenware object. Around the body are four conical bosses with spiral grooves, representing shells. Two more are found on either side of the arched handle. Surrounding the six shells is a compact pattern of raised "feather" motifs, which are unburnished. The vertical spout, the inner border of the arch, the shells, and the flat base, in contrast, are highly burnished.

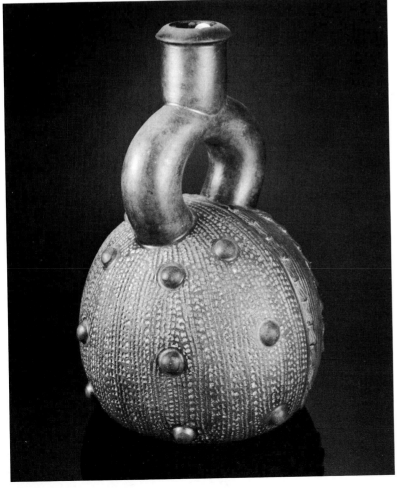

394. Stirrup-Spout Bottle
Peru, North Coast, Early to Middle Cupisnique culture. Early Horizon, 1200–700 B.C.
Burnished black earthenware
Gift, 185:1979; H. 21 cm., Diam. 14 cm.

The textured surface and stocky, thick-lipped spout are characteristic of earlier Chavin ceramic bottles. The stirrup-shaped spout and the flat base are highly burnished, while the body is decorated in raised relief. One hemisphere is extensively punctated and has polished nodes, while the other has vertical rows of feather-like elements separated by scored lines. The two halves of the vessel are divided by a deep groove.

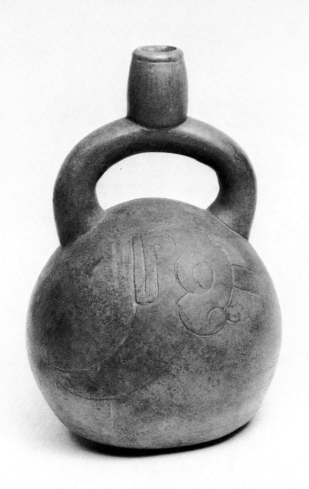

395. Stirrup-Spout Bottle

Peru, North Coast, Middle Cupisnique culture. Early Horizon, 1000–700 B.C.
Red-painted orange earthenware
Gift of May Department Stores Co., 4:1968; H. 23 cm., Diam. 15.5 cm.

The first bichrome ceramics appear on the North Coast in Chavin times. Typically, the zones of paint are outlined with grooves ("zoned-incising"). On either side of this vessel are matched serpent-feline heads (painted red), whose features are thus outlined. They arise from comma-shaped necks, have scrolled eyes with crescent-shaped pupils, and a crested head ornament. All these features are Chavinoid. The stirrup spout is also painted red, while the background of the vessel is polished orange.

396. Stirrup-Spout Bottle

Peru, North Coast, Jequetepeque Valley (Tembladera). Early Horizon, 1000–700 B.C.
Polished black earthenware
Gift, 285:1978; H. 21 cm., Diam. 18 cm.

This example has a concavo-convex body form and a squat, lipped spout. The upper surface is covered with circle motifs impressed in the clay by a tubular reed. Their centers have concave pits.

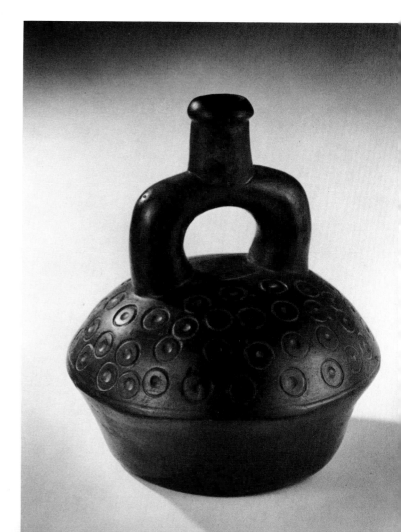

397. Jaguar Effigy Vessel

Peru, North Coast, Jequetepeque Valley (Tembladera). Early Horizon, 700–400 B.C.

Polished black-brown earthenware with red pigment (See color plate)

Gift, 182:1979; H. 22.5 cm., L. 17 cm.

A naturalistic, full-round, crouching feline vessel, with a plain stirrup spout of the Late Chavin type. Note the incised circled spots, leg stripes, pronounced claws, and the mouth with its fangs crossing the lower and upper lips. The mouth area, only, is painted red. The jaguar's curled tail is modeled on the rear.

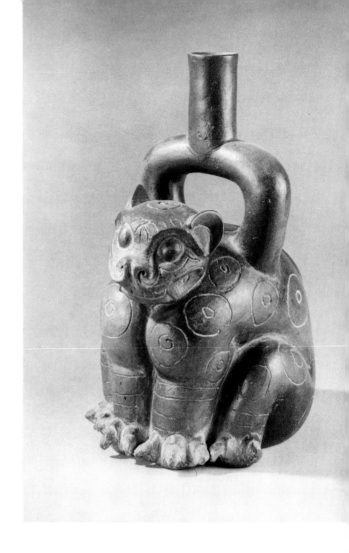

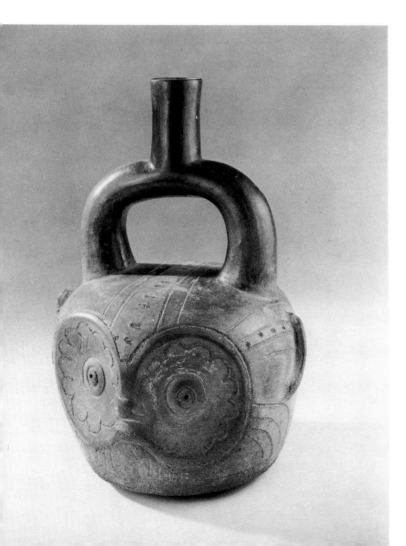

398. Owl Effigy Bottle

Peru, North Coast, Late Cupisnique culture. Early Horizon, 700–400 B.C.

Burnished brown earthenware

Gift, 156:1979; H. 26.5 cm., Diam. 17 cm.

The more ample, taller, stirrup-spout form signals the terminal phase of the Chavin tradition. The large eye cavities suggest the image of an owl. The concentric-circle pupils are surrounded by an incised ruffle motif, while incised bands with punctate impressions flow back over the vessel from the face area. Also note the raised ear and nose elements.

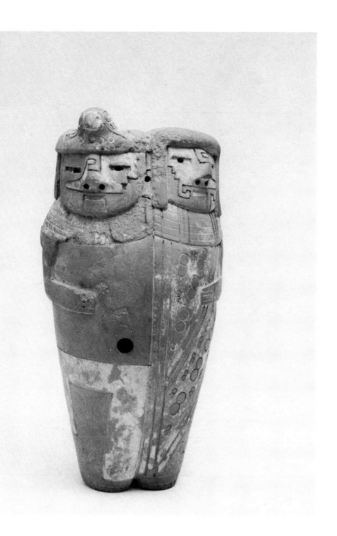

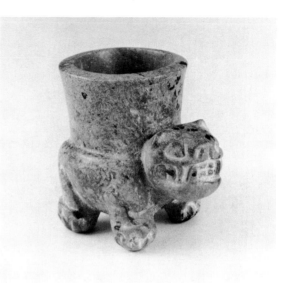

400. Miniature Feline Effigy Vessel, or Mortar

Peru, North Coast (?), Late Chavin culture. Early Horizon, 700–400 B.C.
Cream-colored soapstone with traces of red pigment
Gift, 188:1979; H. 6 cm., L. 6.5 cm.

Small stone vessels are scarce, but very much present, in the inventory of the finest Chavin stone carving. Here we have a relatively naturalistic, full-round, fanged and clawed cat carrying a cylindrical bowl on its back. This may have served as a miniature mortar.

399. Embracing Male and Female Couple

Peru, North Coast, Jequetepeque Valley (Tembladera). Early Horizon, 700–400 B.C.
Reddish-brown earthenware with remains of post-fire red and white pigment (See color plate)
Gift, 186:1979; H. 19 cm.

This rare early type of hollow effigy figure was first discovered at Tembladera about fifteen years ago (see Lapiner, 1976, item 51, for front and back views of a nearly identical object, and for details about the style). The zoned-incised, post-fire painting technique surprisingly parallels contemporary Paracas pottery far to the south [435–440], and is otherwise absent on the North Coast. Circular holes in the front, and the tops of the heads, suggest that the object functioned as an ocarina. (The eyes, nostrils, and ears are also pierced.) The joined couple consists of a male on the left with an avian headdress and loincloth; and a female on the right with a plain hairdo, as well as a full-patterned gown consisting of circles and stripes. The two are separated down the center by a simple, incised groove. The reverse side shows their arms in relief, and crossed, so that they hold each other's shoulders. Both have asymmetrical face painting in the form of stepped frets, and both wear layered collars. The red paint is confined to their face flesh, while white fills the facial patterns and colors the articles of costume.

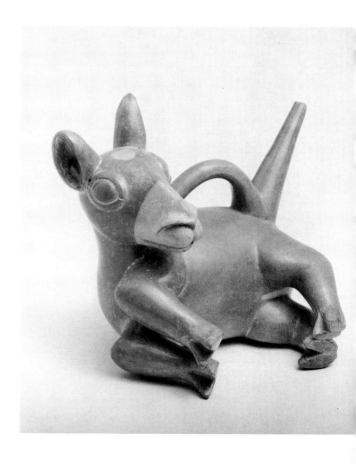

401. Reclining Llama (Facing page)

Peru, North Coast, Early Vicus–Salinar culture. Early Intermediate period, 400–200 B.C.
Cream on polished orange-slipped earthenware (See color plate)
Gift, 346:1978; H. 15 cm., L. 19 cm.

While this vessel probably came from the Piura Valley on the far North Coast, the style reflects the Salinar culture in the center of the North Coast. This is evident in the distinctive angled, tapered spout, joined to an arching tubular handle. (It is also contemporary with the Mochica I style [cf. 408] and prognosticates the Mochica mode of red- and cream-painted pottery.) Like many of these post-Chavin modeled ceramics, the subject matter is ultra naturalistic. Note the cloved hooves, modeled head, inner ear projections, and curled tail. The cream paint is confined to the muzzle, spotted forehead, and genitals. Two tiny vent holes were made at the base of the ears. Though the natural habitat of the llama is in the Andean altiplano, in Pre-Columbian times it was also utilized by civilizations on the coast both as a beast of burden and an animal for sacrifice.

402. Reclining Feline

Peru, North Coast, Early Vicus–Salinar culture. Early Intermediate period, 400–200 B.C.
Polished black earthenware
Gift, 142:1980; H. 14 cm., L. 21 cm. (Ex-coll. Katherine C. White)

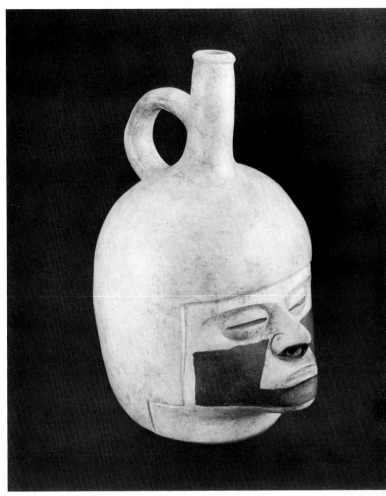

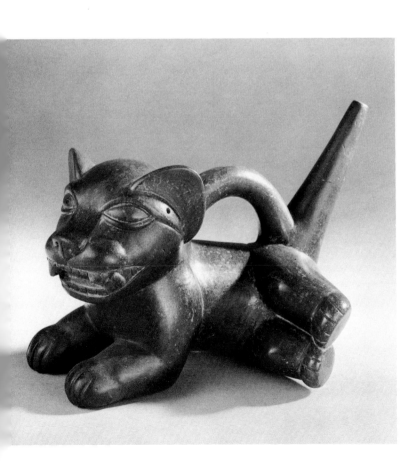

Another naturalistic animal effigy vessel, in every way parallel to the previous object, with the exception of its black monochrome finish. The representation is of a fanged puma or jaguar (compare with the more stylized Late Chavin jaguar ceramic, 398). The hind legs are turned to the side and the tail is curled, in relief, on the rear. As on the llama effigy, the bases of the ears are pierced.

403. Head Effigy Bottle

Peru, North Coast, Piura Valley, Early Vicus culture. Early Intermediate period, 400–200 B.C.
Red on cream-slipped earthenware
Gift, 109:1966; H. 20.5 cm.

This style on the far North Coast parallels the earliest Mochica phase to the south. In fact, some of the most sophisticated modeled ceramics of that early period have been coming out of the Vicus region. Like Mochica I, the rim of the vertical spout is bolstered with a lip. On this vessel, the spout has a hollow loop handle. The entire surface is slipped cream, while the cheeks, chin, and tip of the nose are painted deep red. Note the "coffee bean" eyes set in sharply defined depressions, the prognathic jaw, and the close-fitting headgear.

404. Head Vessel

Peru, North Coast, Piura Valley, Late Vicus culture. Early Intermediate period, 200 B.C.–A.D. 700
Three-color, negative-painted earthenware
Gift, 369:1978; H. 18 cm.

Much of the better preserved Vicus ware shows the addition of white-painted detail over the orange slip, which in turn is decorated in black resist designs. The negative design on this consists of stripes, zigzags, and dots. This vessel has a single spout at the back with a connecting strap handle. The eyebrows are raised, and the exposed teeth are deeply scored. Also the nostrils and double-lobed ears have punctations.

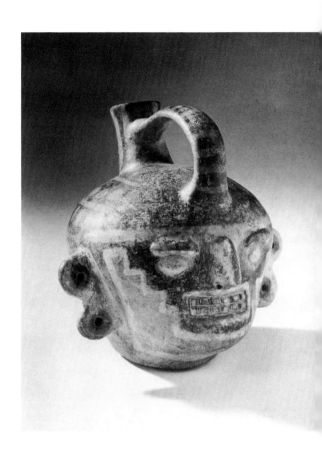

405. Supine Effigy Vessel

Peru, North Coast, Piura Valley, Late Vicus culture. Early Intermediate period, 200 B.C.–A.D. 700
Negative-painted brown earthenware
Gift, 267:1978; H. 23 cm., L. 30 cm.

The Vicus negative style from the far North Coast has been known since the early 1960s. While not scientifically dated, the consensus is that the style is contemporary with the "classic" cultures to the south, as well as the Recuay style [406]. Many of these effigy forms, to our eyes, have a whimsical quality. The face is simply stylized, with "coffee bean" eyes, a thin beaked nose, tablike ears, and the mere suggestion of a mouth. It is probable that the basic features of modeling and negative painting derive from the post-Chavin Salinar and Gallinazo cultures of the North Coast heartland. This vessel consists of a figure stretched out on its back, with the low-relief arms holding its belly from which a loop-handled vessel spout arises. The top half of the figure is slipped orange, over which negative-painted black star shapes and spirals are applied. In this technique the areas of black surround the intended designs, showing the underlying orange slip (see 441 for a discussion of the resist technique).

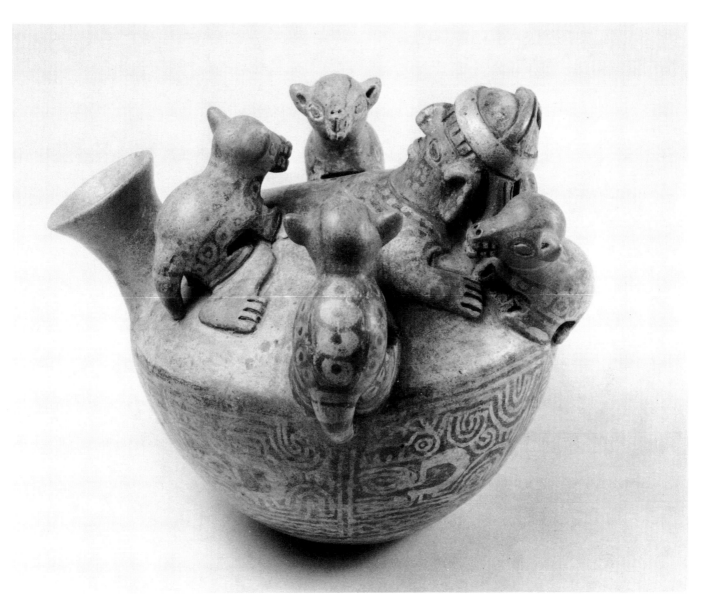

406. Jar Showing Man Being Attacked by Foxes
Peru, North Highlands (Upper Santa Valley), Recuay culture.
Early Intermediate period, 200 B.C.–A.D. 700
Three-color, negative-painted earthenware (See color plate)
Gift, 347:1978; H. 18 cm., Diam. 22 cm. (Illustrated: La-
piner, 1976, item 416)

Recuay style pottery is distinctive for its modeled three-
dimensional scenes surmounting flaring-spouted jars,
and for its "negative" or resist painting (black and red
over cream slip). The black resist can be seen in the fox
effigy panels around the sides of the jar (there are five
such painted panels), as well as the spots on the modeled
foxes. On the top is a splayed, high-relief, human figure
—probably a sacrificial victim about to be devoured by
four foxes. (As with the contemporary Vicus negative
style, this apparently developed out of the earlier Salinar
and Gallinazo styles on the adjacent North Coast.)

407. Seated Nobleman

Peru, North Coast, Mochica I culture. Early Intermediate period, 400–200 B.C.
Polished orange and cream earthenware
Gift, 215:1978; H. 17 cm.

A superbly modeled male effigy vessel, with the early Mochica stirrup-spout form on its back. The lower arms are separated from the body, while the feet on the crossed legs are shown at the bottom. This is the beginning of the cream- and orange-painted pottery tradition on the North Coast. It is evenly slipped orange, with cream paint applied on the spout, the crested headpiece, the collar, the loincloth (visible from the rear), the fingernails, and the eyes. The headgear is tied on with a chin strap and has an attached cloth falling over the back, with orange-painted scrolls.

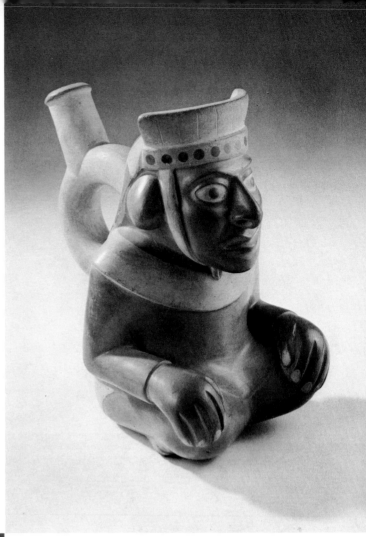

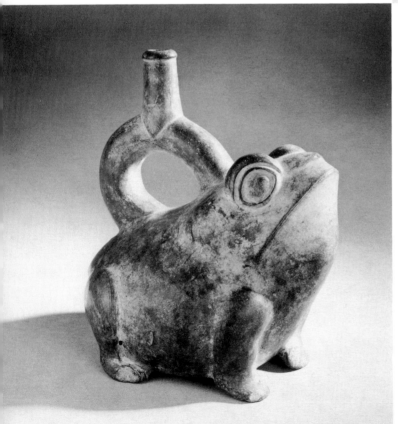

408. Frog Effigy Vessel

Peru, North Coast, Mochica I culture. Early Intermediate period, 400–200 B.C.
Polished black earthenware
Gift, 143:1980; H. 16 cm., L. 15 cm. (Ex-coll. Katherine C. White)

The first phase of the Mochica culture is distinguished not only by modeled naturalistic subject matter but by a relatively small, short stirrup spout with a raised lip around the orifice. The monochrome black ware and the spout form are modified from earlier Chavín canons.

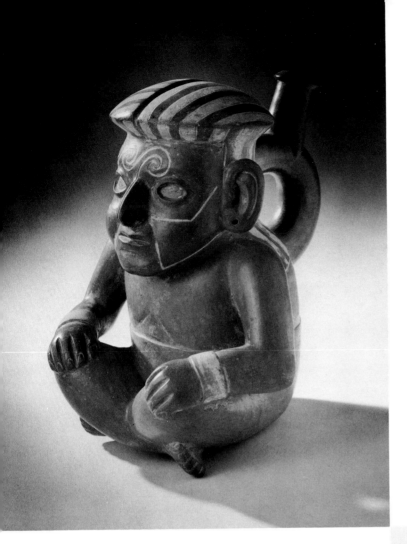

409. Cross-Legged Human Effigy Bottle
Peru, North Coast, Mochica I culture. Early Intermediate period, 400–200 B.C.
Cream on polished orange earthenware
Gift, 162:1979; H. 17.5 cm.

Modeled seated figure with the early Mochica variety of lipped stirrup spout. The earlobes are pierced and there is a tiny perforation in the top of the longitudinally grooved cap. The cap and a falling neck scarf have cream-painted stripes separated from the orange by incised lines. Note the scrolled face decoration and the cream-colored bracelets.

410. Seated Stirrup-Spouted Figure
Peru, North Coast, Mochica III culture. Early Intermediate period, A.D. *1–200*
Red on cream-slipped earthenware
Gift of J. Lionberger Davis, 124:1954; H. 23.5 cm.

A sensitively modeled vessel, with a personage wearing a cloak and a two-dimensionally painted breast panel and cuffs. The headdress and three low-relief trailers behind are similarly painted in red with stepped-fret designs. The portrait-like face also is deep red.

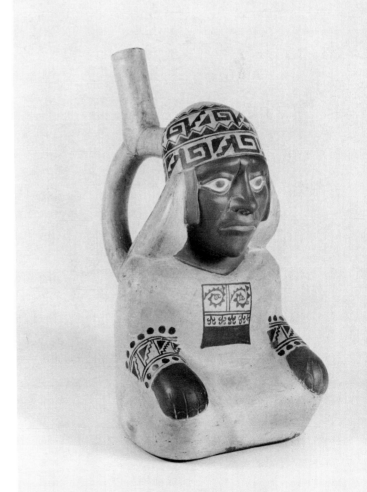

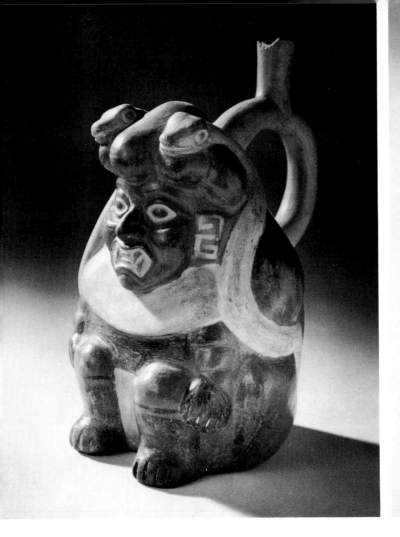

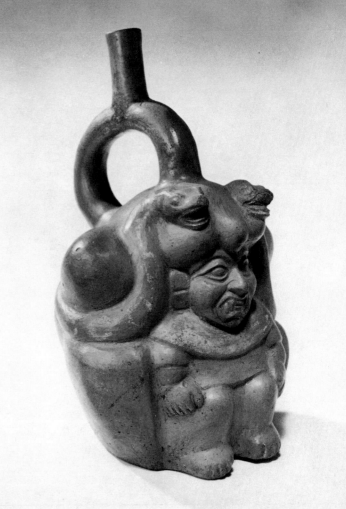

411. Deity on the Sacred Mountain
Peru, North Coast, Mochica III culture. Early Intermediate period, A.D. *1–200*
Red paint on cream-slipped earthenware, with traces of fugitive black (See color plate)
Gift of Mrs. William A. Bernoudy, 295:1955; H. 20.5 cm.

This stirrup-spout vessel depicts a common mythological scene: the fanged deity, Ai'apec, nestled in the protuberances of a sacred mountain. He displays a pair of protective serpents, twined about his head and trailing around the hill behind. The bichrome distribution of red and cream can be seen in the photo; but, in addition, this ceramic retains areas of black detail positively painted on the cheeks, body, legs, and parts of the mountain.

412. Deity on the Sacred Mountain
Peru, North Coast, Mochica III culture. Early Intermediate period, A.D. *1–200*
Cream paint on orange-slipped earthenware
Purchase, 74:1942; H. 25 cm.

A second vessel modeled with the identical theme to the previous one, but in reverse coloration. Strange as it may seem from the quantity of Mochica ceramics, the basic narrative themes in Mochica iconography are relatively limited, and constantly repeated. The variation from the last example is minor. These two may be products of the same potter's "studio," but they were not made in the same mold (as some Mochica pottery was). The areas of cream paint are eroded, but they are visible on the collar, earplugs, and the circles on the serpents.

413. Osprey on a Mountain

Peru, North Coast, Mochica IV culture. Early Intermediate period, A.D. *200–500*
Red paint on cream-slipped earthenware
Gift, 477:1955; H. 25.5 cm.

One of the more anecdotal modeled scenes in Mochica effigy pottery. A full-round osprey is shown seated on a red, trilobed hillock and clutching a spotted dogfish. The lower cream-colored lobes of the hill are painted with three cacti. All the dark details are painted red.

414. Fox-and-Shield Effigy Bottle

Peru, North Coast, Mochica IV culture. Early Intermediate period, A.D. *200–500*
Red- and cream-painted earthenware
Gift, 478:1955; H. 29 cm.

On this stirrup-spout vessel we find an anthropomorphic fox at the top and a large, round, painted shield on the front. The fox wears a conical helmet with chin strap. The shield has a handle that encircles the conically shaped vessel. Painted zones on the back are separated by grooved incising.

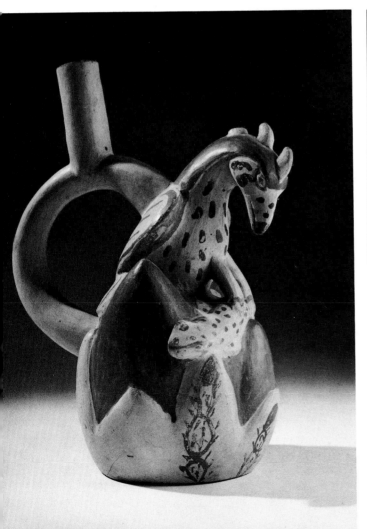

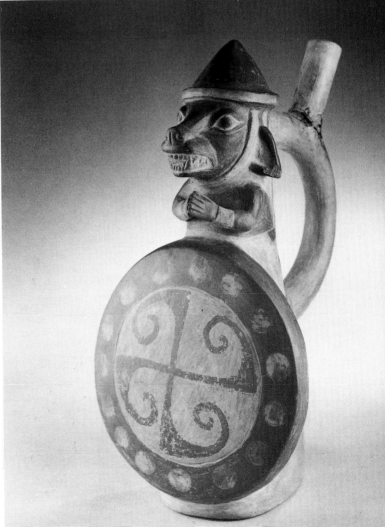

415. Portrait Head Vessel

Peru, North Coast, Mochica IV culture. Early Intermediate period, A.D. 200–500
Cream-painted orange earthenware
Gift, 479:1955; H. 16.5 cm.

Realistic portrait jars are a hallmark of classical Mochica ceramic art, although this is a relatively routine example. Much of the headdress is painted cream, as well as the whites of the eyes. The headband is flanked by two winged birds, possibly ospreys, and ends in a tassel behind. There is a large vessel opening at the top of the head.

416. Head Vessel

Peru, North Coast, Mochica IV culture. Early Intermediate period, A.D. 200–500
Red-painted, polished orange earthenware
Gift of J. Lionberger Davis, 129:1954; H. 18.5 cm.

A somewhat aberrant portrait head vessel, which may have come from the more northern Lambayeque Valley. The domed headdress tilts backward and supports a straight spout and loop handle. These attachments are painted deep red. The vessel is unique in having earplugs with mother-of-pearl shell inlays (presumably original).

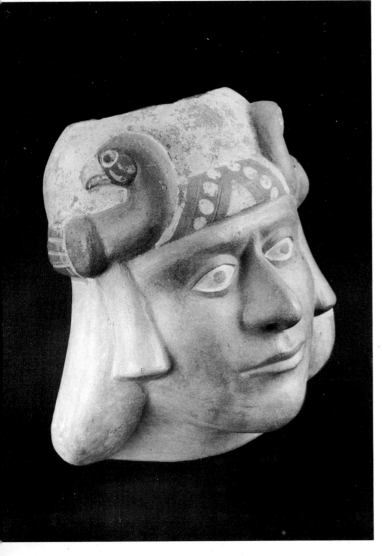

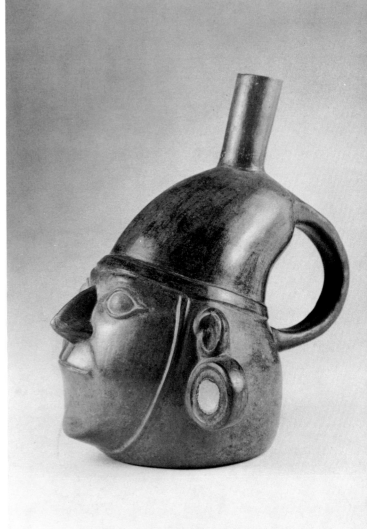

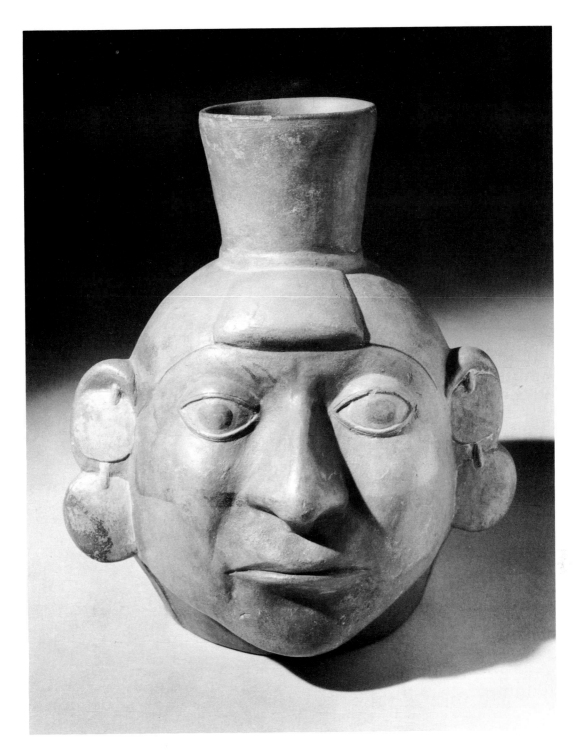

417. Portrait Jar
Peru, North Coast, Mochica V culture. Early Intermediate period, A.D. *500–700*
Painted red earthenware
Gift, 216:1978; H. 32 cm.

An unusually massive, modeled, portrait-type jar, apparently made in a two-piece mold. Each ear displays two disc-shaped ornaments, one above the other. These and the eyes are painted cream. The pupils and horizontal bands leading from the nose are painted black. (While black as a third color was frequently added to Mochica red and cream vessels, the pigment tended to be fugitive, and often has washed off extant grave offerings formerly bearing the black detail.)

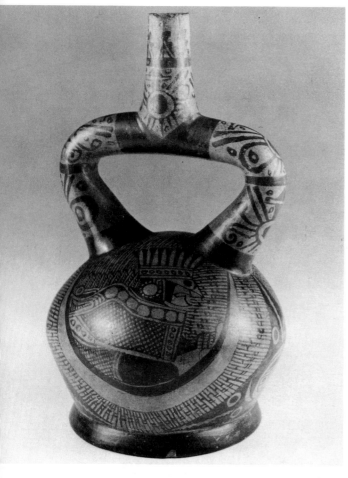

418. Two-Dimensionally Painted Stirrup-Spout Bottle

Peru, North Coast, Mochica V culture. Early Intermediate period, A.D. *500–700*
Red on cream-slipped earthenware
Gift of J. Lionberger Davis, 125:1954; H. 21 cm.

This footed vessel with intricately painted scenes represents the last Mochica developmental phase. On either side is depicted a beaked-faced deity, with serpent collar and netted shirt, seated within a crescent-shaped form. The latter probably symbolizes a balsa boat. The stirrup spout is painted with shield-mace-spear emblems.

419. Painted Skin Fragment

Peru, North Coast, Mochica culture. Early Intermediate period, A.D. *200–700*
Animal skin with red, orange, and brown paint
Purchase, 133:1976; 17.5 × 12.5 cm.

Art in diverse media has been preserved on the arid coast of Peru. While this skin fragment is worm-eaten, the left and upper straight edges seem to be original to the painted panel. The motif features a seated, phallic, beak-nosed warrior who carries a club over his shoulder. He wears a *tumi* knife device at the front of his headband. Preserved mummies demonstrate that human skin was elaborately painted or tattooed on the North Coast.

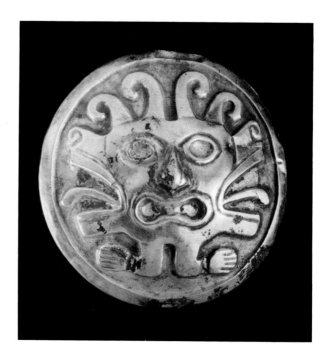

420. Hollow Rattle Pendant (Facing page)
Peru, North Coast (probably Vicus region), Mochica style.
Early Intermediate period, 200 B.C.–A.D. *500*
Gold-copper alloy (tumbaga)
Gift, 214:1978; Diam. 12.5 cm., D. 6 cm.

This pendant is made in two convex sections of sheet
gold, crimped and soldered together around the circum-
ference. Clay pellets were left inside for rattles. Two
pairs of perforations on the top permitted suspension of
the boss-shaped ornament as a breast pendant, or as part
of a necklace. The decoration is deeply embossed in an
alloy of copper *(tumbaga),* whereby the gold content had
been brought to the surface in the annealing process. The
forward motif consists of a full-front anthropomorphic
feline face, flanked by two profile feline snouts with at-
tached forelegs and head volutes. (For sheer composi-
tion, compare the gold pectoral from Colombia, 381.)
The nose of this composite figure is pierced for an orna-
ment now missing. The reverse hemisphere is embossed
with a "Maltese" cross design composed of numerous
tiny raised dots. In Peru, gold working began with the
Early Horizon Chavin civilization, where many of the
basic metallurgical techniques were invented.

For a mate to this object, possibly from the same
workshop or burial, see Lapiner, 1976, item 387. More-
over, a whole group of these gold bosses is known; origi-
nally they most likely were strung together as one large
necklace.

421. Large Double-Lobed Bottle
Peru, North Coast, Early Chimu culture. Middle Horizon,
A.D. *700–1000*
Polished black earthenware
Gift, 349:1978; H. 32 cm., L. 35 cm.

While Chimu black ware is exceedingly prevalent in any
substantive Peruvian collection, this unusual vessel is the
only one illustrated from this collection. Most Chimu
ware was moldmade and therefore relatively mass-pro-
duced, and to some extent degenerate in quality in com-
parison to its Mochica heritage. This example is one of
the rare Chimu ceramics to display clear highland
Tiahuanaco influence on the North Coast. Both the dou-
ble canteen form and the stamped, low-relief panels re-
flect the latter culture during its expansion in the Middle
Horizon. (Note 455, of South Coastal Tiahuanaco cul-
ture, which is of the same form and has very similar
painted panels.) The lobes were made in hemispherical
molds, and it seems likely that the identical reliefs on the
outer sides utilized the very same mold. Details of their
fantastic animal motifs were sharpened by incising. These
panels have awkward animal-headed appendages in the
geometric highland Tiahuanaco manner. A band at the
base contains interlocking serpent heads, while the band
on the circumference contains stepped-fret motifs. That
around the neck of the bottle has condor heads and fur-
ther geometric motifs.

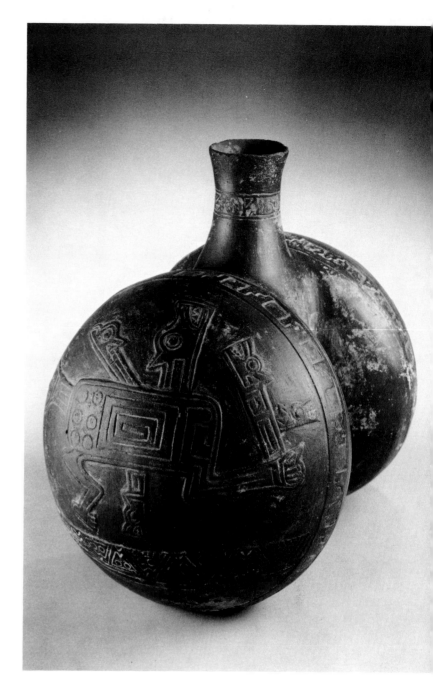

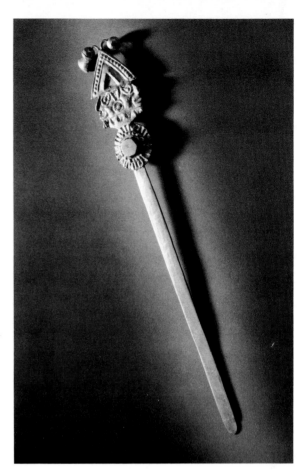

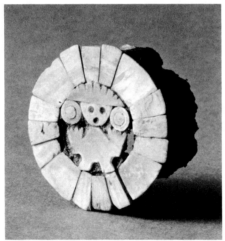

422. Mosaic Earplug
Peru, North Coast, Chimu culture. Late Intermediate period,
A.D. *1000–1400*
Wood and inlaid shell (See color plate)
Gift, 271:1978; H. 2.5 cm., Diam. 4.5 cm.

Well-preserved earplug pairs are frequent finds in Peruvian graves. This single example was carved of wood with a hollow back. The various facets of shell selected for the decorative front inlays, with the displayed human figure, have subtle differences of color: iridescent mother-of-pearl, orange, and purple. Around the circumference of the back are eight inlaid mother-of-pearl discs.

423. Gold *Tupu* (Costume or Hairpin)
Peru, North Coast, Chimu culture. Late Intermediate period,
A.D. *1000–1400*
Hammered gold with inlaid turquoise
Gift of J. Lionberger Davis, 152:1954; L. 17 cm.

A gold pin of greater complexity than first meets the eye. While the pin is hammered flat, the double-headed finial and the medallion were embossed, then folded over in two matching layers. Hollow gold danglers are attached at the top, while both sides of the medallion, as well as the tiny ear spools, are inlaid with blue-green turquoise.

424. Mummy Mask

Peru, North Coast (Lambayeque Valley), Chimu culture. Late Intermediate period, A.D. 1000–1400
Gold-washed copper, with copper attachments and red cinnabar paint
Gift, 378:1978; H. 23.5 cm., W. 41 cm. (Illustrated: Anton and Dockstader, 1968, p. 201)

Large repoussé gold mummy masks are not uncommon from North Coast Chimu graves. They were sewn to the outer wrappings of mummy bundles or basketry "coffins" to represent the face of the deceased. The metal of this mask is either an alloy of gold and copper or a wash of gold (possibly mixed with silver) over the baser metal. The features of the face were pressed out from the reverse side. Green-corroded copper discs have been applied to the earlobes and eyes. (The green conical attachments on the eyes are not original.) Hanging from the nose are a pair of danglers of the same sheet metal as the mask. Remains of red paint indicate that the face was divided into three vertical panels, the outer thirds being defined by the red, with a red triangle on the forehead, and the exposed gold in the center.

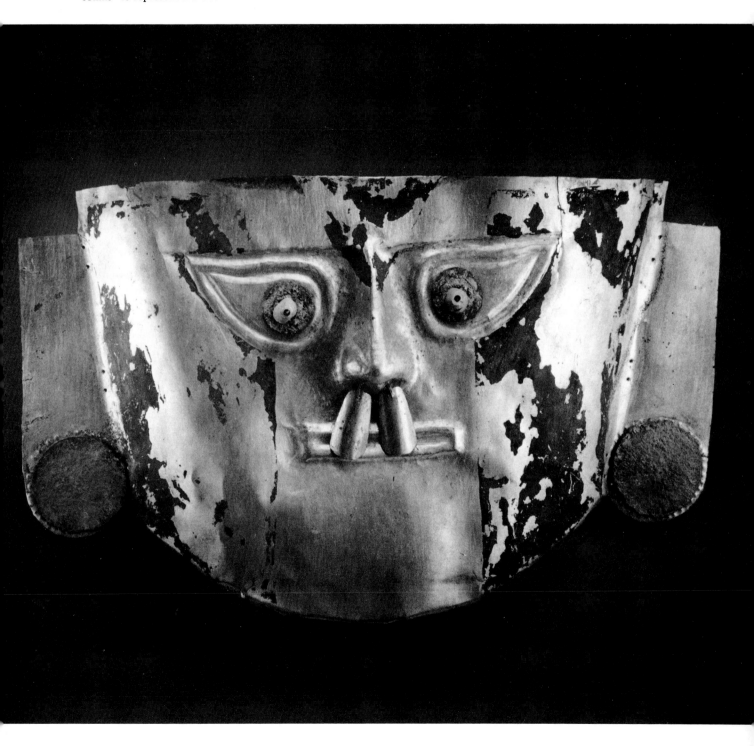

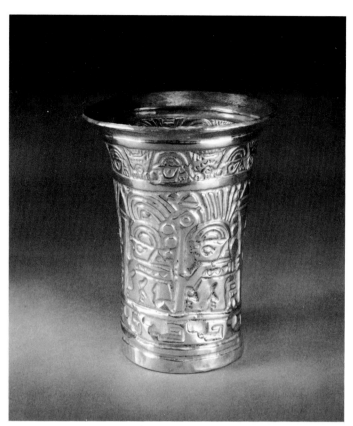

425. Goblet
Peru, North Coast (Lambayeque Valley), Chimu culture. Late Intermediate period, A.D. 1000–1400
Sheet gold with traces of red cinnabar (See color plate)
Gift, 268:1978; H. 17.3 cm., Rim diam. 13.7 cm.

Embossed on the walls of this vessel is a processional scene of six warriors brandishing tall maces or staffs. The lower border contains the familiar running stepped-fret design, and the upper border a series of human heads interspersed with diving birds. The bottom of the goblet bears a single embossed cat. These *"kero"*-shaped goblets were normally hammered over a wooden model from a single heavy sheet of gold. The wooden form had been carved with the relief designs, allowing the malleable gold to be pressed into its recesses. This vessel purportedly is one of a matched set of four (one of which is in the Bliss Collection, Dumbarton Oaks, Washington, D.C.).

426. Large Effigy Beaker
Peru, North Coast, Lambayeque Valley (Batan Grande), Chimu culture. Late Intermediate period, A.D. 1000–1400
Hammered silver
Gift, 392:1978; H. 26.5 cm., Diam. 21.5 cm.

A Chimu silver vessel of common form but unusual size; however, a number of them were found at the site of Batan Grande. (Another from the same series is presently at the Dallas Museum of Fine Arts, and still another at the Brooklyn Museum.) This series of goblets, like the previous one, was hammered from a single sheet of heavy metal over the same carved wooden form. The human figure grasps a spondylus shell in front, while its grooved hair tresses are tied with a medallion behind.

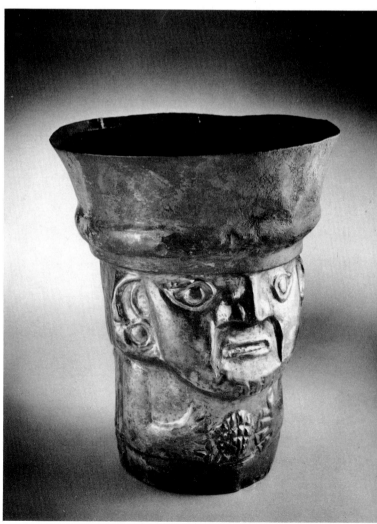

427. Pair of Filigreed Earplugs

Peru, North Coast, Chimu culture. Late Intermediate period,
A.D. *1000–1400*
Sheet silver
*Gift of J. Lionberger Davis, 151:1954; Diam. 6.3 cm., D. 4
cm. (Ex-coll. Moises Saenz, Mexico)*

A pair of oversize hollow earplugs, each forged from two
pieces of silver. The closed cylindrical backings were
hammered over forms, while the openwork fronts are
separate pieces that were crimped and soldered to the
flanged backings. The elaborate motifs were first em-
bossed and then perforated in the negative spaces. The
design features a splayed human figure surrounded by
supplementary heads and figures.

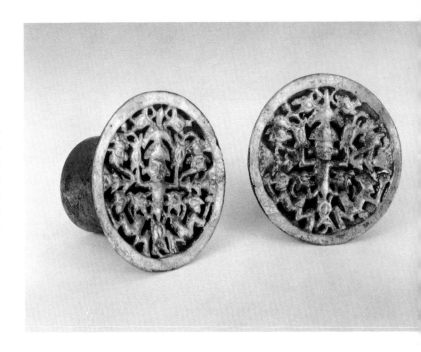

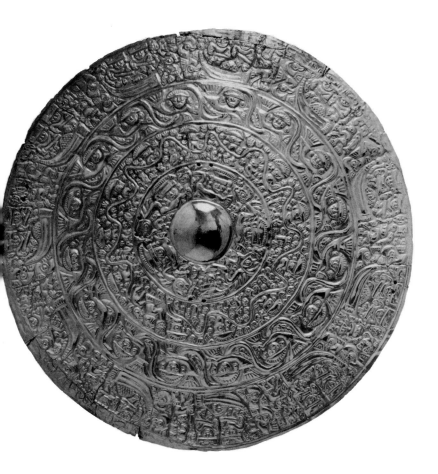

428. Repoussé Disc

*Peru, North Coast, Lambayeque Valley, Chimu culture. Late
Intermediate period,* A.D. *1000–1400*
Sheet silver (See color plate)
Gift, 282:1978; Diam. 34.5 cm.

Almost too large for a breastplate, this could have been
a shield cover, or it (and others like it) may have been
applied to the inner walls of a palace. (Resplendent wall
decoration of gold and silver was described by the
chroniclers for the Inca Sun Temple at Cuzco.) Actually,
this is one of a whole group of similar silver discs that
apparently came out of a Peruvian grave at the same time
(see Lapiner, 1976, item 601; and Dockstader, 1967,
item 150, for two other published examples). The sur-
face is intricately decorated, with four concentric bands
pressed out from behind. While the content of each band
is different, they all show repetitive series of human
figures interrupted by birds and fish. There are pairs of
perforations on opposite edges, and four pairs around
the inner circle, for attachment of the disc.

Central Coast

Surprisingly, somewhat less is known about the desert environs of modern Lima (including the Supe, Chancay, Ancon, and Rimac Valleys) than the North and South Coast Peruvian regions. Most collections, like this one, only represent the Late Intermediate period (A.D. 1000–1400), Chimu-contemporary, Chancay culture. That is amply represented in ceramics, wood sculpture, and textiles. Nevertheless, the impressive site of Pachacamac, south of Lima, is a monumental ceremonial complex that was at its height during the Tiahuanaco-influenced Middle Horizon, and on into the Chancay and Inca periods. The Early Intermediate period is known through the Ancon (or "Early Lima") style, but consisted of rather undistinguished black-white-and-red-ware pottery. The Chancay ceramics [429 and 430] are also relatively crude, if not whimsical in their effigy figures and jars, and feature red or black on a cream-washed ware. The graceful whistling vessel [429] is probably Inca-contemporary in the Chancay region. One Chancay wooden idol or grave object is illustrated [431]. Mummy masks here were also made of wood. Finally, we present three examples of Chancay textiles [432–434] displaying a variety of weaving techniques from ancient Peru. The last object is a spectacular embroidered mantle.

429. Double-Chambered Whistling Vessel

Peru, Central Coast, Late Chancay culture. Late Horizon,
A.D. *1400–1532*
Cream-slipped earthenware
Gift, 370:1978; H. 34 cm., L. 30.5 cm.

Whistling vessels occur in Peru from post-Chavin times onward, and are particularly prevalent in the Chimu black ware. (They also diffused to Mesoamerica; see 205 and 286.) This elegant example, with its extremely tall tapered spout, verges on the Inca horizon in the Chancay area. It is formed of two drum-shaped chambers on footed bases, and connected by a conduit in the middle and a strap handle above. The chamber with the modeled bird has a whistle outlet that gives a piercing sound when the spout is blown, or when liquid is tipped from one chamber to the other.

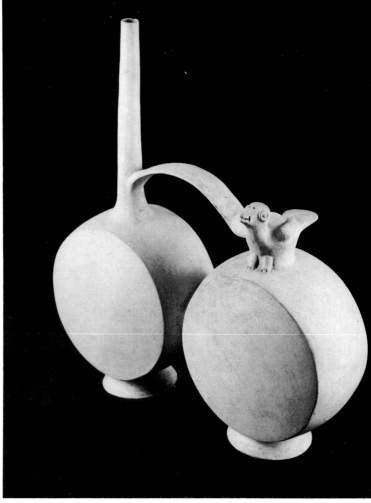

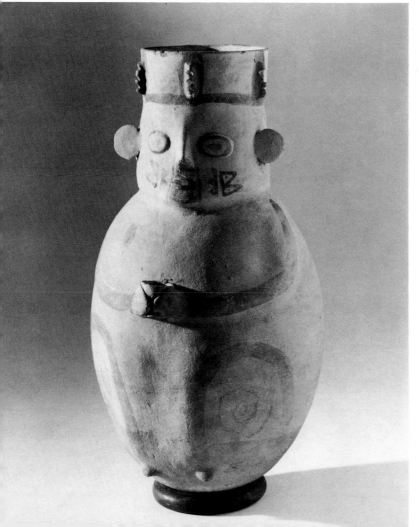

430. Human Effigy Vase

Peru, Central Coast, Chancay culture. Late Intermediate period, A.D. *1000–1400*
Painted orange earthenware
Gift, 128:1980; H. 40.5 cm.

These large round-bottomed vases, popularly called king pots, are rather casually put together and frequently rather whimsical. Cream pigment is sloppily washed over the surface, and here is overpainted with red details. There also are thin black spirals under the red-painted legs. The applied hands hold forth a small clay bowl. Other relief additions include nubbin feet, ears, nose, and notched headdress fillets.

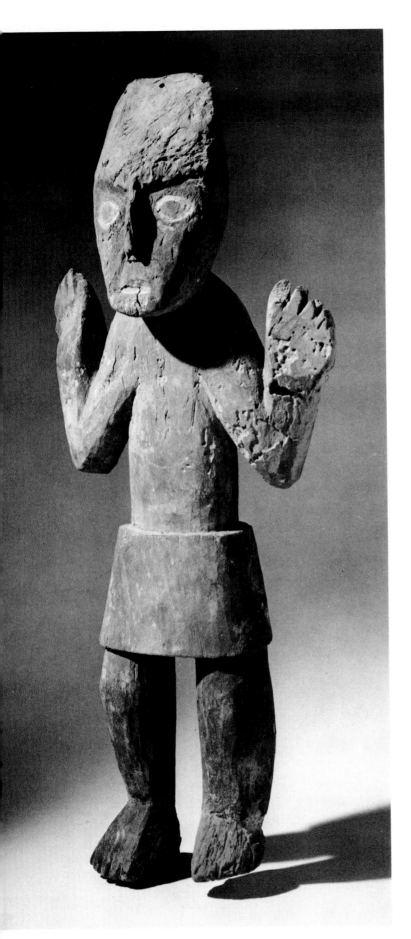

431. Large Standing Figure

Peru, Central Coast, Chancay culture. Late Intermediate period, A.D. *1000–1400*
Wood with traces of black and white paint
Gift, 254:1978; H. 72.5 cm.

Wooden idols, as well as wooden mummy masks, are profuse in Chancay graves. They are often relatively crude in execution. This figure has splayed arms, a skirted loincloth, and a blank staring face. There are three holes at the top of the head for former attachments (cloth or hair).

432. Sash

Peru, Central Coast, Chancay culture (?). Late Intermediate period, A.D. *1000–1400*
Polychrome wool; plain and tapestry weaves
Purchase, 286:1949; L. 255 cm., W. 11.5 cm.

This long, plain-weave band consists of alternating rectangles of red, blue, yellow, and brown; while the end panels have two layers of yellow-brown tapestry weave with yellow, brown, and white tassels. Each side features a geometric catlike animal—yellow on one face, and blue on the other. The Chancay attribution was made by Alan Sawyer; however, the textile was purchased at Chincha on the South Coast, implying that it actually may be from the contemporary Ica culture [cf. 460]. Late Intermediate period textiles from the North, Central, and South coasts are sometimes difficult to distinguish, there being many shared stylistic traits.

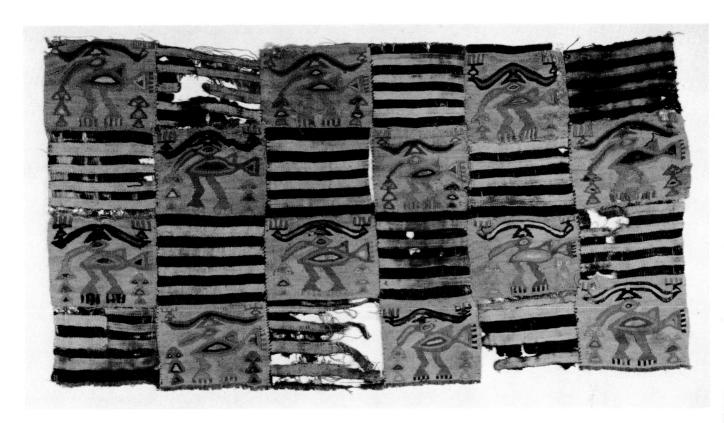

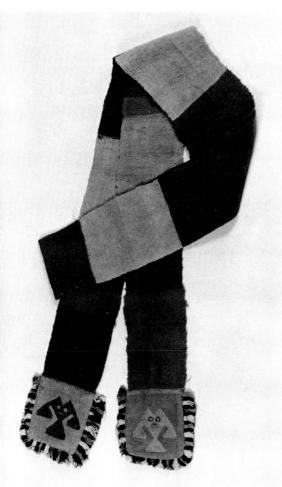

433. Tapestry Panel Fragment

Peru, Central Coast, Chancay culture. Late Intermediate period, A.D. *1000–1400*
Polychrome wool; tapestry weave
Purchase, 1:1932; 30 × 58 cm.

An incomplete textile section demonstrating an extremely fine "eccentric"-weave tapestry technique. In the alternating bird-and-fish panels, the wefts are selectively tamped down, and extra weft strands inserted, to create curves in the design that are not natural to the tapestry-weave technique [also see 458]. The cloth is constructed of six vertical bands sewn together. The striped squares are white and dark brown (the latter dye has rotted the cloth in many spots), while the bird-and-fish squares are dark brown and red, with several shades of yellow-brown.

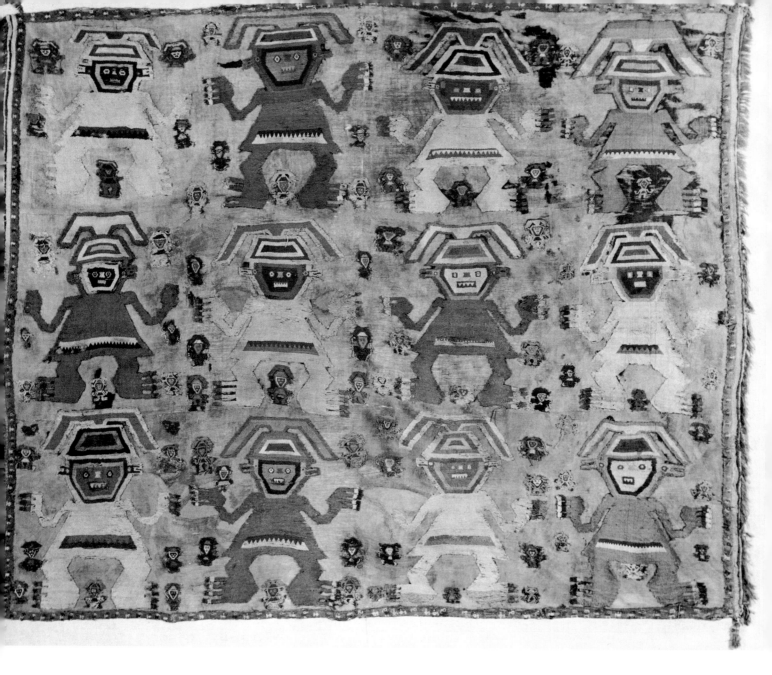

434. Large Embroidered Mantle

Peru, Central Coast, Chancay culture. Late Intermediate period, A.D. *1000–1400*
Cotton gauze with polychrome wool embroidery (See color plate)
Gift, 210:1978; H. 180 cm., W. 230 cm.

A complete textile, with bold, geometric human figures displayed in three rows of four each. These are alternately embroidered in reversals of yellow and red (with brown and white details) on a sheer tan cotton gauze backing (with fragments of a rotted dark brown gauze overlay). A number of miniature human figures are embroidered in the interstices between the large figures. A narrow tapestry border surrounds the mantle and contains tiny brown, yellow, and white birds on red ground. The sides are fringed in red, with yellow and red tassels at the corners. Both the choice of colors and the stylized geometric figures are diagnostic of Chancay textile design.

South Coast

A long continuum of civilization on the extremely arid South Coast began with Paracas, and followed without any appreciable break through the Early Intermediate period Nazca. This is the region of the Paracas peninsula and the Nazca, Ica, and Chincha river valleys. Early Paracas culture (1000–600 B.C.) was influenced by the Chavin from the North Coast and, in fact, the only preserved painted textiles in pure Chavin style were recovered in this region. The Middle Horizon here shows a sharp break in cultural tradition, with strong Wari-Tiahuanaco stimulus from the adjacent highlands. The subsequent Ica culture seems relatively unrelated to the earlier florescent Nazca civilization, but leads naturally into the culminating Inca period. A number of the most representative Inca ceramics, textiles, and examples of featherwork were excavated on the South Coast. Many burials, with well-preserved mummy bundles and artifacts, have been found in the region, but the remains of above-ground architecture are scanty, or at least unimpressive. In the Paracas-Nazca sequence, the double-spout-and-bridge bottle was a persistent ceramic form, in contrast to the stirrup-spout form on the North Coast. Pottery also was polychrome, painted in many subtle colors.

We have sorted the Paracas pottery into Early, Middle, and Late phases, spanning the 1000–100 B.C. era. The first example [435] demonstrates the Early Horizon Chavin influence, with its fanged, feline-mouth image. Paracas pottery is either polished black or red, but is decorated in a unique "post-fire" painting technique. The polychrome pigments were mixed with resin and applied to the vessels after they were fired; they are not always well preserved, and often have been reduced through the ages to a powdery consistency. The designs and zones of color also are always surrounded by incised lines [435–440]. Paracas motifs, whether on pottery or textiles, continued into the Nazca tradition. In the late Paracas period, resist-painted pottery was popular [441]. Paracas mummy bundles, many of them excavated by the Peruvian archaeologist Julio Tello, have yielded a great number of complete textile garments,

of a surprisingly early period and in remarkably good condition. We illustrate an embroidered poncho and a matching mantle with cat-demon motifs [442 and 443], which form a part of a larger set from an entire Paracas costume.

Evolving directly out of Paracas, the Nazca created thin-walled pottery of unsurpassed quality. In this period, 100 B.C.–A.D. 600, polychrome paint was permanently fixed by polishing and firing; as many as a dozen colors were combined on one vessel. In classic Nazca times, the colors were not separated by incisions. As with the Paracas, we have divided the Nazca ceramics [444–451] into Early, Middle, and Late phases, although specialists now recognize even finer subdivisions in the sequence. The Nazca were concerned with fertility in nature, and depicted in two-dimensional painting plants, birds, fish, and animals, as well as a pantheon of mythological beings among whom the cat-demon was preeminent. Nazca pottery occasionally has modeled representations, but far less frequently than in the contemporary Mochica culture. The earlier Nazca pottery has bold geometric or naturalistic motifs, while the later has highly elaborate figures covering the entire surfaces. We encounter "staff-demons," "bloody-mouth" demons, "cactus-spine" demons, and a plethora of trophy heads in the later iconography. Nazca textiles display an astounding diversity of technique and design. Hammered and embossed gold work is also found in the Nazca style.

Around A.D. 600, a foreign style impinged on the Nazca region that has been traced to the Wari culture, near Ayacucho in the South-Central Highlands. Soon after, South Coast ceramics and textiles were converted to highland Tiahuanaco-derived stylistic conventions, which lasted until A.D. 1000. One of our pottery examples [453] actually comes from the highland Wari homeland, and [452] shows this influence on the coast. Two vessels [454 and 455] demonstrate the pure highland Tiahuanaco painted style, with its animal appendages, split eyes, tear bands, double-triangle fangs, and so on, all resembling the carvings on the Gateway of the Sun at Tiahuanaco itself. Two objects in Tiahuanaco style are of different materials: a miniature turquoise figure [456] and a wooden leeboard for a raft [457]. Also there are two Tiahuanaco style textiles from the South Coast: a typical tapestry-weave poncho fragment with its abstract geometric patterning [458], and a complete shirt fabricated in double-cloth technique [459].

The Late Intermediate period Ica culture, A.D. 1000–ca. 1400, is not well represented in this collection [460 and 461]. Ica pottery is characterized by muted colors and tiny repetitive geometric patterning; the textiles reflect the same stylistic tendency (note the Ica tapestry-weave shirt) [461]. In addition, we illustrate a diminutive hollow metal bird effigy attributed to the South Coast Ica culture [460], which was complexly pieced and soldered together from a number of pieces of gilded silver.

The terminal civilization to appear on the coast, of course, was the Inca (A.D. 1450–1532). We have reserved for this section seven examples of Inca arts and crafts [462–468]. Our two examples of Inca pottery [462 and 463] are not entirely representative, though the bird-headed tray is diagnostic. The

most diagnostic Inca pottery form is a conical-bottomed storage jar, with loop handles and a lug for carrying it by a tumpline on human backs. While we have repeated accounts of the marvels of Inca gold and silver so rapidly melted down by the Spaniards, we are able to illustrate only two token examples of this tradition [464 and 465]. The miniature hollow gold llama effigy is one of the best of its kind to survive. The hollow silver effigy is typical, but certainly a "poor show" considering the life-sized metal figures described by the Spaniards in the gardens of the Temple of the Sun at Cuzco. By Chimu and Inca times, bronze was invented. It is exemplified here by one cast effigy *tumi* knife [466]. Belonging to the Inca cultural inventory are wooden *chicha* (corn beer) drinking goblets, which continued to be made into the early Colonial period [467]. Inca textiles have been preserved in some quantity, and show the culmination of ancient loom weaving in the Central Andes. In addition to poncho shirts and other garments, woven slings and coca-leaf bags, carried by any adult Inca male, are especially common. One of the most striking of crafts, well preserved from Inca times, is feather-mosaic work [468]. It is obvious, however, that whatever "burial furniture" has been excavated from graves and preserved in museum and private collections—originally intended to nourish the dead in the next world—represents only a fraction of what must have been in existence when Pizarro arrived on the Pre-Columbian scene.

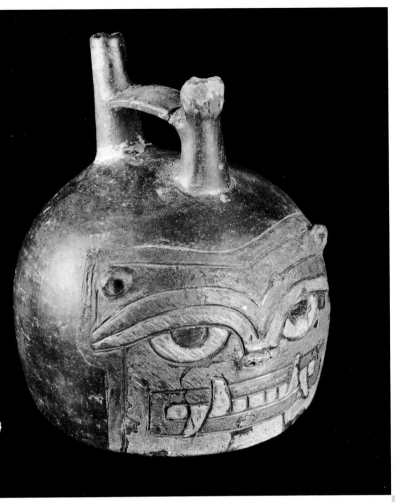

435. Double-Spout-and-Bridge Vessel

*Peru, South Coast, Early Paracas culture. Early Horizon,
1000–600 B.C.*
Resin-painted black earthenware
Gift, 183:1979; H. 18 cm., Diam. 15.5 cm.

An early Paracas bottle with a zoned-incised feline face
mask on the front. Its features are painted after firing the
vessel ("post-fire" painting) with resin-based red, and
dark and light orange colors. The eyes with their pupils
at the top, and the mouth with the double fangs cutting
across both lips, prove Chavinoid stylistic influence from
the North Coast. The feline's ears and nose are in relief.
The front spout formerly held a tiny effigy head.
Whereas the stirrup-spout form became a long tradition
on the North Coast, the double-spout-and-bridge form
became equally pervasive on the South Coast. So too, on
the North Coast ceramic bottles tended to be flat-bot-
tomed, whereas on the South Coast they tended to be
round-bottomed.

436. Falcon Effigy Bottle

*Peru, South Coast, Middle Paracas culture. Early Horizon,
600–300 B.C.*
*Red, green, and white paint on polished black earthenware (See
color plate)*
Gift, 367:1978; H. 16 cm., L. 15 cm.

A resin-painted vessel employing a surprisingly bright
green pigment (a hue permissible only in unfired pig-
ments). Characteristically, the zones of color are outlined
with incisions. A hollow falcon's head on the front is
connected to the rear spout by a strap handle. While the
effigy head has a slit, this vessel does not whistle. The
wings of the bird are modeled in such a way as to suggest
that the body of the vessel represents a domestic house
type rather than a bird [cf. 451]. The front "wings" are
decorated with feather-like chevrons, while the body of
the bird continues down a front panel. The rear section
is incised with conventional whippoorwill motifs.

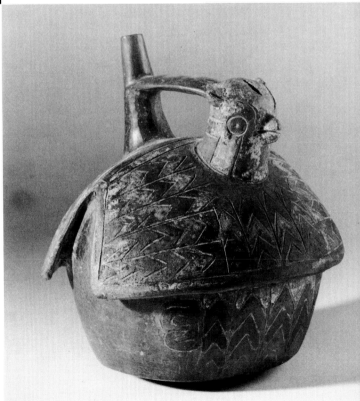

437. Double-Spout-and-Bridge Bottle

Peru, South Coast, Middle Paracas culture. Early Horizon, 600–300 B.C.
Post-fire painted black earthenware
Gift, 160:1980; H. 16 cm., Diam. 20 cm.

This somewhat unusual example has a modeled double-headed serpent that begins on one side of the subglobular vessel, coils around under the bridge handle, and ends in the top center. Zones of well-preserved, resin-based yellow and red paint on the serpent are divided by incisions. Nostrils and nodes on this creature are in raised relief.

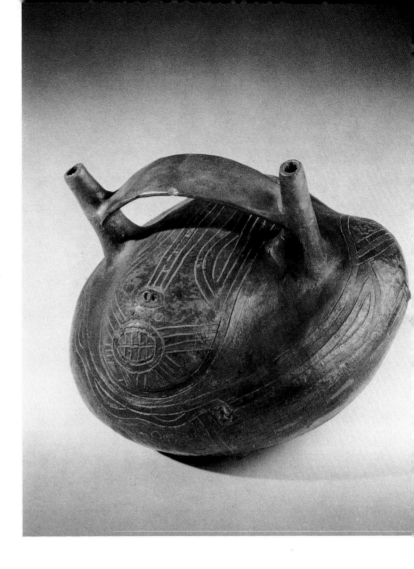

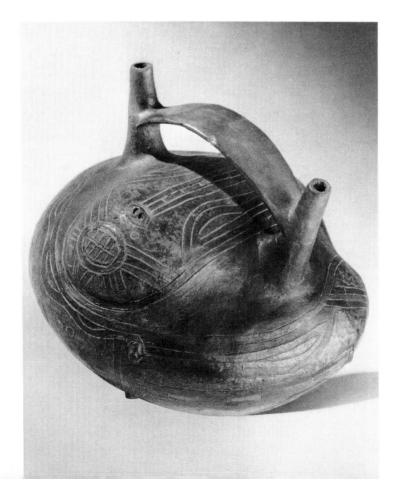

438. Double-Spout-and-Bridge Bottle

Peru, South Coast, Middle Paracas culture. Early Horizon, 600–300 B.C.
Polished black-brown earthenware with post-fire pigment
Purchase, 110:1966; H. 14.5 cm., Diam. 16 cm.

A diagnostic subglobular Paracas vessel with one "blind" spout modeled as a bird. The area of incised and painted decoration covers little more than half of the body. Only traces of powdery red and white pigment remain on the design. The incised panels include abstract geometric feline heads and circles connected by lines.

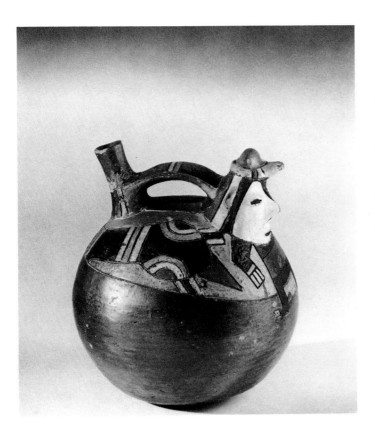

439. Human Effigy Bottle

Peru, South Coast (Ocucaje), Late Paracas culture. Early Intermediate period, 300–100 B.C.
Polished brown earthenware with yellow, cream, red, and black paint
Gift, 368:1978; H. 13.5 cm., Diam. 11 cm. (Illustrated: Lapiner, 1976, item 147)

Globular vessel with spout and strap handle joined to a human head. The body of this figure continues, like a bib, onto the front of the bottle. Around the shoulder is a double-headed serpent, while the handle has stepped-fret designs. These areas are incised and filled with thick, well-preserved resin paint. (Compare with 438, for an example of poorly preserved post-fire paint.)

440. Hollow Standing Figure

Peru, South Coast, Late Paracas culture. Early Intermediate period, 300–100 B.C.
Painted brown earthenware
Gift, 187:1979; H. 21.5 cm.

A rare variation of Late Paracas ceramic work (see Lapiner, 1976, item 202, for a comparable figure). The hand modeling is relatively crude for Paracas standards. A woman is portrayed holding her hood with her right hand and a jar with the other. The figure is post-fire painted with incised zones of red and cream, leaving areas of unslipped brown clay.

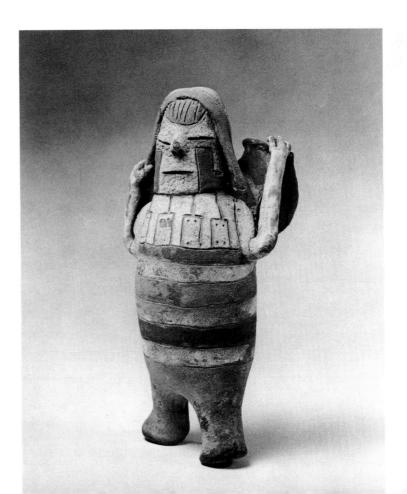

441. Resist-Painted Bottle

Peru, South Coast, Late Paracas culture. Early Intermediate period, 300–100 B.C.
Orange-slipped earthenware with black resist paint
Gift of Alan R. Sawyer, 89:1966; H. 14 cm., Diam. 17 cm.

One spout of this double-spout-and-bridge vessel is closed and modeled as a bird. (Although its mouth is pierced, the vessel does not whistle.) The upper surface of the bottle is painted in a fugitive black pigment leaving negative dots, showing the underlying orange slip. This was accomplished by first applying some resist material such as bees wax, or a vegetable substance, in the negative areas. When the surrounding black pigment was fired onto the vessel, the resist material dissipated to reveal the intended design.

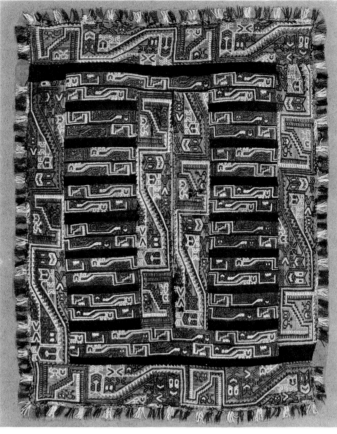

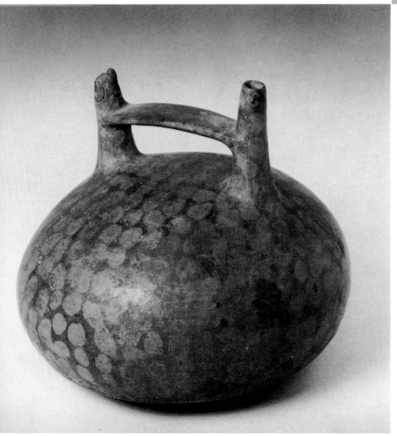

442. Poncho

Peru, South Coast, Late Paracas culture. Early Intermediate period, 300–100 B.C.
Wool embroidery on cotton (See color plate)
Purchase, 24:1956; 76 × 60 cm.

A surprising number of complete embroidered textiles have survived from this early period on the South Coast of Peru—most of them having been applied in layers to sumptuously dressed mummy bundles. Paracas embroidery has long been marveled at for its fine and complex patterning. This garment is a small poncho with hemmed neck slit (photographed laid out in its entirety). The border and filler panels are embroidered in red, black, and yellow wool yarn over plain-weave black cotton. The geometric design consists of repetitive cats with extended bodies and stepped-fret tails, interspersed with smaller profile cats. The border is fringed in black and yellow (and note the intentional asymmetrical gaps at opposite corners).

This article was acquired from John Wise along with a matched set of companion garments, including a large mantle [443], as well as a rectangular wrap-around skirt (218 × 48 cm.), and a long sash or turban (137 × 8 cm.). It is quite likely that all four items came from the same mummy bundle, since they are nearly identical in colors and design. While it would be tempting to illustrate and display them as one complete costume on a manikin (as has been done in the National Museum in Lima), their continued preservation dictates against this.

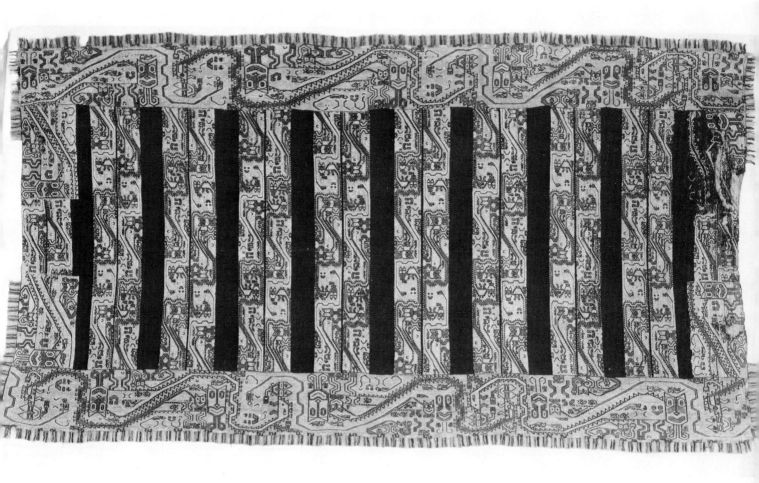

443. Mantle
Peru, South Coast, Late Paracas culture. Early Intermediate period, 300–100 B.C.
Wool embroidery on cotton
Purchase, 21:1956; 260 × 127 cm.

A large, complete Paracas mantle identical in style, technique, and color to the previous poncho, and part of the same costume. On this, the geometric embroidery is, if anything, somewhat more complex. The long, sinuous tails of the primary cats eventually join the bodies of opposing cats. The fringed border is of yellow, red, and black (and note the intentional gaps at the ends). The upper right corner of this fabric has suffered some damage.

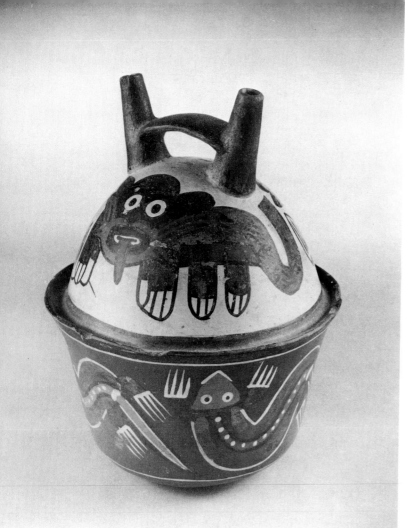

444. Bottle-Bowl
Peru, South Coast, Early Nazca culture. Early Intermediate period, 100 B.C.–A.D. *100*
Polychrome earthenware
Gift of J. Lionberger Davis, 133:1954; H. 19.5 cm., Diam. 16 cm.

The Nazca polychrome pottery tradition grew directly out of the previous Paracas tradition, continuing similar vessel forms but lacking the zoned-incising, and utilizing fired, highly polished, pigments. Here, two basic vessel forms have been modeled together as one—as though a standard spherical double-spout-and-bridge bottle were nesting in a flaring open bowl. The relatively simple polychrome animal motifs, and the liberal areas of plain ground, indicate the early Nazca period. On the top portion, two whiskered, profile, water otters are painted in four colors on a white background. The walls of the bottom portion have four painted lizards on a red background.

445. Human Effigy Bottle
Peru, South Coast, Early Nazca culture. Early Intermediate period, 100 B.C.–A.D. *100*
Polychrome earthenware
Gift, 155:1979; H. 19.5 cm.

Modeled effigy vessels are not as common as plain two-dimensionally painted ceramics in the Nazca tradition. This is polychromed in seven colors on a white ground. The spotted face is orange. The figure is shown holding two different plants, and other vegetal motifs are attached to the arms, indicating that this is some kind of vegetable deity. The vessel has a single spout-and-bridge handle, and there is also a vent hole at the top of the effigy head.

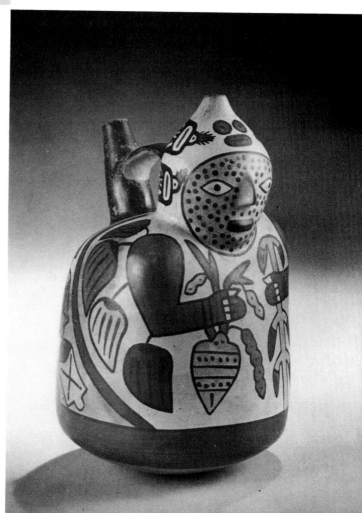

446. Seated Human Effigy Vessel
Peru, South Coast, Middle Nazca culture. Early Intermediate period, A.D. *100–300*
Polychrome earthenware
Gift of J. Lionberger Davis, 146:1954; H. 14.5 cm.

This effigy figure shows the deformity of a protruding lower jaw and a pushed-in face. It wears a fringed, black and white plaid mantle that is thrown over the right shoulder and draped under the left arm. Painted turban straps fall off the back of the head. The left hand is modeled in relief. As in the previous example, there is a single spout-and-bridge as well as a small hole in the top of the head.

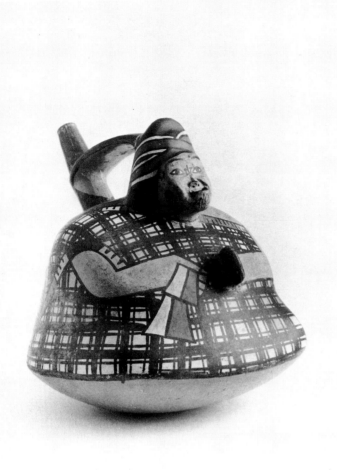

447. Two Polychrome Bowls
Peru, South Coast, Middle Nazca culture. Early Intermediate period, A.D. *100–300*
Polychrome red earthenware
Left: Gift, 227:1979; H. 7 cm., Diam. 19.5 cm. (Ex-coll. Gaffron). Right: Purchase, 73:1942; H. 8 cm., Diam. 21 cm.

Both are typical Middle Nazca flaring bowls, and both are painted in seven different colors. The one on the left features a pair of "staff-god" demons, who flow around the outer vessel walls. This mythical demon has feline whiskers and a spined back filled with trophy-head motifs. The right bowl similarly has two demons disposed around the outer walls. These have scrolled whiskers and scroll-bordered bodies, and are also filled with a series of trophy heads.

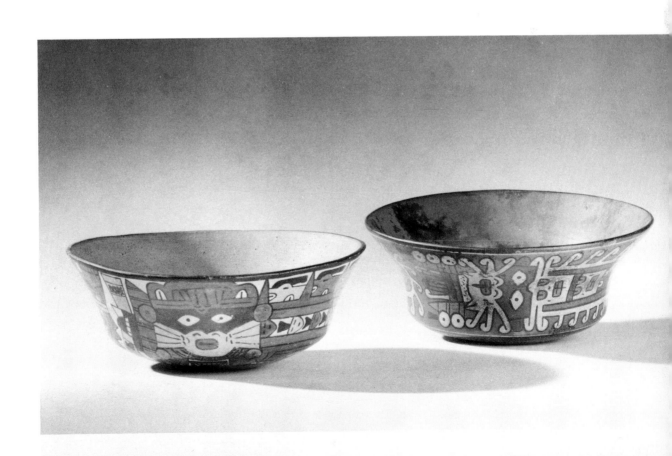

448. Polychrome Bottle

Peru, South Coast, Late Nazca culture. Early Intermediate period, A.D. 300–600
Six-color polychrome earthenware
Gift, 228:1979; H. 15 cm., Diam. 16 cm. (Ex-coll. Gaffron)

A Late Nazca double-spout-and-bridge bottle painted with complex mythological creatures on white background. Spread out on both sides of the shoulder are versions of the so-called cactus-spine demon. The band around the base contains horizontal trophy heads with interlocking headdresses. (On one side is a punctation perpetrated by the grave robber's metal probe.)

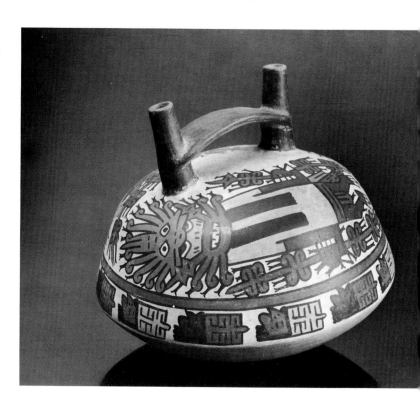

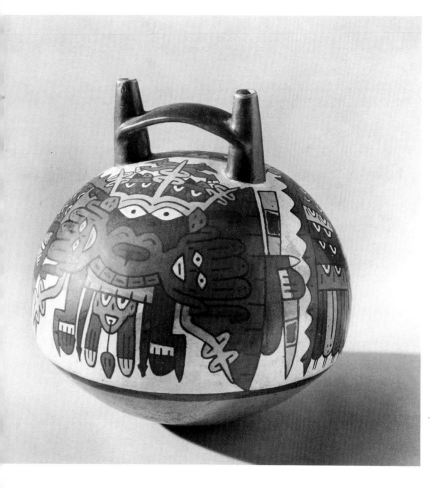

449. Double-Spout-and-Bridge Bottle

Peru, South Coast, Middle Nazca culture. Early Intermediate period, A.D. 100–300
Eight-color polychrome on orange-slipped earthenware (See color plate)
Gift of J. Lionberger Davis, 130:1954; H. 20.5 cm., Diam. 20 cm.

When Nazca polychrome pottery is good, it is exquisite —in thin-walled technology, in color, and in iconography. This example is in such a class. On two sides are identical painted cat demons with horizontal whiskers, segmented bodies, human limbs, and an arm off to the side holding a digging stick (?). Many of the Nazca demons seem to represent agricultural fertility. These complex polychrome images are painted over a white ground.

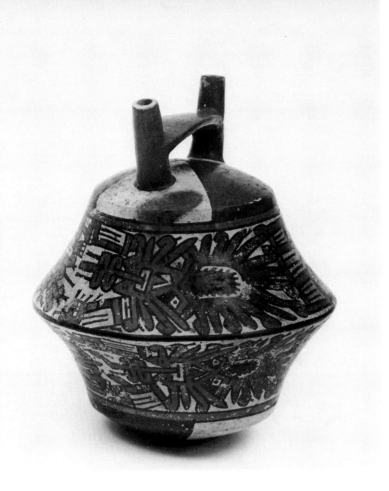

450. Compound Double-Spout-and-Bridge Bottle

Peru, South Coast, Late Nazca culture. Early Intermediate period, A.D. *300–600*
Polychrome earthenware
Gift, 229:1979; H. 18.5 cm., Diam. 17 cm.

Fabricated as one vessel form using the concept of two round-bottomed, flaring-sided, bowls placed one over the other. It is painted in six-color polychrome. Two whiskered "cactus-spine" demons are stretched out horizontally on both the top and bottom "bowls." The round top and bottom are divided into four painted quadrants of alternating black and white—a Late Nazca trait.

451. House-Form Vessel

Peru, South Coast, Late Nazca culture. Early Intermediate period, A.D. *300–600*
Polychrome earthenware
Gift of J. Lionberger Davis, 131:1954; H. 12 cm., L. 12 cm.

Nazca vessels modeled representationally are relatively rare, though this clearly depicts a stepped-gabled house with half-enclosed roof, and a spout that doubles as a chimney. Not clear in the photo is a ridge beam between the gables. Painted on all four sides are simplified human figures holding staffs or stalks. The colors used are: gray, black, cream, light orange, dark orange, and red.

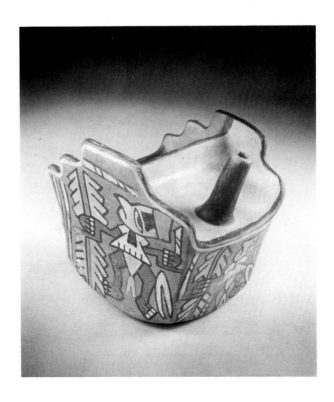

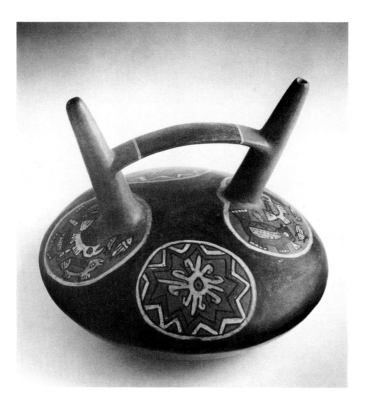

452. Squat Double-Spout-and-Bridge Vessel

Peru, South Coast, Wari style. Middle Horizon, A.D. *600–1000*

Polychrome earthenware

Gift of J. Lionberger Davis, 135:1954; H. 14.5 cm., Diam. 18.5 cm.

The sharply splayed, tapered spouts connected by a handle, as well as the extremely squat, sharp-shouldered, form, are style traits of the terminal Nazca period, during the time of highland Wari-Tiahuanaco intrusion on the South Coast. The two painted medallions with rosettes show a very specific locus of origin from Wari in the South Peruvian Highlands. The pair of medallions at the base of the spouts is painted with clusters of animals, birds, and fish. The medallions and spouts are slipped orange, while the background and the handle are painted black. Other colors include red, light orange, and white.

453. Modeled Feline Vessel

Peru, Central Highlands, Wari style. Middle Horizon, A.D. *600–1000*

Polished orange-slipped earthenware with red, black, and white paint

Gift, 348:1978; H. 26.5 cm., L. 34 cm., W. 23 cm.

An expressive fat feline effigy, with rimmed vessel opening and tapered spout on one side. The peculiar choice of muted colors and decorations shows that this represents Tiahuanaco influence in the highlands and, more specifically, the local Wari variant. The wide, white-painted mouth displays large upper and lower fangs, and the curled tail and the legs have rectangular "stripe" markings. The body has rhomboid "spots" filled with red, outlined in black, and each with four white dots. (This is the only highland "Tiahuanaco" ceramic in the collection.)

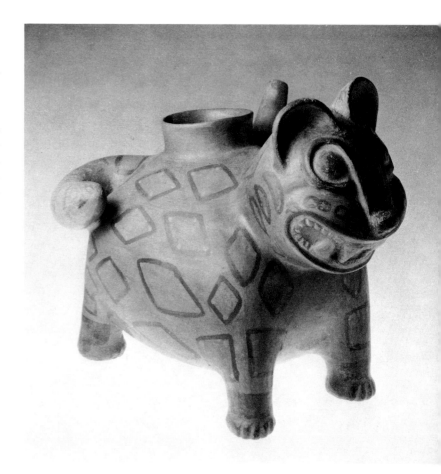

454. Flat-Bottomed Bottle

Peru, South Coast, Coastal Tiahuanaco style. Middle Horizon,
A.D. *600–1000*
Polychrome orange-slipped earthenware (See color plate)
Purchase, 111:1942; H. 19.5 cm.

In style, this is a mate to the previous ceramic, and represents pure highland Tiahuanaco influence on the South Coast. The neck of the bottle is executed as a white-faced death's head, while the standing figure is painted on the front. Prominently displayed on his poncho are four puma heads, with crossed fangs, split eyes, and tear bands. The top chevron band and the five painted colors are identical to the last object.

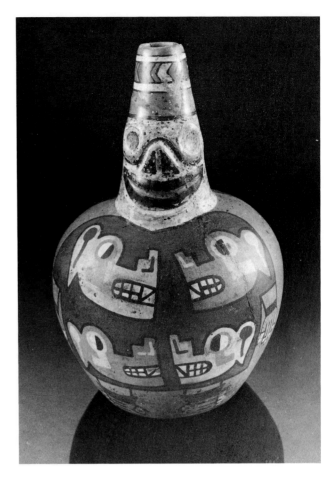

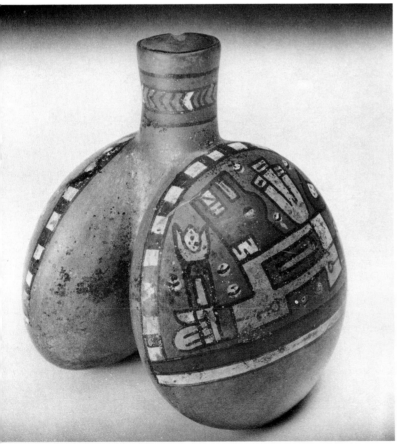

455. Double-Lobed Bottle

Peru, South Coast, Coastal Tiahuanaco style. Middle Horizon,
A.D. *600–1000*
Polychrome orange-slipped earthenware
Purchase, 110:1942; H. 24 cm., L. 21 cm., W. 18 cm.

This is constructed as two canteen shapes joined by a single spout. Both the form and the painted panels are nearly identical to an early Chimu moldmade vessel in the collection [421]. The outsides of both lobes are painted with sprawling animals holding plant stalks, and with puma heads as well as various other geometric appendages. Specific motifs such as the double-triangle fangs, split eyes, and painted tips on the appendages, as well as the chevron band on the vessel neck, all are devices of the Coastal Tiahuanaco style (and ultimately derive from the highland Tiahuanaco site). The painted colors include red, light orange, gray, black, and white.

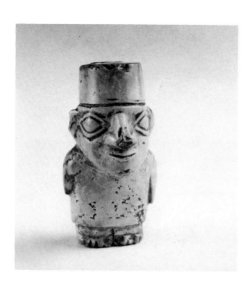

456. Miniature Male Figure
Peru, South Highlands, Tiahuanaco culture. Middle Horizon,
A.D. *600–1000*
Turquoise (See color plate)
Gift of J. Lionberger Davis, 167:1954; H. 3.1 cm.

Objects carved from green turquoise are not only rare in
the Andes but seldom seen in foreign collections. This
tiny figurine has an oversize head with fezlike cap (cop-
ied from actual woven Tiahuanaco headgear), stumpy
arms, and mere suggestions of legs and feet below the
tunic.

457. Leeboard for a Raft
Peru, South Coast (Ica Valley), Coastal Tiahuanaco style.
Middle Horizon, A.D. *600–1000 (or somewhat later)*
Fine-grained wood with traces of red paint
Gift, 241:1978; L. 100.5 cm.

These wooden objects, often found in South Coastal
graves, are of uncertain function. They have been called
grave posts, agricultural implements, and steering boards
for oceangoing rafts (we accept the last function). Note
the semilunar opening for the handle. While many other
known examples are larger and polychrome-painted, this
one has six nicely carved water birds on the handle and
five projecting frets on one side.

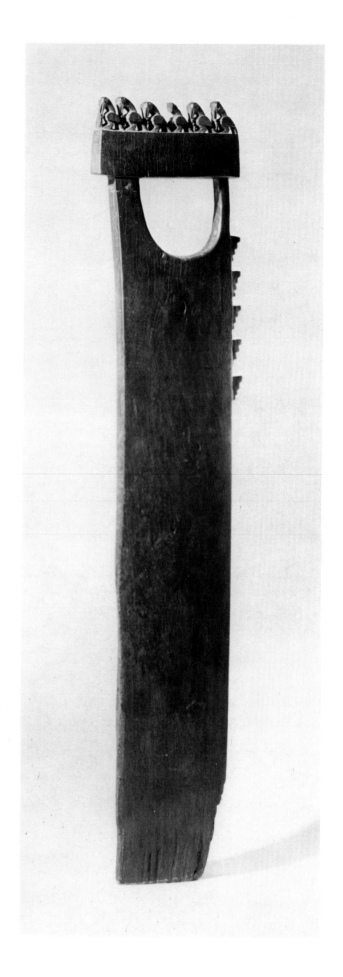

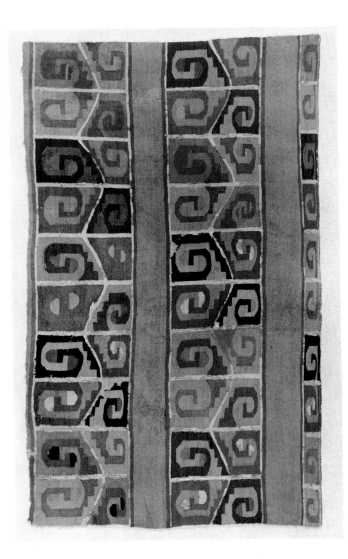

458. Section of Poncho Shirt

Peru, South Coast, Tiahuanaco style. Middle Horizon, A.D.
600–1000
Polychrome wool weft on cotton warp; tapestry weave (See color plate)
Purchase, 44:1967; 36.5 × 74 cm. (Ex-coll. Textile Museum, Washington, D.C.; by exchange)

A classic Tiahuanaco geometric, stepped-spiral, pattern in abstract interlocking panels. The colors include white, dark brown, and blue, along with five subtle shades of beige. Tapestry weave is executed with separate weft strands, adding threads horizontally on the loom with every change of color in the design. In Pre-Columbian Peru, the loose ends automatically left on the reverse side of the cloth were individually tucked into the weave so that, unlike European tapestries, the back is as equally well finished as the front. Another normal result of the tapestry technique is vertical slits following the warp threads where colors change. On this cloth these have been joined. (However, slit, or "kelim," tapestry was also produced in ancient Peru for its special effect.)

459. Shirt

Peru, South Coast, Late Tiahuanaco style. Middle Horizon, ca.
A.D. *1000*
Dyed wool; double-cloth weave
Gift of Edward Murphy, 144:1976; 45 × 74 cm.

Pieced together in the same way as the Ica shirt [461], this consists of six separately woven bands sewn together vertically. The sides are sewn leaving arm holes, and there is a neck slit in the center. Each band is woven in two colors of wool in a two-layer, "double-cloth," technique whereby each color alternates from one face to the other on the loom. Four of the vertical bands are yellow and red, while the two center bands are purple and tan. The lower two-thirds of each side feature spotted double-headed serpents, while plain red or purple bands fold over the shoulder area. This garment is much frayed and stained, but is of relatively unusual construction. (The photo shows the detail of two of the bands, only.)

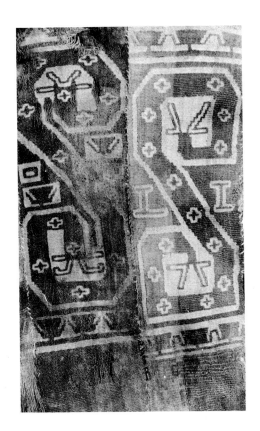

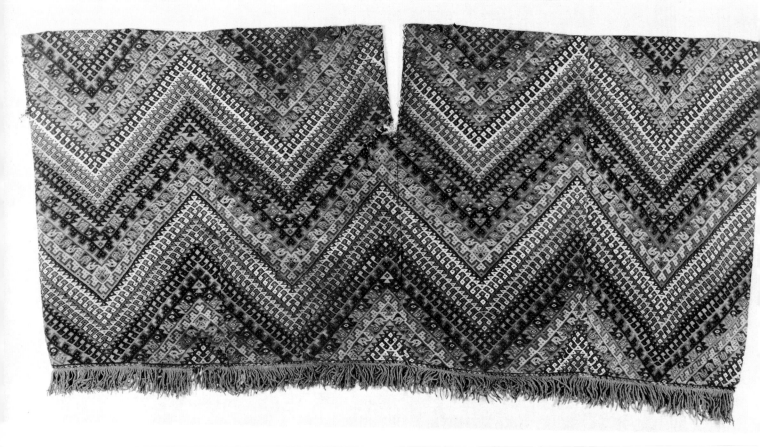

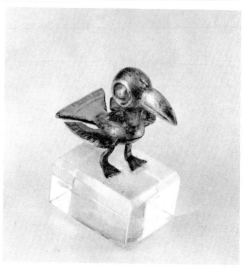

460. Shirt

Peru, South Coast, Ica culture. Late Intermediate period, A.D. *1000–1400*
Dyed wool (llama or alpaca); tapestry weave (See color plate)
Purchase, 284:1949; H. 59 cm., W. 125 cm.

A complete shirt sewn up the sides, leaving arm holes. It was woven in four separate sections, matched and joined vertically, and folded over the shoulder to form the garment. The neck slit is at the center. Tiny, repetitive, geometric birds and other intricate patterns are carried out in the tightly woven tapestry in shades of white, red, yellow, brown, and black. This kind of patterning is also found in the contemporary Ica pottery.

461. Hollow Metal Bird

Peru, South Coast, Ica culture. Late Intermediate period, A.D. *1000–1400*
Silver gilt
Gift of J. Lionberger Davis, 155:1954; H. 2.7 cm., L. 3.2 cm., W. 2.3 cm.

This tiny water bird was fabricated of five pieces of gilded silver, and is hollow. The top and bottom of the body are joined along the edges of the wings and tail. The attached head is made in two soldered pieces. (The longitudinal seam can be seen along the head and beak.) The webbed feet and legs are soldered to the belly. The tops of the wings and tail are engraved with feather designs. (For a discussion of even more complex composite gold effigies from a much earlier period in Peru, see Lechtman, Parsons, and Young, 1975. The latter form a group of seven matched hollow gold jaguars, each made of twelve joined pieces.) Technologically sophisticated metallurgy goes back to Chavin times.

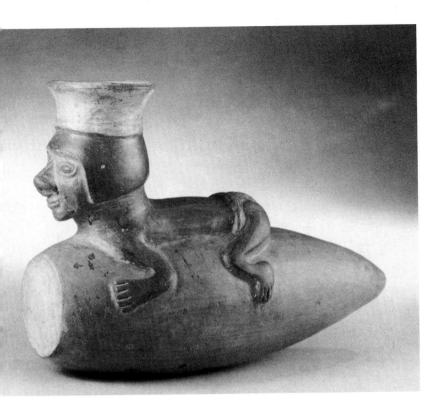

462. "Man on a Boat"

Peru, South Coast (?), Inca culture. Late Horizon, A.D. 1400–1532
Polychrome earthenware
Gift, 371:1978; H. 15 cm., L. 23 cm.

Inca ceramics from the latest Peruvian Pre-Columbian period are not as prevalent in collections as one might imagine (like Aztec pottery, and not to be entirely facetious, perhaps they were trampled underfoot by the conquistadores). This effigy vessel is painted in muted shades of orange, red, black, and cream. There is a spout at the top of the head as well as a perforation at the end for drinking. The torpedo-shaped base is modeled after a bundled balsa-reed boat (still made and used along the North Coast of Peru). A modeled figure in a loincloth clutches the top as he propels the craft "out into the surf."

463. Shallow Bird Effigy Dish

Peru, South Coast (?), Inca culture. Late Horizon, A.D. 1400–1532
Red, cream, and black paint on orange earthenware (See color plate)
Gift of Mrs. John R. Green, 64:1959; H. 7 cm., L. 23.5 cm.

A diagnostic Inca ceramic form, with muted polychrome paint. One side of the dish has a projecting bird's head, while the opposite has two prongs representing tail feathers. The bird head and the rim are black, the wide inner band is cream, and the center circle is red. Painted on this circle is a spotted dogfish. (The bottom shows the orange underslip.)

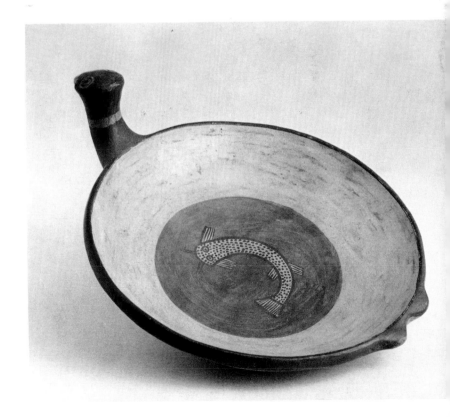

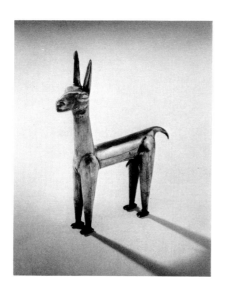

464. Hollow Male Llama Effigy

Peru (provenance unknown), Inca culture. Late Horizon, A.D. *1400–1532*
Sheet gold (See color plate)
Gift of J. Lionberger Davis, 166:1954; H. 6.1 cm., L. 5.3 cm.
(Illustrated: Wardwell, 1968, item 30)

A superb example of a miniature gold llama, characteristic of Inca metallurgy and iconography. The Inca reached the culmination of a long tradition of gold working and, unlike the situation in Mexico, the Spanish conquistadores were amply rewarded in their search for New World treasures, especially gold. This hollow effigy was fabricated of many separate parts [as 461], though the joins were so expertly smoothed and polished, they are not readily apparent.

465. Hollow Female Figure

Peru (provenance unknown), Inca culture. Late Horizon, A.D. *1400–1532*
Sheet silver
Gift of J. Lionberger Davis, 168:1954: H. 6.1 cm.

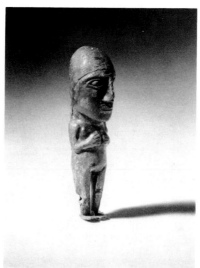

Like the previous hollow gold llama, this human figure is a common subject for Inca metallurgists, here executed in silver. The seams of the component parts are not apparent (except for an indication of a joint along the nose), having been effectively obliterated during manufacture. The hair is shown falling in two long tresses behind, and individual strands are incised in concentric lines. The female organ and breasts also are depicted. There are several corrosion holes in the tarnished thin sheet silver.

466. Effigy *Tumi* Knife

Peru (probably North Coast), Inca culture. Late Horizon, A.D. *1400–1532*
Cast bronze with green corrosion
Gift of J. Lionberger Davis, 160:1954; H. 13.5 cm., W. 10.5 cm.

While the very hard alloy of copper and tin came into general use in Peru by A.D. 1000, it was employed to make rather routine knives, choppers, chisels, and pins. These utensils were often decorated with elaborately cast finials, like those displayed on this crescent-shaped *tumi* knife. The full-round finial portrays a standing male figure with a spiked hairdo and corn cobs in his hands. In addition, the handle has a hollow rattle cast with the object. This is perforated to outline corn plants on one side and a shore bird on the other.

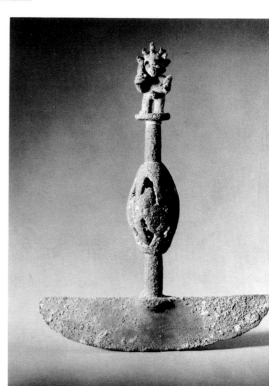

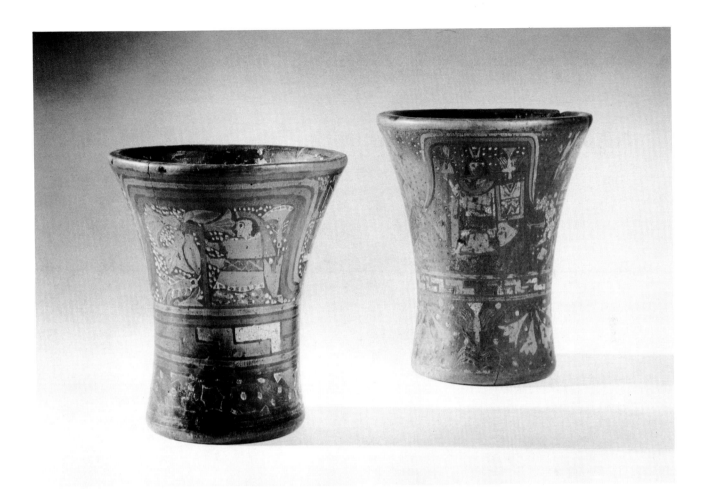

467. Painted Goblets ("*Keros*")

Peru, Highlands, post-Inca. Sixteenth century A.D.
Wood with inlaid pigment
Gift of J. Lionberger Davis, 122 and 123:1954; (left) H. 18 cm., Diam. 16 cm.; (right) H. 16.5., Diam. 15 cm.

Pre-Conquest Inca wooden goblets generally have incised geometric designs, while the *kero* form itself goes back to the highland Tiahuanaco tradition. Elaborately painted vessels such as these are clearly post-Conquest in the Inca tradition, often incorporating some aspects of European heraldry and subject matter (such as horses and stringed musical instruments). These are done in a kind of "paint cloisonné" technique—the areas of design are shallowly excised and subsequently filled with pigments (red, blue-green, cream, and black). The *kero* on the left depicts a regal personage with a flowering plant on one side; another person on the other side displays a shield. The *kero* on the right has a central panel with a standing warrior and a canopy held by two dogs; there also are geometric designs derived from Inca textiles. It shows a Colonial repair where a crack was joined by a lead-filled mortise. The lower borders of both *keros* are filled with flowers. These goblets were used ceremonially for drinking *chicha,* a native corn beer.

468. Feather Mosaic Panel

Peru, South Coast, Inca culture. Late Horizon, A.D. *1400–1532*

Blue macaw and yellow canary feathers on cotton fabric (See color plate)

Purchase, 285:1949; L. 209 cm., H. 68.5 cm.

Feather mosaic panels, ponchos, mummy masks, and coca bags are abundantly preserved in South Coast graves, especially for the late period, which this large rectangular panel represents. Tropical bird feathers were imported from the eastern Montaña of Peru for this purpose. The mosaic, presumably a wall hanging for an Inca shrine, is constructed of thousands of feathers disposed in four alternating quadrants. Each feather was individually tied to cotton strings, which were then attached in overlapping rows to a plain-weave cotton backing. The upper border is hemmed with a band 4 centimeters wide.

According to accession information, this panel was found with about two dozen others in a ceremonial burial with a llama. (These have become dispersed in collections throughout the world, but the present whereabouts of four other identical pieces may be cited: the Musées Royaux d'Art et d'Historie in Brussels; the Bliss Collection at Dumbarton Oaks in Washington, D.C.; the University Museum in Philadelphia; and one recently sold at a Sotheby-Parke Bernet auction in New York.)

Bibliography

Titles marked with an asterisk are recommended for general reading.

Anton, Ferdinand and Frederick Dockstader
Pre-Columbian Art and Later Indian Tribes. New York: Harry N. Abrams, 1968.

*Bennett, Wendell
Ancient Arts of the Andes. New York: The Museum of Modern Art, 1954.

Boos, Frank H. and Philippa D. Shaplin
"A Classic Zapotec Tile Frieze in St. Louis," Archaeology. Vol. 22, No. 1, 1969, pp. 36–43.

*Bushnell, G. H. S.
Peru. New York: Frederick A. Praeger, 1957.
Ancient Arts of the Americas. New York: Frederick A. Praeger, 1965.

*Coe, Michael D.
Mexico. New York: Frederick A. Praeger, 1962.
The Jaguar's Children: Pre-Classic Central Mexico. New York: The Museum of Primitive Art, 1965.
Maya. New York: Frederick A. Praeger, 1966.

*Covarrubias, Miguel
Indian Art of Mexico and Central America. New York: Alfred A. Knopf, 1957.

Disselhoff, H. D. and S. Linne
The Art of Ancient America. New York: Crown Publishers, 1960.

Dockstader, Frederick
Indian Art in South America. New York: the New York Graphic Society, 1967.

*Easby, Elizabeth and John F. Scott
Before Cortes: Sculpture of Middle America. New York: The Metropolitan Museum of Art (distributed by the New York Graphic Society), 1970.

Fewkes, J. Walter
"A Carved Wooden Object from Santo Domingo," Man, No. 78, 1919.

Flor y Canto del Arte Prehispanico de Mexico. Mexico: Fondo Editorial de la Plastica Mexicana, 1964.

Grove, David
"The San Pablo Pantheon Mound: A Middle Preclassic Site in Morelos, Mexico," American Antiquity, Vol. 35, No. 1, 1970, pp. 62–73.

Hunter, Bruce C.
A Guide to Ancient Maya Ruins. Norman, Okla.: University of Oklahoma Press, 1974.

Joralemon, David
"A Study of Olmec Iconography,"

Studies in Pre-Columbian Art and Archaeology, No. 7, 1971, Dumbarton Oaks, Washington, D.C.

Kelemen, Pal
Medieval American Art. 2 vols., New York: The Macmillan Co., 1943.

*Kubler, George
The Art and Architecture of Ancient America. Baltimore: Pelican History of Art, Penguin Books, 1975.

*Lapiner, Alan
Pre-Columbian Art of South America. New York: Harry N. Abrams, 1976.

Lathrap, Donald
Ancient Ecuador: Culture, Clay, and Creativity, 3000–300 B.C. Chicago: Field Museum of Natural History, 1975.

Lechtman, Heather, Lee Parsons, and William Young
"Seven Matched Hollow Gold Jaguars from Peru's Early Horizon," *Studies in Pre-Columbian Art and Archaeology,* No. 16, 1975, Dumbarton Oaks, Washington, D.C.

Liman, Florence and Marshall Durbin
"Some New Glyphs on an Unusual Maya Stela," *American Antiquity.* Vol. 40, No. 3, 1975, pp. 315–320.

*Meggers, Betty
Ecuador. New York: Frederick A. Praeger, 1966.

Nicholson, H. B. and Rainer Berger
"Two Aztec Wood Idols; Iconographic and Chronologic Analysis," *Studies in Pre-Columbian Art and Archaeology,* No. 5, 1968, Dumbarton Oaks, Washington, D.C.

Parsons, Lee
"An Examination of Four Moche Jars from the Same Mold," *American Antiquity,* Vol. 27, No. 4, 1962, pp. 515–519.
Pre-Columbian America. The Art and Archaeology of South, Central, and Middle America. Publications in Anthropology and History, No. 2, 1974,

Milwaukee Public Museum, Milwaukee, Wis.
Ritual Arts of the South Seas. The Morton D. May Collection. St. Louis: The St. Louis Art Museum, 1975.
"The Peripheral Coastal Lowlands and the Middle Classic Period," in *Middle Classic Mesoamerica: A.D. 400–700,* Esther Pasztory, ed., New York: Columbia University Press, 1978, pp. 25–34.
"Post-Olmec Stone Sculpture: The Olmec-Izapan Transition on the Southern Pacific Coast and Highlands," in *The Olmec and Their Neighbors: Essays in Memory of Matthew W. Stirling.* Michael D. Coe and David Grove, organizers; Elizabeth P. Benson, ed. Dumbarton Oaks Research Library and Collections, Washington, D.C., 1979, p. 269 ff.

————, and Peter Jenson
"Boulder Sculpture on the Pacific Coast of Guatemala," *Archaeology,* Vol. 18, No. 2, 1965, pp. 132–144.

*Reichel-Dolmatoff, G.
Colombia. New York: Frederick A. Praeger, 1965.

*Robertson, Donald
Pre-Columbian Architecture. New York: George Braziller, 1963.

*Stone, Doris
Pre-Columbian Man Finds Central America. Cambridge, Mass.: Peabody Museum Press, 1972.

*Von Winning, Hasso
Pre-Columbian Art of Mexico and Central America. New York: Harry N. Abrams, 1968.

Wardell, Allen
The Gold of Ancient America. Boston: The Museum of Fine Arts (distributed by the New York Graphic Society), 1968.

Wauchope, Robert, ed.
Handbook of Middle American Indians. Vols., 1–16, Austin, Tex.: University of Texas Press, 1964–76.

Index

Page numbers in italics indicate illustrations.

Zacatecas style, Terminal Preclassic, 200
 B.C.–A.D. 300, 62
 human effigy jar, 68
 male and female couple, 69
 male drummer, 69
Zapotec art, 129–154
 person with jaguar head mask, Late Classic,
 A.D. 600–900, 153

seated female, Early Classic, A.D. 300–600,
 153
tenoned serpent head, Early Classic, A.D.
 300–600, 153
two sculptured tile friezes, Late Classic,
 A.D. 600–900, 154
 see also Monte Alban
Zapotec culture, 11, 15, 92, 127–128, 184